Painting of
the Gothic Era

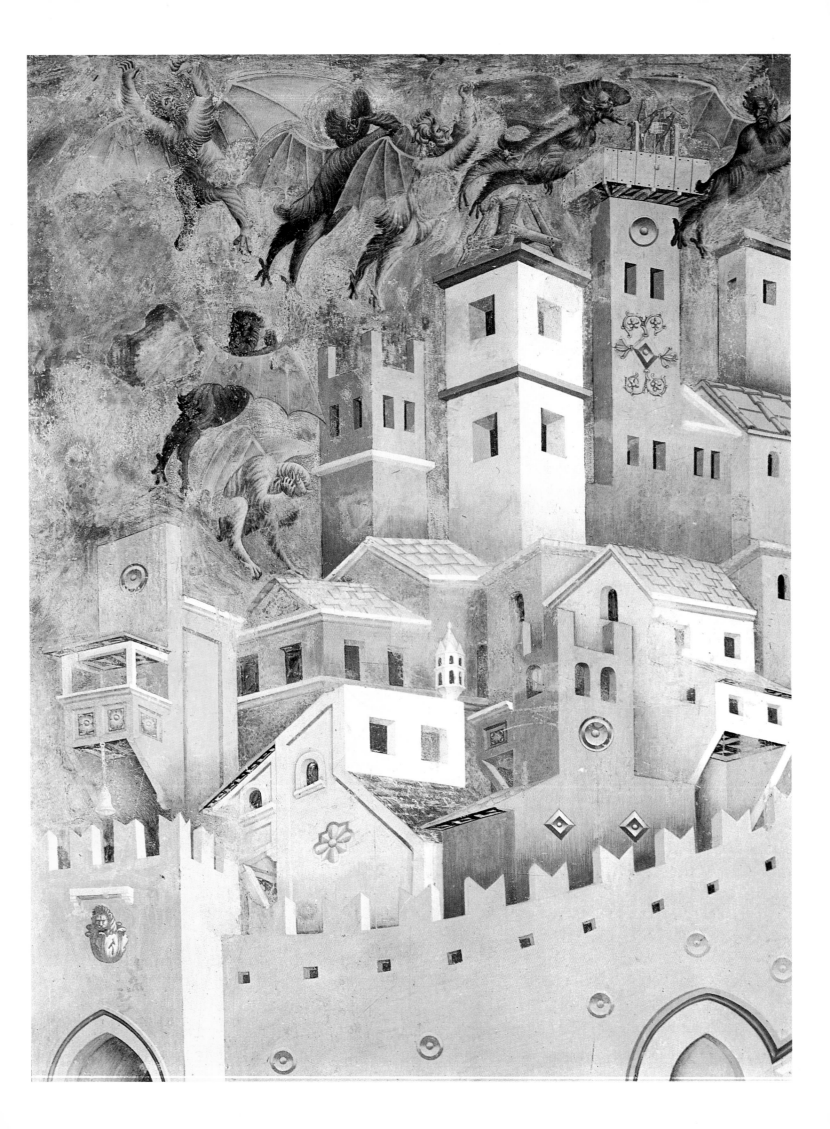

EPOCHS & STYLES

PAINTING OF THE GOTHIC ERA

Edited by
Ingo F. Walther

by Robert Suckale
and Matthias Weniger

TASCHEN

KÖLN LONDON MADRID NEW YORK PARIS TOKYO

Illustration page 2:
Giotto di Bondone
The Devils Cast out of Arezzo (detail), c. 1296/97
Fresco. Assisi, San Francesco, Upper Church

© 1999 Benedikt Taschen Verlag GmbH
Hohenzollernring 53, D – 50672 Köln
Editing and production: Juliane Steinbrecher, Cologne
Translation: Karen Williams, High Raw Green
Cover design: Angelika Taschen, Cologne

Printed in Portugal
ISBN 3-8228-6525-7
GB

Contents

GOTHIC

European Painting from the 13th to the 15th Century

The Gothic era opens a new chapter in the history of art, one which marks the transition from the Middle Ages to the Renaissance and the beginning of secular painting. In contrast to the Middle Ages, whose imagery was rooted entirely in the realms of the hereafter, the artists of the Gothic era looked to the present for their inspiration and thereby arrived at a new realism. Their discovery of a new, material world also led them to a more joyful vision of reality which placed greater emphasis upon feeling.

With the development of court society and the rise of civic culture, the Gothic style blossomed. Art was infused with a new sophistication and elegance. Loving attention to detail, animated use of line, a luminous palette and a masterly technique were typical features of the new style which would quickly take Europe by storm. Gothic art reached its high point in the frescos and panel paintings of Giotto, Duccio, the Lorenzetti brothers, Simone Martini and Fra Angelico in Florence and Siena, in stained glass in France, in the altarpieces of Jan van Eyck and Rogier van der Weyden in the Netherlands, in the exquisite illuminations executed by the Limburg brothers and other miniaturists, in the panels issuing from the courts of Prague and Vienna, and in the Soft Style of the North German masters and the graceful works of Stefan Lochner.

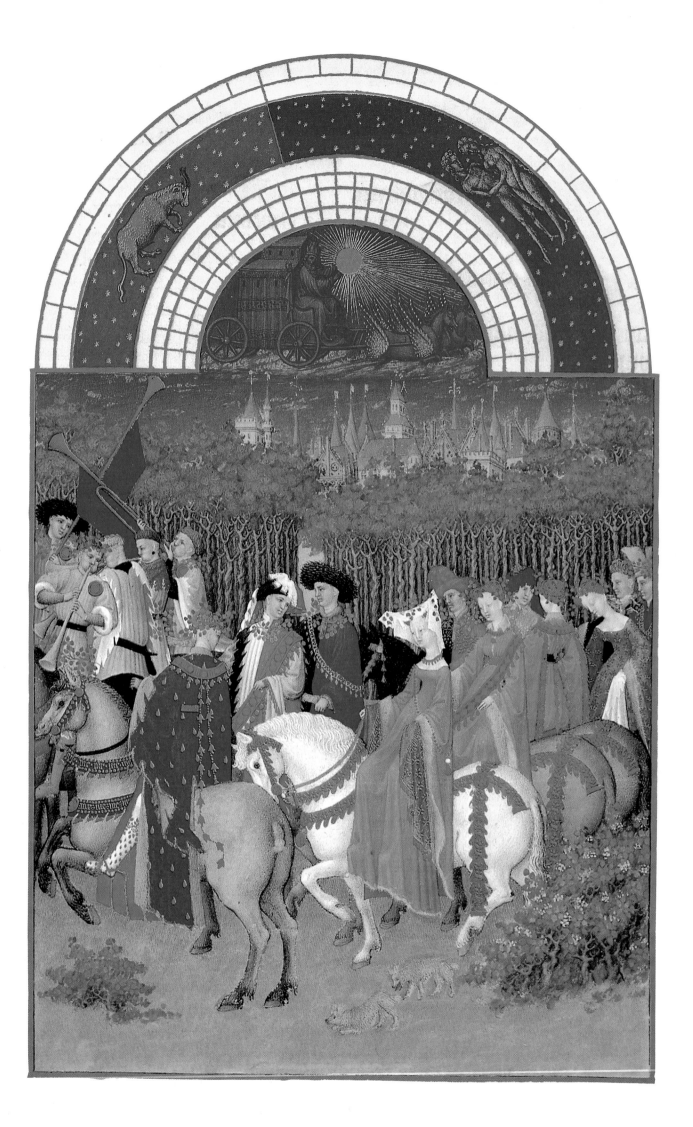

Why "Gothic"?

Gothic was originally a term of contempt. Only much later would it emerge as the name of an epoch. It was unknown to the masters of Gothic painting. It was coined by the Italian theoreticians of the 15th century – as a potent byword for something that needed to be quashed. Even Giorgio Vasari (1511–1574) traced the style explicitly back to the Goths, in his eyes the most heinous of criminals imaginable. It was they, supposedly, who had razed the classical edifices of the Romans and killed their architects, and then filled all Italy with their accursed buildings. They brought with them a German order whose ornamentation and proportions differed drastically from those of classical antiquity. They were shunned by good artists as monstrous and barbaric. Theirs was a style which, even though it had swamped the world, was characterized not by measure and degree, but by confusion and chaos.

Spread and impact of the Gothic style

A more temperate opinion was not to be expected from Vasari, the 16th-century Florentine patriot. Although we are indebted to his biographies of famous artists of the Renaissance for their endless wealth of information, his errors of judgement continue to colour our thinking even today. In truth, there are such fundamental differences between Italy and the rest of western Europe that it is highly questionable whether Giotto (c. 1270–1337) and his followers – for Vasari the heralds of a rebirth of art in the spirit of antiquity – can be subsumed under the overall heading of "Gothic". Of the thousands of paintings which have survived from this period, it is clear in all but a handful of cases from which side of the Alps their artists came. Even the terms used to describe the different phases within the era are very different, with artistic developments in Italy still being known by their century – as Dugento or Duecento, Trecento and Quattrocento.

Leaving aside the phenomenon of the so-called International Gothic or International Style of c. 1400, which we shall be discussing later, the Gothic style never really took root in Italy. A hundred years later, artistic developments in the North and the South had diverged even further than before and around 1300. While the High Renaissance triumphed in the latter in the shape of Raphael (1483–1520) and Leonardo (1452–1519), the Late Gothic masters of Nuremberg, Cologne, Bruges, Antwerp, Barcelona, Burgos, Lisbon and even Paris allowed themselves to be influenced at most only superficially by the new art. On the Iberian peninsula, still closely tied to the arabesques and surface ornament of Islamic

art, the Gothic style would remain dominant until well into the 16th century, and from there even gain a foothold in the new colonies. In Spain and Portugal, as partly also in England and Germany, the Gothic was so strong that it was able to absorb the forms of the Renaissance without relinquishing its own fundamental structures. In certain places where the Renaissance had never really taken hold, it was thus able, after 1600, to pass almost unnoticed into the vocabulary of the Baroque.

The Gothic thereby remained the prevailing style in very different parts of Europe for well over 300 years – longer than the Romanesque before it, and considerably longer than both the Baroque which came after and the second International Style of the 20th century, the three other artistic trends which dominated all Europe and, latterly too, those overseas cultures strongly stamped by the Old World. The power it continued to house was reflected in the Gothic Revival which arose in England after the decline of the Baroque, and which spread to Germany and ultimately to the USA and even Australia.

Characteristics of Gothic painting

What makes up the Gothic style is not quite so easy to grasp in painting as it is in architecture, where pointed arches, rib vaults and multiple-rib pillars usually offer rapid points of reference. What distinguishes Gothic painting is first of all a predominance of line, be it scrolling, undulating or fractured, and ultimately an ornament tied to the plane.

This calligraphic element may be seen as a fundamental constituent of the Gothic style. It is found in its purest form in the gently undulating hems of robes in French painting and sculpture towards 1300, and above all in the draperies which fall in cascades, like thickly waving locks of hair, from the bent arms of figures viewed side on. The style rapidly spread across a broad geographical area; it can be seen in Sweden and Norway (ill. p. 52) by the first third of the 14th century. The rich play of draperies reaches its high point in the years around 1400. Granted a presence virtually of their own by their emphasis and size, they now frame figures viewed frontally.

Draperies in the preceding Early and High Gothic periods assume – again in painting as in sculpture – a far greater variety of expressions. Predominant, however, are thinner, more close-fitting robes with long, parallel folds (ill. p. 12). Narrow pleats are common. In the final phase of the Gothic style, which follows a "Baroque" phase of overspilling, rounded folds, one stereotype replaces another. While robes remain lavishly cut, their folds now assume a crystalline sharpness. Analogous to the draperies, hairstyles and beards are characterized by thick, regular curls.

This emphasis upon line in the Gothic figure is paralleled by a symbolic and ultimately unnatural stylization of the human body itself. The contours of even the earliest Gothic figures are lent a rhythmic sweep. Particularly characteristic of this trend are the frequently very high-waisted figures of the

Paul, Jean and Herman Limburg
Calendar of the months: May, 1414–1416
(from the *Très Riches Heures*, fol. 5 v
Manuscript illumination, 29 x 21 cm
Chantilly, Musée Condé (ms. 65)

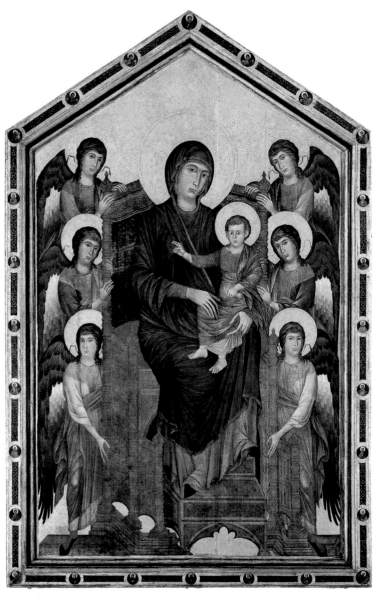

Cimabue
Maestà (Madonna Enthroned), c 1270 (?)
Tempera on wood, 427 x 280 cm
Paris, Musée du Louvre

14th century, whose silhouettes often trace a decidedly S-shaped curve. This love affair with line cannot be entirely divorced from another constituent of the Gothic ideal, namely the very slender, oval facial type which remains a constant throughout the entire period, regardless of all new trends and changing ideals.

Such pointers can only highlight the most obvious features of an epoch; they cannot do justice to all its individual expressions. Thus within High Gothic sculpture there exists a small group of works which come extraordinarily close to the harmonious proportions of the classical human figure. In the midst of the extremely refined art of the French court in the years around 1300, there suddenly appear flat faces of strikingly broad and angular outline, which subsequently became one of the most distinctive features of Lotharingian Madonna statues. In painting, Master Theoderic (doc. from 1359–c. 1381; ills. pp. 17, 66) set himself apart from the overrefinement and

stylization of the Master of Hohenfurth (active c. 1350; ill. p. 64) and the Bohemian master of the *Glatz Madonna* (active c. 1345; ill. p. 63) of just ten years earlier with the powerful, heavy heads of his massive, thickset saints. Here, as never before in Western art, they are people of real flesh and blood. One of his colleagues, later known as Master Bertram of Minden (c. 1340–1414/15; ills. pp. 29, 80), emulated him to some degree, but overall Theoderic's excursion into powerful individualization was carried no further.

The birth of the new style

Even more problematic than the term "Gothic" itself is the precise dating of the period to which it was posthumously applied. Its regional variations, too, demand more specific differentiation. In contrast to what Vasari would have us believe, the Gothic style had its origins not in the Germanic north, but in France, where large numbers of classical buildings were in fact still standing in Vasari's own day. It was the intensive study of these very remains – and not some anti-classical reaction – that inspired the development of Gothic forms of ornament and a new image of man. Thus some of the most impressive examples of French cathedral sculpture owe their origins to this appraisal of antiquity – decades before, towards the end of the 13th century in Rome, the painters Pietro Cavallini (c. 1240/50?–after 1330), Jacopo Torriti (active c. 1270–1300) and Filippo Rusuti (active c. 1297–1317) turned their attention to their classical heritage and thereby laid the foundations for Giotto's revolution.

In St Denis, even before 1150, Abbot Suger (c. 1081–1151) "invented" the ribbed vault which, with its pointed arches and large windows, would lay down the ground plan for the ambulatories of Gothic cathedrals. Elsewhere, however, much remained indebted to the Romanesque style. Even as High Gothic architecture in the region around Paris entered its classical phase with the construction of Chartres at the start of the 13th century, in neighbouring countries, on the Rhine and in Spain, buildings were still springing up in the excessively ornamented style of the Late Romanesque. The new style was not embraced synchronously by all of Europe at once, but rather was adopted by different disciplines of art at different points in time. Even amongst the painters of the French court, old Byzantine traditions persisted into the 13th century. Only towards the middle of the century does a genuinely Gothic style become palpable in painting – an entire century later than in architecture. German and Italian painting, meanwhile, were being swept at the very same time by a fresh wave of Byzantine influence.

On the other hand, this Late Romanesque phase bore the appearance, in Germany in particular, of a rearguard action. The more naturalistic proportions being employed in the portrayal of the human figure and its draperies by their French neighbours had not escaped the notice of the German painters. Instead of adopting this new development directly,

however, they took its powerfully animated robes and stylized them – in a Byzantine manner – with crystalline folds, arriving at what has been aptly termed the zigzag style. This style is found in England, too, although the country's close artistic ties to France also produced more naturalistic forms.

The Gothic style and Italy

The Italian works included in this volume also commence with the end of the 13th century. Although they do not fall under the heading of Gothic painting as such, they exerted an enduring influence upon the Gothic style from almost the very start – and did not remain untouched in return. Their artistic starting-point was the Byzantine Empire, which began on the eastern shores of the Adriatic and which enjoyed close political and cultural links with many of Italy's cities. A series of four Madonna panels, one by the Sienese artist Duccio di Buoninsegna (c. 1255– c. 1319; ill. right and p. 47), two by the Florentine Cimabue (c. 1240– after 1302; ills. pp. 12, 42), and one by his compatriot Giotto (ill. p. 43), might almost have been deliberately designed to illustrate the magnitude of the development which took place within just one generation. Three of them hang in the same room in the Uffizi in Florence.

In all four pictures, the Virgin is seated on an elaborate throne. In the Duccio and the earlier of the two Cimabue paintings, this tapers illogically towards the foreground; a vague attempt at the perspectival effects achieved by earlier generations – right back to classical antiquity. In the two later works, on the other hand, the throne vanishes towards the background. The three earlier thones are ornately fashioned of wood, while Giotto's throne is constructed out of costly stone. We are suddenly confronted with an entirely new vocabulary of form. Above the sides and back of the throne, Giotto deploys pointed arches, trefoil tracery, finials and crockets – the language of Gothic architecture, in other words, already in use in France for over a hundred years, but still very new to Italy. The façades of Siena and Orvieto cathedrals, built during this same period, feature very similar elements and also employ a wealth of coloured marble and costly inlay. While Giotto's throne draws upon the decorative motifs of Islamic art, its curling leaves and scrolling tendrils simultaneously anticipate the ornament which three centuries later would fill the pilasters of the Renaissance.

The very similar poses adopted by the Virgin and Child in the Giotto and the earlier Cimabue suggest that both works looked back to the same Byzantine model. The later Cimabue painting adopts a similar basic format, although the Madonna is seated slightly differently. In the Duccio and both Cimabue paintings, the figures are detailed with extreme care and the folds of their robes rendered with great subtlety. The calligraphic fluency with which Duccio drew the edges of the Virgin's cloak is underlined by the gilding. Despite their angled poses, however, with their knees bent at different heights, the

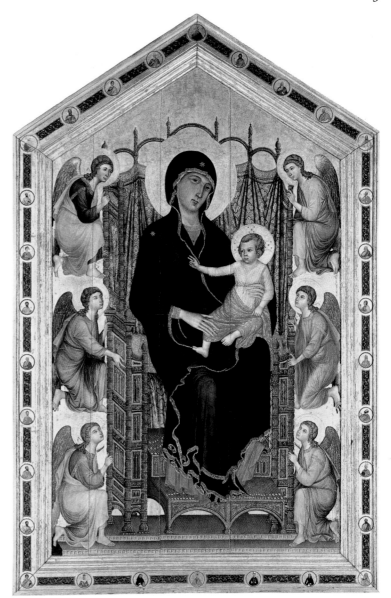

Duccio di Buoninsegna
Rucellai Madonna (Maestà), c. 1285
Tempera on wood, 450 x 290 cm
Florence, Galleria degli Uffizi

three earlier Madonnas ultimately lack true physical substance. They appear to float like cutouts against their lavish backgrounds.

Once again, Giotto does something entirely new. A solid body fills out the draperies; languid, delicate fingers become firm and fleshy. Where robe and body once formed an elegant unity detached from the world, so here a very earthly mother seems to have donned her costly robe purely and uncomfortably for ceremony's sake. Both feet are planted side by side firmly on the ground. In the two earliest paintings, in particular, the Virgin's face reveals the same overly wide bridge of the nose and a mouth which is much too small in relation to the almond-shaped eyes. The modelling of the face has a very graphic quality; line dominates. Thus the artist even draws in the side of the nose upon which the light falls. In Giotto this gives way to blurring shadow; a delicate gauze lies around the eyes, the forehead broadens, the veil sits higher on the head.

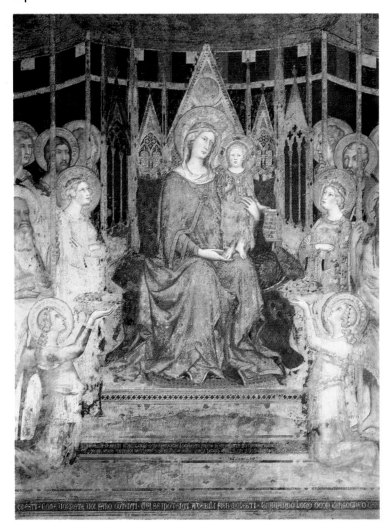

Simone Martini
Maestà, 1315/16
Fresco (detail), 10.58 x 9.77 m (total size)
Siena, Palazzo Pubblico, Museo Civico

had arrived at a more naturalistic treatment of movement, draperies and the distribution of light and shade, is entirely obscured by the force of the revolution wrought by Giotto. His radical change of direction continues to astonish the modern viewer – how much more profoundly it must have shaken his contemporaries. Notwithstanding its Roman predecessors and the influences of antiquity and the French Gothic style, it remains one of the great acts of creation in the history of art.

It was improved upon even in Giotto's own lifetime in the work of the barely less important Sienese artist, Simone Martini (c. 1280/85–1344). In comparison with Giotto's sculptural, block-like figures, with their often correspondingly stiff, awkward, even clumsy gestures, Duccio was already painting with a greater subtlety. Where Giotto portrays raw size, Duccio's figures, more heavily indebted to Byzantine tradition, exhibit greater feeling (ills. pp. 54 f). Duccio's colours, often deeply shaded, shimmer like costly enamel. Although the early works of Simone Martini, born barely twenty years after Giotto, were still characterized by such Byzantine features as the broad bridge of the nose and draperies overlaid with gold leaf, he went on to marry Duccio's achievements both with the new physical type introduced by Giotto and with Giotto's revolutionary understanding of space and architecture.

Simone's enormous *Maestà* fresco in Siena's town hall, depicting the Virgin and Child enthroned and surrounded by saints (ill. left), is distinguished by a particular elegance and beauty of line. Movements are freer, and faces – highly sensitive and often very serious – are more finely modelled and strongly expressive than those of Giotto. While the bearded heads are still largely indebted to Duccio, the slender youthful heads, many of them with half-length hair curling in on itself at the bottom in line with the fashion of the day, are often more "Gothic" than Giotto's. Simone's draperies are again thinner than Giotto's, and their folds more angular. Compared with the plainness of the Florentine master, what is striking overall is the wealth of detail in both the costumes and the setting.

Italy and Bohemia

The innovations pioneered by Giotto and Simone are not simply milestones within the history of Italian art. They serve to illustrate the interplay of mutual influences within non-Byzantine art as a whole, as well as the phenomenon of chronologically staggered developments. Just as Giotto and Simone had absorbed influences from France, so they in turn helped steer painting north of the Alps down entirely new avenues. Even before Giotto's death in 1337, one of the four panels making up the altarpiece for Klosterneuburg near Vienna (ill. p. 53), completed around 1331, quotes literally from the frescos which Giotto executed in 1304–1306 for the Arena Chapel in Padua – one of the first Italian cities which travellers reached after crossing the Alps (ills. pp. 15, 16).

While their closely pleated draperies reflect the ethereal remoteness of the earlier Madonnas, in Giotto both the figures and the fabrics have become heavy and solid. The Virgin's cloak falls into just a few, large folds. Although the three earlier paintings also attempt to differentiate between raised and sunken areas of fabric, the gold on and between the ridges of the red shawl draped around Duccio's infant Christ, and on the Virgin's robes in the later Cimabue, only serve to accentuate the flatness of the overall effect. Giotto, by contrast, already makes highly convincing use of light and shade, limiting gold to the no longer capriciously undulating, but largely flat hems of the Madonna's cloak. What is true of the Virgin and Child is also very much true of Giotto's angels. They are no longer surface decoration, but large, serious figures who, for all their wings, stand or kneel with their full weight on the ground. The lilies and other carefully rendered flowers in their hands also introduce, over and above their symbolic significance, a very robust, earthly element into the exalted heavenly sphere.

The fact that Cimabue and Duccio had already freed themselves significantly from the dominant Byzantine style, and

The remaining three Klosterneuburg panels also testify to the influence of the great Florentine master in their angular faces, austere gestures and in the foreshortening and decoration of their furnishings. That their anonymous artist was nevertheless rooted in the contemporary trends of the North is demonstrated, on the other hand, by the greater animation and curvilinear silhouettes of his figures, and above all by the loose draperies with their richly undulating hems in which they are clad.

A good ten years later we encounter Italian influences again, this time a little further north in Prague, Bohemia, which under Charles IV (1316–1378) became the seat of the Holy Roman Emperor and thus the political as well as the cultural capital of the entire empire. The Bohemian master of the *Glatz Madonna* (ill. p. 63) and his somewhat weaker follower, the Master of Hohenfurth (ill. p. 64; a member of his workshop?) cite Italian head types more faithfully than the Klosterneuburg artist, while the folds of their draperies continue to reflect the tastes of the North. As the *Kaufmann Crucifixion* (ill. p. 62) demonstrates, an exquisite palette featuring striking orange accents becomes characteristic of the Bohemian school, although it could also be seen as a reference to earlier Sienese paintings. The same might be true of the sumptuous detailing of the draperies of the Christ, donor and angels in the Glatz picture. The large panel was originally surrounded by smaller scenes from Christ's childhood, as was the convention in Italy. This was no coincidence: to underline his imperial status, Charles IV was quite blatantly seeking to compete with the leading artistic centres of his day – which meant Tuscany and Paris – and if possible even to surpass them.

Italy and France

The Italian influences finding their way into the Klosterneuburg altar were also being felt strongly in Paris, where the French court was the most spoilt for artists of any in Europe. In 1309, under pressure from the French king Philip the Fair, Pope Clement V (1305–1314) moved his residence from Rome to Avignon, which was closely allied to the French crown lands. He was followed not just by cardinals and the papal court, but also by Italian artists, including for a short time possibly even Giotto himself. Simone Martini certainly spent time in Avignon. He was destined for employment at court not only by the extremely sophisticated elegance of his art, but also by the close contacts he had developed, while still in Italy, with the Anjou family, the then rulers of Naples.

The panel paintings which Simone executed after 1336 are now scattered, but important fragments of his mural decorations for the palace chapel have survived in situ. As a result of conservation measures undertaken in this century, it is even possible to distinguish between the various stages of their execution. The rather damaged frescos themselves have been detached from the detailed preparatory drawings, or sinopie,

underneath and these separated in turn from the original sketch, which remains in its old place. The sinopie, hidden for six hundred years, thereby reveal the delicacy and freedom of Simone's drawing more directly than the finished painting.

From Avignon, the exquisite linearity and powerful, delicate colours of the Sienese artists exerted their influence not only upon the Paris court, where Jean Pucelle (active c. 1319–1335) drew upon them to arrive at a new plasticity and sought to achieve a uniform perspective (ill. p. 51), but also upon nearby Aragon across the Pyrenees (cf. ill. p. 84). Even the Sienese elements of Bohemian court art may have reached Prague via Avignon rather than a more direct source – men such as the bishop who commissioned the *Glatz Madonna* were bound to have spent time at the papal court. Nor should we

Giotto di Bondone
Crucifixion (detail), 1303–1305
Fresco. Padua, Cappella degli Scrovegni all'Arena

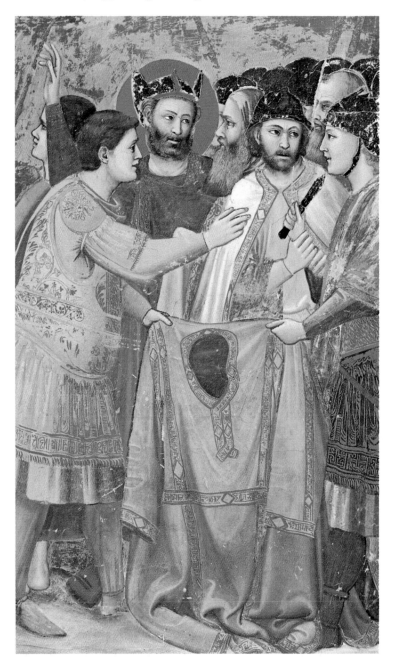

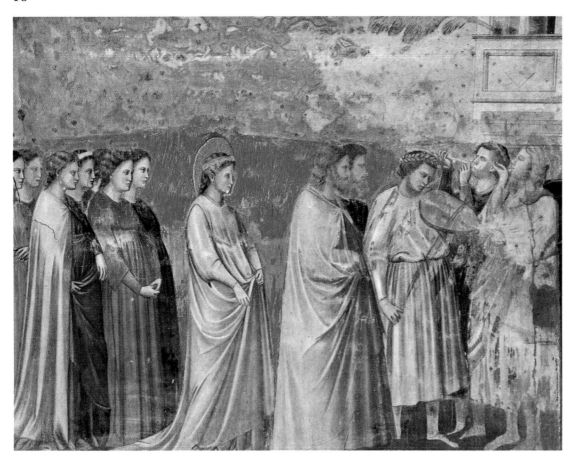

Giotto di Bondone
The Marriage Procession of the Virgin,
1303–1305
Fresco. Padua, Cappella degli
Scrovegni all'Arena

underestimate, in this context, the extent of the artistic exchanges taking place in Avignon itself. According to records, the Italians were working alongside English, Catalan and, in particular of course, French artists.

Pathways to the International Style

Even as an important basis was here being established for the extraordinarily homogeneous style that would stamp itself upon the art of western and central Europe around 1400, so in Tuscany Giotto and Simone Martini had set standards which were almost impossible to surpass. For their contemporaries and followers, consequently, it was a matter of consolidating what had been achieved rather than of embarking upon something new. In Siena, such important painters as Lippo Memmi (active 1317–c. 1350) and Pietro Lorenzetti (c. 1280/90–1348; ill. p. 56 f) further developed the art of Simone, while in Florence Taddeo Gaddi (active c. 1325–1366) and others embraced the legacy of Giotto. A certain artistic paralysis now set in. A contributory factor here was the outbreak in 1348/49 of the Black Death, which spread throughout Europe in just a few months and in some places carried off over half the population, including many artists – Pietro Lorenzetti perhaps among them. Stagnation and increasingly empty routine would make the Italian artists only too eager to embrace the new trends of the International Gothic towards the end of the century.

New impetus would eventually come from the northern centres of Paris and Prague. While the trauma of 1348 contin-

ued to be processed in many places in extremely expressive Crucifixions and Lamentations, the forerunners of the International Gothic were already formulating the new style which, around 1400, would dominate the whole of non-Byzantine Europe. At almost the same time as Theoderic was painting his monumental, melancholy saints for Karlstein castle (ill. p. 17) – the crystallization-point of Charles IV's cultural, political and religious ambitions – the Prague sculptors were unveiling their quite different art, its figures more stereotypical than individual, more elegant than earthly. Their influence immediately began radiating out to neighbouring Silesia, which belonged to Bohemia, and on to Salzburg.

There were enough branches of the Parler dynasty of artists alone to ensure close exchanges with the Rhineland. Characteristic features of this Prague school include Lamentations and, above all, the aptly-named *Schöne Madonnen* ("Beautiful Madonnas"). Alongside their technical perfection, these latter are distinguished by the dynamic sweep of their bodies, an affected pose, faces of an almost saccharine sweetness and in particular a volume of draperies arranged with consummate skill, which tumble down the sides in rich cascades and conclude in a virtuoso sea of undulating hems.

Judging by the quality, number and geographical spread of the works which followed, this aesthetic revolution must have captivated other artists of the day as far away as Italy and even distant Spain. At home, it was translated into painting by the Master of Wittingau (active c. 1380–1390), the last great artist which the Bohemian school, which flow-

ered for just a few decades, would produce. He underlines once again the importance of the new style not just for Bohemia, but for Europe as a whole: almost all the elements which would be central to European painting around 1400 are present in his Wittingau Altar (ill. p. 67). Theoderic's ample figures are reduced to an almost painful thinness: extremities, faces, all are now elongated and fragile; fingers resemble spider's legs. The slender silhouettes are clad all the more expressively in thin, generously cut robes. In a similar fashion to the sculptures mentioned above, the Christ in the Resurrection (ill. p. 66) is enveloped in a cascade of folds ending in a rich swirling hem. Anecdotal details have assumed much greater importance – even where, as in the case of the many birds in the Resurrection, there is little obvious justification for their inclusion in the scene.

The quality of the execution struggles to match the inventiveness of the composition, however. As in the case of the Hohenfurth Altar, the paintings that have come down to us are perhaps only indirect reflections of the true, but now lost masterpieces of their day. There is another striking feature about the Wittingau Altar. As remained the convention in various regions up to the 16th century, the majestic gold ground is restricted to the interior panels, which in Wittingau are reserved – again in line with convention – for standing figures of saints. The narrative scenes on the altar's exterior, on the other hand, employ a red ground dotted with gold stars, which engages in a powerfully expressive interplay with the red of certain draperies. The impression made by the landscape, with its individual elements executed in such particular detail, is also intensified by the complementary colour of the background. There may have been earlier instances of this phenomenon, too, in works that are now lost.

This style had its roots in the Paris court art of the years around 1300, where its forms battled against more abstract tendencies throughout the 14th century. Years before the Wittingau Altar, the Parisian Master of the Narbonne Parament (active c. 1375– um 1400) had demonstrated, in the work which gave him his name (ill. p. 70), his familiarity with the elegant flow of movement, slender silhouettes and the exuberant undulation of fabric hems.

A uniform style throughout western Europe

In the thirty years following the completion of the Wittingau Altar, non-Byzantine painters everywhere competed in their striving towards an ever more exquisite palette and ever more fluid draperies; not without reason is the International Gothic also known as the Soft or Beautiful Style. For the first time, lovingly detailed landscapes became a major element of the composition. For the last time before the Baroque, western European painters shared the same vocabulary, the same aesthetic ideals. Even Italy, entrenched in its old traditions, eagerly embraced the new trend, to the regret of later Renaissance theoreticians of the school of Vasari; the supposedly

unbroken line of development from Giotto to Michelangelo (1475–1564) is a later myth. Gentile da Fabriano (c. 1370–1427; ills. pp. 99 f) and Pisanello (before 1395–1455; ills. pp. 107 ff) were leading figures in both Italian and Gothic art. It is no coincidence that Milan cathedral dates from precisely this period, as a symbol of the triumph of Northern form. There are sociological reasons, too, behind this broad-based stylistic uniformity: the ruling houses of the day were dominated by very similar courtly ideals, which were also finding their way into literature.

What is so truly astonishing about this epoch is the fact that the style was practised so widely, including by many unknown and second-rate artists. But it was also embraced by some of the greatest names in Gothic painting. Apart from Gentile and Pisanello, these included Jean Malouel (c. 1365–1419, ill. p. 82) and Melchior Broederlam (doc. 1381–1409; ill. p. 79) in Paris and the Burgundian capital of Dijon, the Master of the Wilton Dyptych (doc. c. 1390–1395; ill. p. 82) in London (?), Lluís Borrassà (doc. from 1380–c. 1425/26; ill. p. 85) in Catalonia and, in the wealthy Hanseatic city of Dortmund, Konrad of Soest (c. 1370–after 1422; ill. p. 81), who would exert an enormous influence upon west and north German art for decades to come. All of these artists sought to place their own stamp upon the universal style.

Master Theoderic
St Gregory, c. 1360–1365
(from the Chapel of the Holy Cross, Karlstein castle)
Tempera on wood, 113 x 105 cm
Prague, Národni Galeri

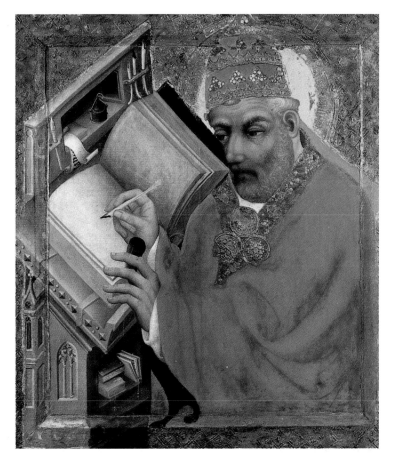

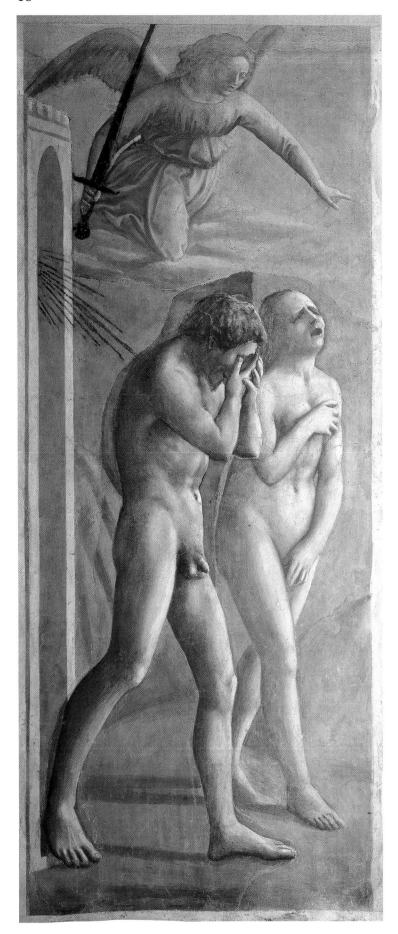

Masaccio
The Expulsion from Paradise, c. 1424/25
Fresco, 214 x 90 cm
Florence, Santa Maria del Carmine, Cappella Brancacci

New departures in Florence and the Netherlands

It was clear by the 1420s at the latest that this rare parallelism would not be a lasting phenomenon. While the Soft Style reached its final flowering in a work such as the Ortenberg Altar (ill. p. 96) – admittedly accompanied by an increasing hardening and stylization of the heads – artists elsewhere had already made a sudden, apparently unexpected break with the past which, like the new departures of Suger and Giotto, would be followed by a period of consolidation and relative quiet. In Florence, Masaccio (1401–1428) and Masolino (1383–after 1435) were laying the foundations of the art of the Renaissance, by infusing Giotto's forgotten compositional formulae with a greater realism and a previously unknown monumentality, derived in turn from a deeper study of antiquity and a closer observation of their own surroundings and the human form. The fragile bodies of the International Gothic are filled with new volume, stances become heavy, profiles broad, shadows deep. In the southern Netherlands, meanwhile, the second great centre of power in western Europe was starting to emerge. Towards the end of the 14th century, Netherlandish artists were already exerting a decisive influence upon developments in Paris, up till then the artistic capital of the North.

Parallel with the new developments in Florence, the brothers Hubert (c. 1370–1426) and Jan van Eyck (c. 1395–1441) – the most important Netherlandish artists of the age – were also turning to the naked human body and lending it a realism unseen since antiquity (ill. p. 104). The paths they followed to the same goal were very different, however. In the case of Masaccio (ill. left), it was a highly intellectual process. His image of humankind is concentrated into archetypes. He is more interested in basic form, flow of movement and volumes than in the surface of things. It was the accurate observation of such surfaces, however, which formed the foundation of Eyckian realism, but which also contained its limitations. Jan van Eyck described the effects of movement without actually understanding them. Thanks to this same eye for detail, however, he succeeded in lending his figures an anatomical quality whose impact was felt even in Italy. Only van Eyck discovered the dimple on Adam's hip, only he described the muscles and sinews around Adam's knee.

Netherlandish empiricism went an astonishingly long way. While Jan van Eyck's contemporary, Filippo Brunelleschi (1377–1446), was "inventing" centralized perspective in Florence, his own pictures contain no unified vanishing point. If his spatial settings frequently seem highly "realistic", it should not be forgotten that the mathematical principles of perspective employed by the Italians strictly speaking contradict the workings of the human eye, which sooner perceives slightly curved lines as straight rather than ones which really are straight. Perspective employing a consistent vanishing point would only find its way into Netherlandish art in the second half of the 15th century.

The Netherlandish love of detail could be celebrated to its fullest in portrayals of untamed nature. Although landscapes as a whole were conceived on a less grandiose scale than in Masaccio, the natural kingdom is portrayed with a precision, technical sophistication and exquisiteness which remain un-equalled today. However different in other respects, even the Italian painting of the Quattrocento regularly drew fruitful inspiration from this same source. Thus the young Raphael was not shy of siting his figures again and again within a Nether-landish natural idyll. This influence of the North upon the South nevertheless still tends to attract much less attention in the literature than the exchanges in the opposite direction.

It has, however, long been known that northern works were eagerly collected south of the Alps. On closer inspection, it thus emerges that an astonishingly high proportion of the works of Hans Memling (c. 1430/40–1494; ill. p. 129) were destined for Italian lovers of art. Rogier van der Weyden (c. 1400–1464; ill. p. 102) and Hugo van der Goes (c. 1440–1482, ill. p. 130 f) both dispatched their paintings across the Alps; Joos van Cleve (c. 1485–1540/41) would later send his biggest altars there. Significantly, a large work by Gerard David (c. 1460–1523; ill. p. 135) for Liguria even modelled itself on the layout of the Italian altarpiece. Down in the far south of Italy, Antonello da Messina (c. 1430–1479) became the champion of Netherlandish ideas possibly without ever having crossed the Alps. Most exciting of all within this process of exchange are the rare personal meetings between artists, such as the work jointly executed at the court of Urbino by the Italian Piero della Francesca (c. 1415/20–1492), the Flemish artist Joos van Gent (active c. 1460–1480) and the Spaniard Pedro Berruguete (c. 1450–1503?). So close and fruitful was their collaboration that trying to identify exactly who painted what continues to cause headaches even today.

The discovery of nature and landscape

The reciprocal influences passing between North and South are illustrated particularly clearly in the backgrounds of the paintings of this era. In England, France and Germany from the final third of the 13th century to the second half of the 14th century, there was a preference for decorative, often very complicated and fussy geometric patterns (ill. p. 50). They live on even in the work of the otherwise anything but conservative Theoderic, and continue to find echoes in the 15th and even early 16th century, not least in the ornamental gold grounds of the Cologne painters (ills. pp. 52, 95) and in particular Stefan Lochner (c. 1400–1451; ills. pp. 126 f).

Making an increasing appearance in the North towards the end of the 14th century are backgrounds of plants and flowers, which soon after 1400 reach an at times breath-taking magnificence. The Master of the Paradise Garden (ill. p. 87) renders each different species in loving detail. But whereas he presents the plants one by one as if in a botanical textbook, the van Eyck brothers weave them, barely twenty years later, into an

organic whole. Grasses no longer stand out palely against a dark ground, as if on a carpet. Here, at least in places, we sense the rampant, untamed growth of nature, following no human rules.

The development of the portrayal of whole landscapes progressed with similar speed. While Giotto observed people and buildings with great care, the rugged, rocky hillsides of his outdoor settings remain for the most part a backdrop of secondary importance (ills. pp. 43 ff). Although he attempts to differentiate trees and plants by species, they remain something of an abbreviated representation of the riches of nature. At the hands of Simone Martini just one generation later, what was simply a foil becomes luxuriant green gardens within which (and not in front of which) the figures act out their parts. In the frescos in the Palazzo Pubblico in Siena (ill. p. 54), panoramas are no longer accessories, but the true protagonists. For all their stylization, they portray familiar real-life landscapes, albeit recognizable more from their architecture and embellishing details than from their barren sugar-loaf hill. When Ambrogio Lorenzetti (c. 1290–um 1348) painted the *Effects of Good Government* (ill. p. 59) in the same building, also well before the middle of the 14th century, he too chose a realistic landscape over a symbolic or allegorical setting. In a broad panorama, he shows the Tuscan hills with their fields, hedges, olive trees and vineyards.

In the north, it would be over fifty years before the three brothers Paul, Jean and Herman Limburg (active c. 1400–1415) would produce landscapes painted with the same loving attention to detail, but often much more fantastical in character (ills. pp. 76 ff). As in the Siena frescos, the identifiable buildings within them serve specifically to reflect glory upon the patron of the work of art concerned. Thus in Siena they proclaimed the success and sphere of influence of the city, while in the Très Riches Heures they reflected the magnificence of the properties owned by the Duc de Berry, for whom the manuscript was executed.

Fantastical, too, are the landscapes of Melchior Broederlam in Dijon, which usher in Early Netherlandish painting (ill. p. 79). Their architecture and rugged cliffs employ formulae which had been developed in Tuscany almost a century earlier, and which had then travelled north, for example via Klosterneuburg and Hohenfurth. Although the *Nativity* by Robert Campin (c. 1375/80–1444; ill. p. 102), also executed for Dijon towards 1430, still employs a snaking track to draw the eye into the background, its route is now bordered by set pieces from the 15th-century viewer's world. Pollarded willows, wicker fencing, fields and contemporary buildings lead towards a distant lake. The rocky outcrop blocking the view has moved to a less obtrusive position above the stable, and appears at least a little more realistic with its patches of turf between bands of rock. At the same time, the landscape is no longer seen entirely from above, but is presented in a more accurate relationship to the figures in the foreground.

A good decade would pass before Konrad Witz (c. 1400–1445) painted, in 1444, a recognizable landscape which no longer relied upon cities and castles for its identification (ill. below). The following years subsequently saw the give and take relationship between South and North reversed. The stylized landscapes of the North, far removed from realism in the modern sense, were enriched by such a carefully-observed wealth of natural detail that even Raphael was unable to resist their charms.

The perfection of technique

Landscape was just one of the temptations drawing collectors to buy Netherlandish art and painters to imitate it. Another was the quality of execution distinguishing its panel paintings, whose standard was never to be equalled. The very wood itself was chosen with particular care. While artists in Italy generally made do with local poplar, and in Spain with pine, in the Netherlands virtually everyone opted for Baltic oak, which was shipped in from far afield. The panels were cut out of the trunk in radial wedges, like slices of cake, in order to prevent any later warping. The softer outermost layers were rejected, so as to forestall any unnecessary extra risk of attack by insects. As a further means of protection, the panels were given solid frames and only then primed, usually on both sides. The wood was thus sealed all round.

As a consequence, the practice of covering the panel with a layer of material, still very common in the 14th century and seen, for example, in the earlier Soest picture (ill. p. 36), the *Kaufmann Crucifixion* (ill. p. 62) and the Schloss Tirol Altar (ill. p. 93), could be largely dropped. On top of the primed panel, whose white ground was intended to shine through the colours laid over it and thereby heighten their luminosity, there was often then executed a detailed preliminary drawing. Only after weeks of preparation, and years even since the original tree had been felled, could painting actually begin. This, too, was an extremely laborious and lengthy process. By no means was the final colour applied straight away *(alla prima)*. Rather, the paint was laid down in several transparent layers (glazes), moving from darker to lighter shades, allowing the underlying layers to shine through. This alone would ensure the tremendous luminosity, durability and exquisite enamel-like sheen of Early Netherlandish panel paintings. Towards the end of the century the number of glazes was gradually reduced, and on occasions in the early 16th century, the white ground or the preliminary drawing was deliberately allowed to shine through.

The paints themselves were naturally not available ready-mixed. Workshop duties in the late Middle Ages included not just painting, but also grinding the pigments. The degree of fineness of the powder thereby influenced the colour it pro-

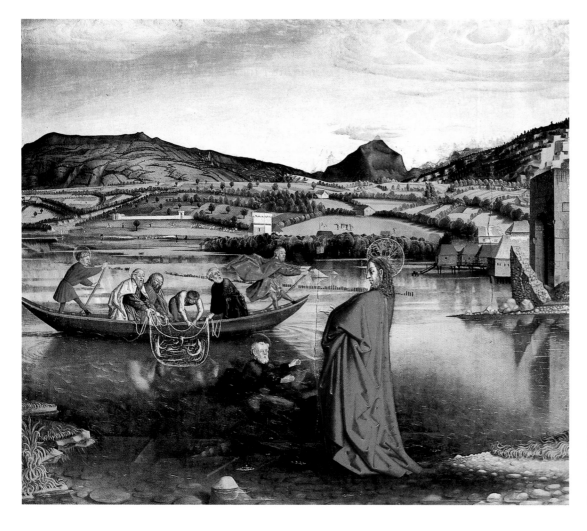

Konrad Witz
The Miraculous Draught of Fishes, 1444
Tempera on wood, 132 x 154 cm
Geneva, Musée d'Art et d'Histoire

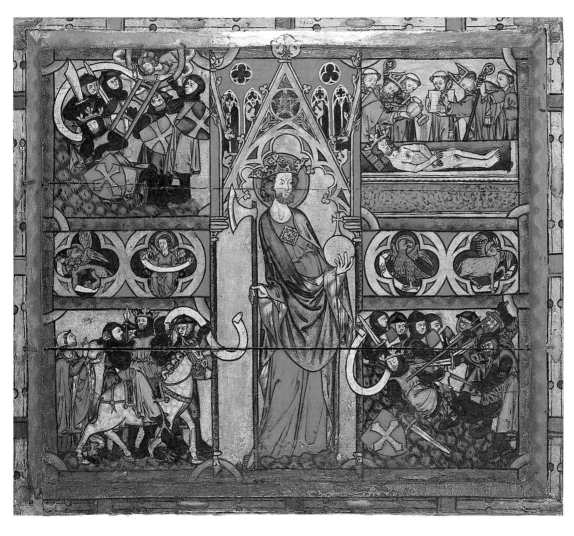

Norwegian Master
St Olaf Antependium, 1350
(from an unknown church)
Mixed technique on wood,
96 x 108 cm
Trondheim, Cathedral

duced. Thus azurite, the most commonly-used blue pigment of the day, only gave a blue effect if it was not ground too finely. A second, important blue pigment was ultramarine. While it offered a greater and more gem-like luminosity, it was obtained from lapis lazuli, which had to be imported from the Orient, from modern-day Afghanistan, and was thus more expensive than gold. Significantly, it was employed with great regularity by the first generation of Early Netherlandish artists, but only extremely sporadically by the technically less ambitious German artists of the day.

Other than in Cologne or even Italy, the Netherlandish artists had almost entirely dispensed with gold, seeking instead to heighten the illusion of reality with a permanently blue sky over a white haze. Areas of gilding, whether grounds, haloes or drapery details, involved a variety of complex procedures. For example, where they were to be given an additional relief pattern by means of pouncing, in other words the hammering of small indentations into the metal, the layer of primer beneath them had to be considerably thicker. Also required was an intermediary bole ground, usually reddish in colour, to which the wafer-thin leaves of precious metal would adhere.

According to the author of the best-known treatise on artist's materials of his day, the painter Cennino Cennini (c. 1370 – c. 1440), pupil of a son of Taddeo Gaddi and thus a "great-grandpupil" of Giotto, one Florentine gold coin yielded a hundred sheets of gold leaf barely the size of the palm of a hand. After the leaf had been laid, it was burnished with a gemstone or a tooth in order to bring out its fascinating sheen. To avoid unnecessary expense, the inclusion of gilded areas within a painting had to be carefully planned in advance. Since the gilding was carried out first, before any actual painting began, the artist had to decide exactly where on his panel the costly material was to go. As a rule, no further gold leaf would then be applied to the remainder of the composition.

Lastly, too, there was the choice of the right binding agent. Since the claim was first made by the art historians of the 16th century, Jan van Eyck has long been credited with the invention of oil painting. The reality is much more complicated. Binders containing oil were known as early as the 13th century, even if they were not yet being deployed with their later sophistication. The fact that they can be found in English (ill. p. 50) and Norwegian (ill. above and p. 52) paintings in particular suggests that artists were already taking into account external factors such as a damp climate. On the other hand, painters in the Netherlands continued to employ egg tempera long after the van Eycks were dead, not least because some pigments failed to mix well with oily binders, which reduced their luminosity.

At the same time, mixed techniques played a far greater role than is generally assumed today. Finally, artists also had to weigh up the characteristics of the individual binders and in particular the oils they employed, since some of them had major implications for the actual painting process. Oils derived from different plants and in different ways dried at different speeds, which meant that in some cases an artist might have to wait many days before the next layer of paint could be applied. This drying process could be speeded up with the help of specific substances.

The artists of the late Middle Ages, and in particular artists in the Netherlands, thus worked within a time frame which, for a public which has grown up with the notion of the artist genius, is almost impossible to grasp. They possessed a detailed knowledge of natural science which, in the following generations and centuries, would increasingly become the sphere of specialist technicians and today the modern chemical industry. Simple, practical calculations were at this stage far more important than the finer points of style, content or even art theory which interest critics and viewers today. Mechanical tasks such as grinding pigments, mixing up paints or burnishing gold grounds took up a large part of their working day. It is only when we take all this into consideration that we start to appreciate why artist apprenticeships in the late Middle Ages generally lasted four years, with the apprentice simply assisting with general tasks at the beginning.

Pictures of St Luke, the patron saint of artists, painting the Virgin provided numerous 15th-century artists with a welcome opportunity to portray the activities of a contemporary artist's workshop. In these we occasionally see an assistant in the background grinding paints. In the painting by Derick Baegert (c. 1440–1515), an angel is lending the Evangelist a hand (ill. p. 23).

The techniques and training described above guaranteed the enduringly high standards and astonishing homogeneity of Early Netherlandish painting which continue to captivate the viewer today. Towards 1500, these same qualities also led it to become a major export not just to Italy, but also to Spain, Portugal and Scandinavia. Mass production, however, inevitably brought about a decline in the rigorous standards of execution which had originally made the school so popular.

Changing motifs and artistic originality

A further consequence of the workshop system was that compositional originality played nowhere near the same role in the Netherlands as it did in later epochs or even in contemporary Italy. In the Netherlands of the 15th century, by contrast, compositional solutions, poses and figural types which were judged to be good were handed down over more than a hundred years. Thus the Last Suppers of the period around 1500, for example, employ elements which were already present in the Last Supper which Konrad of Soest painted for his Bad Wildung altar of 1403 (ill. p. 81). Providing the richest source of all, however, was the œuvre of Rogier van der Weyden, whose *Descent from the Cross* in the Madrid Prado became the most influential painting of the Early Netherlandish school – even before the van Eycks' Ghent Altar (ill. p. 104).

Whereas Jan van Eyck was preoccupied above all with surfaces, Rogier, in this respect more Italian, was interested in structures. As if inspired by fragile marionettes, what is so surprising about Rogier's figures is their – for a Netherlandish artist – astonishingly harmonious proportions and the flexibility of their individual limbs. Whatever other changes might be made, the layout of his Descent, the pose of his Mary Magdalene and the head type of his St John would remain constants until well into the latter phase of the school (cf. ill. p. 102).

Paradoxically, it was precisely this underdeveloped capacity for free, independent observation and the corresponding perpetuation of long-established formulae from one generation to the next which, along with landscape and technique, met with interest in the South. A decisive intermediary role was played in this context by northern woodcuts and copperplate engravings, which like the paintings themselves were distinguished by their extraordinarily high standard of execution. This made them sought-after collector's items which, in contrast to panel paintings, could transport new compositional solutions smoothly and quickly over hundreds of miles.

This time it was Germany which assumed a leading role. Here the genre was carried to its greatest heights by four artists in particular: Master E.S. (active c. 1450–c. 1467), Martin Schongauer (c. 1435/50–1491), Israhel van Meckenem (active c. 1457–c. 1465/70) and Albrecht Dürer (1471–1528), in whose work Raphael was also interested. Schongauer's engravings enjoyed particularly wide distribution, travelling as far as the Iberian peninsula – one of them is supposed to have been coloured by none less than Michelangelo. Dürer, meanwhile, would make up for his disappointment at being unable to study under Schongauer in person by becoming an avid collector of the works he left behind. Schongauer played an important intermediary role, too, having at one stage possibly been active in Rogier's workshop. The impact of his own art made itself felt in the Netherlands, where artists produced paintings which can only be described as colour versions of Schongauer's copper engravings – and this on occasions only months after the originals were first printed. The same was true in Spain, where they were similarly copied by Bartolomé Bermejo (c. 1430– after 1498; ill. p. 140) and Fernando Gallego (c. 1440 – c. 1507).

Derick Baegert
St Luke Painting the Virgin, c. 1485
Mixed technique on wood, 113 x 82 cm
Münster, Westfälisches Landesmuseum
für Kunst und Kulturgeschichte

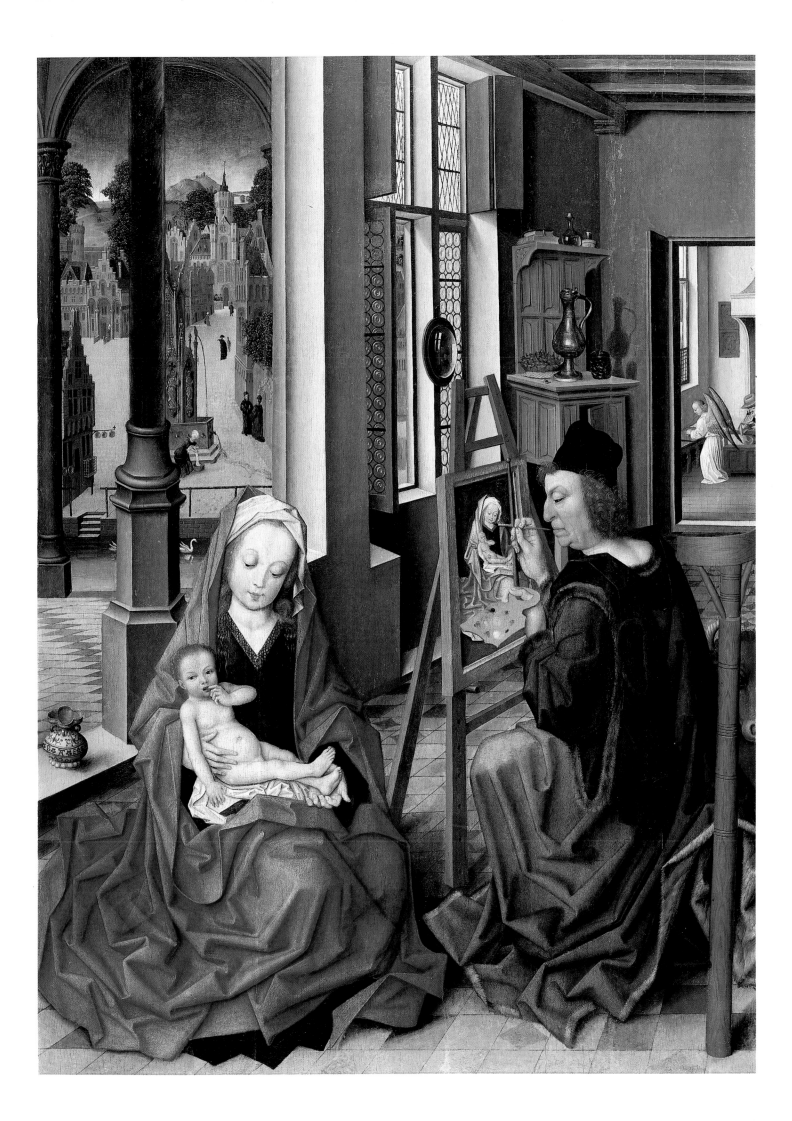

Standardization versus observation

The van Eycks, and many other later Early Netherlandish artists, too, remained indebted to the Middle Ages not just in their working methods. For all the verism they achieved in individual heads, they simply replaced the broad-foreheaded faces of the period around 1400 with their own ideal of an elongated oval. One stylization thus replaced another – thanks not least to Rogier, the master of the type. In other respects, too, until far into the 16th century the only corrections being made were minor adjustments, rather than fundamental

Duccio di Buoninsegna
Christ Entering Jerusalem, 1308–1311
(from the back of the Maestà, formerly on
the high altar of Siena cathedral)
Tempera on wood, 100 x 57 cm
Siena, Museo dell'Opera del Duomo

changes to composition, proportion, the human figure, draperies or landscape. The innovations being pioneered south of the Alps found their way at best into subsidiary details. Even the tracery, crockets and finials of Gothic decoration remained fundamental not just to built architecture but also to goldsmiths, sculptors and painters.

In complete contrast to developments in Italy, this led in most cases to an even greater proliferation of the old forms, to greater overloading rather than greater simplicity. The Netherlandish, German and Spanish artists were so immersed in the formulae of the past that, even when they adopted a Renaissance motif for a capital, frieze or gable, the composition, proportion and structure of the building or furnishing in question remained entirely beholden to the Gothic style. At the same time, and again in contrast to Italy, virtually no new pictorial genres were evolving. Although the individual portrait was becoming increasingly popular, production continued to be dominated by religious subjects.

Perpetuation of the calligraphic element

For all the brilliance of colour, for all the delights of the pictorial surface, however, supremacy continued to lie with two-dimensional line, as can be seen particularly from the few preparatory drawings that survive from the 15th century. The drawings executed directly on the panel itself, as visible today either through the fading glazes above them or with the help of infra-red light, concentrate primarily upon the detailed positioning of the draperies. Whereas heads, hands and elements of landscape are indicated for the most part with the most fleeting of strokes, the contours of drapery folds are precisely laid down and their hollows shaded with generous hatching. The only thing that changed after 1400 with the van Eycks and Campin was the style of these folds: softly undulating hems now gave way to sharp fissures. Whereas the painters of the International Gothic had indulged their love of line in the billowing draperies which enfolded their figures, these had now dropped flat to the ground, lying like a front garden at their wearer's feet and gridded with clearly ridged folds.

The Ghent Altar *Annunciation* (ill. p. 104) can be seen as highly typical of this trend, although it was by no means restricted to kneeling or seated figures. The two Ghent figures are typical in another respect, too. Their draperies are intended to look unstudied, but in truth nothing has been left to chance. In the case of the Virgin, the effect is achieved by the folds which fall first vertically downwards, and which then spill sharply sideways, in a slight overlapping of astonishingly smooth rectangular and trapezoidal planes. Almost more influential would be the numerous triangular forms making up the angel, who is lent additional relief by the wedge-shaped hollows in his robes. No less important than the folds themselves are the strong light and deep shadows which make them visible, and which give the draperies their powerful plasticity.

Master of the Wasservass Calvary
Calvary Hill, c. 1420–1430
Tempera on wood, 131 x 180 cm
Cologne, Wallraf-Richartz-Museum

Impact of the Eycks' innovations

The style of an artist's drapery folds is thus the most reliable criterion by which to determine whether he had come under the spell of the Eyck revolution – more so than broader proportions, more individual faces or the "realistic" representation of plants and other details, aspects which depend more on the individuality of the artist and the subjectivity of the viewer. The impact of the Eycks' innovations upon their contemporaries must have been enormous. When a visit to an exhibition introduces us to a previously unknown direction in art, after leaving the museum we see our surroundings through the eyes of the artist we have just been viewing. The painters who were confronted by the inventions of the van Eycks could no longer see a face, a fold, a fruit tree or a sunset in the same way as before.

Within just five years of the completion of the Ghent Altar, outstanding representatives of this new direction in art had already emerged in various parts of southwest Germany. The Magdalene Altar by Lukas Moser (c. 1390–after 1434) in Tiefenbronn (ill. p. 105) carries the same 1432 date as the van Eycks' own masterpiece, while the Wurzach Altar (ill. p. 121) by the Ulm artist Hans Multscher (c. 1390–c. 1467) is dated 1437. The Albrecht Altar (ill. p. 118) in Vienna must also have arisen around 1437, and the Rottweil artist Konrad Witz appears to have painted his great *Mirror of Salvation* altarpiece in Basle at about the same time. Six hundred miles further west, Nicolás Francés (c. 1434–c. 1468) had already painted the high altar for León cathedral before 1434 (ill. p. 113). They all feature the new realism, the heavy, massive forms and the heavy draperies falling in angular folds.

The waves of Netherlandish influence

This picture was consolidated over the following decades as "Netherlandicizing" currents increasingly gained ground across Europe. In the 1440s, Barthélemy d'Eyck (doc. from 1444– c. 1476) produced his famous *Annunciation* triptych for Aix cathedral (ill. p. 119), while in Naples Colantonio (doc. 1440–1465) made the new style his own (ill. p. 120). In Barcelona, Lluís Dalmau (doc. c. 1428–1461) set about painting, in his 1444/45 *Virgin of the Councillors* (ill. p. 106) for Barcelona's town hall, one of the most faithful imitations of a van Eyck anywhere to be found. In Cologne, the most densely populated city in Germany, Stefan Lochner combined Eyck formulae with clear reminiscences of the Soft Style: the hems of the robes in his *Virgin of the Rose Garden* (ill. p. 127) undulate like waves. Particularly striking here, as in his Darmstadt *Presentation in the Temple* (ill. p. 126), are the delicate, extraordinarily sophisticated harmonies of his palette. In the retrograde handling of scale in their figures, however, both panels lag far behind the van Eycks. Pasty, doll-like faces, overly large gold haloes and gilt grounds embossed with ornate decoration complete the picture.

That Lochner was nevertheless very familiar with developments in the Netherlands can be seen from the *Patron Saints of Cologne* altarpiece which he painted for the chapel in Cologne town hall, and which is today housed in Cologne cathedral. The folds here are far more angular than those of the *Virgin of the Rose Garden* executed a few years later. The *Annunciation* on the altar's exterior (ill. p. 26) recalls the Ghent Altar even at the level of individual motifs in the Vir-

Stefan Lochner
Annunciation, c. 1440–1445
(outer wings of the Patron Saints of
Cologne altarpiece)
Mixed technique on wood,
261 x 284 cm
Cologne, Hohe Domkirche St Petrus
und Maria

gin's spreading draperies. In continuing to deploy elements from the past, however, Lochner was not betraying his incompetence, but was very consciously playing with the motifs and formal canons of different styles and regions – an "un-Gothic", extremely modern approach for which in the 15th century, significantly, parallels existed only in Italy. That we are dealing not with some inferior imitator, but rather with one of the most important Late Gothic artists of all, is surely demonstrated best of all by the fame which he enjoyed for generations to come. His design solutions and nature studies were drawn upon by Schongauer, himself a master of composition, and even Rogier van der Weyden, at that point the most important representative of the Early Netherlandish school. Over half a century after Lochner's death, Albrecht Dürer went to the chapel in Cologne town hall in order to admire for himself the masterpiece which still survives today.

It was precisely the freedom with which Lochner created his art that ensured he would remain an isolated phenomenon, however famous. The Cologne painters of the following decades (ills. pp. 134, 138) would orientate themselves towards their Netherlandish contemporaries, in the first instance primarily towards Rogier's "successor", Dieric Bouts (c. 1410/20 –1475; ill. p. 129). Their borrowings were thereby restricted to selected figural, drapery and landscape forms. Their approach to composition and their techniques of preliminary drawing and execution remained entrenched in local tradition – not just with regards to such obvious features as gold grounds and nimbuses. A constant "updating" of forms derived from the Netherlands can be observed in other European regions, too. The latest trends in Bruges and Antwerp were still being adopted even in distant Portugal right up to the early years of the 16th century.

The separate flowering of the German Late Gothic

While painting in broad areas of Germany had been dominated in the 1460s by fairly similar "Netherlandicizing" traits, towards the end of the 15th century artists in the south of the country increasingly began to emancipate themselves from such influences. Production flourished as private individuals and guilds competed with each other to crown all the main and subsidiary altars in their city and parish churches with altarpieces. Many cities saw the emergence of specialized workshops of high technical quality. Leading centres such as Vienna, Regensburg, Nuremberg, Augsburg, Ulm, Nördlingen, Mainz and Colmar, not to mention Basle and above all Strasburg, became magnets for artists in their own right. They no longer needed to refer back to the Netherlands, particularly

since Cologne lay much closer and the focus across Europe was now shifting towards Italy. Augsburg in particular began to orient itself increasingly towards the South.

Training and workshop organization

As the nature of art production in the late Middle Ages implies, gifted apprentices could only realize their fullest potential within workshops of a correspondingly high standard and – also importantly – attracting a healthy volume of well-paying commissions. The notion of the self-taught artist was unthinkable; even in our own century, only few such artists have reached the very top. The actual artistic style of the master remained of secondary concern, however. The importance of technical skills and the structure of urban society favoured the emergence of artist dynasties. Since the possibilities of setting up a new workshop were only limited, existing businesses were passed on if at all possible from father to son. Most artists acquired their basic knowledge of materials in their father's workshop. The majority of leading painters of the day were sons either of painters, such as Hans Holbein the Younger (1497/98–1543), or of goldsmiths, such as Schongauer and Dürer. Should a master die without leaving a direct heir, his workshop would usually pass, via marriage to his widow, to a particularly gifted pupil or senior journeyman – an arrangement which, in an age with no state welfare system, guaranteed both parties a necessary financial security. Within artisan circles just as between ruling houses, marriages were organized with practical interests in mind – even in this regard, the contrast with the modern image of the Bohemian artist could hardly be greater.

In view of all this, it is hardly surprising that the three greatest artists of their day, Schongauer, Holbein the Younger and Dürer, should have grown up in the major centres of Colmar, Basle and Nuremberg. The decision whether to join a town guild, rigid in structure but guaranteeing a secure livelihood, or to try one's luck as an itinerant artist, which carried the possibility of earning far greater sums at some courts even without a master's qualification, was one that every artist then had to make for himself. Schongauer and Dürer remained faithful to the cities of their birth – notwithstanding Dürer's travels and occasional commissions for the aristocracy.

Despite the rigidity of the guild system, around 1500 the rivalry between the prosperous centres of southern Germany led to the emergence of prominent individuals within the arts. Appreciation of personal styles was growing, as can be seen in certain regions of Italy, even if the lead was being taken by the nobility rather than the civic authorities. Fussy collectors valued originality more than did conservative city notables. Names such as Marco Zoppo (c. 1432–1478), Andrea Mantegna (1431–1506) and Cosmè Tura (1429/30–1495) stand for this new attitude towards the artist, which comes closer to the modern concept of the genius. In the Netherlands, Hugo van der Goes represents an astonishingly similar trend.

Dürer as Gothic artist

At the pinnacle of the German school stood, without a doubt, Albrecht Dürer in Nuremberg. Alongside Rembrandt (1606–1669), Dürer was probably the most important graphic artist of all time, and even in his paintings he remained ultimately a draughtsman. In the arabesque-like play of his sweeping lines and gnarled forms, he also remained the last Gothic artist – despite all his trips to Italy, all his grappling with Venetian fleshiness and southern proportion. Not without reason did he find himself confronted in Italy with the criticism that his works were "not in the Antique style" (letter to Pirckheimer, 7.2.1506) – a reproach which would later also be voiced by Vasari. The extremely sophisticated portrait studies and other works by Holbein the Younger point more emphatically towards the new era of the Renaissance. For that reason he is absent from this book, in contrast to his father Hans Holbein the Elder (c. 1465–1524), also a brilliant technician, whose work was influenced by Italy in its motifs rather than its spirit (ill. p. 142).

The anonymity of the Gothic artist

An artist's social standing varied considerably even between one German city and another, and in particular between the North and Italy. Just how early on the Italian painters had risen above the status of pure artisans can be seen from the fact that we know almost all the leading artists of the 14th century by name. While Vasari and other early writers on art played their part in this, they themselves lived over 200 years after Giotto and had to rely upon earlier records. They were thereby

Duccio di Buoninsegna
The Temptation of Christ on the Mountain, c. 1308–1311
Tempera on wood, 42.2 x 46 cm
New York, The Frick Collection

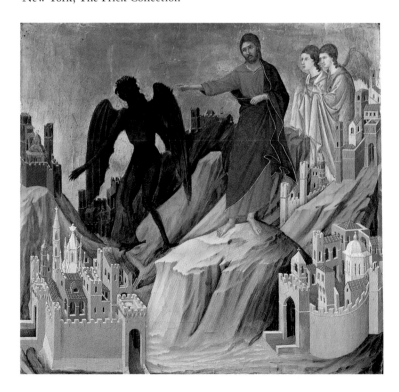

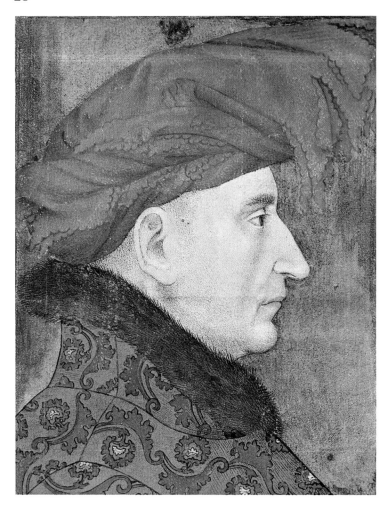

Master of the Rohan Book of Hours
Portrait of Ludwig II of Anjou, c. 1435
Pen and watercolour drawing, 22 x 17 cm
Paris, Bibliothèque Nationale

helped by signatures, which artists in the North were much slower to employ. Although isolated names are known to us from the 14th century (Theoderic, Bertram; ill. p. 29), the majority of artists – including many of the most prominent – remained nameless even in the final phase of Early Netherlandish painting in the early 16th century.

In order to distinguish between these anonymous artists, about a century ago makeshift names were invented for them, inspired either by the characteristics (Master of the Fat [Christ] Child) or, more commonly, the subject (Master of the Life of Mary), patron (Boucicaut Master), location, original location or even previous owner (Master of the Pollinger Panels) of particularly important works. Even amongst museum curators, there is a tendency to choose works by known masters over those by anonymous artists – something for which the works themselves give not the slightest grounds. Without the Boucicaut Master (active 1405–1420; ill. p. 101) or the Master of the Rohan Book of Hours (active c. 1420–1430; ill. left and p. 83), the history of French painting could not be written, not that of Bohemia without the painter of the *Glatz Madonna* (ill. p. 63), the Master of Hohenfurth (ill. p. 64) or the Master of Wittingau (ill. p. 67).

End of the Gothic era

With the passing of the high point of Early Netherlandish painting in the 16th century, so too the age of the anonymous artist came to an end. This, coupled with the complex nature of the production process, the endurance of the workshop system and the still artisan status of the artist, suggests that the Middle Ages, at least in the North, only ended with Dürer. The continuing importance of line, and the fact that paintings were essentially being commissioned for the same purposes and same places as ever, point to the same conclusion. With the advent of the Reformation and iconoclasm, however, all of this would collapse – and with it the economic foundation of the old system.

When Martin Luther (1483–1546) nailed up his theses in 1517, it marked the climax of the religious unrest which had already manifested itself in the outbreak of the Hussite Wars in 1419. It especially affected the flourishing centres of the Netherlands. Whether religious reformationists were purging churches of their visible excrescences and aberrations, or whether they were attacking worldliness and love of luxury – art was always amongst the first in the line of fire. The situation was compounded by the greed of certain rulers, such as Henry VIII (1491–1547), who coveted the treasures previously held by the Church. Artists were hit harder by the religious upheavals than any other secular profession.

In England, Germany and the Netherlands in particular, there was a rapid decline in both production and artistic standards. The chain of compositional solutions and figural types, technical formulae and practical skills which had been handed down through the generations, was abruptly broken. For the artists concerned, this release from old constraints was synonymous with the loss of the basis of their existence. Having previously worked predominantly upon commission, they were now exposed to the tough rules of the free market. Business records confirm that the secular genres of painting, first and foremost the portrait, failed to compensate for this loss of trade. Other than after similar crises in the past, new departures were rare.

Artistic activity was now significantly scaled down and found a niche only amongst the patrician classes in a few towns and cities, and above all in the ever more powerful courts of the nobility. Thus the innovative impulses of the 16th century outside Italy are associated, not without good reason, with the Fontainebleau of François I (1494–1547) and, subsequently, with the Prague of Rudolf II (1552–1612). It is a bitter irony that painters – people with a religious sensibility which went beyond the average – at times even played an active part in destroying sacred works of art, and through their positions in civic guilds were involved in the "cleansing" of churches and thus the sealing of their own fate. On the other hand, in view of the radical changes being wrought by Mantegna, Leonardo, Raphael and Michelangelo, it may also be said that the Late Gothic traditions of the North had already had their day.

Art aside, the era marked the final parting from the Middle Ages in other respects, too. In 1492 Christopher Columbus (1451–1506) reached America, and in that same year the last Jews and Muslims were driven out of Spain – marking the end of a thousand years of tolerance and of scholarly exchange between East and West, as the age seemingly so dark to modern eyes had also stood for. In the long term, paradoxically, Luther's action also led to lesser diversity – all over western, northern and southern Europe, nations began to assume solid shape. As they expanded outwards, inquisitions and Protestant rigorism internally were placing ever tighter restrictions upon the freedom of the individual. Thus Henry VIII in England, François I in France, Charles V (1500–1558) in Germany and Spain, and later his son Philip II (1527–1598) laid the basis for the absolutism of the 17th century.

What survived?

Within just a few months of the Reformation, in many European countries the medieval paintings that had hung for centuries in churches, monasteries and even private homes had been all but destroyed. In England, the sculpture and above all panel paintings, frescos and stained glass of the Middle Ages were almost entirely lost thanks to the "reforms" of Henry VIII. Oliver Cromwell (1599–1658) later completed the work of destruction. The standard of the few works that remain make the loss all the more painful, since – in their less graceful linearity and their drawing, which tends towards caricature – they fall clearly short of the French art to which they are closely related. The picture was equally bleak in the Switzerland of John Calvin (1509–1564).

In France, after the Huguenots, the Baroque and the Revolution, the situation as regards panel painting looked little better, although some patient detective work reveals that far more works have survived than is generally known. In the Netherlands, by far the larger part of medieval church art fell victim to the iconoclasts of the early 16th century – not just in the overwhelmingly Protestant north, the modern-day Kingdom of the Netherlands, but also in Flanders, Brabant and Hainaut in today's Belgium. Hungary's reserves of medieval art, which the surviving fragments suggest were once so rich, were decimated under Turkish rule.

In Bohemia, the art produced around 1350 at the imperial court at Prague, then the most flourishing art centre in northern Europe, had already been largely destroyed by the Hussites within a hundred years. Germany's regions and cities were affected by the Reformation to widely varying degrees. The Upper Rhine and Lake Constance area was another flourishing artistic centre to meet with widespread devastation. Some works survived, only to fall victim to the ravages of later wars – as in the case of the rich treasures of the Palatinate, savagely attacked by Louis XIV (1638–1715).

In some areas churches suffered the loss of virtually all their works of art, while in others they escaped remarkably un-scathed – often, paradoxically, in Protestant areas, where the all-powerful influence of the Baroque was felt less strongly than in Catholic regions. Assisting their survival was the fact that, even though the earlier practice of commissioning and donating an altarpiece had largely fallen out of fashion in Protestant times, people were too reverent or simply too lazy to clear out the old works of art. The volume of surviving works is particularly healthy in Italy – despite the impact of the Baroque and despite the ravages and plunderings of foreign armies, from Charles V to Napoleon I (1769–1821). An astonishing amount has also survived in Spain and – again because of, rather than despite the Reformation – in Scandinavia. Christianity had only recently arrived in Scandinavia, and had brought with it a high demand for church art, which could often only be satisfied by imports. While there was no

Master Bertram of Minden
Rest on the Flight to Egypt, c. 1379–1383
(from the former high altar, or Grabow Altar, in St Peter's, Hamburg)
Mixed technique on wood
Hamburg, Hamburger Kunsthalle

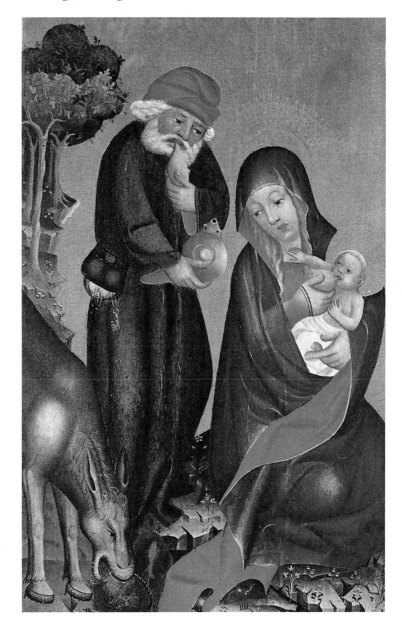

shortage of funds to pay for such art, thanks to wool production, trade and raiding activities in Scandinavia and to ore mining in Spain, it was not always possible for imported paintings conceived for a less sophisticated public, let alone the works produced by local artists, to compete with works from the leading European centres of art. Popular in Spain were enormous retablo walls extending the full height of the eastern nave. In some cases these were only dismantled in our own century and thereby satisfied the demand for new acquisitions, in particular amongst North American museums, for decades!

Even the poorer quality works on the fringes of Europe frequently allow us to draw meaningful conclusions about what has been lost from the centre, however. Thus the development of English painting can virtually only be reconstructed via its reception in Norway, with which England maintained very close maritime trading links. These peripheral regions often offer thematically very unusual paintings for which no parallels survive in the centre. It would nevertheless be wrong to expect the native artists of such "fringe" countries to be no more than second-rate. Thus the Catalan Bernat Martorell (active from 1427–1452) is a figure of European stature. His *Christ and the Samaritan Woman* (ill. p. 115) goes beyond all boundaries of time and place to form one of most successful solutions for this subject ever found.

The Alps are a case apart. Waves of both iconoclastic destruction and radical innovation often passed over their inaccessible valleys and conservative inhabitants without a trace. South Tyrol alone offers a quite extraordinary wealth of murals dating from pre-Carolingian times to the Late Gothic era and beyond, many of them of very high artistic quality. In the shape of Michael Pacher (c. 1435–1498), it brought forth one of the central figures of the late Middle Ages (ill. p. 137). Even his work, however, derives its fascination from its geographical context, namely a region sandwiched between North and South, in which the influences of the two major artistic trends dividing the West are combined in a highly complex fashion.

Thus no region of Europe, however far off the beaten track, has preserved its full complement of medieval art. Even without external catastrophes, wars and iconoclasm, the ravages of countless fires, natural wear and tear, incompetent attempts at restoration or simply industrious woodworms have all taken their toll. Even private collections were not always able to provide a safe haven. The Thirty Years' War (1618–1648) scattered, devastated or utterly destroyed not just cities and landscapes, but also some of Europe's greatest collections of art, including the treasures of Emperor Rudolf II, taken from Prague to Sweden. The Whitehall Fire of 1698 left an irreparable hole in the collections of the English royal family; Holbein the Younger's masterpiece, *Henry VIII's Family*, was just one of the many works destroyed. The fire that ravaged the Alcázar in Madrid over Christmas 1734 engulfed 537 paintings, and thereby one third of the royal collections. As an indirect consequence of the Franco-Prussian War, countless art treasures went down with the Tuileries wing of the Louvre in 1871.

In the same war, Prussian troops bombarded Strasburg Library, while in the First World War, the cultural history of the European continent was permanently impoverished by the loss of Louvain University Library. The archives at Tournai were also reduced to ashes, and with these three libraries not just their illuminated manuscripts and thus many works of art themselves, but also the last possibility of shedding more light on the lives of such important artists as Gerhaerts, Campin and Rogier van der Weyden. At the start of this century in Berlin, Richard von Kaufmann's precious collection of Early Netherlandish art was destroyed by fire. In 1945, 400 paintings from the Berliner Galerie disappeared perhaps for ever, including works central to the Gothic era. Even though we at least have photographs of them, they have vanished from the public eye.

Such documented cases aside, it is impossible to offer any serious estimate of just how much art is no longer with us. But we can gain a sense of the scale of the loss when we remember that the biggest churches in the Late Middle Ages could contain up to a hundred altars. Many of them would have carried altarpieces, which even in the Middle Ages would have been periodically replaced in line with changing fashions. A similar picture emerges from the written documents of the period, which again have survived only in a very fragmentary state, and which record the names of countless artists of whom not a single work has survived. In view of all these factors, taken across Europe as a whole, the percentage of medieval works that has come down to us must be infinitesimal, certainly under 10% and probably under 5%.

To what extent the fraction that has survived is representative of the original whole is another question altogether. There are indications that Netherlandish masterpieces had a considerably higher chance of being saved for posterity. Alongside the Ghent Altar and Rogier's *Descent from the Cross*, a number of other works have survived which were already being written about and enthusiastically copied in their own day. Of the paintings mentioned in the inventories of Margaret of Austria (1480–1530), probably the most important collector of the early 16th century north of the Alps, a relatively large number are also still extant. The same is true of many of the medieval works which appear in the large Flemish gallery paintings of the 17th century. We know that an altar by Quentin Massys

Fra Angelico
St Laurence Receiving the Church
Treasures, c. 1447–1450
Fresco, 271 x 205 cm
Rome, Vatican, Cappella Niccoliana

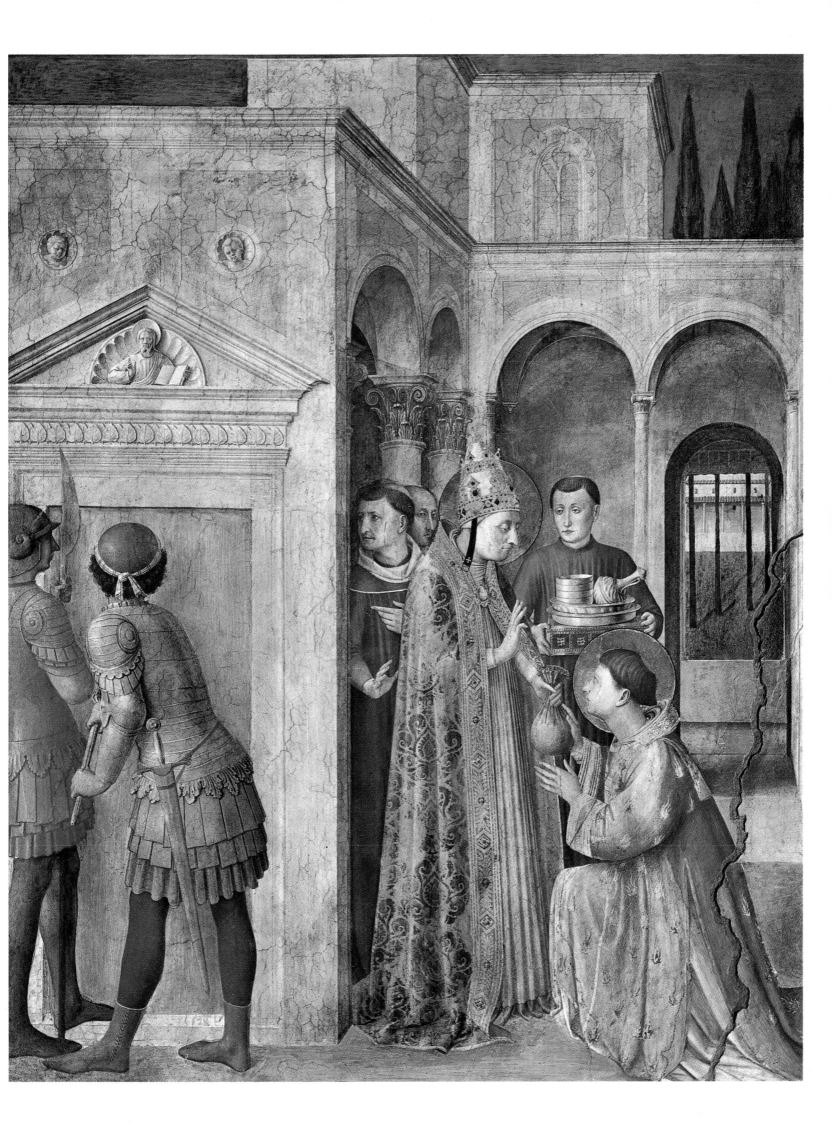

(1465/66–1530) was expressly spared destruction because of its artistic quality, and elsewhere, too, private individuals, clerics and collectors must have stepped in to protect the works of art they loved. Even the greed of the Spanish governors occasionally proved a blessing, albeit not always in the long term.

A number of major works have survived in the form of copies or more or less faithful reproductions, such as Rogier van der Weyden's *Justice* panels, which succumbed to French bombardment along with Brussels town hall in 1695, and the wings of Hugo van der Goes' Monforte Altar (cf. ill. p. 130). Even if it cannot always be so well documented elsewhere as in the field of Early Netherlandish painting, it is naturally to be hoped that in other regions, too, it was the more mundane art that was lost, while the celebrated masterpieces were looked after.

A broad range of characters

The book embraces a wide variety of artists: great innovators whose enormous powers of invention pointed the development of art in a whole new direction, such as Giotto (ills. pp. 43 ff), Simone Martini (ills. pp. 54 f), Pucelle (ill. p. 51), the Boucicaut Master (ill. p. 101), Jan van Eyck (ills. pp. 103 f) and Hugo van der Goes (ills. pp. 130 f); individualists who arrived at highly original and perfect solutions within existing trends, such as Lluís Borrassà (ill. p. 85), Pisanello (ills. pp. 107 f), the Master of the Rohan Book of Hours (ill. p. 83), the Master of the St Bartholomew Altar (ill. p. 139), Martorell (ills. pp. 114 f) and Lochner (ills. pp. 126 f); singular, often particularly delightful characters such as Martinus Opifex in Bavaria (doc. 1440–1456; ill. p. 117) and Juan de Levi in Aragon (doc. 1388–1410; ill. p. 84); and countless great masters who stand largely outside all trends, such as Theoderic (ill. p. 66), Barthélemy d'Eyck (ills. pp. 119, 125) and Jean Fouquet (c. 1414/20–c. 1480; ill. p. 113), and whose influence was limited to a small sphere simply by the fact that they were working either for elite circles or in a geographically remote place. What is so astonishing, in view of the thousands of paintings by different hands and the thousands of artists mentioned in records, is just how few great individuals actually shape the epoch at the end of the day.

Subjects of Gothic art

An overview of Gothic painting will inevitably be dominated by religious, and specifically Christian, art – not just because the term Gothic was originally associated with French cathedrals, but because the Christian faith infused, at least outwardly, many areas of life and above all death in every stratum of society that could afford art. In almost every culture in the history of humankind, the incomprehensible power of death has prompted people to spend more on the apotheosis of their own person or that of a dear one, and on the hope of a life after death, than on any other genre of art. Even more importantly,

the paintings that resulted have survived longer than the decorative artefacts with which they brightened up their daily lives. Many apparently "ordinary" altarpieces were intended by their donors to help ensure the salvation of their souls. The great scholar Nicholas of Cusa (1401–1464) was not the only one to have himself buried directly in front of the altarpiece which he commissioned (ill. p. 134). As over a hundred years earlier in the *Glatz Madonna* (ill. p. 63), the inclusion of his portrait as a figure in prayer ensured that he would be perpetuated for ever in the act of devout worship.

Secular painting concentrated upon the decoration of civic spaces and, increasingly towards the end of the Gothic era, upon the portrait, at first solely those of rulers (ills. pp. 91, 92), but subsequently also the private portrait (ill. p. 91). Even in manuscript illumination, non-religious illustrations remained in the minority. Alongside high art, which was only accessible to a very small section of society, there were undoubtedly other forms of art circulating amongst a much wider public. Considerably fewer of these have survived into the present, however, and the ones that have are much less differentiated in style. This not only makes it harder to date them, but makes it almost impossible to use them as a basis upon which to trace the development of Gothic art. Works of art which were not destined solely for the uppermost echelons of society are represented within these pages in the guise of some of the wall and panel paintings from Scandinavia and Spain.

Panel painting and altarpiece

In view of this concentration upon religious art, it follows that the majority of the works described here are altarpieces. Most are panel paintings, in other words paintings on wood, a medium employed since the late 12th century and in some places still in use even in Baroque times. At first they were hung as an antependium in front of the altar table, while the priest stood behind it and celebrated facing the congregation – a custom which was reinstated after the Second Vatican Council of the years 1962–1965. In the 13th century, following alterations to the liturgy still not fully explained or perhaps simply in line with changing tastes, the painted panels increasingly migrated up and onto the altar table, where they stood at the rear as a retabulum. This implies that the priest must now have been leading the service with his back to the congregation.

Within the altarpiece genre as a whole, a distinction may be made between the simple panel, or *pala*, which was the convention in Italy, and altars with – as a rule, folding – wings, as are found above all north of the Alps and the Pyrenees. These triptychs were only opened out on high days and holidays. The excitement of this moment was heightened for the faithful by the particularly opulent painting of their interiors, usually involving lavish quantities of gold. We occasionally find altars with double sets of wings, which can thus be displayed in

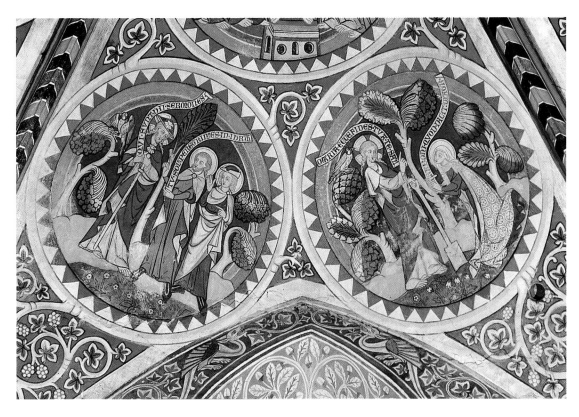

three different ways. This concept of opening out may in part derive both from the idea and the physical shape of the containers used to house relics. The play, evident in the rigid Soest altarpiece (ill. p. 36), upon the silhouette of a triptych is one of the proofs that the folding altar was familiar by the 13th century, even if the majority known to us today only date from the following century.

In Italy and Spain, on the other hand, rigid structures remained overwhelmingly, if not exclusively, the norm, although this did not necessarily preclude them from employing more than one section. Panels of different sizes were combined into larger superstructures, which in Spain and Portugal could extend to fill virtually the entire space behind the altar right up to the ceiling and out to the side walls. Like triptychs in the North, they frequently incorporated sculptures at their centre. These were elaborately painted in techniques similar to those employed for the panels, and were often admired even more greatly than the paintings themselves.

It is clear even from this brief overview that the Gothic panel painting needs to be considered in its original context, namely inside a church, on an altar table, perhaps topped by further panels and even, in some cases, accompanied by holy relics and a donor's tomb. In their relief patterning and lavish use of gold leaf, the earliest examples of such paintings offer parallels with works executed by goldsmiths, such as caskets made to house the bones of saints venerated at the altar. The new genre of paintings destined for collectors and galleries was one that only began to emerge right at the end of the Gothic era. It would subsequently remain the norm until the gradual dissolution of the traditional forms of art in the 20th century.

Canvas paintings

Paintings on a textile backing are similarly only found in larger numbers as from around 1500. Over the following years they would become increasingly widespread, not least because of the lower costs involved. The use of less durable paint materials and a less thorough preparation of the ground meant they deteriorated easily. They were also treated with less care, since their value was considered to be lower. It was precisely this perception of canvas as having a lower worth that meant it was selected only rarely before 1500 for important works of art. The potential of the new medium only began to be recognized by painters such as Dürer. Unfortunately, many such paintings have suffered irreparable damage even in recent times as a result of inappropriate treatment. Specifically, canvases do not tolerate the protective coatings of varnish which have been applied, often thoughtlessly, in the modern museums of the 19th and 20th century.

Wall painting

In Italian art from Giotto to Raphael, wall painting is at least as important as panel painting. In contrast to the murals surviving in smaller numbers in the North, in which the pigments bound in oil or egg tempera were generally applied directly on top of a dry ground, artists in Italy mostly employed the true fresco technique. Fresco means fresh: the pictures were painted on plaster that was still damp, in sections which had to be completed at one stretch, with only gold accents and a few other colours being added later. The possibility for corrections was only limited, and thus the painting of vast surfaces such as those confronting Andrea da Firenze (doc. from 1343– after 1377) in Santa Maria Novella – the mural he

painted (ill. p. 69) was executed in 156 different sections – demanded very precise preliminary studies and a highly efficient and concentrated organization of labour. Outside Italy and the Alps, however, the frescoed interior of Wienhausen monastery church from the years around 1355 (ill. p. 33) and the few other remnants which survive can only hint at the role which murals played in the North. Façade paintings such as those still visible in a number of southern German and Alpine regions must also have commanded a more prominent presence in daily life than devotional panels.

Stained glass and manuscript illumination

To restrict this study to the genres of wall and panel painting would be to do an injustice to the very artists who stood at their fore. From Simone Martini to Martorell and Jan van Eyck, all also turned their hand to designs for stained-glass windows, tapestries, and the illumination of manuscripts. Following the destruction of so many altarpieces, in many regions stained glass and manuscript illuminations remain the only witnesses to artistic developments. Manuscripts also have the advantage of facing a much lower risk of subsequent deliberate damage, overpainting, restoration or fading, so that as a rule they convey the artist's original intentions much more directly than panel paintings or murals. Alongside a number of miniatures, the present volume also includes examples of stained glass and unusual paintings such as the Hildesheim ceiling (ill. p. 38).

Everyday art

Finally, it must be remembered that medieval painters were employed in another, important sphere of art of which practically nothing survives. Even in the accounts of the leading Gothic masters, more receipts have survived which refer to the painting of banners, standards, steeple balls, festival decorations and the like than for the production of art works in the modern sense. The raising, off Stockholm, of the warship Wasa, built a century after the end of the Gothic era, has given us an insight into the numbers of woodcarvers and painters who would have been employed on "artefacts" of this type. In those days there were hundreds of such ships, albeit only a few of such magnificence.

In order to appreciate the significance of such decorative art for the aesthetic of the Middle Ages, we need only consider the impact upon our own daily lives of film sets and design, and how much more strongly these affect us than the works of contemporary artists. Pop artists such as Andy Warhol, Robert Rauschenberg and Jasper Johns have not been the only ones to reflect this everyday aesthetic; although the impermanent art forms of the Middle Ages are almost entirely lost, the miniatures by the Boucicaut Master (ill. p. 101) and the Limburg brothers (ill. pp. 76 ff) suggest that their influence was already strong. Bearing all these factors in mind, the scattered remains that are brought together within these pages can nevertheless offer a colourful and many-sided picture of the Gothic age in art.

ROBERT SUCKALE is the author of the extended captions on the following pages: 35, 39 below, 42–49, 51 below, 54–60, 62, 64, 66–68, 71 above, 72, 73, 74 below, 75–79, 81 below, 82, 83, 86, 87, 88 below, 90, 91 above, 92 below, 93 below, 94 above, 95 above, 96 above, 97–100, 105, 107–112 and 126. He also wrote the biographies of the corresponding artists. The other biographies were witten by Norbert Wolf (63) and Manfred Wundram (12).

MATTHIAS WENIGER wrote the introduction and the extended captions on the following pages: 36–38, 39 above, 40, 41, 50, 51 above, 52, 53, 61, 63, 65, 69, 70, 71 below, 74 above, 80, 81 above, 84, 85, 88 above, 89, 91 below, 92 below, 93 above, 94 below, 95 below, 96 below, 101–104, 106, 113–125 and 128–144.

BONAVENTURA BERLINGHIERI

ACTIVE 1228–1274

To his contemporaries, Francis of Assis (1183–1226) appeared to be a second Christ, but one whose presence was much more glowing and immediate than the ascended Son of God. Such was his reputation that the visits he paid to places were commemorated in paintings, as for example in Subiaco. Yet just nine years after his death and seven after his canonization, he was being portrayed in this work from Pescia as an aged stylite from a wall of Byzantine icons. Its severity and frontality cannot be explained by the fact that it is an altarpiece. There was, in fact, much resistance to the foundation and running of the Franciscan order of poverty and lay mission. This is probably the reason why St Francis is presented as a heavenly and hence unchallengeable authority.

This is also underlined by the smaller scenes on either side. Presented in unchronological order, they show, top left, Francis receiving the stigmata, the seal of his similarity to Christ; next his sermon to the birds, as an illustration of the fact that the animal kingdom immediately recognized Francis as sent by God, and also of the saint's great love for nature. Miracles which he performed during his lifetime or which took place at his tomb serve to confirm his divine powers (bottom left: Curing a crippled child; right from top: Healing cripples, healing the lame man, driving out demons from the possessed).

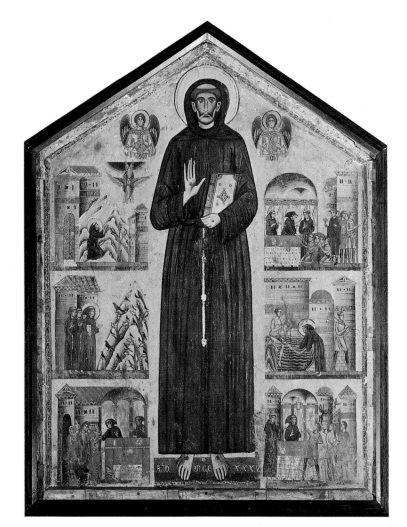

Bonaventura
Berlinghieri
St Francis and Scenes from
his Life, 1235
Tempera on wood,
160 x 123 cm
Pescia, San Francesco

FRENCH MASTER

ACTIVE C. 1213

The magnificent psalter commissioned for the private use of Queen Ingeborg, probably by her husband Philippe Auguste, is the most important French illuminated manuscript to survive from the 13th century. At the time the psalter was executed, the sculpture cycle at Chartres cathedral was well on the way to completion and that of Reims already begun, and the west portals of Notre-Dame in Paris were being built. Its compositions and many of its motifs nevertheless follow the Byzantine tradition, as represented by the great mosaic cycles in Sicily, for example, while the gold ground and the border look ahead to later 13th-century developments.

The Paris artist restricts himself to the generally muted colours of Eastern art. In imitation of classical models, however, he moderates the severity of his forms through the use of more softly moulded draperies, without thereby reverting to earlier, ornamental styles. The figures are shown in calm poses even in the most dramatic situations. The picture is kept two-dimensional and provided with the barest of backgrounds. The figures remain the yardstick, obscuring unimportant details. Their severity and dignity recall the greater monumentality being sought by contemporary sculptors. In embracing such a style, however, the workshop would also have reflected the tastes of the French royal court.

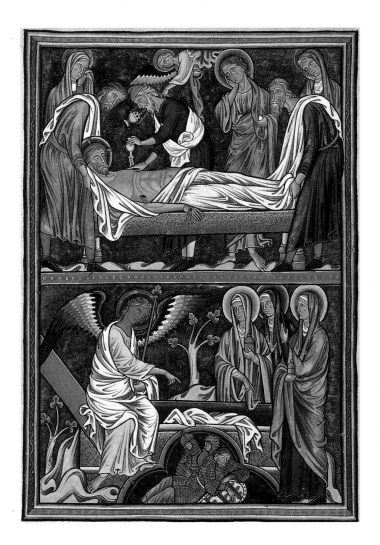

Workshop of the Ingeborg
Psalter
Embalming of the Body of
Christ and The Three Marys at
the Empty Tomb, c. 1213
(miniature from the Psalter of
Queen Ingeborg of Denmark,
fol. 28 v)
Manuscript illumination,
30.4 x 20.4 cm
Chantilly, Musée Condé
(ms. 1695)

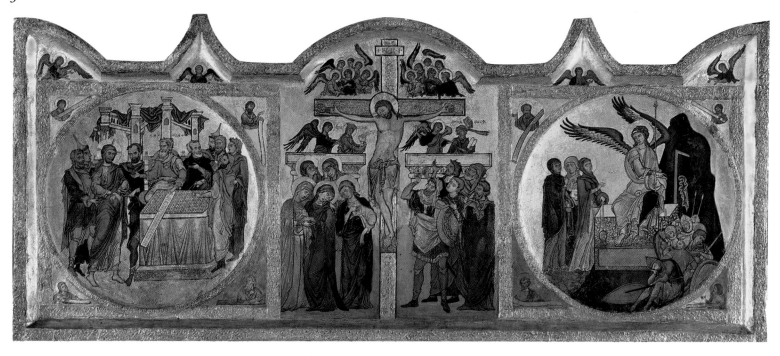

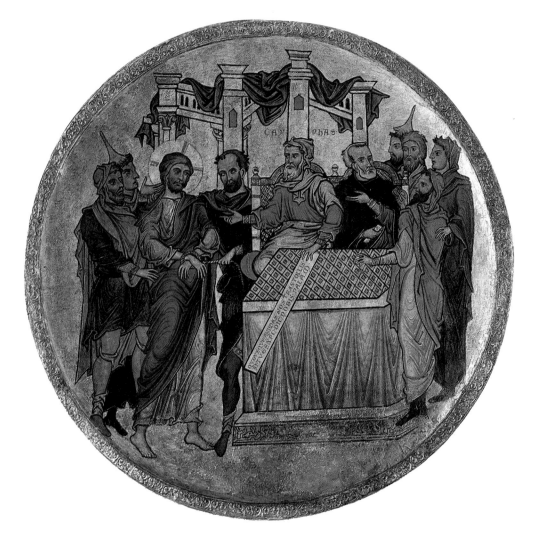

WESTPHALIAN MASTER

ACTIVE C. 1230–1240

The silhouette of the *Crucifixion* retable evokes the impression that this is a triptych whose wings can be closed over the central field. This is contradicted within the actual painting, however, by the two scenes portrayed in circular, plate-like depressions on the right and left. While the artist thus makes an early play upon the various types of altar, such relief effects would have no future. They did not marry happily with the two-dimensional nature of the medium, and presented too great a challenge to the panel-maker, who fashioned the altar out of a single plank of oak. Before being painted, the oak panel and the separately manufactured bars of the frame were first covered with animal hide, then covered with canvas, primed and then gilded. The inner and outer bars of the frame are decorated with embossed strips of metal.

With its depictions, *Crucifixion* and *Resurrection*, the pictorial programme brings together the two most important moments in the history of salvation, while in its *Trial* it takes up the anti-Jewish polemic which had gained in intensity following the resolutions that had been taken by the IVth Lateran Council of 1215. With their pointed hats and cloaks over their heads, Jesus's antagonists are clearly identified as Jews, in line with the demands of the Council.

Beneath the arms of the Cross, the Church and Judaism are opposed in the figures of Ecclesia and Synagogue. The blood streaming into the chalice is a play upon the Sacrifice of the Mass being celebrated in front of the altar. Synagogue is being driven out. Her eyes are blindfolded and do not behold the dawning of the age of salvation brought by the Christian Messiah. At Christ's feet, again in the spirit of the Lateran Council, is a call to conversion: the gestures of Jesus's former opponents crowding around the captain reveal that they have now recognized the Messiah in the crucified Christ.

Above:
Westphalian Master
Trial, Crucifixion and Resurrection, c. 1230–1240
(*Crucifixion* retable from the Wiesenkirche church in Soest)
Tempera on canvas on leather on oak, 86 x 195.5 cm
Berlin, Gemäldegalerie, Staatliche Museen zu Berlin – Preussischer Kulturbesitz

Westphalian Master
Trial, c. 1230–1240
(Left field of the *Crucifixion* retable from the Wiesenkirche church in Soest)

WESTPHALIAN MASTER

ACTIVE C. 1260–1270

Curiously, the early history of German panel painting is bound up particularly closely with Soest in Westphalia. In the Wiesenkirche alone, there stood in the 19th century not just the *Crucifixion* retable, but also the somewhat later altarpiece of the *Throne of Grace with the Virgin and St John*. Although it is simpler in construction, the fact that the original frame is lost prevents us from drawing any more specific comparisons.

Resonances of architecture and goldsmithery are nevertheless present in the pillars, which are glued on in relief, and in the embossed surfaces over the semi-circular arches. Notches in the bottom suggest that the panel was designed to be stood on an altar table. In artistic terms, the younger panel has liberated itself somewhat from the overwhelming influence of the Byzantine style. It nevertheless takes to a particular extreme one characteristic of Eastern art that was already tentatively present in the *Crucifixion* altarpiece: hems with bizarrely angular outlines resembling pleated metal. In order to create enough space for these abstract, crystalline structures, the draperies are placed like a screen in front of the figures. In the earlier work, on the other hand, figures and robes are conceived more as a whole, and are treated with greater plasticity. The folds in the later work are more animated than the figures.

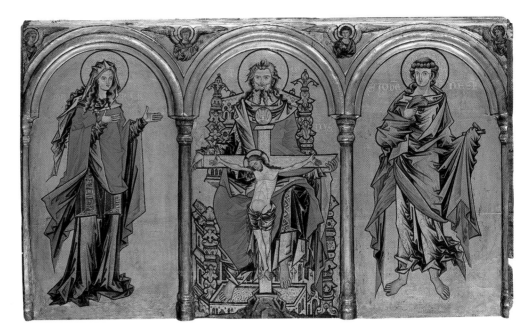

Westphalian Master
Throne of Grace with Mary and St John, c. 1260–1270
(altarpiece in three sections from the Wiesenkirche church in Soest)
Tempera on oak, 71 x 120 cm
Berlin, Gemäldegalerie, Staatliche Museen zu Berlin – Preussischer Kulturbesitz

ENGLISH MASTER

ACTIVE C. 1250

The elongated figures of this English psalter possess a much greater naturalism than those of the Soest *Throne of Grace* (ill. above). Mary's body is defined beneath her robes with much greater confidence, and her silhouette has lost all heavy-handedness. The figure of John underlines the artist's preference for affected gestures. The new Gothic style is articulated most emphatically of all in the proportions of Jesus's body, which are much closer to life than in the two Soest panels or earlier manuscript illuminations from France. The loin-cloth no longer clings to the body, but is generously cut with loose folds creating a sense of volume, and thereby distances itself from the Byzantine mannerisms of the Late Romanesque era. Christ's thighs are no longer merely the continuation of his trunk. Even compared with the second Soest altarpiece, the faces have lost yet more of the severity of the Romanesque. Despite her grief, the Virgin's expression exudes a previously unknown sweetness. Her cloak plays around her face far more loosely than in the earlier of the Soest panels. The triangular facial shape employed for Christ, John and Mary, with its overly broad forehead, is one we shall encounter frequently in 14th-century art. John's eyebrows, drawn up over the corners of his eyes, are an entirely new means of expressing his sentiments. The folds of the draperies are emphatically modelled by light and shade.

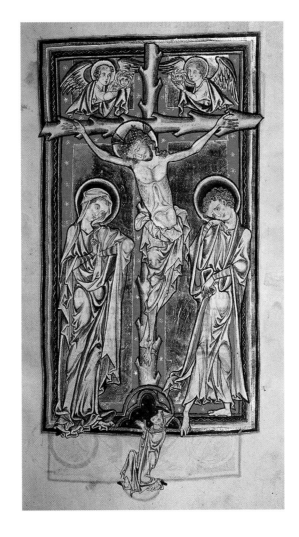

Master of the Evesham Psalter
Crucifixion, c. 1246
(miniature from the Evesham Psalter, fol. 6 r)
Body colour and metal leaf on parchment,
31 x 20 cm
London, British Library (ms. add. 44874)

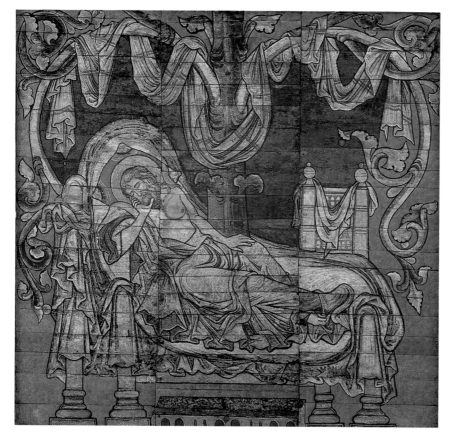

Lower Saxon Workshop
Jesse, c. 1240
(from the ceiling of St Michael's, Hildesheim)
Tempera on oak, 136 x 128 cm (total size c. 2760 x 870 cm)
Hildesheim, St Michael's

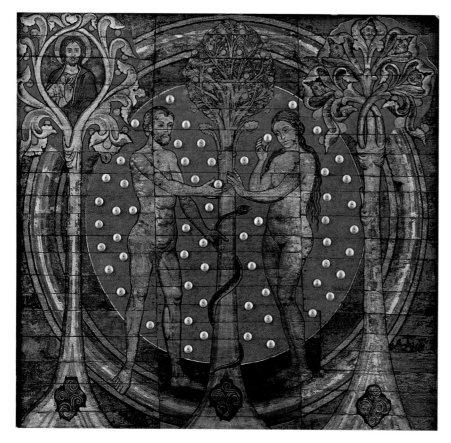

Lower Saxon Workshop
The Fall, c. 1240
(from the ceiling of St Michael's, Hildesheim)
Tempera on oak, 136 x 128 cm (total size c. 2760 x 870 cm)
Hildesheim, St Michael's

LOWER SAXON WORKSHOP
ACTIVE C. 1230–1240

St Michael's in Hildesheim represents a landmark in early medieval architecture far beyond the bounds of Germany alone. Preserved within its walls was a fragment of the True Cross, which had been entrusted to the monastery's founder, Bernward of Hildesheim, canonized in 1192. When it was decided, towards the middle of the 13th century, to paint the wooden ceiling of the nave, it is therefore unsurprising that the decorative scheme chosen should be the Root of Jesse. This establishes a family tree for Jesus and simultaneously links it to the Legend of the Cross and the concept of the Tree of Life. According to medieval thinking, the wood of Christ's Cross was obtained from the Tree of Knowledge, the tree whose fruit Adam and Eve were forbidden to eat. Just as it cost Adam and Eve Paradise, so, through Christ's crucifixion, it became the instrument of humankind's salvation.

The ceiling correspondingly presents the Fall and Christ in Glory as the two ends of a central axis running as a compositional framework through eight large fields. Linking these two ends in the six intermediate fields are the figures of the sleeping Jesse, the enthroned kings David, Solomon, Hezekiah and Joshua, understood as Christ's Old Testament forebears, and Mary the Queen of Heaven and Mother of God. These are bordered by smaller fields complementing the sequence with rivers of Paradise, prophets, evangelists and, on the outermost edges, further ancestors of Christ.

The family tree itself begins with the slumbering figure of Jesse in the field above the *Fall*. The elderly Jesse is reclining on a large bed of state. There is not yet any differentiation between the size of its front and rear posts; perspective representation has still to undergo its astonishing development of the following years. Jesse's figure, half turned towards us, nevertheless impresses the viewer with a classicism that recalls portrayals of Antique gods. His naked upper body is enveloped in generous swathes of drapery, whose sharply defined contours are characteristic of the zigzag style. Growing out of the sturdy trunk are branches bearing stylized leaves, delineating a heart-shaped ground around the bed.

The paintings are actually executed on a framework of oak boards. This is not a mural, therefore, but a gigantic panel painting which was first prepared in the usual fashion, namely with a ground and then preliminary drawings. Only in the Grisons has anything similar survived from the Middle Ages. Luminous blue lapis lazuli dominates the ceiling, while vermilion, which provides the ground to some of the geometric fields, lends these and various large areas of drapery their rich gleam. Interestingly, the dominant colours are thereby similar to those found in stained glass, where the Root of Jesse, a subject known from much earlier times, had already been translated into a large format in the 12th century in the windows of St Denis and Chartres (ill. p. 40).

SOUTHERN GERMAN MASTER

ACTIVE C. 1250

As the miracle which was central to the story of Christian salvation, the Resurrection presented painters over and over again with the problem of how to create at least an impression of Christ leaving the tomb within a two-dimensional medium. Some have Christ emerging out of the sealed sarcophagus, others have him floating above it. In having his powerful Christ figure step energetically out of the tomb, the Rheinau Master has found a particularly successful solution to this vexing problem. The skill with which he animates his surfaces through the abrupt juxtaposition of forms, and his extremely striking palette, are typical features of his art.

The viewer is in turn directed to the risen Christ by the gestures and upturned eyes of the guards. The lid of the tomb cleverly divides them into two groups. The soldier crouching on the left and his counterpart reclining on the right provide a perfect conclusion to the lower pictorial field. The blood seems to flow freshly out of Christ's wounds. Unlike most of his colleagues, the artist did not choose to portray the body in the position of crucifixion. His free handling of the zigzag style confirms the miniaturist's individuality. It is precisely this independence which has made it difficult to determine the manuscript's precise origin within the Regensburg-Salzburg area.

Master of the Rheinau Psalter
Resurrection, c. 1250 (miniature from the *Rheinau Psalter*, fol. 107 r)
Body colour and metal leaf on parchment, 26.7 x 18.6 cm (dimensions of page)
Zurich, Zentralbibliothek (Cod. Rh. 167)

FRENCH MASTER

ACTIVE 1258–1270

This exquisite manuscript was produced for King Louis IX of France. A series of 78 full-page miniatures of scenes from the first books of the Old Testament, presented in pairs, precede the actual text of the psalter. The background architecture, with its prominent rose windows, cites the Gothic style of church architecture of which Louis was a major patron. Its function here is ornamental rather than representational, and the painter uses it to divide the narrative into two halves.

On the left we see Joshua commanding the sun and the moon to stand still until the decisive battle against the Amorite kings is won. On the right we see the enemy being chased back into their cities. Although the events have been brought forward into the contemporary setting of the 13th century, much remains unreal: the reds and blues presented in an alternating succession of pure and diluted tones against a gold ground do not designate the actual colours of the objects they describe, but are a form of costly decoration comparable to the dazzling stained-glass windows of Chartres. The slender figures of Joshua and the soldiers hardly call to mind a patriarch and one of the greatest miracles in Israel's early history, but rather illustrate the new ideal of the perfect courtier. The refined style of this art is almost an end in itself, and its very sophistication a source of pleasure for the reader.

Workshop of the Louis Psalter
Joshua Stops the Sun and Moon, c. 1258–1270 (miniature from the *Psalter of Louis IX of France*, fol. 46 r)
Manuscript illumination, 21 x 14.5 cm
Paris, Bibliothèque Nationale (ms. lat. 10525)

French Master
The Good Samaritan and Genesis, c. 1205–1215
(detail of a stained-glass window from the southern
side aisle of the nave)
Chartres, Notre-Dame cathedral

FRENCH MASTER

ACTIVE C. 1205–1215

Few visitors to France's 13th-century cathedrals are aware of the complex religious programmes which lie hidden in each pane of their colourful windows. As in the illuminated manuscripts of the same era, so-called typological schemes were particularly popular. These juxtaposed episodes from the Old Testament with the events in the New Testament which, as "types", they foreshadowed. This concept lay at the heart of the artistic programme governing the side aisles at Chartres: the north-facing windows, which lie in the shade, are dominated by episodes from the Old Testament, in which God reveals himself to Israel. The windows on the south side, on the other hand, are devoted to the themes of resurrection and salvation.

Our detail is taken from a lancet window and is related to the overall programme in a particularly subtle theological way. The fact that its two subjects are not separated as clearly as in the typological window in Bourges (ill. p. 41) is precisely what allows them to mirror each other in all the more sophisticated ways. Starting from the donors portrayed at the base of the window, the painting leads via the parable of the Good Samaritan to the Fall and the Expulsion from Paradise to, at the apex, Christ in Glory: the journey thus leads from Creation to the end of the history of salvation. According to the parable, it was the Samaritan of all people, as a member of a despised minority, who went to the aid of a man attacked by robbers, after priests and Levites had passed him by. Since late antiquity, the traveller had been understood as sinful humankind, while the Samaritan stood for Christ himself. Consequently he wears a nimbus containing a cross. Christ was also the New Adam, who through his death on the Cross expiated the sins of the first Adam.

In his nakedness, Adam anticipates the state of the stripped and robbed traveller. In the central quatrefoil the two stories intersect. Above the picture of the traveller being looked after at the inn, we see Adam seated in Paradise in a scene devoid, astonishingly, of all narrative detail. To the left we see the creation of the first man, and on the right the creation of Eve from Adam's rib. The Creator, too, wears a nimbus containing a cross – representations of God the Father and Christ were often not clearly differentiated in this period. In the top lobe of the quatrefoil, we see God warning Adam and Eve not to eat of the Tree of Knowledge. This is followed in the three fields above by their disobeying his command and, in consequence, their expulsion from Paradise. Satan has assumed the shape of the snake, just as humankind's sins took the form of the traveller.

Beneath the central quatrefoil we see the Samaritan tending the wounded traveller at the side of the road and transporting him to the inn on his mount. As in the case of the only slightly earlier Hildesheim ceiling (ill. p. 38), red and blue grounds underlie the compositions.

FRENCH MASTER

ACTIVE C. 1210–1215

The deep colours of this window, dominated by reds and blues, are typical of High Gothic stained glass at its peak. The window, with its multiple scenes, occupied one of the most important positions within the highly sophisticated programme which graced the ambulatory of Bourges cathedral, in use in 1214. As was especially popular at that time, it juxtaposes episodes from the Old Testament with the events they foreshadowed in the life of Christ. At the centre of our detail is the quatrefoil featuring a strongly abbreviated representation of the Road to Calvary. In the outer round we see Isaac, bottom left, bringing the wood for his own sacrifice behind his father, who bears a knife, just as Christ had to carry the instrument of his death to Calvary. Like the wood of the Cross, however, the kindling becomes the instrument of salvation as, seen here below right, the angel of God intervenes at the last moment. Top right we see the lamb being sacrificed in Isaac's stead.

The remaining segment of the circle represents an extremely free interpretation of I Kings 17, as first found in the 12th century: the widow of Zarephath, from the story of Elijah, is piling up wood in the shape of a cross,. Below, the butchers who donated the window are seen at work, slaughtering and filleting a pig and a cow in a composition skilfully tailored to the shape of the field.

French Master
The Road to Calvary and Donors, before 1214 (detail from the lower section of a window donated by the Guild of Butchers) Stained glass, lancet window, c. 360 x 220 cm (total size)
Bourges, Saint-Etienne cathedral, ambulatory

FRENCH MASTER

ACTIVE C. 1250

This miniature comes from a famous group of exquisite *Bible moralisée* manuscripts. These were executed with in the immediate circle of the royal court and they can certainly be seen as the epitome of French painting in the High Gothic era. The present example may have been commissioned by a king of Navarre and a daughter of Louis IX of France. The title page was sure to have been of interest to contemporaries for its carefully observed pair of compasses alone; this was the period, after all, when the cathedrals of France were being constructed with supreme architectural skill. According to the French caption, God is here portrayed as the Creator of Heaven and Earth, Sun, Moon and all the elements.

The irregular yellow form, to whose centre the moving arm of the compass points, represents the earth, surrounded by the stars and, beyond them, a fringe of stylized cloud. God, stepping forward, pushes the disc before him like a bowling ball. His human-like figure stands at the very centre of the picture, uncluttered by accessories. His right foot even steps out of the bottom border and onto the plain page. His robes dissolve into a tissue of thin pleats. The folds, border and head type place the miniaturist firmly within the – barely a generation older – tradition of French court art around the *Ingeborg Psalter* (ill. p. 35).

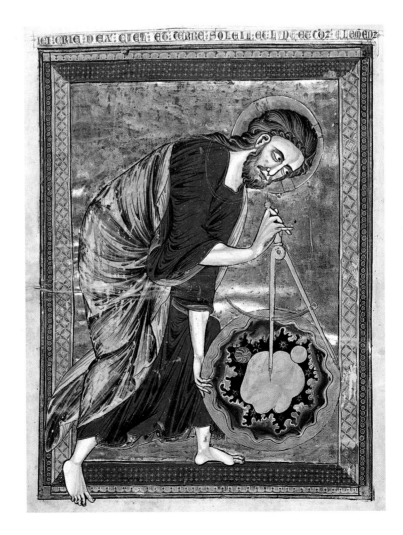

Master of the Bible moralisée
Demiurge (God as Architect), c. 1250 (miniature from the *Bible moralisée*, fol. 1 v) Body colour and gold on parchment, 34.4 x 26 cm
Vienna, Österreichische Nationalbibliothek (Codex Vindobonensis 2554)

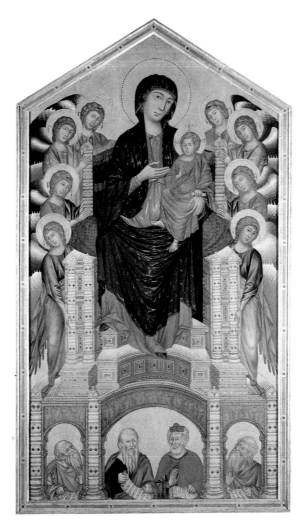

Cimabue
Madonna and Child Enthroned with Angels
and Prophets (Maestà), after 1285
(from Santa Trinità, Florence)
Tempera on wood, 385 x 223 cm
Florence, Galleria degli Uffizi

CIMABUE

C. 1240–AFTER 1302

This Madonna was originally an altarpiece, at that time a new type of commission, but one which rapidly became popular. The presence of Christ evoked by the painting was intended to make the Sacrifice of the Mass appear more concrete and at the same time to reinforce the divine authority of the priest reading the Mass.

The painter was required to create a work which combined solemn, monumental effect with an image that was easy to read. The plinth-like arrangement of the prophets indicates that, both chronologically and theologically, they provide the steps which lead up to Mary and Christ. Their banderoles refer to Mary's virginity and Christ's role as Saviour. The organization of the painting, with its central emphasis, symmetry and balanced sides, is beautifully clear. The artist only deviates from this order in the figure of the Virgin, who is seen at a slight angle and who thereby focuses more attention upon her son.

The composition of the painting is clear and simple, the drawing precise. The seated and standing poses are nevertheless strangely removed from reality and lack tectonic cohesion. The individual motifs betray Byzantine sources. Apparent in the execution are certain traits of the fresco painter, with little attention paid to finer details. The panel has been unanimously attributed to Cimabue ever since its first mention by Vasari (1568).

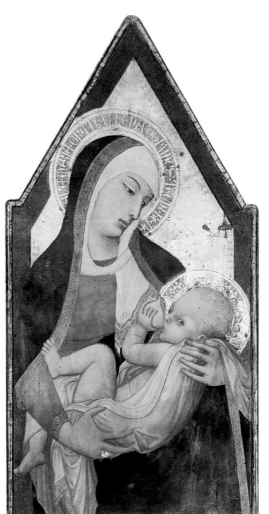

Ambrogio Lorenzetti
Nursing Madonna, c. 1320–1330
Tempera on wood, 90 x 48 cm
Siena, Pontificio Seminario Regionale

AMBROGIO LORENZETTI

C. 1290–C. 1348

This is an example of a type of painting widespread in Italian art, namely the large Madonna icon. It perpetuated an older, Byzantine tradition in a relatively unadulterated form, but served a wider range of functions. Big enough to stand on side altars, such panels could also be added to more sizeable altarpieces, hung in a prominent place in a chapel or in a larger room in the home. They were less suitable for close-up viewing, however. They thus occupy a niche between large, more formal altarpieces and private devotional images.

The motif of this panel nevertheless belongs to the sphere of private worship: Mary is nursing her child while standing up – a representative pose taken from older icon painting. With a serious expression on her face, she looks at her son, not at the viewer. Such is the curiosity of the infant Jesus, however, that he almost forgets his thirst. His left leg is raised in a kick. He is a healthy baby, his body more solid than that of his mother, and he is cradled in a veil – a successful motif which would be reused by later artists (cf. ill. p. 73).

The veil serves to emphasize the shape of the Child's body and conclude the bottom of the painting. The tender harmony of mother and child is typical of Ambrogio's sweet and contemplative art.

GIOTTO DI BONDONE
1266 (?)–1337

This panel by Giotto, which hangs in the same room in the Uffizi as Cimabue's painting opposite, clearly demonstrates the significant distance separating Giotto from all that had gone before. Giotto's painting, perhaps just twenty years the younger, has the same function and subject as Cimabue's, is almost the same size and employs a similarly symmetrical composition. There is a greater three-dimensional conviction to Giotto's throne, however: it is not to be understood as having descended from Heaven – as Cimabue unconvincingly attempts to portray it – but rests on two stone steps decorated with slabs of marble and colourful inlay. It is roofed by an ornamental canopy in Gothic forms which replaces a built architectural setting. The steps serve both to raise up the Madonna just as a plinth elevates a statue, and at the same time to create an empty space at the bottom of the composition corresponding to the area obscured by the officiating priest and the altar cross.

The accompanying figures are crowded into the sides of the painting, their heads lower than that of the Child. All eyes are turned towards the Virgin, with a reverence further heightened by the introduction of two kneeling angels in the foreground. She alone looks out of the picture at the worshipper/viewer; it is to her that we must turn. Mary's role as intercessor is thus more clearly illustrated here than in Cimabue. The weight of her seated body is clearly palpable, even as she draws herself up and presents her son. She is indeed the Seat of Wisdom.

Giotto does not pattern her robes with the gold weave of Byzantine fabrics, the formula conventionally used to identify heavenly beings; nor does he employ colours solely of diamond-like purity and sumptuousness, but includes broken tones, as seen in the green of the two angels standing on either side. His palette thereby appears to belong more to this world (the blue of the Virgin's mantle has greatly deepened and is too flat). Dress is portrayed just as it would appear in real life. In line with 13th-century sculpture, however, it nevertheless also serves a compositional purpose: the clear silhouette of the Madonna's cloak emphasizes the block-like nature of the central group. Its width reinforces the Virgin's monumentality, while the folds of the drapery lend her structure and at the same time guide the viewer's gaze to the infant Christ.

Giotto portrays the Virgin by selecting the most dignified and the most beautiful of human features and heightening them to a sublime degree. Despite this exaggeration of the norm, the Madonna does not seem alien. Instead, she is a vision of regal grandeur. By contrast, Cimabue's Madonna appears distanced, an impression fuelled by the tall, narrow format of the painting and Mary's elevated position. The structure of Giotto's composition is easier to read. The top line of the plinth demarcates the bottom quarter of the painting, the front edge of the seat its middle. The panel is one of the few works whose attribution to Giotto is unchallenged.

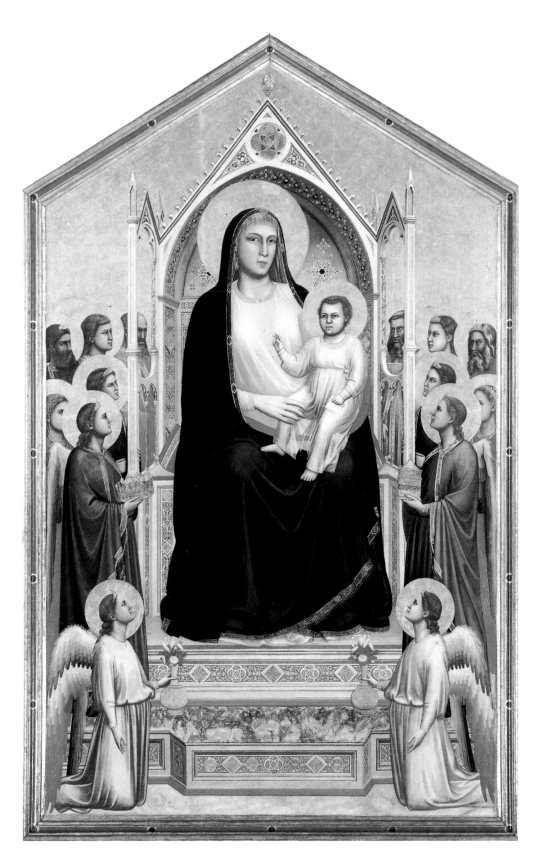

Giotto di Bondone
Enthroned Madonna with Saints (Ognissanti Madonna), c. 1305–1310
(from Ognissanti church, Florence)
Tempera on wood, 325 x 204 cm
Florence, Galleria degli Uffizi

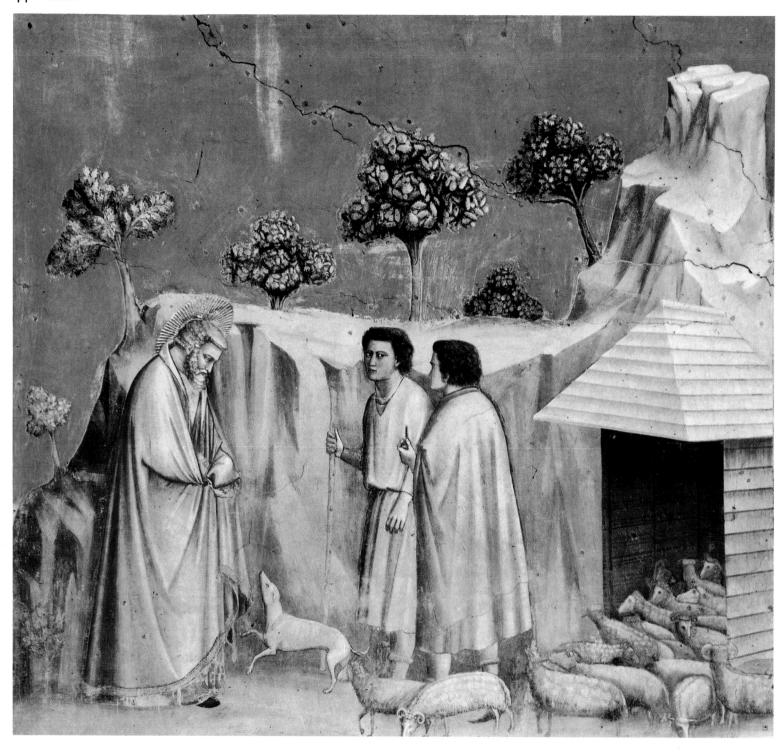

Giotto di Bondone
Joachim Takes Refuge in the Wilderness, 1303–1305
Fresco, c. 185 x 200 cm
Padua, Arena Chapel (Cappella degli Scrovegni
all'Arena)

GIOTTO DI BONDONE

1266 (?)–1337

This fresco might perhaps more accurately be
called "Joachim Downcast". Joachim, the fu-
ture father of Mary, has been to the Temple,
where his sacrifice was refused. Bitter and
ashamed (owing to the disgrace of being child-
less), he returns not to his home, but to the
solitude of his flocks. He approaches slowly,
sunk deep in thought; he sees neither the dog
who greets him joyfully nor the shepherds be-
fore him, whose sympathy for him is plain to
see. The rocks behind provide an almost archi-
tectural backdrop which concludes the group
and subtly paraphrases the composition. An
impression of three-dimensional space is cre-
ated by the depth and rounding of the figures

and the staggered organization of the three
men. Indeed, such is his sense of spatial depth
that Giotto even treats Joachim's nimbus in
three-dimensional terms.

The scene is one of maximum simplicity
and at the same time maximum effectiveness.
In contrast to other subjects from the New
Testament, Giotto could allow himself much
greater freedom in his treatment of episodes
from the lives of Joachim and Anna, which
were taken from apocryphal biblical writings
and legends and were governed by virtually no
iconographical traditions. The two frescos
shown here were the first that he painted for
the chapel which Enrico Scrovegni had built in
the so-called Arena, a former Roman am-
phitheatre. Giotto executed them largely sin-
gle-handed, and they are rightly considered the
masterpieces of the cycle as a whole.

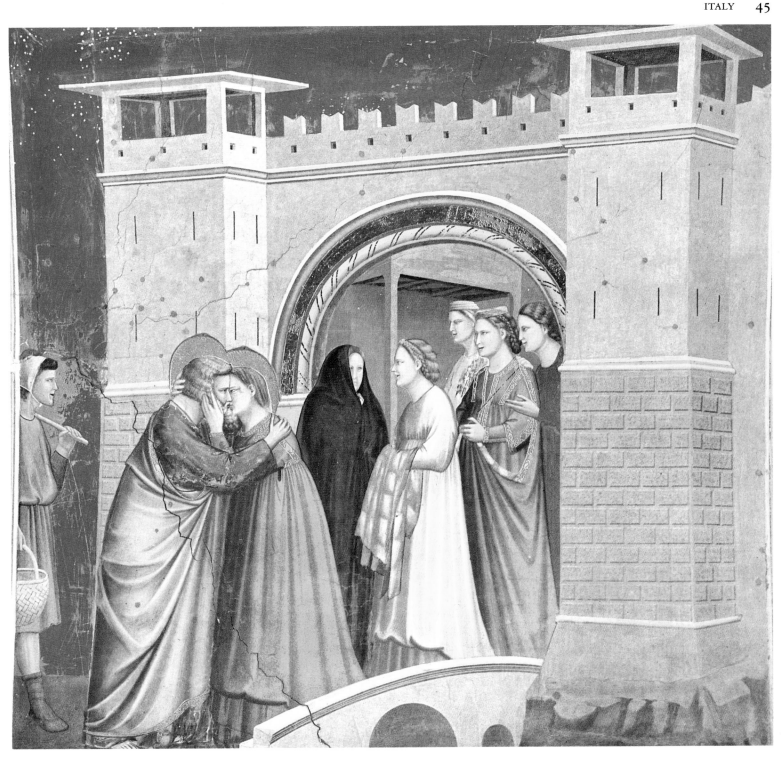

One day, while out in the fields, Joachim was visited by an angel who told him of the future birth of his daughter Mary and of the important role she would play in the salvation of humankind. An angel also appeared to Anna, Joachim's wife, in Jerusalem. Joachim immediately returned to the city. Here we see husband and wife meeting at the Golden Gate, where they joyfully embrace each other.

In contrast to the previous fresco, in which Giotto expresses Joachim's sadness through a small number of isolated and calm figures, this scene is presented as a festive procession. The elderly Joachim, arriving at a more measured pace, has halted on the left-hand side of the composition, his companion cut off by its edge. The viewer is thus skilfully informed that the two have been frozen in mid-movement. Anna, on the other hand, has already passed under the gate, accompanied by a train of four women.

Giotto translates this group of women into contemporary life. In order to prevent their general expressions of joy from devolving into monotony, and to underline the caesura between Anna and her companions, he introduces a woman shrouded in a dark cape, as if to show that even such an occasion for celebration contains an element of future sadness.

It is apparent in this fresco that areas of blue, which were applied in a second stage of painting, often failed to adhere for long. The same is true of other sections painted *al secco*, such as the ornamentation of the Golden Gate and the gold braid on the clothes. This loss is partly compensated, however, by the fact that we are better able to study the underpainting and hence the overall design process.

Giotto di Bondone
Anna and Joachim Meet at the Golden Gate, 1303–1305
Fresco, c. 185 x 200 cm
Padua, Arena Chapel (Cappella degli Scrovegni all'Arena)

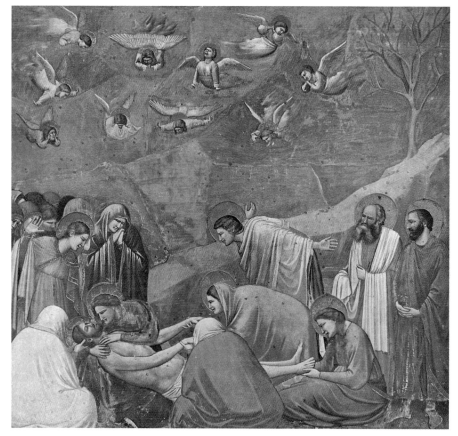

Giotto di Bondone
The Lamentation of Christ, 1303–1305
Fresco, c. 185 x 200 cm
Padua, Arena Chapel (Cappella degli Scrovegni all'Arena)

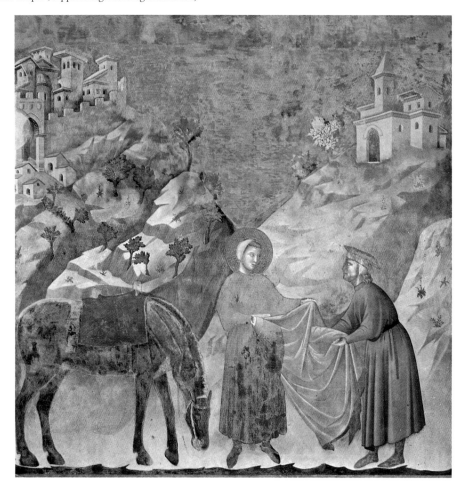

Giotto di Bondone and assistants
St Francis Giving his Cloak to a Poor Man, 1296–1299
Fresco, 270 x 230 cm. Assisi, San Francesco, Upper Church

GIOTTO DI BONDONE
1266 (?)–1337

The Lamentation of Christ is located two rows beneath the story of Joachim and Anna and on the opposite, well-lit wall of the Arena Chapel, in the immediate proximity of the visitor. Giotto's figures and narratives are typically characterized by a subdued degree of animation. This means that the scope for intensifying their expressiveness is correspondingly large. The most powerful outbursts of feeling within the entire cycle are demonstrated here by the figures in the *Lamentation*. They are not caught up in a single wave of pain, however; instead, each individual conveys a different set of emotions. In the foreground, two block-like women sit numb and frozen. By obscuring part of Christ's corpse, they concentrate the viewer's attention upon the central group of mother and son. Composed in her anguish, Mary embraces the body of Christ in farewell. Mary Magdalene, at Christ's feet, bows her head in silent grief. The woman in the middle, in a tender and original motif, raises Christ's arms as if to pull him to his feet, but simultaneously abandons the attempt upon catching sight of his wounds. John, in great distress, has flung back his arms, in a similar fashion to the angels in the sky. In line with their advanced years, Joseph of Arimathaea and Nicodemus on the right react in a more restrained but nevertheless individual fashion. Even nature is caught up in the mourning. The tree on the right has died, and the landscape is barren. Particularly effective is Giotto's decision to locate the main focus of the scene low down in the far left-hand corner, and to draw down the landscape in the background in a diagonal towards the head of Christ.

This scene from the life of St Francis illustrates the compassion and love which Francis felt for the poor, even before his conversion. The wealthy son of a cloth merchant, he meets a nobleman who has fallen on hard times and spontaneously gives him his cloak. While the nobleman is not shown in rags, he nevertheless lacks a cloak in keeping with his class. There is thus only a vague parallel between this story and the famous tale of St Martin, who cut his cloak in two in order to give one half to a beggar. In view of the somewhat puzzling and one-sided selection of scenes making up the St Francis cycle in the Upper Church, one might even ask whether the present fresco was intended to show that the Franciscan ideal of poverty was not aimed against the social order *per se*. Francis is not captured in an act of spontaneous giving, but is presented in hierarchical fashion in the central axis of the composition. The figures are lined up in a row at the front of the picture, without appearing to have anything of substance to stand on. Neither the size nor the shape of the pictorial field have been exploited with any true mastery, while the treatment of the bodies and the handling of spatial depth are artistically far removed from the first frescos in the chapel. In view of both its execution and its design, the fresco is thus considered to be the work of one of Giotto's assistants.

DUCCIO DI BUONINSEGNA

C. 1255 – C. 1319

Mary is presented in the central axis and looks out at the viewer/worshipper. Behind her, four angels hold up a silk, gold-bordered cloth of honour, which together with her throne identifies her as the Queen of Heaven and the Seat of Wisdom. Christ is holding her fingers, symbolizing the mystic marriage between Son and Mother of God. The motif of the mantle spreading behind the three Franciscan monks identifies the Madonna as the Virgin of the Protecting Cloak. This small devotional panel is the painted pendant to a hymn to the Virgin.

The artist clearly changed his mind in several places, deviating from the preliminary sketch scored in outline onto the surface. He frequently painted over the previously applied gold ground, something which not only demonstrates a carefree attitude to cost but which also explains why much of the paint has since peeled off. The throne, too, has been painted on top of the curtain of the ground, in order to emphasize the kneeling Franciscan monks more strongly. This highly unusual, ongoing experimentation is evidence that Duccio carried out his commissions in neither a routine nor a coolly calculated manner. Unfortunately, the delicacy of his modelling is also to blame for the fact that nothing has survived of what was formerly, no doubt, the very rich decoration of the Virgin's clothing. The painting today appears more two-dimensional and hence more severe that originally intended. There may have been two wings attached to this small panel, allowing it to be closed to view. Even these are unlikely to have contained any more details about the donor, however. The three monks cannot be interpreted as identifiable individuals; they kneel here in witness to the Franciscan veneration of the Mother of God.

This panel was originally part of the predella, since broken up, of the high altar retable in Siena cathedral. Its poor condition is a result of its low location. It was originally framed by individual portraits of the prophets, including a picture of King Solomon. Destined as it was for the front of a hieratic altarpiece, even this small scene is strict and dignified in its composition.

The centre is emphasized by the architecture of the background, and in particular the triangular gable. The figures are presented in strict relief. Characteristic motifs include the group of horses in classical style, borrowed from the Three Kings relief by Nicola and Giovanni Pisano on the pulpit in Siena cathedral, and the Virgin's throne. The palette concentrates upon the pure triad of blue, red and gold, as found in French court art and as commonly employed by Duccio for his highest-ranking figures, at least on the altar front. Within this strict framework there are many subtleties: the shift from red as the main colour accent on the left to blue on the right, for example, the use of contour and the cave roof to emphasize the Mother and Child group, and the manner in which the composition takes up the panel's frame.

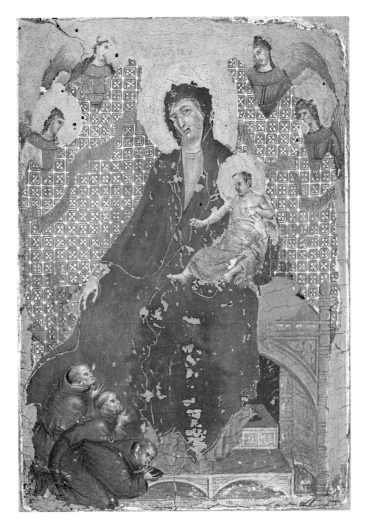

Duccio di Buoninsegna
Madonna of the Franciscans,
c. 1300
Tempera on wood, 24 x 16 cm
Siena, Pinacoteca Nazionale

Below:
Duccio di Buoninsegna
Adoration of the Magi,
1308–1311
(detail of the predella of the
Maestà)
Tempera on wood, 42.5 x 44 cm
Siena, Museo dell'Opera del
Duomo

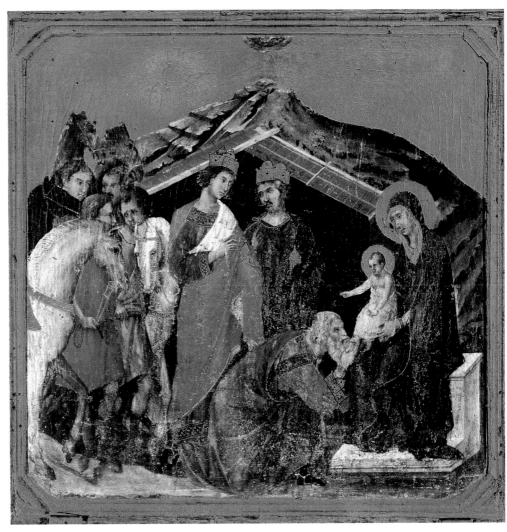

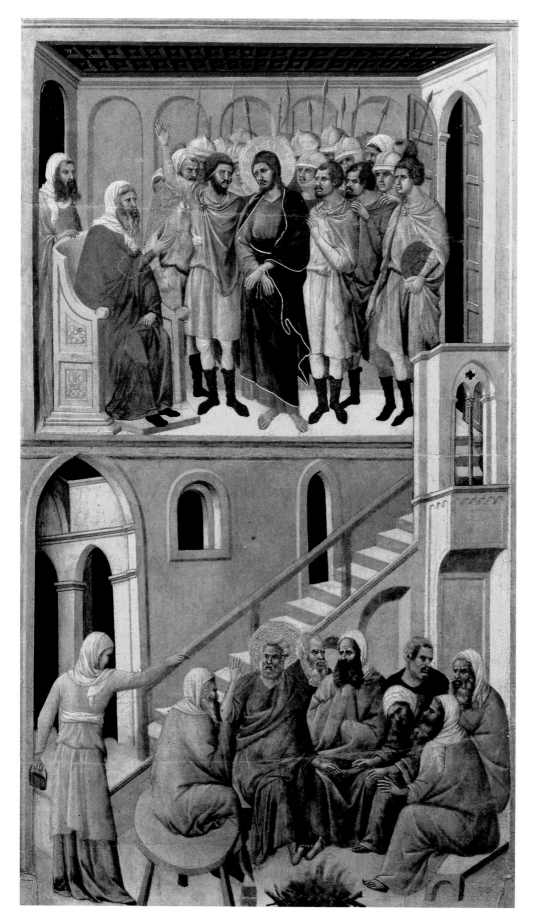

Duccio di Buoninsegna
Peter's First Denial of Christ and Christ Before the High Priest Annas, 1308–1311
(from the back of the Maestà formerly on the high altar of Siena cathedral)
Tempera on wood, 99 x 53.5 cm. Siena, Museo dell'Opera del Duomo

DUCCIO DI BUONINSEGNA

C. 1255 – C. 1319

What is surprising about this panel is the way in which Duccio has taken two separate events from the Bible (albeit unfolding in the same building) and made them into one picture.

Above we see Christ before Annas, the high priest to whom he was taken after his arrest and who now seeks a reason to convict him. The scene shows Christ's interrogation and, more particularly, the false evidence being offered against him by different people. Below, in what is presented as the courtyard of the high priest's palace, Peter is seated in a circle of the priest's men, warming his feet at the fire. Viewers contemplating the rear of Duccio's *Maestà* would have known, from the order of the pictures, to read the panel from bottom to top. They would thus have understood the *Denial* as the first scene and *Christ Before the High Priest Annas* as the second. This sequence is affirmed both by the figure of the servant girl, seen from behind in the act of turning to mount the stairs, and by the stairs themselves. Indeed, the pose of the servant girl is a stroke of artistic genius. Her outstretched arm may be understood both as gripping the railing and simultaneously as pointing at Peter. Her isolated position at the left-hand edge of the composition immediately identifies her as an important figure playing an explanatory role, yet one who is not amongst the main characters.

A rich network of relationships is interwoven between the lower and the upper scenes, partly through analogy and partly through contrast. The spatial relationship between the servant girl and Peter is similar to that between Annas and Christ. The theme introduced in the lower half is taken up and amplified above: Christ stands alone in front of the soldiers, distinguished from them by the style and colour of his dress. Peter, on the other hand, has mingled with Annas' men and is hard to pick out from the group. He is sitting down and taking it easy, warming his feet by the fire, while his similarly barefoot master suffers. Whereas the figures in the lower scene form an almost complete circle, those above are presented more frontally. The architecture below is portrayed in some detail and includes a succession of receding planes, whereas the events above take place parallel to the pictorial plane, on a shallow stage whose wings and backdrop are provided by a symmetrical fake architecture. The ceiling lines vanish towards the centre, emphasizing Christ. There are many more such comparisons to be made, but we should mention in particular the intensification of colour which accompanies the progression from bottom to top, not just in the main characters. A striking feature from an art-historical point of view is the fact that the panel combines design principles which we would normally date to different epochs. Thus the flatter, symmetrical upper scene would usually be considered older, and the more plastic lower scene, with its greater spatial depth reminiscent of Giotto, more recent. Duccio here employs both in order to distinguish between the solemnity and importance of the two events.

MASO DI BANCO

ACTIVE 1320–1350

This fresco is the lowest and hence most easily visible of a cycle devoted to the life of St Silvester, the pope who converted Empress Helena to Christianity and baptized Emperor Constantine. The cycle, which is located in the Bardi di Vernio burial chapel, represents Maso di Banco's most important piece of work and earned high praise from Ghiberti. Pope Silvester is here seen, on the left, taming a dragon which had made its home in the Forum Romanum in Rome and which had already poisoned numerous people with its foul breath. The narrative then switches direction, and the Pope reappears in the centre, in the act of resurrecting two of the dragon's victims. Emperor Constantine and a group of companions are shown standing on the right.

Maso offers his own version of the historical ruins of the Forum, using its walls and arches to structure his composition. Thus the wall behind the central figure of the Pope is interrupted by a gap, creating a caesura which is further emphasized by the arch in the background. The architecture subdivides the scene, reinforces the directions in which the characters are looking and the narrative is unfolding, and furthermore lends the picture a severe, two-dimensional character. The individual bodies and objects are also rendered in a precise, almost crystalline fashion, albeit lacking in plasticity or movement.

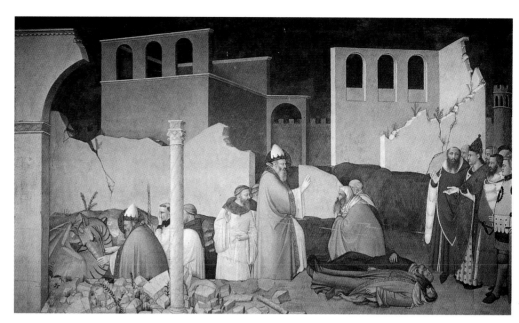

Maso di Banco
St Sylvester Sealing the Dragon's Mouth, c.1340–1350
Fresco, 535 cm (total width)
Florence, Santa Croce, Cappella Bardi di Vernio

TOMMASO DA MODENA

1325/26–1379

In a cycle of twelve large frescos, Tommaso relates the legend of St Ursula, daughter of the king of Brittany, and her 11,000 virgins, their journey to Rome and their martyrdom at the hands of the Huns in Cologne. As so often the case, the cycle was commissioned following the acquisition of a holy relic. Were we ignorant of the religious nature of its content, we might easily mistake the present fresco – whose colours are no longer seen in their full glory owing to the loss of most of the *a secco* painting – for a scene from the world of court society.

The figures are clad in the latest fashions: tight-fitting clothes emphasize the bodies of both the women and the men. Where forms are not sufficiently rounded, they are improved upon by the artist. The shortness of the men's tunics is underlined by their long sleeves.

Tommaso's artistic approach is similarly inspired by the real world. He has taken his characters from the well-fed middle classes and religious circles of Treviso, portraying them more as individuals than as types. Despite the large numbers of figures involved, he nevertheless groups them in a successful manner. It was this unaffected view of reality more than the study of older Tuscan art that led to the flowering of painting in Upper Italy from the mid–14th century.

Tommaso da Modena The Departure of St Ursula, c. 1355–1358
(from the cycle in the choir of the Augustinian anchorite church of Santa Margherita)
Fresco (detail), 233.5 x 220 cm (total size). Treviso, Museo Civico

Master of the Westminster Altar
Westminster Altar, c. 1270–1290 (middle and left-hand fields)
Mixed technique on oak, 333.5 x 95.8 x 4.7 cm (total size)
London, Westminster Abbey

ENGLISH MASTER

ACTIVE C. 1270–1290

Despite the damage it has suffered, this work of extraordinarily high quality provides important insights into altar typology and the development of painting techniques. It was probably executed on site for the high altar of Westminster Abbey. Along with the Soest panel (ill. p. 36 f), it numbers amongst the earliest surviving retables, and was also not designed to be folding. Its size is equal that of the largest Italian altarpieces; nothing comparable exists in the North. It thereby imitates works of goldsmithery in its use of plaster, coloured glass (in places on a silver ground), enamel and seven different kinds of gilding on all its framing elements. The middle and the narrower outer fields feature individual saints beneath a baldachin structure: in the middle, Christ in Glory between Mary and John, and to the side Peter and Paul. The geometric division of the remaining fields is inspired by Islamic art, whose decorative patterns were increasingly finding their way via Spain to other Christian countries as a byword for luxury. The Spanish princess Eleanor of Castille was queen of England from 1274 to 1290 at the side of her husband Edward I. As far as can be concluded from the fragmentary body of works surviving from this period, the forms of the baldachins and the miracles performed by Christ in the four star-shaped fields seem to bear parallels with northern French painting.

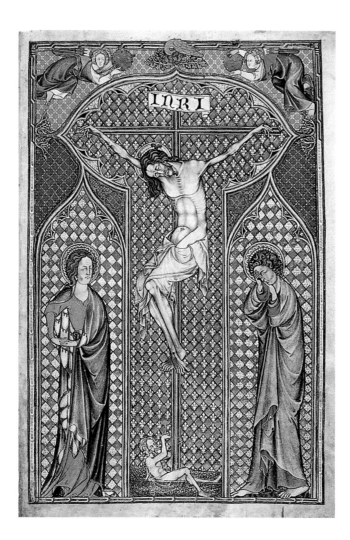

Master of the Psalter of Robert de Lisle
Crucifixion, before 1339
(miniature from the *Psalter of Robert de Lisle*, part 2, fol. 132 v)
Body colour and metal leaf on parchment, 33 x 23 cm
London, British Library
(ms. Arundel 83)

ENGLISH MASTER

ACTIVE BEFORE 1339

In the first half of the 14th century, tile-like backgrounds covered with abstract geometric patterns appear with growing frequency both in manuscript illumination and in panel and wall painting. They reach a particular height of aesthetic sophistication in the psalter from the east of England which Baron Robert de Lisle gave to his daughter in 1339.

A T-shaped field filled with delicate tracery provides the foil for the central crucifix. To the right and left, Mary and John are contained within two similar fields whose borders fuse with those of the T. The grounds of all three fields feature a lozenge pattern of the same format. They are treated so differently in terms of their ornamentation and palette, however, that, contrary to convention, Christ and his companions are organized into clearly separate spaces. Even the strips of ground on which they stand, the only token elements of landscape, are different. In the case of the two lateral figures, they are barely noticeable, whereas the slender cross rises out of a broader stretch of vegetation. Holding its foot is Adam, rising up out of the tomb draped only in a veil. His sin is redeemed: God has sacrificed his only son, just as the pelican at the top tears opens its breast for its young. As the young birds drink the blood of their parent, so Adam catches Jesus's blood in the Communion cup.

PARISIAN MASTER

ACTIVE C. 1290–1318

This breviary, probably executed for the King himself, marks the pinnacle of the flowering of the arts under Philip the Fair, the influence of which would be felt well into the 14th century. The present illumination, located between calendar and text, is of outstanding quality. It already looks forward to the art of Jean Pucelle a whole generation later (ill. below). In the top half, the youthful David kneels before Samuel, who anoints him with oil poured from a horn. On the right, against the backdrop of Bethlehem, Jesse, David's father, and his seven other sons are gesticulating in astonishment. In the lower field, Israel led by Saul watches anxiously as the young, unarmed David slays Goliath with a single stone from his sling. Although the miniaturist sticks closely to the Biblical text, he succeeds in configuring his groups with a rhythmical mastery. The subtlety of his composition is underlined, for example, by the swathe of cloak which Jesse holds up behind David like a screen, and which separates David from his family at a formal level, too. Byzantine formulae are finally overcome. The generous folds of drapery are lent a greater sculptural quality by the bold use of light and shade. The long faces with their broad foreheads are extraordinarily animated. Their locks of hair writhe like little snakes. Elements of landscape insert themselves between the figures and decorative foil of the background.

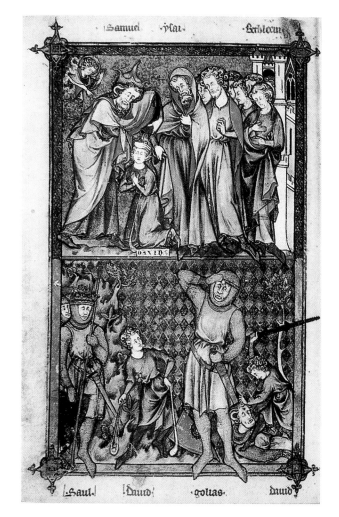

Master of the Breviary of Philip the Fair
The Anointing of David and David and Goliath, c. 1290–1295
(miniature from the *Breviary of Philip the Fair*, fol. 7 v)
Body colour and metal leaf on parchment, 21 x 13.3 cm
Paris, Bibliothèque Nationale
(ms. lat. 1023)

JEAN PUCELLE

ACTIVE C. 1319–1335

The Book of Hours which Jean Pucelle illustrated for Jeanne d'Evreux marks the climax of Parisian court painting. It was a gift from King Charles IV to his wife, who was one of the most cultured and active patrons of art of her day. Along with a number of other women at court, she thereby played an influential role in shaping contemporary French taste in art.

In the initial D beneath a scene of the Annuciation, the queen is shown reading at her prie-dieu. The manuscript was evidently intended to surprise its recipient, and it is indeed surprising in both its small format and its widespread renunciation of colour. Pucelle executed every aspect of the work himself, something rare and remarkable in itself. Scenes from Jesus' childhood and Passion are organized in pairs in front of each section of the book. The borders are inventively ornamented, here with children's and party games, together with grotesque figures and beings, partly to amuse the reader and partly in witty allusion to the main illustrations.

Both the compositions and the portrayal of space are derived from Duccio's *Maestà* (ills. pp. 13, 48), but are enriched with the addition of imaginative details and inventions (such as the angel captured in flight below and to the right of the Virgin), making this Book of Hours a collection of miniature works of art.

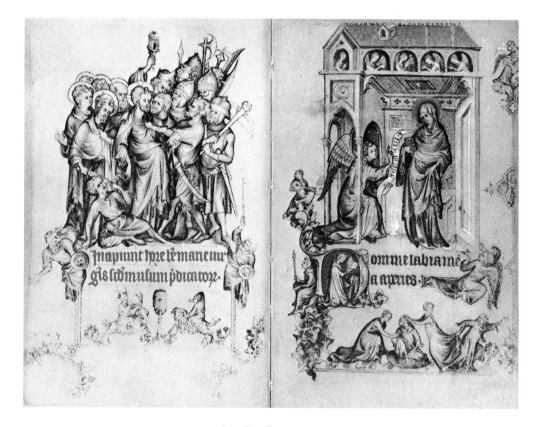

Jean Pucelle
The Betrayal of Christ and The Annunciation, 1325–1328
(miniatures from the *Book of Hours of Jeanne d'Evreux*, fol. 15 v and 16 r)
Manuscript illumination, 9.4 x 6.4 cm (dimensions of page)
New York, The Metropolitan Museum of Art, The Cloisters

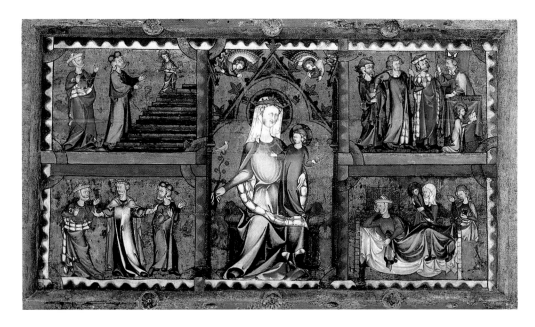

Norwegian Master
Antependium from the church in Odda (Hardanger), before or c. 1350
Mixed technique on wood, 36 x 55 cm
Bergen, Historisk Museum

Cologne Workshop (?)
The Baptism of Constantine; "The Donation of Constantine";
Sylvester's Dispute with the Jewish Scholars,
c. 1335 (from the north parclose in Cologne cathedral)
Mixed technique on plaster
Cologne, Hohe Domkirche St Petrus und Maria

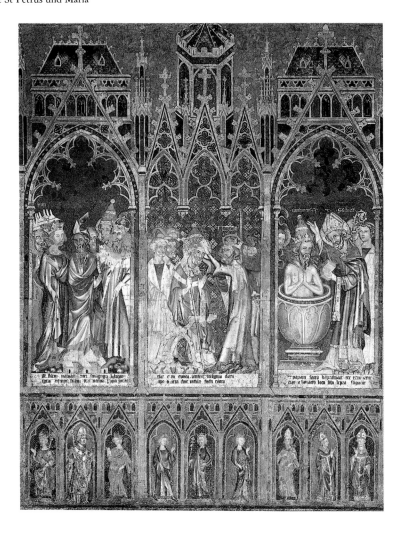

NORWEGIAN MASTER

ACTIVE C. 1340–1350

Some thirty antependia from the years between 1250 and 1350 have survived in Norway, together with wooden baldachins, church furnishings, illuminated manuscripts and even entire painted interiors. They are grouped above all around Trondheim, Bergen and Oslo. These Norwegian works closely followed trends in England from the same period, and can thus shed a little light on stylistic developments in this important European centre, whose own art was subsequently devasted in waves of iconoclasm even more brutal than those elsewhere. The Norwegian antependia of the 13th century and the English Westminster Altar (ill. p. 50) together represent the oldest known examples of oil painting in medieval Europe. These early panels thereby fall short of the perfection achieved by the Early Nether-landish artists at the start of the 15th century, and famed as far away as Italy. One of the most beautiful and interesting of the Norwegian antependia is this small panel from Odda. Its subtle, shimmering highlights lend a remarkable metallic sheen to the large, smooth areas of drapery. These are edged by deep folds running at times right up to the chest. The panel portrays scenes from the childhood of Mary, taken from *The Golden Legend*, including the separation of her mother Anna from her infertile father Joachim by the angry high priest, and the choice of a husband for Mary.

COLOGNE WORKSHOP (?)

ACTIVE C. 1330–1340

The walls above the stalls were only painted over a decade after the consecration of the choir (in 1322), using a technique borrowed from panel painting. At the core of the artistic programme lies the life of Pope Sylvester, which takes up two of the six fields. According to a document which was exposed as a fake during this very same period, Emperor Constantine gave the western provinces of the Roman Empire to Sylvester by way of thanks for his baptism.

Whereas, in the preceding scenes of the interpretation of his dream and his baptism, Constantine wears a pointed hat with two gold hoops, with his crown resting on the lower one, the roles are now reversed. The Emperor gives the Pope the conical hat and from now on wears simply the crown, now adorned with a bow. The following three fields show how his mother Helena makes objections to Constantine's baptism, but then finally embraces the new faith herself – along with all the scholars brought to argue her case, of whom the Cologne painter shows virtually nothing but their Jewish hats. The bishop who probably commissioned the painting was particularly dependent upon the support of the Pope, whose side the Cologne church had taken against Ludwig of Bavaria. In stylistic terms, local practice seems to blend with influences from England and in particular France.

VIENNESE MASTER (?)

ACTIVE C. 1330

Following a fire in 1330, the four new panels painted for the exterior of the altar in Klosterneuburg, just outside Vienna, represent the most important early reaction in the North to the works of Giotto. Both geographically and chronologically, they thereby also provide a vital link with Bohemia, where the *Kaufmann Crucifixion* (ill. p. 62) was executed just ten years later. While the *Resurrection* panel cites Giotto quite directly, the Gothic hairstyles and linear folds of drapery in the three other scenes – the *Crucifixion*, the *Death of the Virgin* and the *Coronation of the Virgin* – make any stylistic dependance upon the Italian artist less obvious.

The pictorial programme juxtaposes the deaths and apotheoses of Christ and his mother. Mary thereby represents the heavenly bride and the personification of the Church. Her immediate assumption, the subject of lengthy theological controversy, is not directly shown. Instead, Christ appears amongst the group of disciples within the *Death of the Virgin* panel in order to receive his mother's soul, which is depicted as a small-scale version of herself. The apostles gathered around her deathbed, and holding a cross, candles and incense burners, convey an impression of 14th-century death rites. The most striking invention by the Klosterneuburg artist is the throne being flown in by two angels, upon which Mary's crown already awaits her.

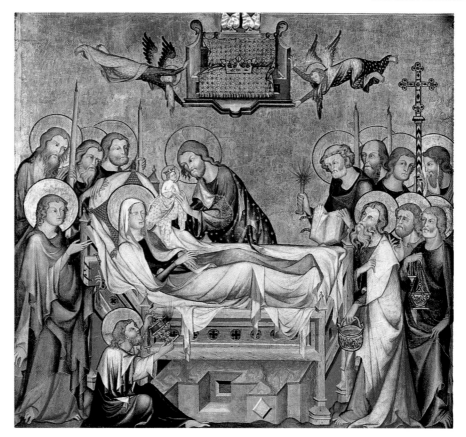

Master of the Klosterneuburg Altar
Death of the Virgin, 1331 (?) (from the Klosterneuburg Altar)
Mixed technique on wood, 108 x 119 cm
Klosterneuburg, Chorherrenstift, Stiftsmuseum

UPPER RHENISH MASTER (?)

ACTIVE C. 1310–1320

The poet portrayed here, a member of the Schenk family of knights, contributed six songs to the famous collection of German lyric poetry, the Manesse song manuscript. They tell of the lover's yearning for his beloved, who bestows her favour upon him only in his dreams and who keeps his heart prisoner even when she is far away. A singer and the lady he adores face each other in the majority of the 137 full-page miniatures in the manuscript. The singer, dressed for a battle, tournament or journey, kneels respectfully before his lady and receives his helmet from her before he departs. With his hands folded, he turns towards his lady, whose slender figure is emphasized by the graceful folds of her blue dress. The knight's green tunic is adorned in several places with a large white A, which may be taken to denote "amor" (love) and the singer's heraldic device. In a decorative relationship to the lower pictorial field, a peacock is stepping between the leaves of the tree as it looks back at a falcon taking wing. The figures illustrate the High Gothic ideal of beauty in its late form: a face surrounded by curling locks of hair and designating simply a type, and a slender body adopting a gentle, slightly S-shaped pose, giving rise to a rich play of draperies. It may be assumed that the preliminary drawing, in black pencil, and the subsequent illumination were executed by the same artist.

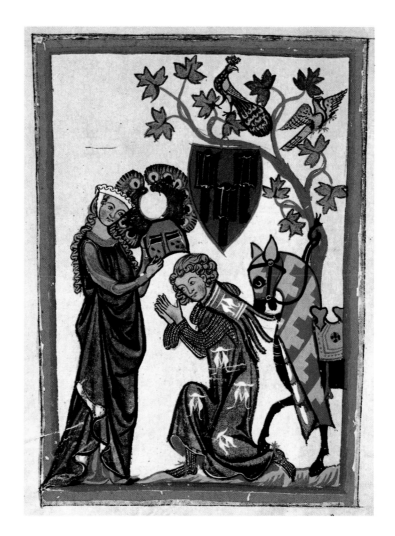

Upper Rhenish Master (?)
Schenk of Limburg,
c. 1310–1320
(miniature from the *Great Heidelberg* or *Manesse song manuscript*, fol. 82 v)
Coloured pen drawing on parchment, c. 35 x 25 cm (dimensions of page)
Heidelberg, University Library (ms. Palat. germ. 848)

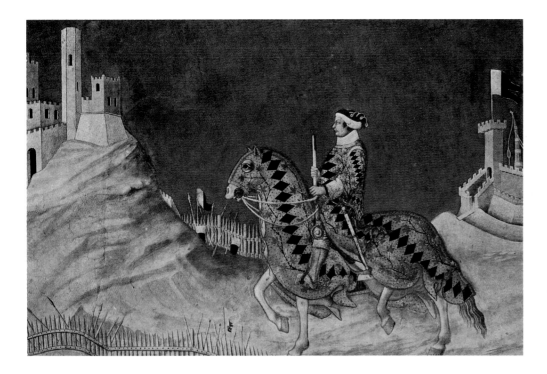

Simone Martini
Guidoriccio da Fogliano, c. 1328
Fresco (detail), 340 x 968 cm (total size)
Siena, Palazzo Pubblico, Sala del Mappamondo

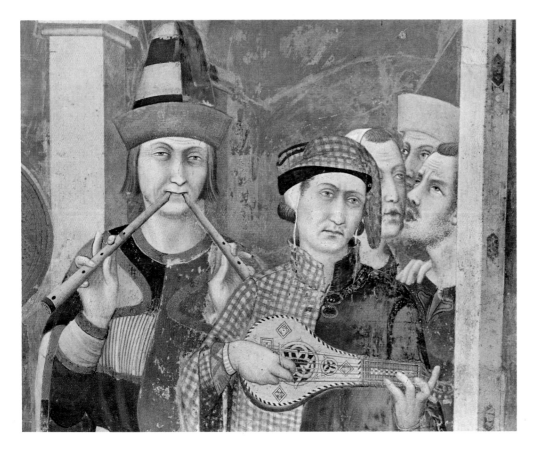

Simone Martini
Musicians. Detail: St Martin is Dubbed
a Knight, 1317–1319
Fresco, 265 x 200 cm (total size)
Assisi, San Franceso, Lower Church

SIMONE MARTINI

C. 1280/85–1344

Simone's fresco is located in the Sala del Mappamondo on the wall opposite his other masterpiece, the *Maestà* (ill. p. 14). It was painted in honour of the military commander Guidoriccio da Fogliano and shows a topographical view of the besieged town of Montemassi on the left and the Sienese fortress on the right. The siege took place in 1328, following the end of Ludwig of Bavaria's Italian campaign, when the papal party – which included Siena – sought to turn the Emperor's imminent defeat to their advantage. The rider and the location are treated as two separate entities. The commander is not shown engaged in actual battle. The location is almost abstract, although probably based on a study from nature. The equestrian portrait of the commander is projected like a monument against the landscape.

Men like Guidoriccio were a phenomenon of the 14th century and were born of the rise of mercenary armies over civilian forces. According to Jacob Burckhardt, these condottieri developed something of a right to an official portrait, and the state a duty to provide it. In the figure of Guidoriccio, Simone portrays a military type rather than an individual, but nevertheless pays precise attention to his splendid appearance, heightened by the large diamond patterns on a gold ground which adorn the horse's caparison and the rider's magnificent cloak like the tails of kites.

The decoration of the Lower Church in Assisi was funded by a donation from a Franciscan cardinal who died in 1312. The cardinal had been an ardent supporter of the house of Anjou, in whose service he had helped with the acquisition of Hungary. The cycle comprises ten scenes from the life of St Martin, starting with the episode in which he divides his cloak with the beggar and finishing with his death. Despite its church setting, the cycle is a work of court art; painted by Simone Martini, himself ennobled while in Anjou service, it glorifies the French ruling house through the figure of St Martin, who was both French and Hungarian. It thereby gave implicit blessing to French dominion over the kingdom of Hungary and lent support to the Anjou party all over Italy and in its struggle for the imperial crown. But while the episode in which St Martin is dubbed a knight belongs to the chivalric and secular world, not so the style of Simone's painting.

Although the detail reproduced here shows a group of musicians – their faces by no means noble – in colourful dress, they are fully absorbed in their music-making. This is particularly true of the singers. The severity of the line, the stylization, and the limited scope of movement and space within Simone's composition distance the scene from the viewer. The fresco is recognizably the work of a panel painter. Simone's attempt to create an iridescent effect by superimposing two different colours within the brim of the recorder-players's hat, and his focus upon fine details, show him applying the techniques of panel painting to the medium of fresco.

These two panels originally formed part of the
same polyptych, painted for Cardinal Orsini.
The four other panels are currently housed in
Antwerp (*Annunciation* and *Crucifixion*) and
Berlin (*Entombment*). In these small-scale devo-
tional pictures, Simone reveals a very different
side to his art. The personal nature of these
paintings, which were intended for private
worship, demanded an approach and a treat-
ment different to the fresco or the altarpiece.
These are small, almost miniature-like pictures
full of figures.

Particularly striking is their impassioned
movement: here, a stream of people is flowing
out of the city of Jerusalem in the directions
indicated by the arms of the cross. But this is
no narrative in the conventional sense: al-
though Christ is shown walking, he neverthe-
less appears frozen in mid-step like a statue,
inviting the viewer to reflect upon his tragic
fate. Of secondary importance, but clearly es-
tablished, is the relationship between Christ
and his mother. Mary raises her arms as if
wanting to help carry the cross in a gesture
which is simultaneously one of lamentation.
But she can neither help her son nor stop the
procession to Calvary; the captain who will
recognize Christ's divinity beneath the cross
braces his shield against her.

Looking back, Christ takes his leave of his
mother. Our eyes are also drawn to Mary Mag-
dalene, dressed in crimson with her arms raised
in despair above her head. Simone's introduc-
tion of new narrative details, his deviation
from the conventional norm and his composi-
tional mastery of both serve to demonstrate his
great artistry.

Simone Martini
The Road to Calvary, c. 1315 (or later)
(part of the Orsini Polyptych)
Tempera on wood, 29.5 x 20.5 cm
Paris, Musée National du Louvre

As the donor of the polyptych, Cardinal Orsini
did not have himself portrayed at the foot of
the cross in the *Crucifixion* panel as was usually
done, but rather in the *Deposition*. The striking,
steep diagonal of the ladder establishes the
chief axis of the composition. The main group
of figures is at the extreme left. In retaining
the wooden cross as the centre, the painter pays
reverence to this most sacred of holy relics.
Mary throws herself towards her son, while
John attempts to restrain her. Like Mary, the
entire main group faces towards the dead
Christ, including the donor; indeed, even the
brush strokes of the ground lead in this direc-
tion.

A visual caesura to the right of the cross en-
sures that this single wave of motion is not
weakened. The faces and gestures of the figures
on the right also point towards Christ, in par-
ticular the emphatically visible figure of Mary
Magdalene. Beside her, a woman holds two
nails from the cross in her cloaked hands (a
sign of respect) – a further reference to the cult
of relics from Christ's Passion. The same fig-
ures appear repeatedly in the polyptych, fusing
the individual scenes into a cyclical whole.
Each panel nevertheless remains an original
and unique devotional picture. With their
jewel-like luminosity, their finely gradated nu-
ances of colour and their delicate execution,
however, they simultaneously provide an inex-
haustible source of delight for the eye and this
would undoubtedly have corresponded to the
donor's wishes.

Simone Martini
The Deposition, c. 1315 (or later)
(part of the Orsini Polyptych)
Tempera on wood, 29.7 x 20.5 cm
Antwerp, Koninklijk Museum voor Schone
Kunsten

Pietro Lorenzetti
Sobach's Dream, 1329
(from the predella of the high altar of Santa Maria
del Carmine, Siena)
Tempera on wood, 37 x 44 cm
Siena, Pinacoteca Nazionale

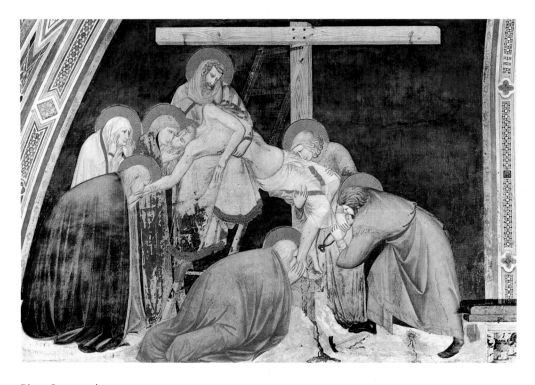

Pietro Lorenzetti
Deposition, c. 1320–1330
Fresco, 232 x 377 cm
Assisi, San Francesco, Lower Church

PIETRO LORENZETTI

c. 1280/90–1348 (?)

In 1327/28 Lorenzetti was commissioned to paint a winged altar for the Carmelite church in Siena. He only handed the finished work over to the Carmelites once they had paid his fee – 150 gold florins – in full. In the present scene, an angel appears in a dream to the father of the prophet Elijah and tells him that his son will be the founder of the Carmelite order.

While altarpieces obeyed a strict and hierarchical format in line with their function, artists enjoyed much greater freedom in the design of predelle. Pietro was one of the first to exploit this. He thereby indulged his personal preferences – for large and boldly patterned surfaces, for example, seen here in the blanket and the floor tiles, which also reflect the painter's remarkable feel for the qualities of materials. The palette is also very much Lorenzetti's own, dominated by greeny greys and tonal sequences in rich gradations. What appears to be subjectivism also opens up new and advantageous ways of treating the main theme, a dream: the dreamer is thrust not to the very front of the picture, as one might customarily expect, but into the depths of the room. The remaining areas of the picture are given over not to a continuous gold ground, but to a complex architecture which is neither drawn from real life nor even possible. The picture is an architectural fantasy of an unusually modern kind and as such alludes to the mysterious nature of the world of dreams.

Of all his fellow Sienese painters, Pietro Lorenzetti made the most intense study of Giotto's design principles. In his Passiontide cycle for the Lower Chapel in Assisi, which he executed in several stages between 1320 and 1330, in part with the aid of assistants, his style assumed an increasing simplicity as his richly animated use of line gave way to powerfully expressive, unbroken curves. In the *Deposition*, undoubtedly executed by Lorenzetti himself, this development reaches a high point. Only the slenderly proportioned body of Christ, its limbs indicating a number of contrasting directions, betrays the Sienese origins of the artist. Spatial depth is established primarily by the three-dimensional grouping of modelled figures. Individual figures can thereby be traced directly back to Giotto: Mary Magdalene, for example, who is seen kneeling at the foot of the cross, is based on the figure of Joachim making his sacrifice in the Arena Chapel in Padua.

Rather than portraying a specific moment during the Deposition, Lorenzetti suggests a chronological sequence of events. The oblique traced by Christ's body is reinforced by the line of bowed heads and upper bodies which descends from the head of Joseph of Arimathaea down to the figure in the bottom right-hand corner, Nicodemus, who is pulling out the nails from Christ's feet with a pair of pliers. This same line seems to continue into the *Entombment* on the opposite side of the end wall of the Orsini Chapel.

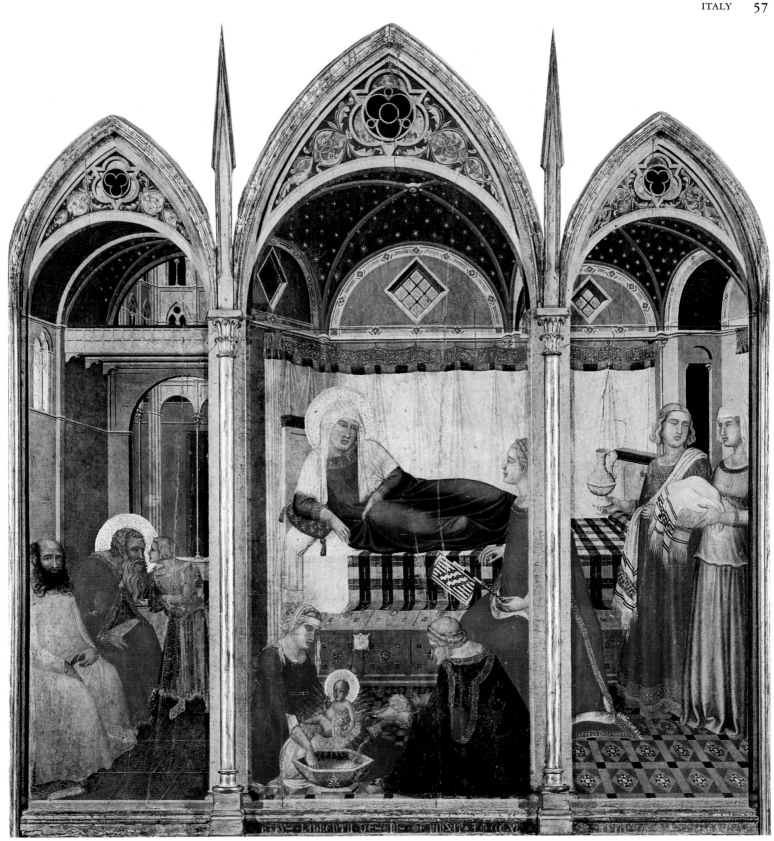

The scene is set within an illusionistic archi-
tecture. Through open arches, which also
frame the painting, we glimpse two rooms of
different size. In the centre and on the right we
see a group of women, and on the left Joachim
and his companions. The curtain around the
bed has been pulled back so that Anna, whose
broad and heavy figure is reminiscent of
Giotto, can be seen. The painted starry vault
simultaneously lends the room a sacred charac-
ter. Clearly framed at the centre of the compo-
sition, Anna is immediately identified as its
focal point.

Contrary to the convention of the day,
whereby paintings were read from left to right,
this work must be decoded in the opposite di-
rection. The artist thereby took into account
the fact that the altar on which it was destined
to stand could only be approached from the
right. For this reason, too, only the room on
the left opens further inward. The precise exe-
cution of the interior and scene is just as inno-
vative as the artistic concept underpinning the
whole. Also expressed here, is Lorenzetti's
predilection for cool colour tones, particularly
greens and greys.

Pietro Lorenzetti
Birth of the Virgin, 1342
(from Siena cathedral)
Tempera on wood, 188 x 183 cm
Siena, Museo dell'Opera del Duomo

Ambrogio Lorenzetti
Allegory of Good Government, c. 1337–1340
Fresco (detail), 296 x 1398 cm (total size)
Top right: Allegorical personifications of Faith,
Charity and Hope
Left: Peace, Fortitude, Prudence
Middle: Good Government
Right: Magnanimity, Temperance, Justice
Siena, Palazzo Pubblico, Sala dei Nove

AMBROGIO LORENZETTI

C. 1290 – C. 1348 (?)

We tend to see Gothic art as something re-
served exclusively for churches, and there can
be no doubt that the development of new
artistic techniques and media was primarily
fuelled by ecclesiastical commissions. There is
nevertheless evidence that a large and impor-
tant body of secular art was also created be-
tween the 13th and 15th centuries. Historical
sources document commissions for paintings,
almost none of which have survived into the
present. Examples include portraits of traitors,
debtors and political opponents, often sus-
pended by their legs in disgrace. Large fresco
cycles were also common both in city palaces
and in houses. There are descriptions of pic-
tures of bathhouses, gardens, castles and illus-
trated chivalric romances. While frescos
painted outdoors have long since weathered
away, others were lost for more complex rea-
sons.

In the 17th and 18th centuries there was
generally little sense of the artistic value of ear-
lier art. Age continued to count only in the
Church: the frescos in San Francesco in Assisi,
for example, were virtually equal to holy relics.

The Church was essentially concerned with
continuity and did not recognize the fluctua-
tions experienced by systems of government.
In the sphere of secular art, on the other hand,
every change in ruler, in party and even in day-
to-day politics (such as a switch of allegiance)
threatened any paintings created to champion
the ideas and teachings of those previously in
power. In short, secular art was destroyed more
thoroughly than religious art. This is why the
present set of frescos, located in Siena's Town
Hall, are so precious. They give us an idea of
what we have lost.

At the time when they were painted, Siena
had a republican constitution, but was *de facto*
an oligarchy controlled by the merchant
classes. Lorenzetti's frescos adorned the Sala dei
Nove, the council chamber housing the meet-
ings of the so-called "Nine", Siena's highest
decision-making body. Since members of the
public were probably admitted to the chamber
at times, the cycle would also have served as a
form of propaganda. The scenes illustrated here
form part of a comprehensive intellectual pro-
gramme expressed in artistic (allegorical)
terms.

The central theme is stated on the end wall
opposite the window. The large figure right of
centre is the personification of Good Govern-

ment, representing both the city of Siena and the public weal. On the far left we see Justice with her scales, guided by Wisdom (Sapientia) above. To her right is Concordia, who holds a rope in a play upon her name (*corda* = rope). This rope is held by the 24 city councillors below, some of them clearly portraits.

Lorenzetti has orchestrated the cycle in such a way that, upon entering the chamber, the spectator is presented first with the gruesome personifications of Bad Government, and then, on turning to the right, with the figure of Justice as its counterpart. The procession of city councillors then leads the eye to the main group composed of Good Government and the cardinal virtues. The right-hand wall bears the large fresco of *The Effects of Good Government*. Lorenzetti's cycle should be read not simply horizontally from left to right, however, but also vertically, and above all with regard to its intellectual axes. One such axis can be identified on the *Good Government* wall in the classical-style figure of Peace (*Pax*) portrayed in a semi-reclining pose between the personifications of Justice and Good Government. Not without reason is this room frequently referred to in older sources as the Peace Chamber.

In the fresco on the wall on the right, undoubtedly the most impressive part of the cycle today, the effects of Peace and Good Government are spread out in detail. Ambrogio offers us a view of Siena as if seen over the city wall. The figures in the foreground are clearly larger than those further back, and the buildings in front are similarly taller than those beyond. Even if the figures are still not exactly the right size in relation to the architecture, Lorenzetti nevertheless applies the rules of perspective with an accuracy previously unseen. His pictorial space thereby appears not just deeper but altogether more real. A few anomalies nevertheless creep in: the buildings behind and to the left of the ring of dancers are lit from the right, for example, while those to the right are lit from the left. The general direction of movement of the figures also changes at this point. The richly dressed, disproportionately tall dancers might be called the main axis of this portrayal of the city and the activities of the people living in it. The group are seen performing the steps of a circle dance in a demonstration of Ambrogio's mastery of space and rhythm.

In concentrating his artistic efforts upon this group of dancers, Lorenzetti has a deliberate aim in mind. For this same group also contains the key to the meaning of the fresco, summarized in the words of St Bernard of Siena: *la pace e allegrezza* – peace is joy.

The right-hand section of the fresco echoes this theme in its evocative depiction of the Tuscan countryside, showing people hunting, riding and working in the fields. It also introduces a second theme, namely the security brought by peace, represented in the personification of Securitas (above left). No one has any fears, everyone works for the good of the city or brings his wares to market. The frescos were only given their present titles by Achille Lanzi in 1792; as Lorenzo Ghiberti (1378–1455) testifies in his *Commentarii*, they were previously known as *Peace and War*.

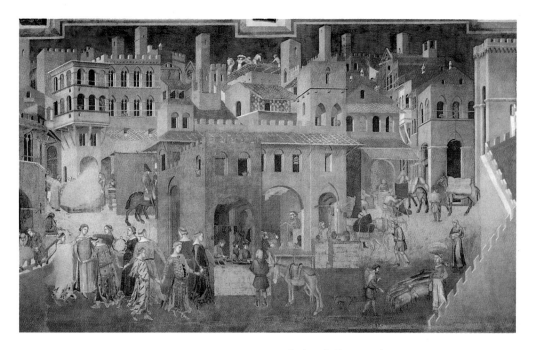

Ambrogio Lorenzetti
Life in the City, c. 1337–1340
From: The Effects of Good Government
Fresco (detail). Siena, Palazzo Pubblico, Sala dei Nove

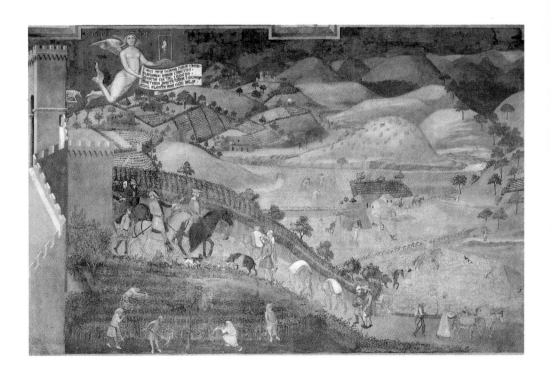

Ambrogio Lorenzetti
Life in the Country, c. 1337–1340
From: The Effects of Good Government
Fresco (detail). Siena, Palazzo Pubblico, Sala dei Nove

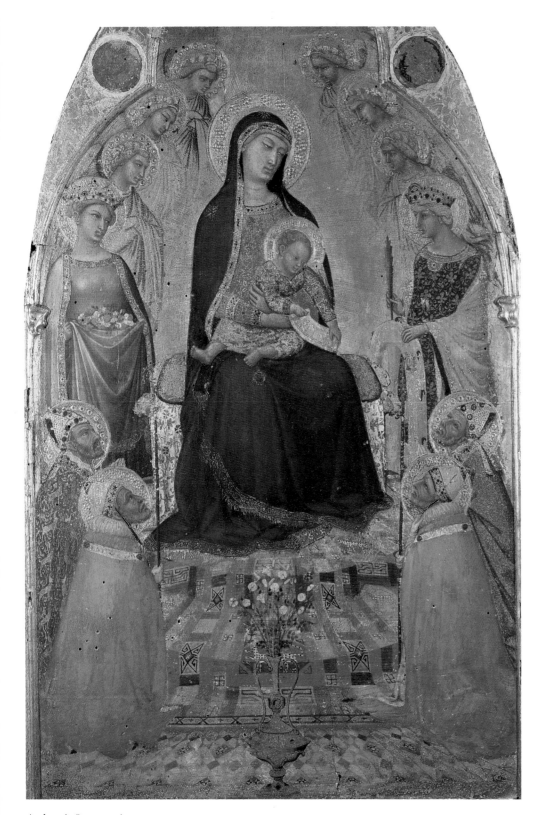

Ambrogio Lorenzetti
Madonna and Child Enthroned, with Angels and Saints, c. 1340
Tempera on wood, 50.5 x 34.5 cm
Siena, Pinacoteca Nazionale

AMBROGIO LORENZETTI

C. 1290 – C. 1348 (?)

This small domestic altar, cropped and in poor condition, originally featured two wings and would have been more differentiated in its palette and in its modelling of the draperies. It was probably executed for a member of the clergy with a special interest in its compositional structure, which follows that of an altarpiece, and its theological patrons (Pope Clemens and Gregory the Great, two holy bishops, and SS Dorothy and Catherine). The references to altar painting are nevertheless only faint: Mary sits not on a throne but on a folding chair as she clasps her son – who is pointing to a verse from the Lord's Prayer ("Thy Will be done") on a banderole – in a maternal embrace. Overall, too, the fine details of the execution and the wealth of objects on display place the panel firmly in the sphere of the private devotional picture.

In a bold compositional device, the saints and angels are grouped in the shape of a mandorla around the aureoled Madonna. This clear basic form reveals a complexity of its own: the figures are staggered both in height and depth around the throne. The kneeling figures of the popes, seen almost from behind, direct the eye to the centre in a movement taken up by the stripes of the carpet. The bishops kneeling behind and slightly above them are seen in profile. The female saints, meanwhile, stand above the foreground figures but behind the Virgin. The angels are painted on top of the gold ground, lending them luminosity and the appearance of floating above and behind the Madonna like celestial beings.

The stripes of the oriental carpet and the rising steps of the throne establish a tangible, earthly foreground which vanishes into the dazzling light of a heavenly, rationally no longer comprehensible dimension beyond. Blue and red, together with gold, make up a pure triad of colour which is echoed in a succession of ever paler hues, and which also serves a compositional function. Just as the blue of Dorothy's robe is lighter than Mary's, so too her facial expression is softer: her beauty belongs more to this earth than the Madonna, who continues to embody the more severe type favoured by tradition.

The sumptuous carpets, brocades and silks and the oriental gold vase are ornamental extras, further enhanced by the delicacy and detail of their execution. In his treatment of the gold grounds and fabrics, Lorenzetti draws upon the most sophisticated aesthetic effects of Simone Martini. Although the carnations and roses in the vase carry a symbolic significance, it is evident from devotional pictures of this kind that they provided an early forum for artists to explore their love of art for art's sake.

In the emphasis which it places upon the popes, and in its subtle variations upon the French royal colours of gold, blue and red, the painting may also be seen as covertly approving the alliance between the papacy, at that time based in Avignon on the Rhône, and France; Siena at that time supported the French house of Anjou which ruled Italy and remained loyal to the pope.

FERRER BASSA

C. 1285–1348

As stipulated in his contract, Ferrer Bassa's masterpiece is executed in oil, and not in "true" fresco technique. Bassa adopts his weighty figures and the astonishingly modern naturalness of his setting from the Sienese artist Pietro Lorenzetti (ill. p. 56 f). In this instance the Virgin is seated within an open portico rising on very slender pillars. Its walls are hung with a cloth of honour edged in gold and strewn with flowers. The wall behind the angel is both more elaborate and more sumptuous: below, panels of marble with a red, yellow and grey grain, and above, stuccoed scrolling vegetation, already quite Renaissance in character, on a red ground. Ferrer is most successful of all in his protagonists. Unlike most artists in the Middle Ages and the Renaissance, he depicts his angel floating well above the ground. The angel gestures emphatically towards the solid figure of the Virgin, who shrinks away from him, pressing herself fearfully into the corner. Her right hand is raised protectively in front of her breast, while her left hand puts down the book she has been piously studying. The facial expressions are almost more powerful than those of Lorenzetti himself: on the one hand, Gabriel's almost entreating gaze, on the other, the open astonishment on the full face of the young woman with her delicately blushing cheeks. Both figures wear the short, blond hairstyle seen in Lorenzetti's work.

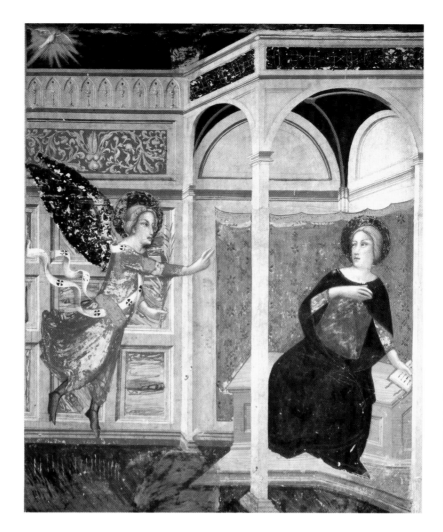

Ferrer Bassa
Annunciation,
1346
(wall painting in
St Michael's
chapel)
Oil on plaster.
Pedralbes
monastery
(near Barcelona)

ARNAU BASSA

DOC. 1345–1348

Although Arnau must have been well acquainted with the Sienese painting of his generation, his works seem less "Italian" than those of his father Ferrer. His figures are more slender, more animated, more "Gothic"; their flesh is modelled with much greater confidence. The St Mark Altar was evidently commissioned in 1346; records show a payment was made that same year. It was executed for the Shoemakers' Guild, of whom St Mark was the patron saint, and was destined for the chapel dedicated to him in Barcelona cathedral. Two coats of arms filled with shoes, as borne by the guild, can still be found in the altarpiece. This may also explain why Arnau takes the story of Anianus, a familiar element of pictorial cycles devoted to St Mark, as the subject of his central panel and two of the six lateral fields. It also allows him a detailed portrait of a contemporary shoemaker's workshop. According to *The Golden Legend*, Mark's shoe fell apart just as he arrived in Alexandria on a missionary journey. A local cobbler, Anianus, wounded his hand while repairing it. The Evangelist healed the injury in miraculous fashion, converted Anianus and later appointed him bishop of Alexandria, which is the large scene in the centre here. Illustrated on the left are two successive episodes in the story: in the middle, the wounding and healing of Anianus' hand, and at the bottom his conversion and baptism.

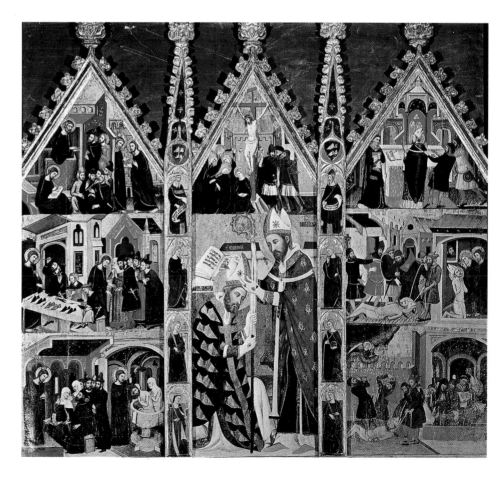

Arnau Bassa St Mark Altar, 1346
(from St Mark's chapel in Barcelona cathedral ?)
Tempera on wood, 226 x 250 cm. Manresa, Santa Maria

Master of the Kaufmann Crucifixion
Crucifixion, c. 1340
Tempera on wood, 76 x 29.5 cm
Berlin, Gemäldegalerie, Staatliche Museen
zu Berlin – Preussischer Kulturbesitz

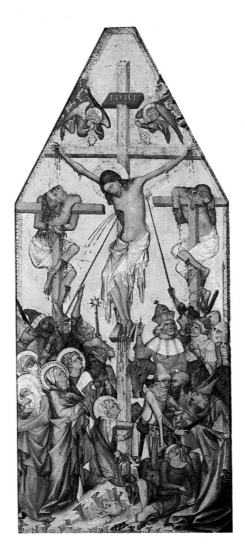

Below:
Master of the Eichhorn Madonna
Eichhorn Madonna (from Eichhorn, Moravia), c. 1350
Tempera on wood, 79 x 63 cm
Prague, Národni Galeri

BOHEMIAN MASTER

C. 1340

The importance of Passiontide in the Italian re-
ligious calendar and the corresponding popular-
ity of the Crucifixion as a motif in art rapidly
spread north of the Alps. The master of the pre-
sent *Crucifixion* seems to have been inspired by
Italian models in his rich use of embossing and
in certain aspects of his technique, such as the
different coloured ground given to the faces.
Unlike the Master of the Berlin Nativity, how-
ever, the artist here equals the skill and ability
of his Italian counterparts. He is unafraid to let
his figures be sliced by the edges of the frame.

This Bohemian master also employs fore-
shortening of the most difficult kind, such as
profil perdu. But he remains an artist who
thinks entirely for himself. He has clearly in-
vented a number of figures and motifs: the two
thieves crucified to the right and left of Christ
are barely conceivable in Italian art, for exam-
ple. Other elements of the scene have been
reinterpreted in an original way, such as the
dice player sprawled at the foot of the cross.
Particularly distinctive is the artist's palette.
He does not subscribe to a hierarchy of colour
in which pure, strong colours carry greater
symbolic weight than broken and diluted
tones, which serve to indicate lesser impor-
tance. By preferring lighter shades for the fore-
ground and darker colours for the background,
however, he establishes an innovative transi-
tion from light to dark.

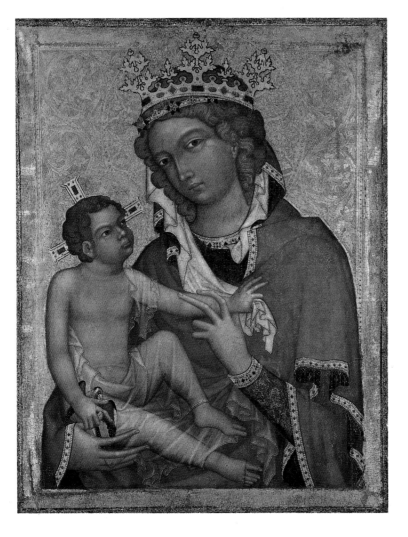

BOHEMIAN MASTER

C. 1350

The genre of the large-format Italian-Byzantine
Madonna icon was introduced into Bohemia by
Charles IV, King of Bohemia and Holy Roman
Emperor, who also greatly furthered its cult.
The severity and devoutness of its Byzantine
motifs, the enamel-like brilliance of its palette,
the exquisite beauty of its forms and its use of a
gold ground strewn with engraved and em-
bossed ornament were both foreign and fasci-
nating. These types of pictures underwent sev-
eral changes in Bohemia. Thus the Madonna
was given a crown, and often a gold circlet and
other items of jewellery. Her face was made as
beautiful as possible. The success of these panels
was extraordinary. Never before in central Eu-
rope had pictures occupied such a focal position
in religious worship. Many were attributed
with miraculous powers and even became the
object of pilgrimages. Unlike other types of
icons, however, the Madonna icon did not come
to assume a standardized format. Astonishing
features of the regal *Eichhorn Madonna* are its
monumental composition, extending to all four
sides of the frame, and in particular the figure of
Christ, highly serious in expression and not at
all childlike. In his right hand he clutches a
goldfinch (a symbol of the Passion); with his
left he grasps the Virgin's veil, which will one
day serve as his loincloth on the cross and of
which Prague cathedral boasted a large piece
amongst its holy relics.

BOHEMIAN MASTER

ACTIVE C. 1345

Historically, iconographically and in terms of its painting technique, the *Glatz Madonna* is a key work of the Bohemian school. It stems from the Silesian town of Glatz, which at the time it was painted belonged to the diocese of Prague. It was here that the donor Ernst of Pardubitz, later the first archbishop of Prague, spent part of his childhood, and it was in here, in 1364, that he would also be buried. According to a description of the painting dating from 1664, it at that time stood in the collegiate church which Ernst had founded when bishop, and was surrounded, in the Italian or Byzantine fashion, by a series of smaller paintings. Although the patriarchal cross hovering in front of Ernst was executed at an early stage of the painting, it was perhaps not planned right from the start. The painting can thus be dated fairly accurately to the period between 1343, when Ernst was made a bishop, and 1344, when Prague was elevated to an archbishopric. The cloth of honour held up by two angels veils the traditional gold ground. The throne's architectural surround is treated as a real edifice: angels look out through windows with wooden shutters, or appear from beneath large semi-circular arches. Behind the apparently so playful, lovingly evoked details are concealed numerous Marian symbols. The lions are a reference to the throne of Solomon, the black wall in the lower section to Mary as a "garden enclosed", the wood of the back of the throne to the "cedars of Lebanon", and the star at the upper edge of the picture to Mary's honorary title "Star of the Ocean".

The hymn of the same title was sung chiefly at the Feast of the Annunciation, on which Archbishop Ernst had been born and to which he dedicated his collegiate church in Glatz. Ernst himself had extolled King Charles IV as the new Solomon at the papal court in Avignon, which may also explain why Mary's regal dignity is so greatly emphasized in the Glatz painting. Corresponding to the idea of the throne of Solomon, too, is the Byzantine motif of the scroll in the hand of the infant Christ, who thereby appears as the "Word made flesh" as described in the Gospel of St John. Not even Mary's dark skin colour seems a coincidence. The bride in the Song of Songs was black, and the House of Luxemburg, from which Charles IV was descended, traced its origins back to the Biblical progenitor of all Africans. With his bishop's insignia laid down on the steps of the thone, Ernst presents himself as Mary's vassal and at the same time demonstrates his humility. The technique employed in the painting is as subtle as its content. The artist uses an oily binder which allows colours to melt into each other at their point of transition, as familiar from enamel. The luxurious oriental-style fabrics employed for the bishop, Child and canopy are portrayed with extreme sophistication. Shot with gold, they are of a type produced in Italy.

Master of the Glatz Madonna
Glatz Madonna, c. 1343/44
Mixed technique on poplar, 186 x 95 cm
Berlin, Gemäldegalerie, Staatliche Museen zu Berlin –
Preussischer Kulturbesitz

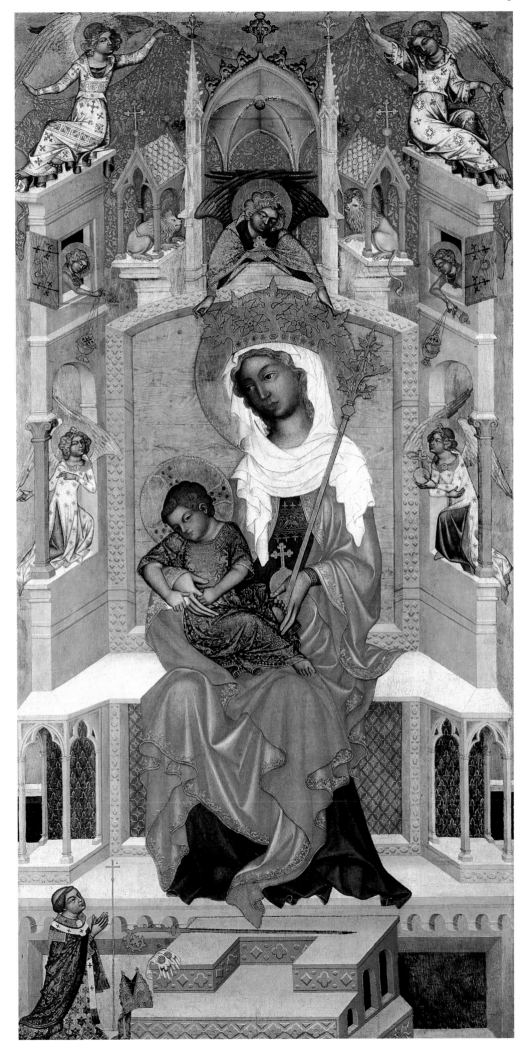

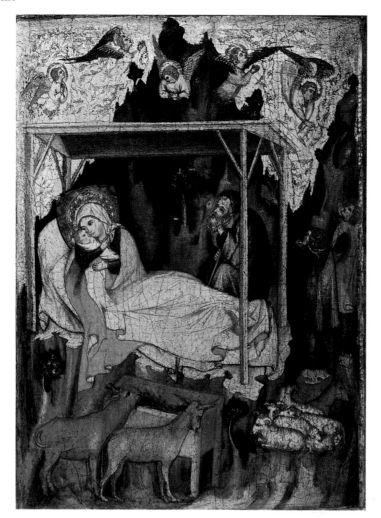

Master of the Berlin Nativity
Nativity, c. 1330–1340
Tempera on wood, 33 x 24 cm
Berlin, Gemäldegalerie,
Staatliche Museen zu Berlin –
Preussischer Kulturbesitz

BAVARIAN MASTER

ACTIVE C. 1330–1340

The Berlin *Nativity* forms one half of a diptych (the other half, a *Crucifixion*, is located in the Bührle Collection, Zurich). It bears a *Man of Sorrows* on the reverse (the back of the *Crucifixion* features a *vera icon*). Diptychs, which consist of a hinged pair of panels, were a major type of private devotional picture and their small and handy format made them particularly suitable as travelling altars.

In contrast to the *Crucifixion*, in which motifs from Sienese painting predominate, the present panel copies Giotto's fresco of c. 1303/05 in the Arena Chapel in Padua. As a comparison between the two clearly shows, however, the German artist sought to avoid the bold overlapping demonstrated by Giotto's figures and therefore made a few alterations to the composition. Particularly significant is the change in the mother-child relationship: instead of lifting her son out of the crib as in Giotto's fresco, Mary is now shown clasping him closely to her – a motif belonging to the sphere of the devotional picture. Indeed, the artist appears to have taken a scene from monumental painting and translated it into a small format without a second thought. Giotto's powerful figures are replaced by small genre motifs, particularly in the background, where a bear and a deer, a boar and a weasel populate the landscape for the entertainment of the spectator.

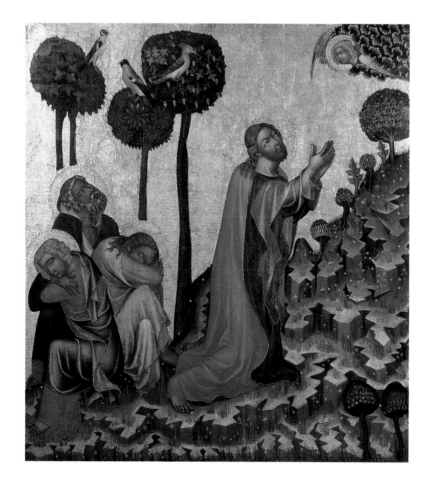

Master of Hohenfurth
The Agony in the Garden, c. 1350 (panel from the Hohenfurth Altar)
Tempera on canvas on wood, 100 x 92 cm. Prague, Národni Galeri

BOHEMIAN MASTER

ACTIVE C. 1350

This painting is part of a larger altarpiece comprising nine panels in three rows of three. It was donated by one of the lords of Rosenberg. The family owned large tracts of southern Bohemia and also played a leading role in court society in Prague. Thanks to their later refusal to join the Hussite movement, a small number of older works of art in their possession have survived intact, giving us an idea of the rich flowering of Prague painting between 1330 and 1410. The Hohenfurth Altar itself, however, is rather a mediocre work. A typical feature of Bohemian art during this era is its combination of certain Byzantine or Upper Italian-Byzantine stylistic elements, such as flesh colouring and facial type, with calligraphic drawing and motifs of Western art.

It is most improbable that the artist had made a first-hand study of Italian art. His starting-point was more likely a local Prague synthesis of the various trends in European painting which Charles IV had brought with him to his new capital. The stylistic differences between these sources have not been ironed out, as is evident from the contrast between the Mount of Olives, which is thoroughly unrealistic in character, and the highly accurate renditions of the birds, which might have been taken from the pattern book of an Upper Italian painter.

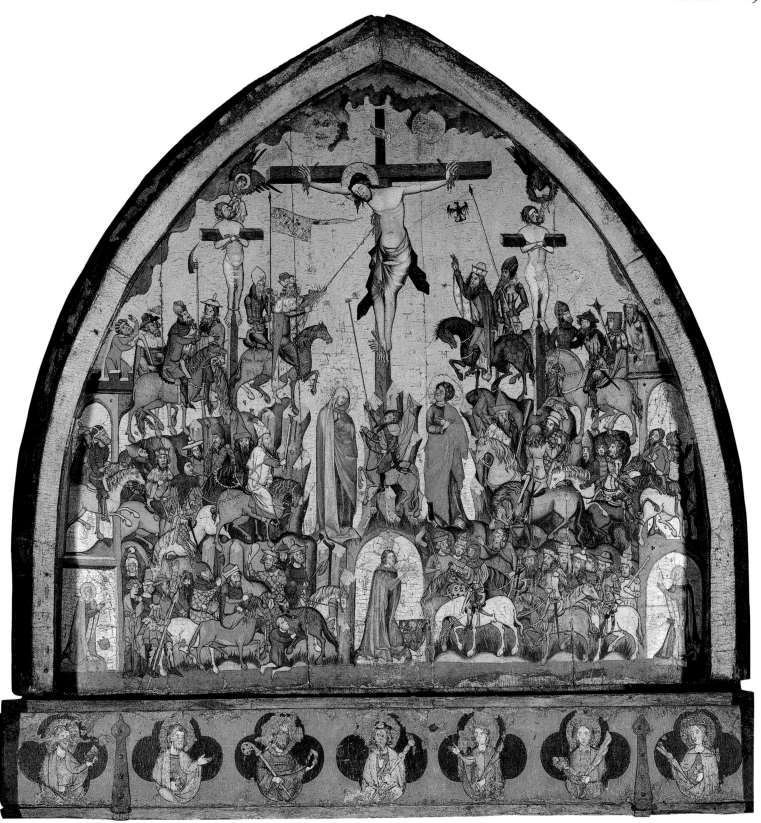

THURINGIAN WORKSHOP

ACTIVE C. 1350

The artist has responded to the unusual format by organizing his composition into three levels, one on top of the other, and presenting his figures as if on a stage. In addition to the crucified Christ, Mary, John and donors, he incorporates 53 figures into the work – 28 of them on horseback. The "trench" in which the central group are standing is even deeper than usual. Christ's soaring Cross is emphasized by its high plinth and creates space beneath for a donor's niche,

differentiated by its gold ground. The painting is of outstanding significance in artistic terms due to its unusual juxtaposition of two different levels of stylistic development. The crucified Christ, Mary, John and donors are not just larger in size than the other figures, but are executed in a quite different fashion, revealing powerful modelling and shimmering highlights in their draperies and bodies. The artist who executed them, and who was evidently influenced by Bohemian painting, can hardly be responsible for the remaining figures, who are drawn with emphatic outlines and painted with a relative lack of nuance.

Thuringian Workshop
Parclose Retable with Crucifixion, c. 1350
Mixed technique on wood
Erfurt, Predigerkirche

**Circle of
Master Theoderic**
Crucifixion, c. 1370
(from the Na Slovanech
Emmaus monastery, Prague)
Tempera on wood,
132 x 98 cm
Prague, Národni Galeri

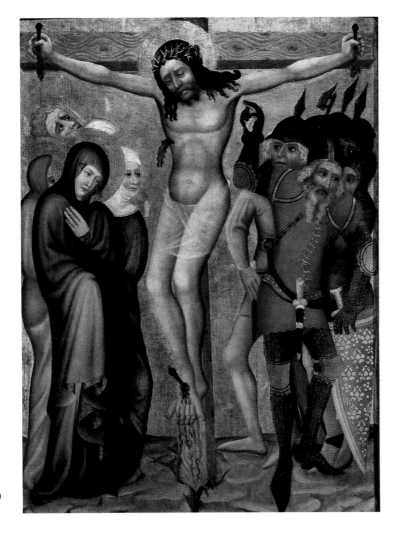

Below:
Master Theoderic
St Jerome, c. 1360–1365
(from the Chapel of the
Holy Cross, Karlstein castle)
Tempera on wood,
113 x 105 cm
Prague, Národni Galeri

MASTER THEODERIC

DOC. FROM 1359–C. 1381

Master Theoderic represents an innovative trend in Bohemian art after 1360 whose sources are not immediately to be found in the painting of other countries. Rather, the artists of his circle took their inspiration from southern German sculpture. Even group paintings are composed out of monumental individual figures. This *Crucifixion* might more accurately be called the "Crucified Christ between Mary and the Captain". Stretched out on the cross, Christ occupies the entire height and width of the panel. His body is solid, even massive. There is a sense of cramped oppression amongst the figures, who also seem to harry the viewer. Just as the painter pays scant regard to anatomical accuracy, so he shows little interest in drapery: robes simply veil the figures and heighten their already block-like character. There is an innovative understanding of light: the colours of the figures are brighter at the front, darker at the sides; line as boundary is absent. The figures are not illuminated from one side, but appear to emit light themselves: the captain a glowing red, Mary a luminous pallor, Christ a waxy transparency. This is directly related to the underlying theme of the composition: we are presented not with the drama of Christ's death on the cross, but with the calm contained in his words: "It is finished".

This picture was originally painted for the Chapel of the Holy Cross in Karlstein castle, designated by Emperor Charles IV to house the imperial treasures, which included a large piece of the True Cross, the Holy Lance and the Holy Nail, and other holy relics of note. The gilt ceiling of the chapel was decorated with stars made out of gilded glass, representing Heaven, and with frescos. The walls were adorned with 133 panel paintings presenting a hierarchical "host" of saints. The impression of being not simply in front of a representation of Heaven, but of being in Heaven itself, was reinforced by the semi-precious stones studding the walls. 550 candles filled the dark chamber with light. Their flickering flames not only emphasized the glitter of the gilded décor but also made the colours sparkle. Within this chapel, so the emperor desired, the churches of Heaven and earth were to meet; it was to demonstrate both his imperial might and its divine legitimation. Master Theoderic, who played a major role in the decoration of the chapel, deliberately created the paintings as wall panels. In their restriction to head and hands, however, they also have something of an icon-like quality. They deliberately lack spatial depth. Their attributes, such as the book held by St Jerome in the present example, are disproportionately large. The saints portrayed were lent a potency above and beyond their artistic presence by the fact that each of their frames contained a relic associated with them.

Whether this panel stems from the hand of Master Theoderic himself, or whether it is the work of one of his assistants, is a question which remains unanswered.

BOHEMIAN MASTER

ACTIVE C. 1380–1390

The retable which once stood on the high altar of the Augustinian Canons' church in Wittingau (today Třeboň) today survives only in fragments. It is nevertheless clear that the two panels on this page, formerly visible on the weekday side of the altar, are the works of a master of European standing. A comparison with the Hohenfurth Master's *Agony in the Garden* (ill. p. 64) reveals just how far Bohemian art had advanced in thirty years. The present version is more homogeneous and concentrates upon portraying its theme in an appropriate manner: Christ in mortal fear, the sleeping disciples and – on the left – Judas approaching with his henchmen.

The landscape, which the artist creates to suit his own requirements, thereby serves as a useful compositional device. The serpentine figure of Christ is powerfully expressive; drops of bloody sweat have formed on his brow. Instead of the usual formula of blue and red, the painter clothes him in grey. The penumbral mood of the palette suggests the darkness of night. The intensity with which the artist has re-thought and re-interpreted his subject is also clear in his *Resurrection*. The risen Christ has floated through and out of the closed and sealed tomb. We are shown not the moment of resurrection, but the state of being resurrected. The painter presents the event as a true miracle. The watchmen fix their eyes on the apparition as if entranced.

While *The Agony in the Garden* takes place in twilight, the light in the *Resurrection* is more vibrant. The painter displays a feel for the expressive powers of objects; never before have weapons appeared sharper or shields more spiked. But he has a feel, too, for beautiful rhythmical forms, as can be seen in the sequence of curves in Peter's robe. This delight in softly undulating lines is by no means in conflict with the artist's more profound approach to his theme. Studied in depth, these two panels yield a wealth of detail which extends not only to individual members of the natural world, such as the many birds, but to much more besides. Striking features include the looseness of the brushwork and the varying treatment of the surfaces. Helmets and nimbuses are painted in different layers of glaze, as if the artist was already acquainted with the techniques of oil painting. Effects of light and colour are richly gradated. Looking closely, too, we can see that the artist has frequently deviated from his own preliminary sketches, scored into the ground and still clearly visible. It is evident that this painter, even as he established the types which others would copy, did not approach his composition with fixed ideas, but continued to rework his subject even in the final stages of execution. A notable exception is the figure of the resurrected Christ, in which he clearly cites an older, more static and two-dimensional type in the manner of the Master of the Hohenfurth *Crucifixion*. The composition of *The Agony in the Garden* is as unusual as it is skilful: the diagonal wall of rock slices the picture into two halves, the left-hand side dominated by the figure of Christ, the right-hand side by the disciples.

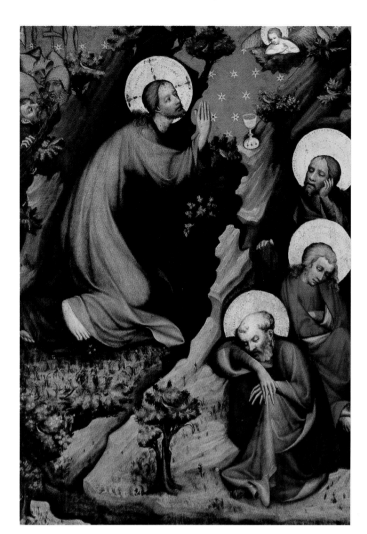

Master of Wittingau
The Agony in the Garden,
c. 1380–1390
(from the altar of the Augustinian Canons' church of St Aegidius)
Tempera on wood, 132 x 92 cm
Prague, Národni Galeri

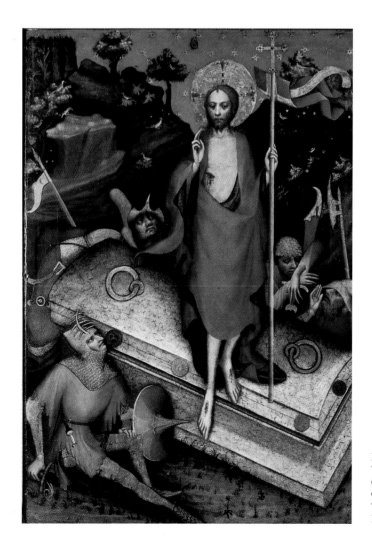

Master of Wittingau
The Resurrection, c. 1380–1390
(from the altar of the Augustinian Canons' church of St Aegidius)
Tempera on wood, 132 x 92 cm
Prague, Národni Galeri

Barnaba da Modena
Madonna and Child, 1370
Tempera on wood,
101 x 69 cm
Turin, Galleria Sabauda

BARNABA DA MODENA
DOC. 1361–1383

In comparison to works by Tommaso, also from Modena, this panel may at first sight appear something of an anachronism. Its broad, richly decorated gold ground and the Madonna's mantle, covered with Byzantine-style gold ornament, seem to look even further back than the first half of the 13th century.

On the other hand, the Byzantine herringbone pattern is undeniably given a modern linear roundness. The standing Christ is also a contemporary type. His face clearly betrays the influence of child paintings by Ambrogio Lorenzetti.

To dismiss Barnaba's art as simply an imitation of the Venetian-Byzantine style, however, would be to ignore the historical situation. For the plague years of 1347/48 had prompted two reactions: the resolution to enjoy life to the full, and a renewed embrace of religion. Even the pious severity of older art now seemed too profane, to say nothing of Tommaso's worldly visions. A new, retrospective style was now expressly sought for devotional images. Artists thus spoke two languages, depending on the commission in hand; similar works in the "devout style" from the hand of Tommaso are also extant.

Giovanni da Milano
Pietà, 1365
(from San Girolamo della Costa, Florence)
Tempera on wood, 122 x 58 cm
Florence, Galleria dell'Accademia

GIOVANNI DA MILANO
ACTIVE 1346–1369

Is it a Pietà, or is it a Deposition? This is far from being a narrative painting. It is clear from the way in which Mary clasps her son and moves her right arm, that she is not meant to be seen as holding his full weight. She is tenderly saying her last farewell, and thereby pointing to the wound in his side so greatly venerated in 14th-century religious practice: it was through this wound that Christ's heart was pierced, releasing a stream of water and blood which, according to earlier theological thinking, signified the moment of the birth of the Church and the establishment of the sacraments of baptism and the Eucharist. As a sign of God's love for humankind, the wound was an object of devotion not just in the specific context of the Sacred Heart.

Correspondingly, the starting-point of the present panel is not a narrative genre of painting, but rather the half-length devotional image of the Man of Sorrows, a Byzantine icon widespread in western Europe since the 13th century as the embodiment of the Passion and its re-enactment in the Sacrifice of the Mass. Such was the degree of freedom granted the artist in this type of picture that he was at liberty to narrow, widen or modify its scope. Giovanni's figures have thereby assumed a physical realism and animation which were fully in line with the religious trends of his day.

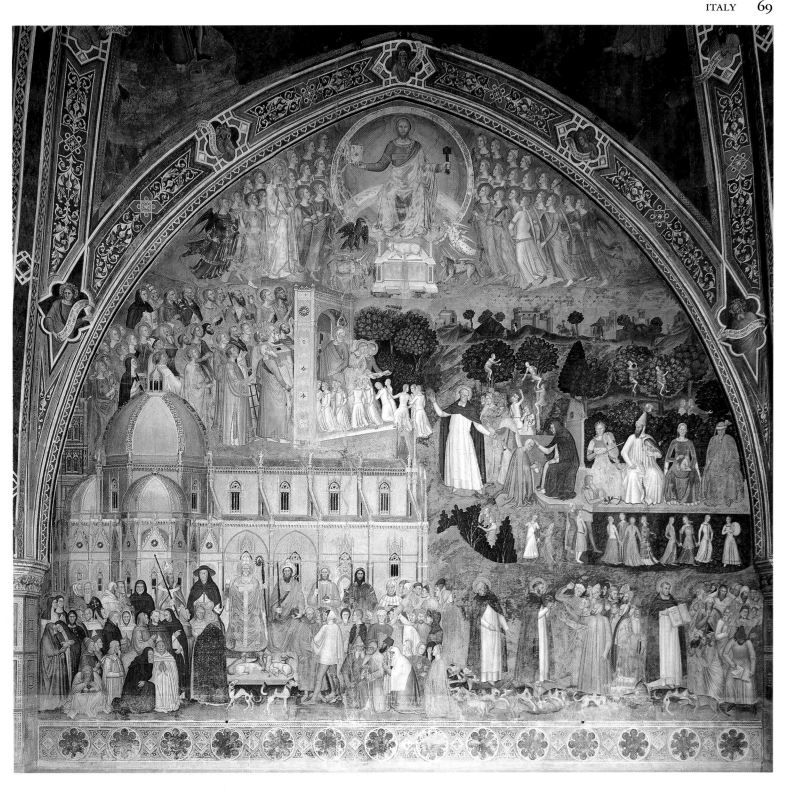

ANDREA DA FIRENZE

DOC. FROM 1343 – AFTER 1377

The frescos decorating the chapterhouse of Santa Maria Novella celebrate the Church and in particular the Dominican Order, whose brothers gathered within its walls. In the most famous fresco in the chapel, Dominic, the founder of the order, is portrayed as the intermediary between sinful Earth and Paradise. Standing almost exactly in the centre, his entire body points, like a human signpost, in the direction of salvation, towards St Peter, who guards the gate to Heaven. Confessing his sins at Dominic's feet is the donor, buried here in 1355. In the zone of Heaven, angels are gathered around the figure of Christ in Glory, en-

throned on a rainbow. The fresco is dominated less by this aureole, however, than by the element to which it owes its particular fame: its astonishingly accurate side view of Florence cathedral, Santa Maria del Fiore, and its detached campanile, at that time only thirty years old. Andrea has thereby anticipated the completion of the cathedral – it would be more than fifty years before Brunelleschi's magnificent cupola was actually finished. It is no coincidence that the souls in Paradise should stand on top of this real building, which serves as a symbol of the universal church. The vicars of Christ on earth have gathered in front of the cathedral, with the Pope at their centre. The guard dogs in front of him make a play upon the colours and name of the order (*domini canes* = dogs of the Lord).

Andrea da Firenze and assistants
Triumph of the Church, c. 1367
(detail from the east wall of the Cappellone degli Spagnoli). Fresco
Florence, Santa Maria Novella, Chiostro Verde

Master of the Narbonne Parament
Entombment, Descent into Hell and Noli me tangere, c. 1375
(detail from the Narbonne Parament)
Ink on silk, 77.5 x 286 cm (total size)
Paris, Musée du Louvre

Master of the Narbonne Parament
Adoration of the Child, c. 1390 (?)
(miniature from the *Très Belles Heures de Notre-Dame*, fol. 4 v)
Body colour on parchment, 29 x 21 cm (dimensions of page)
Turin, Museo Civico d'Arte Antica (Inv. no. 47)

FRENCH MASTER

ACTIVE C. 1370 – C. 1400

In the case of this monochrome painting, a technique known as grisaille, we must be looking at a Parisian work commissioned by a royal patron. On either side of the central *Crucifixion*, Charles V (d. 1380) and his wife Jeanne de Bourbon (d. 1378) are kneeling in prayer. Paraments such as this were hung, facing the congregation, over altars during Lent. While the artist presents three scenes from the Passion on the left, on the right the Lenten theme is almost overshadowed by the promise of Easter. The *Entombment* is followed by the *Descent into Hell*: according to medieval thinking, after his death on the Cross, Christ freed the righteous of the Old Testament who were awaiting salvation in Limbo. His slender silhouette, already dressed as if after his resurrection and with his victory banner fluttering from his staff, hovers dancingly over the entrance to the abyss, shaped like a dog's head. Jesus snatches Adam and Eve from its jaws, their sins redeemed by his death. The sequence concludes with Mary Magdalene meeting the resurrected Christ. Although familiar with contemporary Italian art, the painter is still drawing upon the visual imagery of the miniaturist Jean Pucelle (ill. p. 51) from half a century earlier. He abandons the serpentine curves of Pucelle's figures, however, and at the same time creates an entirely new sense of depth with his deep shadows. The powerfully expressive faces with their large, pensive eyes are highly characteristic of his style.

The *Très Belles Heures de Notre-Dame*, a famous late medieval book of hours, was divided up into several parts even before its completion. The Master of the Narbonne Parament played a leading role in the first of the many stages in which the manuscript was illuminated (cf. ills. pp. 76 ff). It would seem that the *Adoration of the Child* was only designed and begun by him, however, and then completed by a colleague. The lower hem of the Virgin's cloak, with its undulating loops of cloth, is very similar to that of the queen on the parament, while Mary's profile also recalls that of her counterpart in the parament *Lamentation*. Compared with the slender silhouettes of the parament, on the other hand, the figure of Joseph, with loose swathes of drapery flapping around him, strikes a foreign note. The carpet of angel's heads making up the background is typical of a number of further miniatures in this and other closely related de luxe manuscripts.

Whereas Nativity scenes in the past had portrayed the Virgin still lying in bed (cf. ill. p. 64), she has here sunk reverently to her knees, so as to be the first to worship her son, who lies in the hay. This was the version of events related a good century earlier by the Italian Franciscan monk Johannes de Caulibus. He also set the Nativity in a cave, something which was familiar in Italy from Byzantine tradition, but unknown in the North. The miniaturist models the cave in bizarre forms around the silhouette of the Holy Family.

ALTICHIERO DA ZEVIO

C. 1320/30 – C. 1385/90

We know almost nothing about this Veronese painter, but his frescos show him to be one of the great narrators of the 14th century and an artist who deserved greater fame. He does not use the martyrdom of St George as an opportunity to portray a scene of great commotion. Instead, he concentrates upon the tension preceding the execution.

The saint kneels in humble resignation. His executioner is scrutinizing his victim before taking aim with his sword. His assistant holds a cloth ready. The heathen priest – betraying the greatest animation of any of the characters – is still attempting to convert George, but all the onlookers sense that his words will fall on deaf ears. The commander is therefore already issuing the order to proceed. Aware of the terrible scene that is about to be enacted, an anxious father moves to lead his young son away.

A number of distinct but close moments in time are here brought together and interpreted in terms of different emotional reactions. The tension in the air is heightened by the threatening phalanx of soldiers and their lances, and indeed even by the steep cliffs looming in the background. With a keen eye for individual and social behaviour, Altichiero brings this execution scene to life, without forgetting that it concerns the martyrdom of a saint which took place long ago in a distant land.

Altichiero da Zevio
The Beheading of St George, c. 1382
(from a fresco cycle of scenes from the lives of Christ and SS Lucy, Catherine and George)
Fresco (detail)
Padua, Oratorio di San Giorgio

In St George's chapel in Padua, Altichiero ventures his first attempt at buildings which are seen half from the side and yet which recede astonishingly correctly into the background. This bold use of perspective, which anticipates the achievements of the High Renaissance, is perhaps at its most impressive in the scene of the burial of St Lucy. Only a few details betray the fact that the search for a unified vanishing-point is not yet quite over.

While a number of the heads recall Giotto with their broad faces and flat eyes, in the group of onlookers front left Altichiero gives us profiles observed with a sensitivity that already looks forward to Hans Holbein the Younger. In view of such modernity, it is surprising that he should show the saint taking her last Communion beneath the arches in the left-hand background, without adapting the size of the figures to their distance. The brilliant artist was not in the least interested in realism in the modern sense, however. Thus the Romanesque round-arch friezes and Antique-style columns of the church (which would in fact only be erected over St Lucy's grave), together with the imaginary architecture, are probably just intended to refer us to an age long gone. Similarly out of keeping with the early epoch of Christian persecution are the ceremony being conducted in accordance with the liturgy of the artist's own day and the contemporary dress worn by a number of the onlookers.

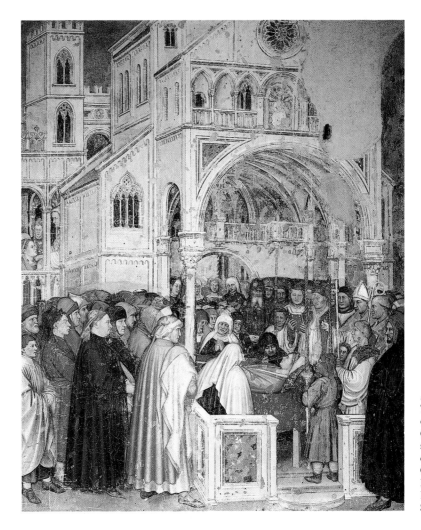

Altichiero da Zevio
The Burial of St Lucy, c. 1382
(from a fresco cycle of scenes from the lives of Christ and SS Lucy, Catherine and George)
Fresco (detail)
Padua, Oratorio di San Giorgio

Workshop of the Wenceslas Bible
Emperor Wenceslas as an Astronomer, c. 1395–1400 (title page of Ptolemy's *Quadripartitus*, fol. 1 r)
Manuscript illumination
41 x 30.5 cm
Vienna, Österreichische Nationalbibliothek
(Cod. 2271)

BOHEMIAN MASTER
ACTIVE C. 1390–1410

In the initial on the title page of Ptolemy's major work of classical astronomy, the *Quadripartitus*, Emperor Wenceslas is shown as an astronomer seated at his desk. He is entering numbers into tables on a tablet. Astronomy, which in those days also included astrology, dominated the thinking of the epoch and in particular Wenceslas' own mentality: his belief that all events were predetermined by the stars both corresponded to and fed his inability to make decisions. Wenceslas was one of the greatest book-lovers of the era around 1400. He exerted a direct influence upon the style in which his manuscripts were illustrated, florid decoration being something he liked. He and his favourites (who probably formed a secret society) also thought up the symbolism behind the illuminations, such as the young women seen here freeing the emperor from the "W" in which he is trapped as if in a pillory. They represent Venus – or Wenceslas' wife – in allegorical disguise. The knotted scarves, or love knots as they were known, which they wear around their necks and hips are a symbol of Wenceslas' fidelity to his wife Sophie. The wild men stand for the wildness of the forces of nature and at the same time for Wenceslas. This symbolism also has a very real, erotically sensual side, which is further heightened by the artist's treatment of his motifs and his lavish use of gold leaf.

Master of the Pähl Altar
The Crucifixion of Christ between John the Baptist and St Barbara, c. 1400
(altarpiece from the chapel of Pähl castle)
Tempera on wood, 103.5 x 68 (central panel) and 103.5 x 28.5 cm (wings)
Munich, Bayerisches Nationalmuseum

BOHEMIAN MASTER
ACTIVE C. 1400

This work was probably painted for the altar of a prince's chapel. While the crucified Christ filling the central panel follows on from the *Crucifixion* by Master Theoderic (ill. p. 66), the composition here feels less crowded and the figures to either side have more room to move. Colour and form are developed with a subtlety of the highest aesthetic order. The gold ground is decorated with embossed reliefs together with the delicate, barely visible engraved figures of angels.

The muted reds and blues of the central panel strike a different note to the grisaille-like grey and beige of John the Baptist and the brown of St Barbara, the most fashionable colour around 1400.

In the design of the figures, too, there are differences between the central panel and the wings. Mary's silhouette is severe, yet of almost Nazarene sweetness. Her profile view highlights her gesture of holding up a bloodstained veil, a motif taken from Byzantine tradition. By contrast, John the Evangelist is almost as static in expression and pose as the Virgin in Master Theoderic's *Crucifixion*. The draperies of the saints in the two wings, on the other hand, are both richer and more beautiful in their composition. The Pähl Altar transforms the more passionate style of the Master of Wittingau (ill. p. 67) into an art which is noble and calm.

BOHEMIAN MASTER

ACTIVE C. 1390–1400

This panel has a frame (not shown) lavishly ornamented with a dozen free-standing wood reliefs portraying saints, angels and a donor. Precious stones would originally have been mounted between the figures. This frame alone lends the panel an aura of extraordinary rarity, something extending both to the beauty of the Madonna and the beauty of the painting.

Mary, according to theological thinking the most beautiful of all women, is also portrayed as such, with a sweet mouth, golden hair, serene countenance and unblemished features. At the same time, however, she comes so close to the feminine ideal of the time that one can understand why Bohemia's iconoclasts accused such paintings of the Virgin as showing nothing more than beautiful women.

To portray Mary as the humble wife of Joseph the carpenter and at the same time as the Queen of Heaven was always an impossible challenge. Here, the sacred ideal crosses over into the sphere of the profane. There is affectation in the position of Mary's hands, while her fingers sink into the soft body of the child. Although her dress covers her body so thoroughly that we barely suspect it is there, and in so doing removes something of the painting's sensuality, the wealth of forms and the play of red and blue draperies are clearly pursued as ends in themselves. They are not means of expression, but a feast for the eye.

Master of the St Vitus Madonna
Madonna, c. 1390–1400
(from St Vitus', Prague)
Tempera on wood,
89 x 77 cm (incl. frame)
Prague, Národni Galeri

BOHEMIAN MASTER

ACTIVE C. 1400

The *St Vitus Madonna* was revered as a painting possessing miraculous powers and it existed in numerous copies. The work itself, however, is only a copy of an older picture. It was derived from the Italian Madonna icon (cf. ill. p. 42), a genre which appears to have arisen in Bologna around 1340 and which – according to the inscription on another, similar panel – is descended from a portrait of the Virgin painted by St Luke. Such paintings could easily be expanded into full-length figures or portraits of the Madonna enthroned, or could be added to an Adoration of the Magi. They also existed in the form of sculpture. Indeed, it was sculptors who first lent them the sensual and physical qualities to which the Master of the St Vitus Madonna aspired. He thereby gave the Madonna type the sweetness and radiance which led to the increase in its veneration and its widespread copying.

In the *Neuhaus Madonna*, the same pictorial type has been translated into a domestic devotional panel. Mary is enthroned in glory, yet appears even more sweet and doll-like. The child is as winsome as a real baby. The veil covering his body is a charming idea, visually attractive and at the same time accenting and underlining the child's significance. The draperies, the palette and the childlike charm of the figures all recall the manuscript illumination of the day.

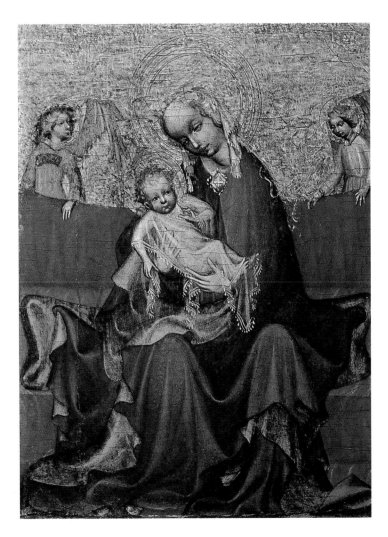

Master of the Neuhaus Madonna
Madonna, c. 1400
Tempera on wood,
25 x 19 cm
Prague, Národni Galeri

Workshop of the Papal Palace
Fishing, 1343 (detail from the north wall of the Deer
Room in the Tour de la Garde-Robe)
Al secco painting and fresco
Avignon, Papal Palace

WORKSHOP OF THE PAPAL PALACE

ACTIVE C. 1340

The "Babylonian exile" of the Popes (1309 –
1376) transformed the previously somewhat
insignificant city of Avignon into the most
magnificent residence in Europe. A huge papal
palace was built which was decorated by artists
from Italy, and specifically Siena, with none
less than Simone Martini (ills. pp. 54 f) at their
head. The surviving murals convey a unique
impression of a court of the day. The preference
for motifs taken from the animal and plant
kingdoms reaches its high point in the Pope's
favourite relaxation room, the Deer Room, a
testament to the nobility's passion for hunting.
It is the oldest representation of Nature on
such a grand scale, of such ambition, and with
such fidelity to life.

 Hunting with falcons, ferrets and decoy
birds, and scenes of bathing and harvesting, are
interwoven with individual trees and plants in
a rich tapestry extending across all four walls.
The only wall uninterrupted by doors or win-
dows is dominated by a large pool rendered in
a perspective fashion, around which various
different means of fishing are portrayed. As in
the case of the birds and plants, we are shown a
wealth of different species of fish; there is even
a dolphin. The choice of subject and its execu-
tion seem to reflect both French and Italian
ideas, although the project would ultimatley
have been headed by an Italian.

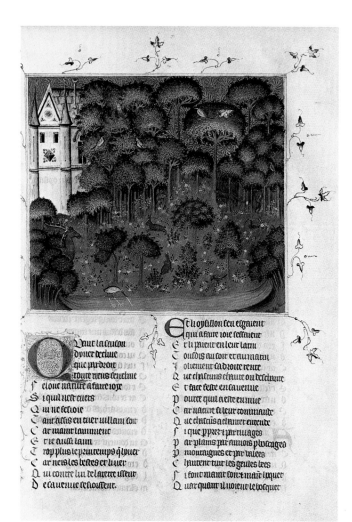

Master of Guillaume de Machaut
The Secret Garden, c. 1350–1355
(miniature from *The Tale of the Lion*,
fol. 103 r)
Manuscript illumination,
30 x 21 cm (dimensions of page)
Paris, Bibliothèque Nationale
(ms. fr. 1586)

FRENCH MASTER

ACTIVE C. 1350–1355

This miniature introduces the *Tale of the Lion*
by Guillaume de Machaut. The author de-
scribes a garden from which he is separated by
a river. He nevertheless succeeds in gaining ac-
cess to the garden, where he meets numerous
animals, and in particular a lion, who symbol-
izes the fidelity of the lover and who eventu-
ally leads him to the beloved. The landscape is
described – and illustrated – as an unreal idyll,
in no recognizable location and with no indica-
tion of time of day or year. Landscapes of this
kind had a literary tradition going back to
classical antiquity, but no similar history in
painting.

 The magical garden is pictured in the
form of a small panel at the start of the text.
More or less conventional in its treatment of
individual details, the overall effect is never-
theless astonishing. The trees are painted in
standard formulae extending both to their
shapes and colours. The distribution of blue
and yellow flowers obeys decorative conven-
tion, as does the gold patterning of the blue
background.

 The animals are portrayed with greater ani-
mation and are closer to life, indicative of a
society which loved hunting and animal en-
closures. The garden as a whole, however,
becomes an enchanted park, painted in a naïve
style, but full of fascination and charm for the
viewer even today.

GIOVANNINO DE' GRASSI (?)

DOC. FROM 1389–1398

The *Tacuinum Sanitatis* (Book of Health) owes its origins to an 11th-century Arab treatise which was translated for the Hohenstaufen king Manfred in the 13th century and which from the mid-14th century onwards assumed the form of an illuminated manuscript with explanatory texts. In the present picture, a peasant is digging onions and a woman is collecting them in her lap. A net full of the vegetables is already hanging from the tree. The text underneath describes the best onions as white and juicy and credits onions with the beneficial properties of assisting urine formation and increasing virility, as well as with the possible disadvantage of causing headaches, which can be relieved with vinegar and milk.

It is striking that the plants discussed in the *Tacuinum Sanitatis* are presented not in isolation and in botanical detail, but in the context of their harvest or use. Since the seasons and the ground are also observed and depicted with great accuracy, these illuminations contain the beginnings of a new, objective approach to landscape. They also detail social differences in physiognomy, dress and pose which would not have escaped the reader. This realistic style of portrayal was a phenomenon of court culture and arose in the courts of the Upper Italian condottieri, with their lack of tradition and their sober, objective attitude towards their environment.

Circle of Giovannino de' Grassi
Onions, c. 1380–1390
(miniature from the herbal
Tacuinum Sanitatis, fol. 24 v)
Manuscript illumination,
32.3 x 25 cm (dimensions of page)
(from the collection of the wife of
Duke Leopold III of Austria, née
Visconti)
Paris, Bibliothèque Nationale
(ms. nouv. acq. Iat. 1673)

JACQUES IVERNY

ACTIVE 1411–1435

The Marchese Tommaso II of Saluzzo, the father of the man who commissioned this fresco, had spent some time at the French court, where he had written the allegorical tale of the *Straying Knight*. This chivalric romance brings together all the themes which fascinated aristocratic society at the time, including the story of the Nine Heroes and Nine Heroines. Tommaso's son subsequently commissioned a cycle of frescos depicting these figures, accompanied by corresponding verses from the romance, for the hall of his castle.

Five of the heroines are seen here. They are all exotic and legendary figures from the past, such as Queen Semiramis (second from the right) and the Amazon Penthesilea. Although almost all of them bear weapons, they are presented as court ladies rather than as heroines. They are standing on a carpet-like meadow bedecked with flowers. Shields hanging from the trees on their right bear fantasy coats of arms. The women are dressed in contemporary court fashions of the costliest kind, composed of gold brocades, ermines, jewels, gold crowns and floral wreaths. These elaborate costumes serve in themselves to reinforce the element of fantasy within the composition. The cycle is a rare example of secular art and at the same time a document of French court culture in the early 15th century, far removed from reality and cocooned in its own imaginary world.

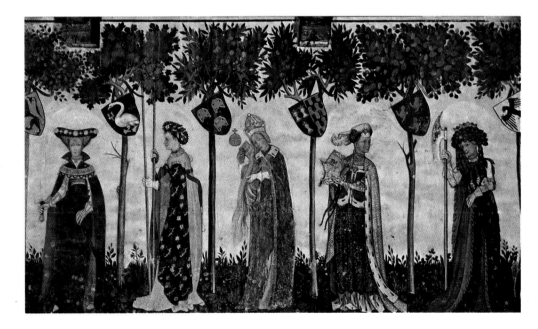

Jacques Iverny
Five Heroines, c. 1420
Fresco (detail) in the hall of La Manta castle, wall height 5 m
La Manta castle near Saluzzo, Piemont

**Paul, Jean and Herman
Limburg**
The Temptation of Christ,
1414–1416
(miniature from the *Très
Riches Heures,* showing
Méhun-sur-Yèvre castle,
fol. 161 v)
Manuscript illumination,
29 x 21 cm
Chantilly, Musée Condé
(ms. 65)

LIMBURG BROTHERS
AFTER 1385–1416 (?)

This picture introduces the readings for the
first Sunday in Lent. In it, the Limburg
brothers offer a rare depiction of the third of
the temptations to which Christ was exposed
after his 40–day fast in the wilderness. Satan
takes Christ to the top of a high mountain,
shows him all the kingdoms of the world and
promises to give them to him if Christ will
worship him. We are presented with a sweep-
ing landscape of mountains, cities, rivers and
oceans – an attempt to go beyond symbolism
and give an impression of the true size of the
world. This "global" perspective was a feature
of the Renaissance and would be found right
up to Pieter Bruegel the Elder. The present
miniature only acquires its inner tension,
however, from the presence of the Duc de
Berry's favourite château of Méhun-sur-Yèvre.
We see the Duke's swans swimming in the
moat and, on the right, a bear which has
climbed up into a tree to escape a lion – per-
haps an allusion to the serious political crises
of the day. Are these the earthly riches that
Christ did not want? Are they those of the
devil? Is the castle a symbol of the ephemeral-
ity of all things? Only court artists enjoying
the full trust of their patron could risk posing
such questions.

In the case of the château of Méhun-sur-Yèvre
in the previous miniature, bird's-eye and
worm's-eye views of the various components of
the architecture are abruptly juxtaposed. Here,
however, the buildings in the background are
presented with topographical accuracy and in a
convincing perspective. On the left we see the
many-turreted Palais de la Cité in Paris, the
residence of the king, and on the right the
Sainte-Chapelle. This astonishing heterogene-
ity within one and the same Book of Hours is
also paralleled in the landscape: the global
landscape of the *Temptation of Christ* appears
fantastical compared to the objective portrayal
of this meadow. We must therefore conclude
that the Limburg brothers adopted a different
approach depending on their subject. So accu-
rate are their powers of observation in this il-
lustration for the month of June, for example,
that they may be seen as the forerunners to the
van Eyck brothers. Thus they capture the vari-
ous different greens of the meadow and the
dried hay. They cannot simply be called natu-
ralists, however, since their miniature clearly
aims at another effect: it is first and foremost
intended to provide a welcome change for the
eye of the spoiled collector.
 Every ruler at some point develops a yearn-
ing for the simple life. The peasants portrayed
here are seen through the eyes of the non-
labouring classes – to whom the Limburg
brothers, in their privileged position as court
artists, also belonged. These are not the faces of
peasants nor the wearied bodies of those who
toil in the fields. And yet a sense of two oppo-
site worlds nevertheless emerges from the con-
trast between the life of aristocratic society (ill.
p. 77) and that of the peasant, marking a step
in the direction of greater artistic freedom and
a more objective portrayal of reality.

Paul, Jean and Herman Limburg
Calendar of the months: June, 1414–1416
(miniature from the *Très Riches Heures,* showing the Palace de la Cité and Sainte-Chapelle in Paris, fol. 6 v)
Manuscript illumination, 29 x 21 cm. Chantilly, Musée Condé (ms. 65)

Calendar illuminations for the month of January usually portrayed the double-headed god Janus banqueting at table in a small medallion. In this last and most important Book of Hours, commissioned by the Duc de Berry at the age of about 75, the calendar illustrations become the central focus. The conventionally somewhat token indications of the seasons and the labours of the months here give way to full-page illuminations, in which the typical activities associated with each month are set in a seasonal landscape featuring one of the castles belonging to the Duke or the French king in the background. In the arches above, we see the ruling planetary divinity and the astrological sign of the month.

In this picture of *January*, the Duc de Berry has himself portrayed at a banquet in an allusion to Janus. He is seated on a bench draped in a blue cloth. At a respectful distance further along the bench sits one other man, probably the Bishop of Chartres, one of the Duke's favoured advisors. Rather than flaunting the symbols of his rule, the artists highlight the Duke's special status through artistic means. Thus the yellow screen ostensibly designed to protect him from the heat of the open fire takesthe form of a nimbus, and at the same time provides an effective foil against which the Duke's blue robe (painted with the most expensive lapis lazuli) stands out clearly. This section of the painting is further emphasized by the red baldachin above, decorated with the fleur-de-lys coats of arms and the two heraldic animals of the swan and the bear. On the table beside the Duke stands an elaborately crafted piece of gold tableware, the most striking in the entire room: this is the Gold Salt Ship, detailed in the Duke's inventories. Beneath the inscription "approche, approche", the chamberlain to the left of the Duke invites the guests to present themselves. Two pages in the foreground divide the long table into two unequal halves, whereby the direction in which they are facing and gesturing lends greater weight to the half occupied by the Duke. The Limburg brothers thereby demonstrate the ease with which they handle compositional devices which were still so new in Giotto's *Lamentation of Christ* (ill. p. 46). In a display of skill, the artists show the Duke – in compositional terms the central focus of the picture – facing the other guests and thus captured in what appears a realistic and candid moment of the banquet. The Duke's attention is directed not solely to his neighbour on the bench, but also to the strangers approaching from behind and being invited to draw nearer by the chamberlain.

In this picture we learn a great deal not just about life at court and the protocol of the day, but also about lifestyles. The furniture is crudely built, but hidden beneath sumptuous cloths. The large fireplace forms the focal point of the room, near which everything takes place. The walls are hung with tapestries; like a picture within a picture, and in a play upon the different levels of reality, these show battle scenes from the Trojan War, yet feature knights dressed in contemporary armour and a non-Antique manner of composition. Displayed on the table on the left is a selection from the Duke's valuable collection of gold and silverware, in a demonstration of luxury and wealth.

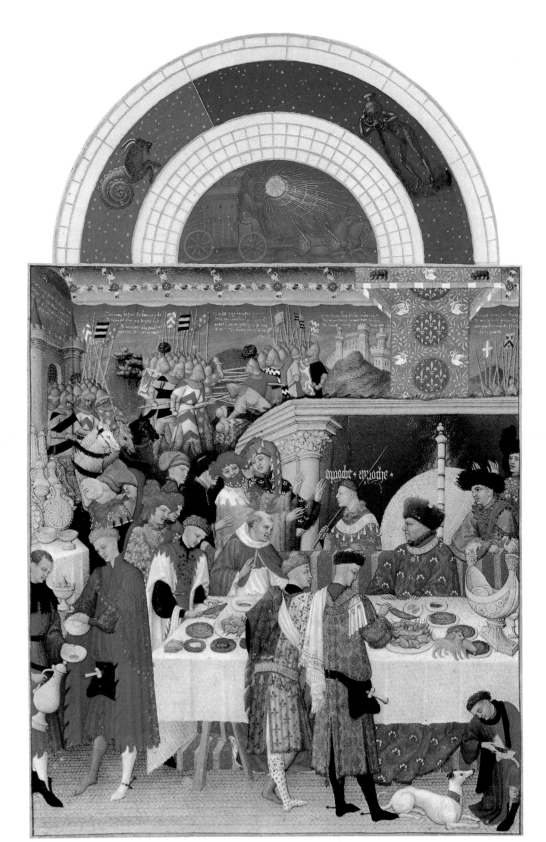

Paul, Jean and Herman Limburg
Calendar of the months: January, 1414–1416
(miniature from the *Très Riches Heures*, fol. 1 v)
Manuscript illumination, 29 x 21 cm
Chantilly, Musée Condé (ms. 65)

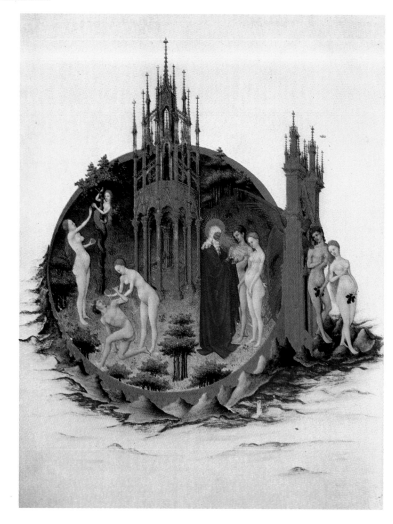

Paul, Jean and Herman Limburg
The Expulsion from Paradise, 1414–1416
(miniature from the *Très Riches Heures*, fol. 25 v)
Manuscript illumination, 29 x 21 cm
Chantilly, Musée Condé (ms. 65)

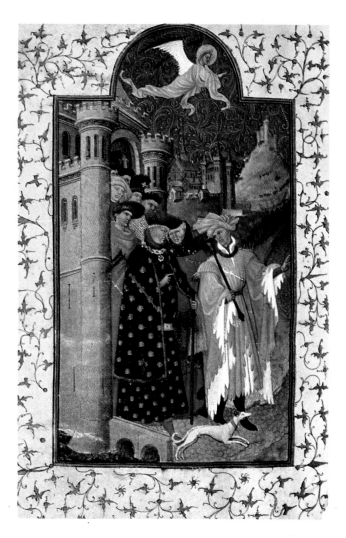

Paul, Jean and Herman Limburg
Miniature Accompanying the Prayer "Before setting out on a journey", after 1410
(miniature from the *Petites Heures*, fol. 288 v)
Manuscript illumination, 21.5 x 14.5 cm
Paris, Bibliothèque Nationale (ms. lat. 18014)

LIMBURG BROTHERS

AFTER 1385–1416 (?)

This miniature was probably included by the brothers on their own initiative, since it treats a subject not normally found in Books of Hours. The Fall nevertheless represents a thoroughly appropriate antithesis to the Annunciation scene which follows. On the left we see Eve being tempted by the serpent; in the centre, Eve offers Adam the forbidden fruit; to the right, God the Father pronounces judgement on the unhappy pair, and on the far right Adam and Eve are expelled from the Garden of Eden by a seraphim. The setting is equally original: Paradise is conceived as a visionary plateau in the mountains above the clouds, and appears as a symbolic ring. There is no attempt to portray the figures in correct proportion to the environment. Seen from another angle, the picture might also be described as a large item of goldsmith's work decorated with rich enamel painting. The well in the Garden of Eden might easily serve as a table fountain fit for a prince. But this neither removes nor explains the contradictions within the picture. In the naked figure of Eve, standing opposite God the Father in a Gothic robe, we see a female body corresponding to the erotic ideal of the time. Artistic virtuosity has clearly become one of the main themes of this miniature. Seen in this light, the other illuminations in the manuscript may also be understood in a new way. Artificiality of this kind was only possible – even during such an era of transition – in manuscript illumination and only for a small handful of patrons. Yet it is precisely such magnificent illuminations which point up the contradictions inherent in this seemingly so harmonious style.

This illumination was added by the Limburg brothers to the first of the sumptuous Books of Hours commissioned by the Duc de Berry, the *Petites Heures*. Originally begun by Jean Noir, a pupil of Pucelle, who worked on it between 1372–1375, it was subsequently taken up again by the new court painter Jacquemart de Hesdin. Although the Duc de Berry's tastes were constantly changing and he regularly took new artists into his employ, he continued to attach great value to this manuscript, as witnessed by the late addition of the Limburg illumination.

The Limburg brothers oriented themselves in part towards the existing illustrations, as in the case of the tendril border. A notable feature of this scene is the fact that the guardian angel to whom the prayer is addressed is relegated to a secondary position in the lunette at the top, while the main part of the picture is dominated by a portrait of the Duke dressed for a journey, accompanied by his Lord Marshal and attendants. Charles V, the Duc de Berry's eldest brother, frequently had himself depicted in manuscript illuminations and on church portals, whereby his image signified not just the person, but also the office of king. The inclusion of the Duc de Berry in the present miniature, however, is a pure instance of self-portraiture. It is a conspicuous fact that the Duke liked to have himself portrayed – as here – several times within one book.

NETHERLANDISH MASTER

ACTIVE C. 1400

This panel, the wing of a domestic altar, illustrates the way in which artists in northern Europe approached the private devotional picture in the period around 1400 – namely, with a strange mix of the other-worldly and ideal with the familiar and genre-like. Mary reclines on a golden silk cloth which forms a sort of aureole around her. This delicate cloth, however, is itself lying on sheafs of corn. The family is so poor that Joseph has to cut a nappy for the baby out of one of the legs of his trousers. Yet the wet nurse, seen placing the naked infant Jesus in the crib, wears a brocade dress and an apron, which would surely make a much better nappy.

We should not question the inconsistencies within the picture, however. Certain motifs have their own explanation: around 1400, for example, a tradition of pilgrimage sprang up in Aachen around the holy relic of Joseph's trousers. The ears of corn, too, are symbolic of the bread of the Eucharist. But this does not remove the contradictions within the painting. The background has an icon-like unnaturalness – yet the reverse of the panel bears a relatively successful landscape. There is clearly a large need for ornament. While the figure of Mary is noble and dignified, other elements seem to have been taken from a doll's house, such as the animals and the little table bearing items of crockery. This was what patrons and donors wanted.

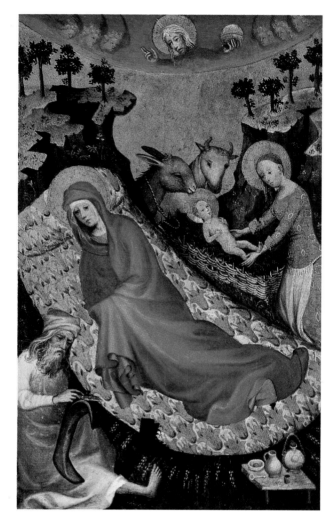

Master of the Antwerp Polyptych
Nativity, c. 1400
Tempera on wood, 33 x 21 cm
Antwerp, Museum Mayer
van den Bergh

MELCHIOR BROEDERLAM

DOC. 1381–1409

The carved middle section of the altarpiece to which this wing belongs is lavishly gilded. The eye, however, is involuntarily drawn to the painted panels on either side which, strictly speaking, occupy a subordinate position. The reason for this lies in the beauty of their colours and in their wealth of detail. The artist reinterprets the traditionally austere and solemn character of the altarpiece and spreads a colourful world before us. True, the *Presentation in the Temple* making up the left half of this wing recalls Ambrogio Lorenzetti's famous panel painting of 1342, but the hieratic composition is here further embellished with a host of details, an exquisitely slender architecture and an even more sumptuous palette. In the *Flight to Egypt* on the right, meanwhile, Broederlam goes far beyond the conventional limits of altarpiece painting. The richness of his landscape and his use of genre motifs sooner belong to the realms of manuscript illumination and art destined for the private sphere. In his fidelity to nature and finely gradated palette, however, Broederlam far surpasses contemporary illuminators. He pays loving attention to the donkey's coat, and to the miraculous well from which Holy Family were able to drink in the desert. The multi-layered, innovative and contradictory nature of the International Gothic around 1400 are all visible within this one picture.

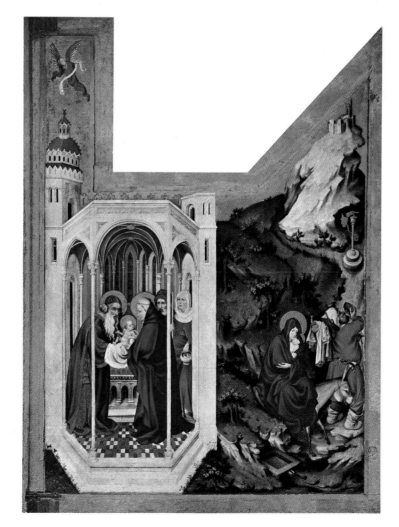

Melchior Broederlam
The Presentation in the
Temple and The Flight
to Egypt, 1394–1399
(left-hand wing of the
Chartreuse de Champmol
Altar)
Tempera on wood,
167 x 130 cm. Dijon,
Musée des Beaux-Arts

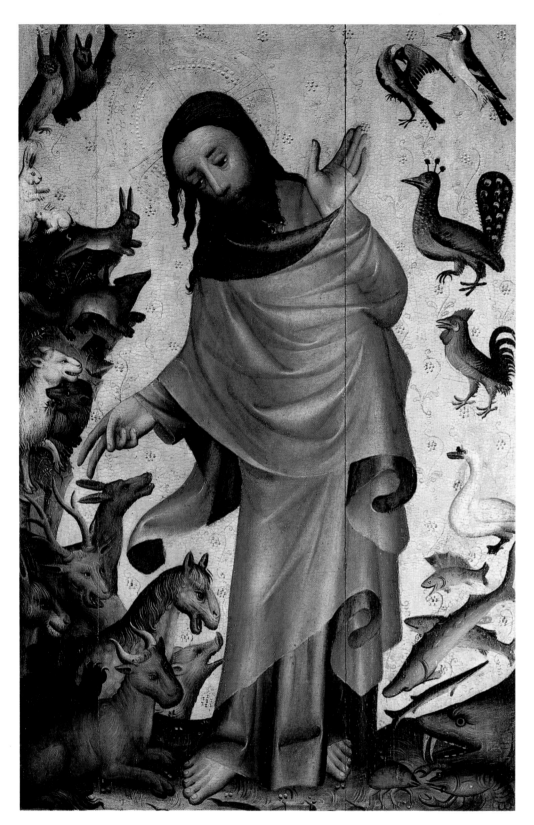

Master Bertram of Minden
The Creation of the Animals, c. 1379–1383
(from the former high altar, or Grabow Altar, in St Peter's, Hamburg)
Mixed technique on wood, 180 x 720 cm (total size, open)
Hamburg, Hamburger Kunsthalle

MASTER BERTRAM OF MINDEN

C. 1340 – C. 1414/15

On the former high altar of St Peter's church in Hamburg stood one of the largest, most important and, in terms of its content, most complex altarpieces to survive from the 14th century. In 1731 large parts of it reached Grabow in Mecklenburg, from where they only made their way back to Hamburg at the beginning of this century. The date 1379 can be found in the shrine; according to Hamburg records from the 16th century, the altar was "made" in 1383. Analogous to many comparable altarpieces, a *Coronation of the Virgin* originally stood in the centre of the carved interior. It was framed by the figures of 44 saints arranged on two levels. When the inner of the double set of wings was closed, the viewer was presented with 24 fields of equal size, of which no less than 14 relate, in highly unusual detail, the story of Creation right up to Cain's murder of his brother Abel. These are followed by four Old Testament scenes, leaving just six for the childhood of Christ.

The fourth to sixth fields depict the creation of the plants, the animals and man, whereby the compositions make reference to one another. The figure of God in the fifth, middle field appears between two vertical tiers of creatures. The mammals are assigned to a steep ledge on the left, while the birds are placed one above the other against the gold ground on the right, as if decorating the border of a page of manuscript. Bertram was more interested in the skilful organization of his pictorial fields than in narrative realism. The subtlety of his composition can be seen in the main figure: Bertram creates space for God's raised left hand by having him bend forward, while the arabesque of cloth breaking out from the main body of his robes repeats the gesture of his right hand. Similarly ornately scrolling motifs determine the Creator's left side, heralding the cascading draperies of the International Gothic of the years around 1400.

Bertram makes no attempt to show the birds in flight. They are nevertheless observed with considerably greater accuracy than the large mammals, which are harder to identify. Their greater fidelity to nature, coupled with the fact that they give the impression of being cut out, suggests that Bertram was able to refer either to studies he had made himself or to specimen sheets of birds, such as are known to exist from this period. A particular role was played in this regard by painters of illuminated manuscripts – a genre in which Bertram was also active. Undoubtedly the easiest to study were the fish, especially for someone living in Hamburg, and indeed, they seem to be particularly close to life. Yet Bertram includes no contextual details of land or water. The ground itself nevertheless deserves particular attention. It is missing entirely from the scene of God separating the light from the darkness, perhaps because of the subject. From very abstract forms, Bertram moves towards ever more naturalistic grounds. His landscapes clearly reveal French influences, while his massive figures are derived from Master Theoderic (ill. p. 66).

KONRAD OF SOEST

C. 1370 – AFTER 1422

As one of the supreme exponents of Gothic painting, Konrad approaches the traditional theme of the Annunciation – one of the most frequently treated subjects within Christian art – with innovative freshness. The angel approaches the Virgin softly from behind. They strike up an intimate conversation which is far more appropriate to its subject than the theatrical gestures of some of Konrad's colleagues. While in other works the intervention of God is indicated by beams of light streaming into a domestic interior, Konrad employs dark clouds which flare like tongues of flame into the uniform gold ground. They direct the eye diagonally downwards to the dove of the Holy Ghost descending towards Mary.

Although one of Konrad's primary concerns is to create a true-to-life setting, his handling of space remains insecure. We can therefore conjecture that the large baldachin is intended not to represent the Virgin's bedchamber, as familiar from many Annunciations, but rather her study. Draped over her prie-dieu is a brocade cloth whose pattern copies those of imported oriental fabrics. Its ornately scrolling edges find an echo in the draperies and the banderole.

An unusual feature of the altar is the tall, pearl-studded crown which Konrad shows Mary wearing in a number of scenes. Like her girdle, it spells out her name in Gothic letters. Konrad has concealed his own name, too, within the largely hidden pages of her book. The half-surprised, half-defensive gesture with which the Virgin starts up from her devotions can be found in very similar form in Stefan Lochner (ill. p. 126 f) and Rogier van der Weyden (ill. p. 102).

This panel of the *Nativity* is another one of many which the great Westphalian painter produced for the parish church of St Nikolaus in Bad Wildungen.

In this instance he was required to create an image worthy of the high altar, yet which was also suitable for devotional contemplation. In accordance with the conventions of devotional painting of the day, it was thereby to extend wherever possible to additional details and narrative features.

The artist has cleverly fulfilled this multiple challenge: mother and child are fittingly highlighted as the only figures with nimbuses, and are framed by the architecture of the stable (the upright which separates off the angel appearing to the shepherds on the right was added at a later date). A gloriole of angels in red and gold is visible behind the Virgin's head.

Mother and child are nevertheless shown in the tenderest of poses, as familiar from Pisanello (cf. ill. p. 107), and which can undoubtedly be traced back to a Netherlandish Madonna type. Taken in isolation, the half-length group could serve equally well as a complete (devotional) picture in itself. At the same time, however, the remainder of the composition is richly garnished with domestic details, and in the figure of Joseph cooking over the fire we see a portrait of the loving father.

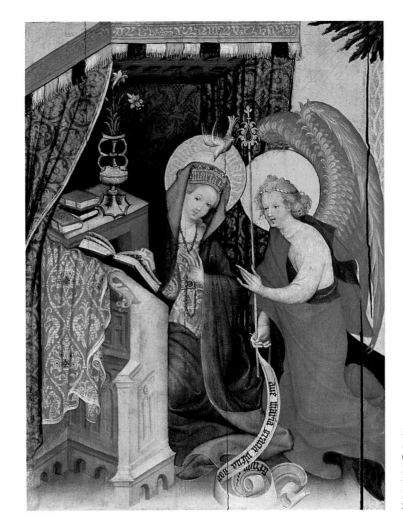

Konrad of Soest
Annunciation, 1403
(from the Wildung Altar)
Mixed technique on oak,
79 x 56 cm
Bad Wildungen,
St Nikolaus

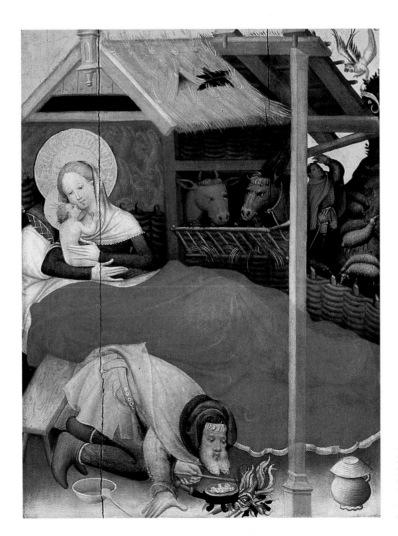

Konrad of Soest
Nativity, 1403
Mixed technique on oak,
73 x 56 cm
Bad Wildungen,
St Nikolaus

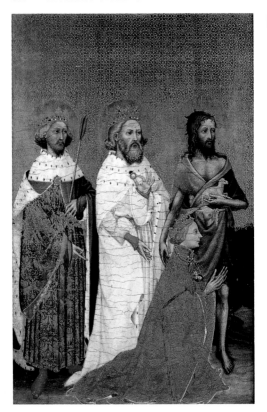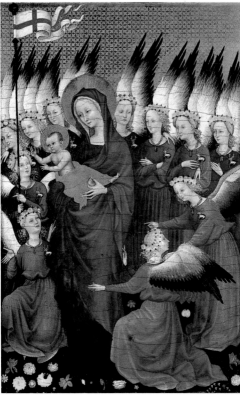

Master of the Wilton Diptych
The Wilton Diptych
Left: King Richard II of England (kneeling) with his patron saints
Edward the Confessor, Edmund of East Anglia and John the Baptist
Right: Virgin and Child with eleven angels, c. 1395 (or later)
Tempera on wood, each 45.7 x 29.2 cm. London, National Gallery

ENGLISH MASTER

DOC. 1390–1395

This is a more modern, more courtly form of the diptych. In the left-hand panel, the English king is being presented by his patron saints to the Madonna and Child, seen surrounded by a ring of angels in the right-hand panel, and with whom he appears to enjoy almost equal status. The diptych thus serves both as a devotional painting and as a staged piece of self-promotion for the king. The reproduction opposite can convey only an imperfect idea of the painting's highly sophisticated technique. Thus, for example, a tiny picture of the British Isles with a white castle can be found on the globe above the flag. The flowers beneath the Virgin's feet are portrayed in the greatest of detail, as are the small stags on the angels' robes and the brocade patterns on the clothes worn by the aristocratic figures on the left, with their folds and other decorative features, in part embossed and engraved as well as painted. The diptych was probably executed by an English master, but one who was thoroughly acquainted with the art being practised at the French courts. He was clearly equally familiar with the Bohemian type of the beautiful Madonna (cf. ill. p. 73) – Richard II's first marriage had been to a Bohemian royal princess. A distinctive feature of this work in the aptly-named International Gothic style is its use of foreshortening, whereby the artist borrows Italian motifs in a demonstration of his virtuosity.

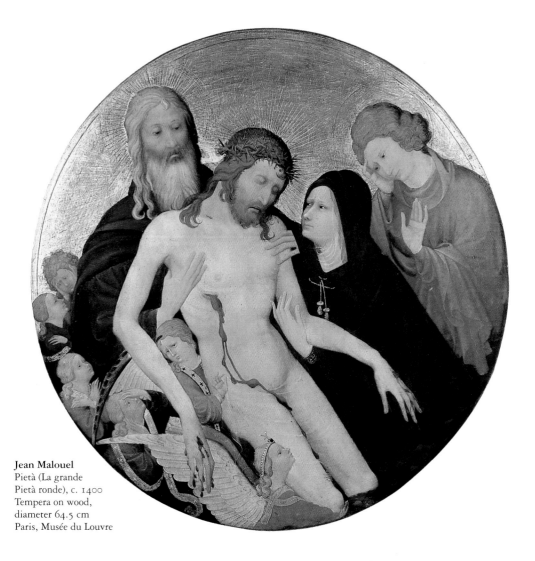

Jean Malouel
Pietà (La grande
Pietà ronde), c. 1400
Tempera on wood,
diameter 64.5 cm
Paris, Musée du Louvre

JEAN MALOUEL

C. 1365–1419

Malouel was one of the many Netherlandish artists working for the French princes and their courts. He was an uncle of the Limburg brothers. As court painter to the dukes of Burgundy in Dijon, he was employed on the decoration of the Carthusian monastery at Champmol and also worked in Paris. The present panel bears the Burgundy coat of arms on the reverse and was clearly painted at the commission of the ducal family. The circular shape of this devotional painting is derived from that of the Italian tondo. It combines and condenses a number of different themes. Thus the notion of the Trinity as portrayed in the image of the Throne of Grace is here fused with the lamentation of the dead Christ by Mary and John. Similarly, the wounds of Christ – and in particular the heart wound, pointing to the transubstantiation of the wine of the Eucharist into the blood of Christ and to the heart wound as the origin of the sacraments – are combined with a Pietà, i.e. the presentation of Christ's body, which is also a symbol of the Host. The finely modelled body is treated with supreme delicacy. The paint is applied extremely thinly in places. Other transparent varnishes and new binders are also employed – an indication that the panel was painted during an era of technical transition which would reach its first high point in the art of the van Eycks just a few years later.

HENRI BELLECHOSE

C. 1380 – C. 1442

Like his teacher Malouel, whom he succeeded as court painter, Bellechose came from the Netherlands. The centre of this painting is occupied by a large figure of the crucified, bleeding Christ. Above him, the presence of God the Father and the dove of the Holy Ghost surrounded by angelic hosts simultaneously makes the work a picture of the Trinity and of redemption. By contrast, the scenes taking place on either side at first appear somewhat inappropriate: on the left we see the last communion of St Denis, and on the right his martyrdom on Montmartre hill in Paris. St Denis, the legendary first bishop of Paris, was the national patron of France and the special patron saint of the French royal house, to which the Burgundian dukes also belonged. The blue and gold of the liturgical robes in this picture refer to the colours of the royal fleur-de-lys. St Denis was believed to have been a disciple of St Paul. According to legend, Christ appeared to St Denis in prison in order to give him the Last Communion in person. This episode underlined his particular closeness to Christ and hence his preferential status amongst the church saints. His martyrdom, however, may be seen as the highest form of imitation of Christ, and as drawing the closest possible parallel between saint, kneeling humbly at Christ's feet, and Saviour.

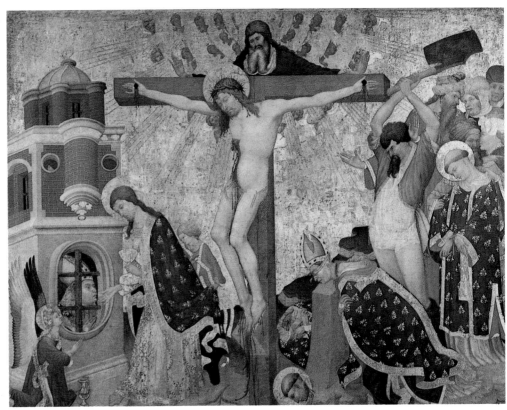

Henri Bellechose
The Last Communion and Martyrdom of St Denis, c. 1416
(altarpiece from St Denis)
Tempera on wood on canvas, 162 x 211 cm
Paris, Musée du Louvre

FRENCH MASTER

ACTIVE C. 1420–1430

The work of the Limburg brothers inspired two extreme reactions amongst the artists who followed. Stated simplistically, these were naturalism, in the shape of the van Eyck brothers, and expressionism, in the figure of the Master of the Rohan Book of Hours. In the case of the present picture, we are initially tempted to ask what possible connection it could have with the Limburg brothers. But the manuscript reveals that its painter had both the *Belles Heures* and the *Très Riches Heures* before him as he worked. His response was renunciation – of beautiful colours, of sensual bodies, and of the portrayal of space and nature. Even careful technique, that professional imperative, is lacking in the decoration of the nimbuses, for example. The painter feels a revulsion for the beauties of the International Gothic. Christ lies on the ground, his naked body distorted by rigor mortis. Mary flings herself over him and is only just caught by John. Even God the Father, who usually remains distanced on his throne above the clouds, is looking down at his son with an expression of great sorrow. The figural group is extremely simple: situated left of the cross, it breaks out of the frame. The sky is the blue of a dark night. All the compositional means employed in this miniature derive from earlier French and Italian painting. And yet together they offer the most abrupt possible rejection of the old art.

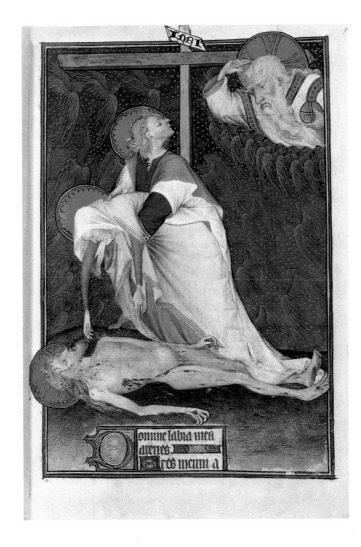

Master of the Rohan Book
of Hours
Lamentation, c. 1420–1427
(miniature from the *Book of Hours
of Jolanthe of Aragon*, fol. 135 r)
Manuscript illumination,
29 x 21 cm
Paris, Bibliothèque Nationale
(ms. Iat. 9471)

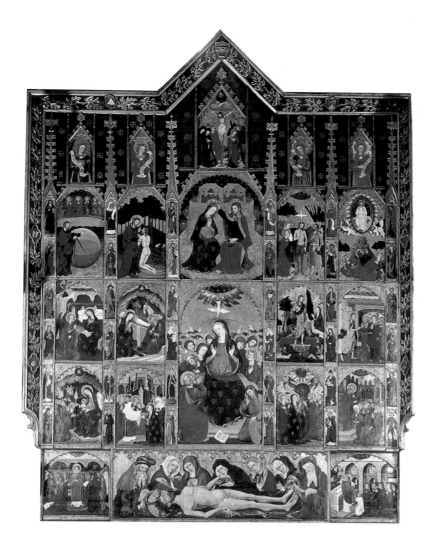

Pere Serra
Holy Ghost Altar,
1394
Tempera on wood
Manresa, Santa
Marìa

PERE SERRA

DOC. C. 1343–1405

The Holy Ghost altar in St Mary's church in Manresa has survived almost intact in its original location. Within a projecting *guardapolvos* (dust protector), four vertical *calles* (streets) – two on either side and each comprising three Biblical scenes one on top of the other – border the considerably wider and taller fields of the central axis. These altogether five axes are crowned by the *Crucifixion* in the middle and by angels holding banderoles above the *calles*, and are edged by narrower vertical strips made up of smaller fields. The foot of the altarpiece features a wide-format *Lamentation*, borrowed from an altar executed 15 years earlier by Borrassà (ill. p. 85), between two smaller scenes. The altar thereby comprises a total of 54 pictorial fields.

Commissioned by the local Brotherhood of the Holy Ghost, it is not surprising that the Pentecost theme appears twice: in the sermon delivered by St Peter, and in the more conventional central scene, which is not directly incorporated into the overall narrative sequence. In his loving portrayal of the Garden of Eden and the Valley of Jordan, Serra was following current trends in Italian art. The richness of form, fabric and colour achieved in the draperies, and the cascading folds of God's robes in the Creation scene, are all characteristic of the evolution towards the International Gothic style of c. 1400. The lavish use of gold leaf on the Virgin's robes is typical of Catalan painting.

Juan de Levi
Peter Recognizes the Risen Christ on the Lake Shore, c. 1400
(from the St Peter Altar from Calatayud)
Tempera on wood. Vic, Museu Diocesà

JUAN DE LEVI

DOC. 1388–1410

As the descendant of a Jewish family, Juan was excluded from numerous professions, but not, astonishingly, from the execution of Christian altarpieces. His unmistakable style, with its luminous palette and pale faces with emphatic outlines and often caricature-like features, indicates that he was familiar with Sienese painting.

The left-hand scene could be interpreted as any one of three episodes from the Bible, which late medieval artists sometimes failed to clearly distinguish apart: Peter's calling (according to St Luke), Peter attempting to walk on the water, but having to be rescued by Christ due to his lack of faith (St Matthew), and – the episode meant here – his encounter with the risen Christ (St John). Peter is the only one of the disciples to recognize a man standing on the lake shore as Jesus. He leaps out of the boat and hurries towards him, upon which Jesus makes him the shepherd of his church.

The numerous companions present in all three episodes are here represented by a single youth, probably the apostle James, who was closely associated with Spain. His golden coat displays the richly undulating folds of the years around 1400. The boat rises high out of the water, the storm billowing the sail. Few other painters have portrayed so lovingly such a wealth and variety of fish.

LLUÍS BORRASSÀ

DOC. FROM 1380–C. 1425

The *Nativity* was originally part of the high altar of the Cistercian monastery of Santes Creus in Spain. Like neighbouring Poblet, Santes Creus enjoyed royal patronage and ranked amongst the wealthiest and most richly furnished monasteries of the order. Although the work was replaced in the 17th century by a Baroque altarpiece, dismantled and its parts dispersed, large sections of the painting and its architectural frame have been preserved, together with the sculptures which adorned it. Surviving records name three artists as having worked on the altar: Pere Serra, Guerau Gener and Lluís Borrassà. Although Pere Serra was awarded the highest fee in the contract agreed in 1402, he died (between 1405 and 1408) at the start of the project and left virtually no traces of any involvement on it. Guerau Gener also did not live to see the completion of the altarpiece. He had already come into contact with Borrassà once before, but was subsequently active in Valencia.

Things were different for Lluís Borrassà. Of the three painters of the altarpiece, he alone must have been responsible for the *Nativity*. The luminosity of the palette, the wealth and elegance of the movements, the sophistication of the execution and the masterly portrayal of sentiment and realistic detail are all distinguishing features of his art. He thereby ranks among the leading representatives of the International Gothic not just within Catalonia, but far beyond.

Joseph's elegantly sweeping coat gleams a magnificent red. In Mary's robes, the same colour appears as the lining, shining deep between the undulating hems so typical of the day. Even the strange cracks in the ground at the bottom of the picture take up the strange forms. The blue exterior of the Virgin's cloak is still patterned with gold as in the Manresa altarpiece by Serra (ill. p. 84). Similarly indebted to tradition are the nimbuses of gold leaf, their surfaces further animated by embossing. Catalan painters gave scalloped haloes to figures from the Old Testament, of whom Joseph counts as one of the last representatives. Borrassà shows Joseph sunk in quiet adoration. He is physically divided from the group of mother and Child by the roof support, which rests on a properly carpentered foot; the post in the left-hand background, on the other hand, is simply wedged into the ground.

A particularly delightful feature of this painting are the four angels. They look as if they are trying, out of curiosity, to get a better view of their new-born Lord, but in fact they are mending the holes in the thatching. Borrassà paints them with particular care. The red of their wings and robes establishes an attractive contrast with the blue, grey and brown of their surroundings. A fifth angel above them, again with a red lining to his cloak, brings the glad tidings to the shepherd seated in the background. The text on the banderole reads: "The Saviour is born in Bethlehem. Go and worship him."

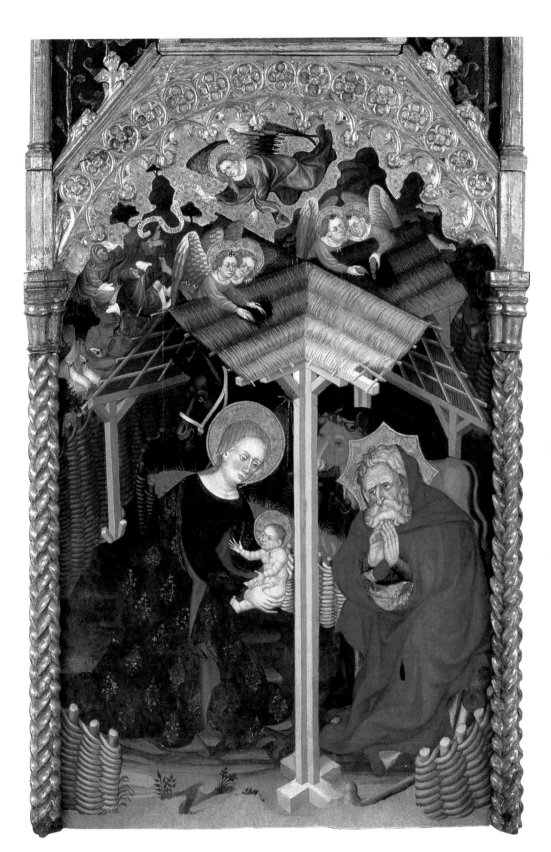

Lluís Borrassà
Nativity, 1403–1411
(from the altar from Santes Creus)
Tempera on wood, 184 x 121 cm
Barcelona, Museu Nacional d'Art de Catalunya

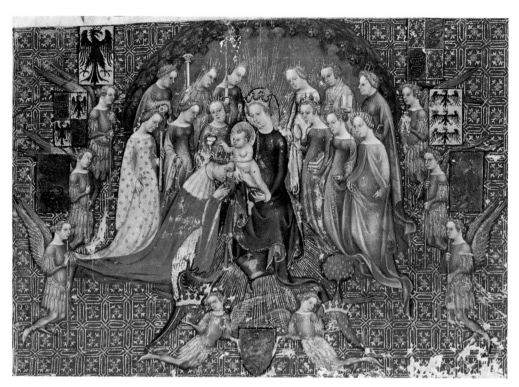

Michelino da Besozzo
The Christ Child Crowns the Duke, c. 1402/03
(miniature from P. da Castelletto's obituary for
Giangaleazzo Visconti, fol. 1 r)
Body colour and gold leaf on parchment, 37.5 x 25 cm
Paris, Bibliothèque Nationale (ms. lat. 5888)

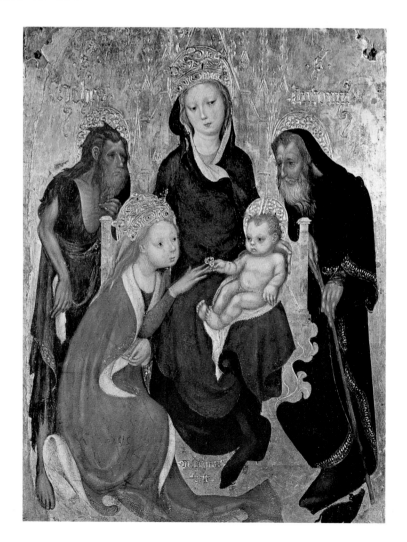

Michelino da Besozzo
The Mystic Marriage
of St Catherine,
c. 1410–1420
Tempera on wood,
75 x 58 cm
Siena, Pinacoteca
Nazionale

MICHELINO DA BESOZZO

DOC. 1388–1442

The court artist Michelino was also a miniaturist, a panel painter and an architect employed on Milan cathedral. His patron, Duke Giangaleazzo Visconti, was the most powerful despot of his day and ruled almost the whole of Upper Italy until his death. He was brother-in-law both to the French King Charles V and his brothers Duke Jean de Berry and Philip the Bold, and to Emperor Wenceslas of Bohemia. In the Italian principalities, which were ruled efficiently and energetically, art too had a permanent place. At a public level it was a form of propaganda and lavish display, but it also served to satisfy more sophisticated aesthetic needs.

This illumination testifies to the presumptuous settings in which ruling figures liked to be portrayed. Giangaleazzo has been taken up to Heaven. He has not even had to knock at St Peter's gate, but is seen here being crowned by the infant Christ. The crown itself is modelled on imperial crowns of late antiquity – a clever, ambiguous motif which can signify both the Duke's claim to be king of Italy and the crown of heavenly bliss. The central group, here attended by the twelve virtues, obeys the typical and familiar arrangement employed in paintings of the Coronation of the Virgin. The angels are portrayed as court pages presenting the Duke's arms, jousting helmets and alliances.

The whole is painted using the polished means of Sienese sacred art, with its gradated colours and gold ornament. The border is richly decorated with prophets, whose words refer both to the Duke and Christ alike. This is followed by a genealogy tracing the descent of the Visconti from Aeneas and his mother Venus. It is no contradiction, however, that the same duke should also sponsor realistic studies of animals and plants, for which Michelino was famous.

In this (poorly preserved) panel the artist strikes a different note. It is true that the gold is skilfully worked, the throne given a fine matt finish, and the nimbuses and signature (beneath Mary) worked in relief; originally, the crowns were even studded with precious stones. But such lavishness was nothing out of the ordinary. It is clear from the composition of the main group that the artist has given much greater thought to his subject that in the case of the miniature. The Virgin gently pushes the shy Catherine towards the infant Christ, whose helplessness is very accurately studied. Catherine cautiously holds out her hand to receive the ring.

Animated form is one of the main aims of Michelino's art – in the contours of the throne, in the scoop of the draperies and their undulating hems, even in his brush strokes. The result is not mere ornament, however, but an enrichment of the expressiveness of the whole. Michelino's position as court artist allowed him to be original. Counter to prevailing convention, he thus makes no attempt to convey spatial depth or to distinguish between the gold ground and the floor.

UPPER RHENISH MASTER

ACTIVE C. 1410–1430

Perhaps intended for a canoness or abbess, this panel offers an original variation upon the theme of the Virgin of the Rose Garden. Although Mary, reading a book in the upper half of the picture, is recognizably the most important figure in the composition, contrary to the conventions of the day she is neither the central focus of events nor even the central axis of the composition. At her feet, St Catherine is playing with Christ; to her left, St Dorothy is picking cherries, and in the bottom left-hand corner St Barbara is ladling water out of the well. Seated on the right are St Michael, with the devil at his feet, and St George with a small dragon; the legendary figure of St Oswald is leaning against the trunk of the tree.

There is a deliberateness and reflectiveness to all the activities taking place. Nowhere is the tenderness of the mood disturbed. Our eye wanders across the picture, stopping to contemplate each figure and natural detail in isolation. The painting as a whole is infused with Marian symbolism: the enclosed garden protected within its solid walls is an image of Mary's intact virginity. At the same time, it establishes an internal frame within the composition. With its delight in details, this type of devotional painting renders harmless such elements as the dragon accompanying St George and opens the door to more subjective interpretations of traditional themes of painting.

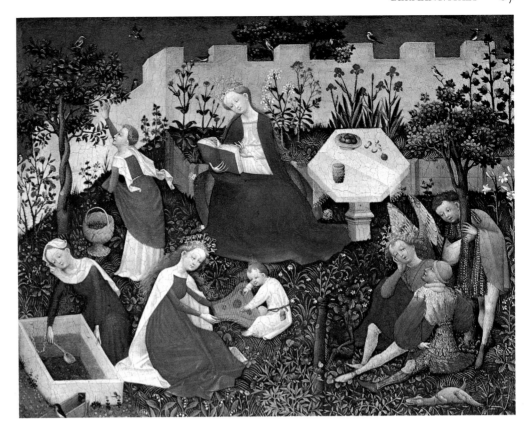

Master of the Paradise Garden
Garden of Paradise (Virgin in Hortus Conclusus with Saints), c. 1410
Mixed technique on wood, 26 x 33 cm
Frankfurt am Main, Städelsches Kunstinstitut und
Städtische Galerie

STEFANO DI GIOVANNI

C. 1374/75 – AFTER 1438

Presented with this panel, we begin to wonder whether it is indeed painted or in fact fashioned in gold. The distribution of blue and red across the surface recalls the manner in which goldsmiths studded their works with sapphires and rubies. The colours are applied with the brilliance of enamel. By dulling and glazing the areas of gold in a highly varied manner, the artist makes them glitter and shine in ever different ways. In the years around 1400, the subject of the *Virgin of the Rose Garden* was to be found not only in painting, but also in goldsmithery, as for example in the so-called *Golden Horse* in Altötting, one of the best examples of French court goldwork of the epoch. The contemporary taste for gems and gem-like qualities, and the poetic treatment given to holy objects, thereby led each medium to accommodate aspects of the other: goldsmiths sought to imitate the colours and the scenic dimension of painting, while painters sought to recreate the effects of light and sophisticated luxury of metalwork. Virtuosity and originality, however, were expected of every artist of the day. Stefano gives of his best above all in the gracefully animated figures of the angels and in the accurate reproduction of the birds, in emulation of his model Michelino da Besozzo. Alongside drawings, numerous frescos have also survived from Stefano's hand, the majority of them in and around Verona.

Stefano di Giovanni
(Stefano da Verona)
The Virgin of the Rose
Garden, c. 1425
Tempera on wood,
129 x 95 cm. Verona,
Museo di Castelvecchio

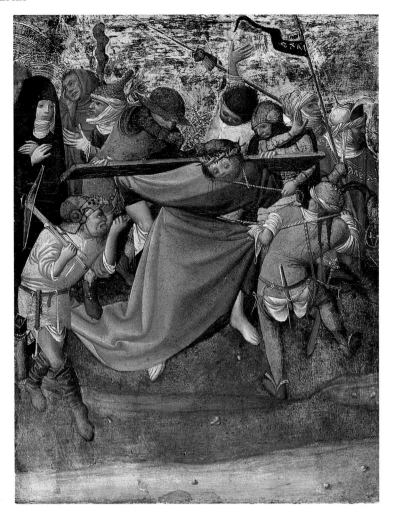

Master of the Worcester Road to Calvary
Worcester Road to Calvary, c. 1420–1425
Tempera on wood,
23.8 x 18.8 cm
Chicago (IL), The Art Institute of Chicago,
Charles H. and Mary F. S.
Worcester Collection,
1947.79

BAVARIAN MASTER

ACTIVE C. 1420–1435

The drama and cruelty inherent in this scene are portrayed with a forcefulness and mercilessness which have rarely been equalled. The brilliant painter even sacrifices anatomical accuracy to his overall effect, although a satirical drawing in London makes it clear that, in terms of figure drawing, he was more than a match for his contemporaries. Instead of proportioning and modelling Christ's body in naturalistic detail, he shows him buckling dramatically at the hips, around which the rope is bound. His extremely short upper body strains upwards in a countermovement to the soldiers pulling at him. His arms are too short, his feet huge. Large, broad swathes of drapery swing to and fro, creating an area of stillness in the heart of the heaving throng, which surrounds its victim like a pack of dogs (Psalm 22). One might almost think that Jesus was trying to use the cross as a lever, twisting it in desperation to create some space; more probably, however, he is about to collapse at any moment under its weight. In contrast to this starkness and the faces of Christ and his mother, which are treated gently in the manner of the day, the dress and actions of the soldiers are described in great detail. The slovenly clothing of the motley crowd thereby serves to underline the dignity maintained by Jesus. We will encounter many of the grimaces, raised fists, implements and sequences of movement again over the course of the 15th century.

BOHEMIAN MASTER

ACTIVE C. 1415–1430

In comparing the *Gerona Martyrology* with the art of the Limburg brothers, it must also be said that Bohemia went on to produce no van Eyck, nor indeed could it have done. Hussite criticism of the use of images led to the virtual cessation of artistic production, and above all to contempt for all art aimed at a sensually beautiful effect.

Although the donors of this work were probably not followers of Hus, they were nevertheless influenced by his ideas; it is striking that the feastday side of this altarpiece should be made up of a *Road to Calvary* and a *Crucifixion*, one above the other. Nor is there anything festive about their appearance: on the contrary, they are dominated by soldiers and henchmen. In the top right-hand corner of the present panel, Calvary is brutally portrayed as a hill of skulls; the stench of rotting bodies forces bypassers to hold their nose. The colours are dull and gloomy or, in the case of the red, burning; they are never deliberately beautiful. The figures are grouped not in an artful and organized fashion but in a jostling throng. The unpleasant side of the Passion is deliberately emphasized. The chief interest is in the content; from an artistic point of view, the panel simply reworks old motifs, such as Simone Martini's Mary Magdalene with arms upraised (cf. ill. p. 55) on the left, and has a limited range of existing pictorial means.

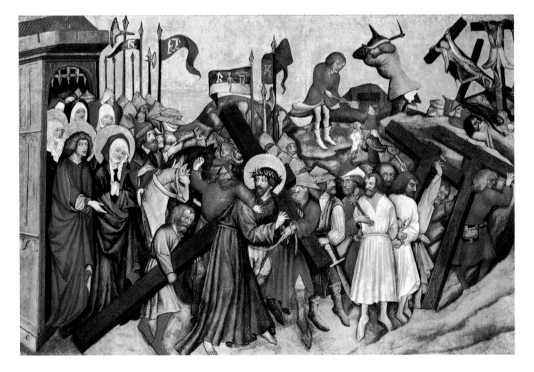

Master of the Raigern Road to Calvary
The Road to Calvary, c. 1415–1420
(panel from the Raigern Altar)
Tempera on wood, 99 x 147 cm
Brno, Moravské Museum

HANS VON BRUNECK

DOC. 1440/41

Within the rich inventory of wall paintings in the South Tyrol, the cloister of Bressanone cathedral ranks among the most impressive. The frescos by Hans von Bruneck decorating the fourth arcade are thereby of particular quality. Angels holding excerpts from the Gloria, the hymnic prayer of praise sung during the celebration of the Mass, float around the keystone. They are followed by the symbols of the Evangelists and the four Fathers of the Church. The busts of eight prophets round

off the programme. The text written on the ground directly above these fields, now hard to read, yields the date 1417.

From an artistic point of view, the very sensitively modelled, thoughtful faces deserve particular mention, as do the greenish fields around the Evangelists, which play with effects of perspective, the three-dimensional differentiation of the background, and the harmonious interplay of the decorative borders composed of outward-pointing trefoils. The soft, richly animated fall of a number of broad, thin draperies still belongs to the tradition of the International Gothic, but the weight and naturalism of other forms already herald its end.

Hans von Bruneck
Angels, Symbols of the Evangelists, Busts of Prophets, 1417
(detail of the frescos in the fourth arcade of Bressanone cathedral cloister)
Bressanone, cathedral

Jean Bondol
The Donor presents the Bible
to King Charles V of France,
Paris, 1371
(title page of the *Bible of Jean
de Vaudetar,* fol. 2 r)
Manuscript illumination,
29.5 x 21.5 cm
The Hague, Museum
Meermanno-Westreenianum
(ms. 10 B 23)

JEAN BONDOL

DOC. 1368–1381

Knowing that Charles V (the Wise) was a great
lover of books, his counsellor commissioned a
bible decorated with 269 beautiful illumina-
tions. The king had a title page inserted in
which Jean Bondol of Bruges, his court
painter, shows him being presented with the
book.

This is the only surviving work from the
hand of the Flemish artist. Evocative of a panel
painting, it nevertheless takes up the conven-
tions of court manuscript illumination in the
grisaille of the clothing (cf. ill. p. 74). In so
doing, it simultaneously highlights the most
important element of the composition: the two
portraits. The artist offers us a merciless, far
from regal picture of the 35-year-old king,
with his overly large head and long nose, his
pale face – he was a scholar rather than a mili-
tary man – and the stoop of his weakly built
body.

While this "natural" objectivity apparently
pleased the king, it contrasts strongly with the
rich heraldic décor of the background. Other
outstanding features include the artist's rendi-
tion of light and shade and the accuracy with
which he portrays objects and materials, such
as the wood of the royal chair, the delicate
weave of the king's cap and the structure of
the stone tracery. This illumination represents
the earliest example of Early Netherlandish
realism.

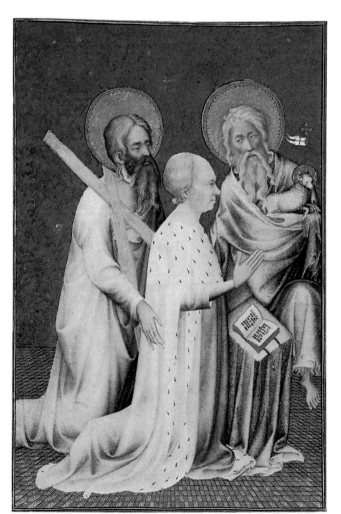

André Beauneveu
The Duc de Berry between his Patron
Saints Andrew and John
the Baptist, c. 1390
(preface page to the *Très Belles Heures,*
fol. 1)
Manuscript illumination,
27.5 x 18.5 cm
Brussels, Bibliothèque Royale
(Ms. 11060-61)

ANDRÉ BEAUNEVEU

BEFORE 1335–1401

This illumination represents the left half of a
diptych-style sheet which served to introduce
of this sheet a sumptuous manuscript by
Jacquemart de Hesdin. It is the work of a
sculptor, although in terms of its composition
and background it is more like a panel paint-
ing on parchment. The other half of this sheet
is a depiction of a nursing Madonna enthroned.

The Duke is as large as his patron saints.
This is far more than simply a matter of con-
sistency of scale, but implies that the living
person is as important as the saints. Strictly
speaking, the Duke is even more important,
since he occupies the centre of the composi-
tion; John the Baptist and St Andrew are
merely assisting him. Nothing similar is to be
found in panel painting for the next thirty
years.

The clothing of all the figures is painted in
the subdued grisaille which we saw in Jean
Bondol (ill. above). The palette is dominated
by red, blue and gold, the same triad as found
in the psalter for Louis IX (ill. p. 39). Here,
however, gold is used with greater restraint.
The same three colours are seen in the back-
ground, which does not consist of the usual
tendrils scrolling beyond the bounds of the
miniature, but which incorporates small dec-
orative forms with the Duke's coat of arms, to-
gether with garlands of flowers sheltering but-
terflies and birds.

GIRARD D'ORLÉANS (?)

DOC. 1344–1361

This painting of King John II is one of the earliest surviving autonomous portraits in European art. It is true that there had been portraits of rulers ever since classical antiquity – the importance of such models is reflected in the choice of pure profile in the present work, a pose typical of Antique coins and medals. Medieval portraits, however, did not show a king's individual traits, but rather his ideal and typical characteristics.

It was only with the major change in thinking ushered in towards the end of the 13th century that individuality began to be recognized, in a reversal of the previous belief that ideas were the higher, true reality, and individuals merely their imperfect expression. From now on, the individual was real, while ideas and concepts were simply "names". As a consequence, increasing value came to be attached to experience (empiricism), and less to philosophical thinking (theory). This nominalism came from Italy, as did a new genre of portrait painting which emphasized the empirical. Certain elements of the ideal and typical lingered on, however: here, in line with an earlier convention, the king is given the red hair considered most suitable for a ruler, together with a Roman nose. Rather than appearing with his royal insignia, the king is shown wearing a collar similar to those worn by scholars, in order to underline his wisdom.

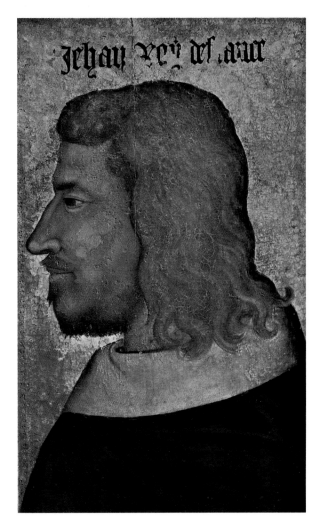

Girard d'Orléans (?)
Portrait of John II "The Good", King of France, c. 1349
Tempera on canvas on wood,
59.8 x 44.6 cm
Paris, Musée du Louvre

FRANCO-FLEMISH MASTER

ACTIVE C. 1410

Only a handful of individual portraits survive from the period before the second quarter of the 15th century. The Washington painting is alone amongst them in depicting a woman. Portraiture suffered more than any other genre from the fact that interest in the sitter generally overrode any interest in the quality of the execution. In no other field do we find so many copies; portraits of rulers were reproduced in entire series. Surviving inventories would nevertheless indicate that only very few portraits were painted at all in this early era.

Various aspects of its technique indicate that this *Portrait of a Lady* is a very early example of the genre. Thus the necklace and the girdle employ metal leaf overlaid with colour glazes, as found in many early paintings. At the same time, the painting has undergone numerous alterations, some of them dating back a very long time. The turban is still heavily overpainted, and the back of the head has been extended.

There was originally a pendant suspended from the chain which would no doubt have helped identify the sitter; she probably lived at the French court. This is indicated by the strict profile view (cf. ill. p. 92). The three-quarter view which would set the trend for the future, as chosen for the portrait of Rudolf IV in Vienna, is reserved here for the body, in order to allow a greater wealth of detail.

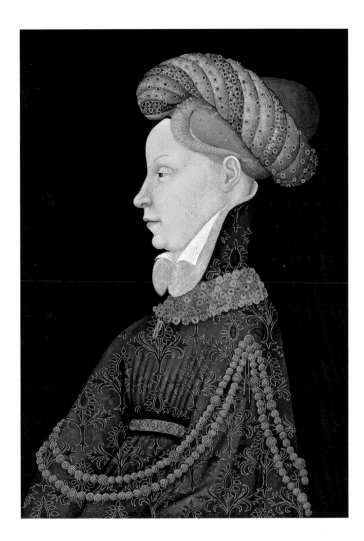

Franco-Flemish Master
Portrait of a Lady, c. 1410
Mixed technique on wood,
52 x 36.6 cm
Washington, National Gallery of Art, Andrew W. Mellon Collection

**Workshop of the
Gerona Martyrology**
The Story of Creation, c. 1415
(frontispiece of the *Boskovic Bible*)
Manuscript illumination
41.5 x 28.5 cm
Olomouc, University Library
(M III 3)

BOHEMIAN MASTER
ACTIVE C. 1405–1425

This miniature is representative of a group of
outstanding manuscripts from the period
around 1405–1425, which must have corre-
sponded to panel paintings no longer extant.
The artist uses gloss paints on gold and silver –
a highly unusual technique for this genre, and
a very complicated process both at the sketch-
ing stage and in the actual execution.

The quality of the art and the sophistica-
tion of the design are also correspondingly
high. The top medallion is both the first and
last in the series, showing God the Father en-
throned and at the same time representing the
seventh day, on which God rested. The days of
Creation are arranged in order from top to
bottom on the left and from bottom to top on
the right.

The chaos in the background gradually
evolves – more and more clearly from medal-
lion to medallion – into landscapes filled with
plants, animals and people, whereby the
curved horizon in each case lies only just below
the upper edge of the picture. God the Father
is portrayed in all seven medallions, each time
in a new and highly convincing pose. His
changing position within the frame neverthe-
less obeys the requirements of each composi-
tion. This manuscript illumination is more
than simply an exalted form of decorative art;
the workshop is a Bohemian parallel to the
Limburg brothers.

Viennese or Bohemian Master (?)
Portrait of Duke Rudolf IV of Austria
(1339–1365), c. 1360–1365
Mixed technique on parchment on
spruce, 48.5 x 31 cm (incl. frame)
Vienna, Erzbischöfliches Dom- und
Diözesanmuseum

VIENNESE MASTER (?)
ACTIVE C. 1360–1365

Although this portrait was later hung near
Rudolf's tomb, there is no reference to his death
in the inscription. That it may have been com-
missioned by Rudolf himself is further indi-
cated by the fact that he is portrayed as an arch-
duke (*Archidux*, as the Latin inscription reads), a
rank which Rudolf unlawfully awarded himself.
Rudolf also had himself carved in stone in St
Stephen's cathedral wearing the pointed arch-
duke's hat, whose bow makes reference to the
imperial crown. If the painting was indeed exe-
cuted before 1365, it is the oldest autonomous
portrait in the history of German art. It was ad-
mittedly intended less to capture an accurate
likeness, however, than to reinforce Rudolf's
political status. The shape of the bow evidently
cites more or less exactly the bow in the crown
of the Bohemian king Charles IV, whose daugh-
ter Catherine Rudolf married in 1357. The so-
lidity of the areas of flesh contrasts abruptly
with the treatment of the blonde hair and in
particular the very two-dimensional portrayal
of the serrated hat and the coat. The apparent
lack of connection between the circlet and the
bow has led some to conclude that the portrait
was painted before the archbishop's hat had ac-
tually been made. If this were the case, how-
ever, the portrait would have made no sense to
Rudolf's contemporaries. Nor would such a
theory explain why the painter also rendered
the shoulder area flat, just like the hat.

AUSTRIAN MASTER (?)

ACTIVE C. 1370

The early date explains why Mary is still shown lying in bed in the Byzantine fashion (cf. ills. pp. 64, 81). The artist, however, is in a class far ahead of his time. Light and shade lend powerful volume to his very blocklike figures. The draperies fall close to the body like sacks; only rarely is the severity of their contours disturbed by curving hems and fluttering folds. Displaying a remarkable delight in abstraction and a no less astonishing freedom *vis-à-vis* the ruling conventions in art, the painter does not even attempt to veil the naked upper body of the young mother with sheets or clothing.

Another highly original motif is the washing of the Christ Child. This motif was usually only to be found in the context of the births of St John and Mary. A maid is assisting Mary and is evidently putting the water jug back in a sort of cupboard. The Virgin's prettily patterned pillows also testify to the contemporary bias of the setting, although this is never allowed to disturb the magnificent simplicity of the composition. Particularly impressive in this regard is the way in which the ox and ass form a compact bow around Mary's feet, which can be made out beneath her clothes. Joseph's trousers are laid out demonstratively: according to a legend which enjoyed popularity at that time, he used them to make nappies for the newborn Child.

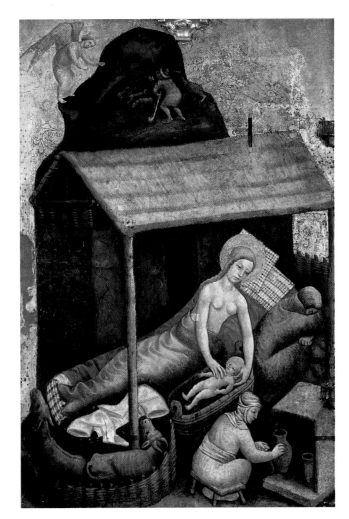

Master of the Schloss Tirol Altar
Nativity, c. 1370–1372
(from the Schloss Tirol Altar)
Tempera on wood
Innsbruck, Tiroler Landesmuseum
Ferdinandeum

AUSTRIAN MASTER

ACTIVE C. 1420–1435

This small panel may be seen as the Austrian counterpart to Fra Angelico's *Entombment* in San Marco, Florence, from the years 1438–1443 (ill. p. 111). It, too, expands upon the Man of Sorrows theme in a highly personal and unique manner.

Christ has been taken down from the cross and rests slumped against its foot. He does not have the stiffness of a corpse, however, but appears almost alive, in a pose of resignation. The seated figures of Mary and John appear to be lost in meditation rather than preparing to lay the body in the tomb, visible in the rock on the left. None of the other assistants, such as Nicodemus and Joseph of Arimathaea, are present.

This private, devotional panel serves a number of different purposes. On the one hand, it is a meditation upon the Passion and upon the individual instruments of Christ's martyrdom, which are leaned up against the cross. At the same time, however, meditation is itself a theme of the painting: Mary and Joseph are models with whom the viewer can identify. Unlike older Passion panels of this kind, however, the scene is not set somewhere outside time and space. This is Calvary, immersed in the gloom of an almost night-time sky against an empty landscape and a stark city wall – details conveying the essential mood of the painting.

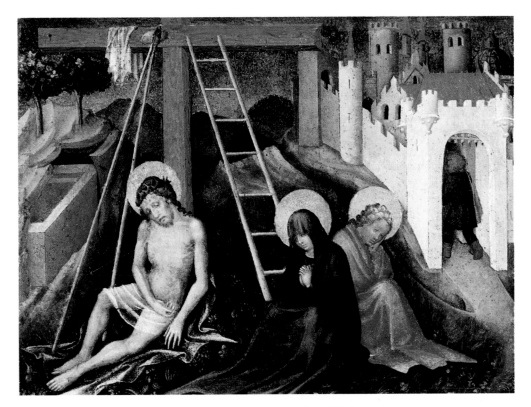

Master of the Offerings
Christ at the Foot of the Cross with Mary and John, c. 1420
Mixed technique on wood, 25 x 34 cm
Berlin, Gemäldegalerie, Staatliche Museen zu Berlin –
Preussischer Kulturbesitz

Master Francke
The Miracle of the Wall, 1414
(from the St Barbara Altar, Turku)
Mixed technique on wood, 91.5 x 54 cm
Helsinki, Kansallismuseo

Below:

Master Francke
Nativity, 1424–1436
(from the St Thomas à Becket Altar)
Mixed technique on oak, 99 x 89 cm
(individual panel)
Hamburg, Hamburger Kunsthalle

MASTER FRANCKE

C. 1380 – C. 1436

This panel is one of a cycle devoted to the legend of St Barbara in Turku cathedral (Finland). It shows the episode in which Barbara's father, in angry pursuit of his daughter, finds his path blocked by a wall which has suddenly and miraculously materialized. The father, in sumptuous oriental dress, rushes in from the left with his fist clenched and his sword drawn.

The wall passes diagonally across the picture from top left to bottom right and completely bars the way ahead. It becomes an image of insurmountability. To the viewer, the wall is like a piece of theatrical scenery. It does not obstruct our view of the saint in the background. The falling diagonal of the top of the wall becomes a rising diagonal in the silhouette of the hills behind, where space is opened up rather than blocked. Spatial depth is not an end in itself in Franke's art, but a vehicle of his narrative; it remains subordinate to the figures and – as a means of setting the scene – to the composition as whole.

A striking feature of the panel is its twilight atmosphere. The artist thereby attaches greater importance to achieving a rich gradation of light than simply to contrasting strong planes of colour. In this he shows himself to belong to a younger generation of painters influenced by the new art coming out of the Netherlands.

The surviving panels of the St Thomas à Becket Altar are characterized above all by the graphic vividness with which the soldiers are depicted, the barrenness of the rocky landscape, and the powerful overlapping with which Francke lends his narratives a whole new sense of drama. The red ground studded with gold stars is already familiar to us from the Master of Wittingau (ill. p. 67). As appropriate to its theme, the *Nativity* is the most lyrical and tender panel of the altar. Despite its gracefulness and its predominantly pale skin tone, as typical for the day, Mary's head is relatively broad and heavy. Contributing in no small way to the popularity of the altar was the extraordinarily rich and gentle, almost park-like landscape present in the surviving panels; the foreground, however, is here sandy, bare and unwelcoming. Did the Infant Christ not appear to be bedded in the rays of light emanating from him, and did the angel's luminous red wing not seem to shield him protectively? The fact that he is made to lie on the bare ground with not even a blanket to cover him would be all the more shocking. Master Franke thereby gives expression, for the first time in northern Germany, to an idea going back to the vision of St Bridget. The blue cloak which the three angels hold up like a fence around the Virgin is a very personal invention by Francke, and offers a rich opportunity for the overlappings which he loved so much. According to St Bridget, Mary took off her cloak in order to worship the Child in her white dress and with her hair uncovered. God the Father looks down from a corona of clouds, which are treated with remarkable animation for the time. With his hands raised in blessing, he alone is set against a gold background.

MASTER OF ST VERONICA

ACTIVE C. 1400–1420

Veronica is a creation of legend. She arose out of the *vera icon*, the supposedly "true image" of Christ which variously took the form of panel paintings, shrouds (as in Turin) and painted cloths. The story of St Veronica is associated with one such piece of cloth, known as the sudarium. According to legend, Veronica offered Christ her veil as he passed her on the way to Calvary. After he had wiped his brow, his image remained miraculously imprinted upon it. The popularity of the subject in art was fuelled by the fact that the sudarium was one of the main objects of pilgrimages to Rome in the Middle Ages, and that veneration of such pictures earned many indulgences. Furthermore, many Christians hopefully believed that the vision of this miraculous picture warded off the threat of sudden death.

Thus the sudarium bearing the "true image" of Christ is both the real subject and the centre of this panel. The smaller figure of Veronica holds up the cloth with an expression of devotion. The two groups of small angels contemplate in the sudarium both the mystery and the entirety of the Passion. These angels are painted in the most delicate of colours and with a sophisticated technique, and testify to the great skill and sensitivity of the artist – something to which Goethe would draw admiring attention in 1815.

With this densely populated scene of Calvary hill, the leading Cologne painter before Stefan Lochner introduced the cathedral city to a new pictorial type. Compared with its forerunner in Erfurt (ill. p. 65) of half a century earlier, the ratios of size are far more to scale, the groups more closely interlinked. Their arrangement remains traditional: around the Cross are mounted soldiers, including the worshipping figure of the "good captain" and blind Longinus holding the lance; although his hand is at this point having to be guided, he will soon be able to see the blood spilling from the wound in Christ's side. In the left-hand foreground, the relatives of Christ stand around his mother, who is ashen with grief, while on the right soldiers are tossing the dice for Jesus's coat. Their finely drawn faces and their part fashionable, part oriental dress point in particular to influences from further west.

Fashions will hardly change between now and Lochner. In his work, too, we will see bellies sagging over low-slung belts, knee-length costumes and turban cloths looped around hats. Lochner will even adopt the figure with the oriental scimitar in the right-hand foreground into his own painting for the cathedral – an astonishing homage to the older master. The palette, which ranges from delicate hues to colours of an exquisite, enamel-like luminosity, again points to influences from the west, as do the horses in their magnificent trappings; for all their discrepancies of proportion and their wooden poses, they are well observed.

Master of St Veronica
St Veronica with the Sudarium, c. 1420 (probably from St Severin, Cologne)
Mixed technique on wood, covered with canvas, 78.1 x 48.2 cm
Munich, Bayerische Staatsgemäldesammlungen, Alte Pinakothek

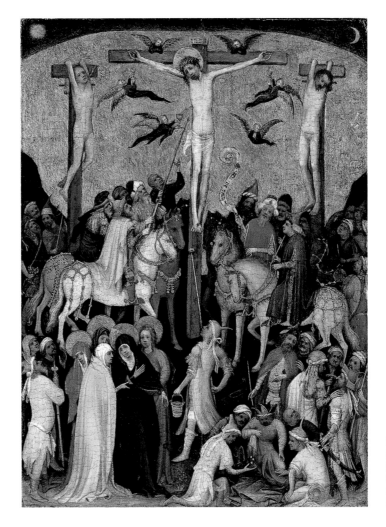

Master of St Veronica
Calvary Hill (the so-called Small Calvary), c. 1415
Oil on oak, 50.7 x 37.5 cm
Cologne, Wallraf-Richartz-Museum

Master of the London Throne of Grace Madonna, c. 1420
(fragment of a votive panel from the Benedictine foundation of St Lambrecht,
Styria). Tempera on wood, 58 x 55.5 cm. Graz, Landesmuseum

AUSTRIAN MASTER
ACTIVE C. 1420–1440

This panel only makes full sense when seen in conjunction with the two groups of donors who appear beneath the Madonna kneeling on a patch of grass against a gold background, accompanied by their patron saints. Mary is thus to be understood as a heavenly apparition. At the same time, however, she recalls the woman clothed with the sun and pursued by a dragon described in Revelations (and who was theologically associated with the Mother of God), as well as the vision of the Virgin seen by St Anthony Abbot on the day of Christ's birth (the so-called Madonna Aracoeli; cf. ill. p. 107), and the Virgin who has been assumed into Heaven. None of these are contradicted by the fact that she has the infant Christ on her lap: this is a picture of Mary in her role as eternal mother and – even more importantly in the context of a votive panel – intercessor.

The blue of the Virgin's mantle is gently gradated from dark to light, lending it a luminous quality such as we have already seen in Bohemian painting.

The golden glory and the vibrant red aureole with its angels compose, together with this blue, a powerful triad of intensely radiating colour reminiscent of older paintings. Mary thereby appears as the truly celestial Queen of Heaven, crowned by angels.

MIDDLE-RHENISH MASTER
ACTIVE C. 1410–1440

When the wings of the Ortenberg Altar were opened out on feast days, Paradise itself seemed to be revealed amidst the dazzling display of silver and gold. The background, crowns, haloes and the nimbus around the head of the newborn Christ Child are all rendered in gold leaf, applied on top of the linen which covers the actual wood panel. The draperies, musical instruments and angels' wings are executed in silver, which had to be insulated to prevent it oxidizing, something which demanded great technical skill. This is undoubtedly one of the reasons why no other altar has survived which employs so much silver. The few other colours making up the rest of the palette are finely tuned to the harmony of silver and gold.

A group of blessed virgins, most of them relatives of Mary, are gathered together within a Paradise garden strewn with flowers. Prominent at their centre is Mary herself. Medieval scholars had reconstructed her family tree from scattered references in the Gospels; it was so complicated that the artist has identified each relation in her halo. These "holy kindred" can theoretically number up to twenty-eight people, but in Ortenberg the husbands have been omitted – only the head of Joachim, Mary's father, appears between Mary and her mother Anna. All the more successfully has the artist incorporated the three crowned virgins Agnes, Barbara and Dorothy.

Master of the Holy Kindred
The Holy Kindred, c. 1425–1430
(central panel of the Ortenberg Altar)
Mixed technique on wood, 100 x 162 cm
Darmstadt, Hessisches Landesmuseum

LORENZO MONACO

C. 1370 – C. 1425

The model for this painting, in which an Annunciation takes the place of the usual enthroned Madonna as the centre of the altarpiece, was provided by Simone Martini's *Annunciation* of 1333 in Siena cathedral. It was from here that Lorenzo adopted the motif of the Virgin surprised by the angel, albeit in a modified form. Building upon Simone's sophisticated technical skills, Lorenzo embosses and engraves the various different areas of gold leaf and gloss paint and thereby makes the gold sparkle and shine. He uses the least worldly colours of yellow, red/violet and blue for his palette, which he lightens to such an extent that they acquire a brightness similar to the gleam of gold. Rhythmical curves, just one of the formal tools of older Sienese painting, are here adopted as the chief design principle. Bodily actions are translated into a sequence of folds and curving contours, thereby softening the violence of Mary's reaction.

At the same time, her pose is enriched as it dissolves into a wealth of movements and countermovements. Above all, by carrying the lightness of his palette and the fluidity of his line to such extremes, the painter succeeds in convincing the viewer that the Archangel Gabriel is indeed floating on a cloud of light inside the room.

In the late 15th century, in keeping with the taste of the day, this panel was given a rectangular frame and an Annunciation and prophets were added to its spandrels. It probably originally featured a predella. The *Adoration of the Magi* was at that time a very popular subject. The homage offered by the Three Kings, one from each of the three known continents and representing the three stages of man, to the "new-born King of the Jews" underlined Christ's status as the king of kings. Hence, too, the name Epiphany for the festival on 6 January (epiphany = the appearance of a divinity). The oldest king, Caspar, represents Asia, considered the noblest continent since it was here that Jerusalem, the centre of the world, was to be found. Caspar brings gold, a symbol of Christ's power. The second, middle-aged king, Melchior, symbolizes Europe and bears frankincense as a token of Christ's priesthood. Balthasar, the youngest, represents Africa and presents myrrh as a symbol of Christ's Passion and sacrifice on the cross.

In the years around 1400, this subject was prized as an opportunity to mount a display of courtly pomp, to paint a party of travellers, and also to portray exotic peoples in a fashion true to life. Thus the present panel includes Africans, Turks and Mongols each wearing their own distinctive dress and, in particular, striking hats. There is even a camel behind the mounted figures on the right. The composition incorporates several different moments in time: on the right, the figures are watching the star of Bethlehem, i.e. the comet, that led them to the stable, while in the middle and on the left we see the procession and the Adoration.

Lorenzo Monaco
Annunciation,
c. 1410-1415
(detail of an altar in the Badia, Florence)
Tempera on wood,
130 x 230 cm (total size)
Florence, Galleria dell'Accademia

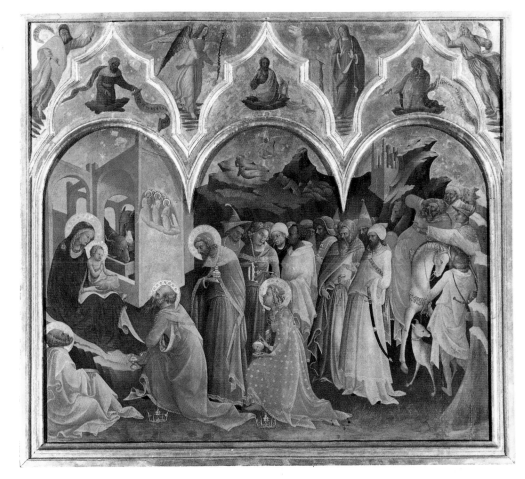

Lorenzo Monaco Adoration of the Magi, 1421/22
Tempera on wood, 144 x 177 cm. Florence, Galleria degli Uffizi

Sassetta
The Mystic Marriage of St Francis,
1437-1444
(from the back of the Borgo San
Sepolcro altarpiece)
Tempera on wood, 95 x 58 cm
Chantilly, Musée Condé

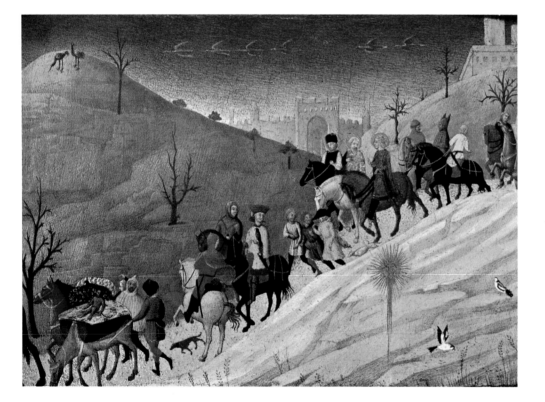

Sassetta
The Procession of the Magi, c. 1432-1436
(fragment of a picture showing the Adoration of the Magi)
Tempera on wood, 21.3 x 29 cm
New York, The Metropolitan Museum of Art

SASSETTA

C. 1392–1450

Sassetta was the most important painter in
Siena in the early 15th century. The city had
lost its former political and economic status
and was unwillingly forced to recognize the su-
periority of Florence. Artists, however, showed
themselves no more open to Florentine trends
than before. On the contrary: the ties between
the Sienese and Florentine painters were less
close now than they had been in the first half
of the 14th century, during the most intense
period of rivalry between the two cities. Both
camps had since turned their attention largely
back to their artistic pasts. Sassetta is an illus-
tration, however, of how this could neverthe-
less produce significant results.

The panel seen here was once part of a
winged altarpiece whose components were
separated at the start of the 19th century. It
was originally painted for the Franciscan
church in Borgo San Sepolcro. It tells the
story of how, on a broad plain between
Campiglia and San Quirico not far from Siena,
St Francis encountered three poor women who
were identical in age, stature and appearance.
They greeted him with the words "Welcome
Lady Poverty" and then disappeared. Bonaven-
tura, who relates the tale, interprets the three
women as Poverty, Chastity and Obedience.
The painting is thus both an allegory and a
highly dramatic narrative. Sassetta has elabo-
rated somewhat upon the story. The three
women are no longer identical in dress, for
example: Poverty wears Franciscan brown,
Chastity white (the colour of the lily) and
Obedience burgundy red. Nor are we simply
shown a meeting, but the mystic marriage of
St Francis to Poverty – a motif from the fres-
cos by the school of Giotto in the Lower
Church of San Francesco in Assisi. The true
magic of this painting lies in its background.
The sweeping plain is seen in the clear but
still subdued light of early morning. The
landscape, with its mountains seen in sharp
silhouette in the background and its mono-
chrome colours, is reminiscent of Simone
Martini, albeit viewed through Sassetta's eyes:
it incorporates both the rectangular fields of
the Tuscan countryside and trees dotted irreg-
ularly across the hillsides. The entire palette is
oriented towards the Franciscan brown. Al-
though the towns and castles scattered across
the countryside are Tuscan in their cubic archi-
tectural style, they nevertheless appear unreal.

This *Procession of the Magi* is just a fragment in
which Sassetta, inspired by the sumptuous
compositions of Lombard painters, shows the
Three Kings on their way to Bethlehem. The
landscape is wintery and parched, in keeping
with the season of Christ's birth, and immersed
in a cold, bright light. The blue of the sky in-
tensifies towards the top of the painting. A
line of stylized birds of passage is seen over-
head. In the background we can identify a gate
in the style of the Porta Romana in Siena. The
choice and use of colour recall the art of Fra
Angelico, whose painting in Cortona had im-
pressed Sassetta. But Sassetta's paintings are of
a more austere and rigorous beauty.

GENTILE DA FABRIANO

C. 1370–1427

The last surviving work by Gentile da Fabriano documents, in this pilgrimage scene, an interesting chapter in the history of religion. It shows the viewer the pilgrimage to the tomb of St Nicholas in Bari, the popularity of the pilgrimage site, and also, in the figure of the man front left, an instance of miraculous healing. At the same time, it is sober and objective in its view, cataloguing the different forms of religious zeal and containing no indication of the presence of the heavenly spheres or of any divine intervention. With astonishing historical fidelity, Gentile depicts a 12th-century mosaic in the apse of the church, and beneath it – in what appears to be an old-fashioned style – the very five scenes from the life of St Nicholas which can be seen on the predella of the Quaratesi altarpiece. The gloomy lighting inside the old church is rendered with the same fidelity as, for example, the Madonna icon on the side wall of the left apse. The growing awareness of historical change, one of the great achievements of the humanistic 15th century, was thus something of which Gentile was fully a part. It was during this time that proof emerged that Emperor Constantine had not, after all, bestowed the Papal States upon the pope. A clearer line began to be drawn between epochs – one of the conditions which would permit a conscious return to classical antiquity.

The present scene, part of the same predella, illustrates the legendary episode in which Nicholas saved three impoverished girls from prostitution by tossing three gold balls through their window one night. It is conceived in quite different terms to the panel above. It was long considered to be a work by Masaccio – an understandable error which shows that there is no firm break between the Gothic and the Renaissance, but at best a change of paradigm whose advent is announced sometimes clearly, sometimes less obviously in advance.

The panel offers us a view into a simple bedroom, in which four people are preparing to go to bed. (The use of just one bed by the entire family, and by both sexes and all ages, shows how poor they are.) Gentile draws upon the genre of family painting in composing the scene: we see the father smiling kindly at his daughter's efforts to assist him, and there is no suggestion of the threat that hangs over their existence. For the artist, however, the most interesting challenge was probably to portray the figures in complex and highly foreshortened poses: one daughter binding her hair in a scarf as she apparently catches sight of the saint at the window, the other in the process of pulling off her dress. Gentile, a foreign painter of the older generation, thereby offered the city of Florence – where a new generation of artists was in the process of making Florentine art the foremost in Italy – a deliberate demonstration of his skill and talent.

According to an inscription now lost, the altar, praised by Vasari as Gentile's greatest work, was completed in May 1425.

Gentile da Fabriano
A Miracle of St Nicholas, 1425
(from the predella of the Quaratesi triptych from San Niccolò, Florence)
Tempera on wood, 35 x 36 cm
Washington, National Gallery of Art

Gentile da Fabriano
St Nicholas and the Three Gold Balls, 1425
(from the predella of the Quaratesi triptych from San Niccolò, Florence)
Tempera on wood, 36 x 36 cm
Rome, Musei Vaticani, Pinacoteca Vaticana

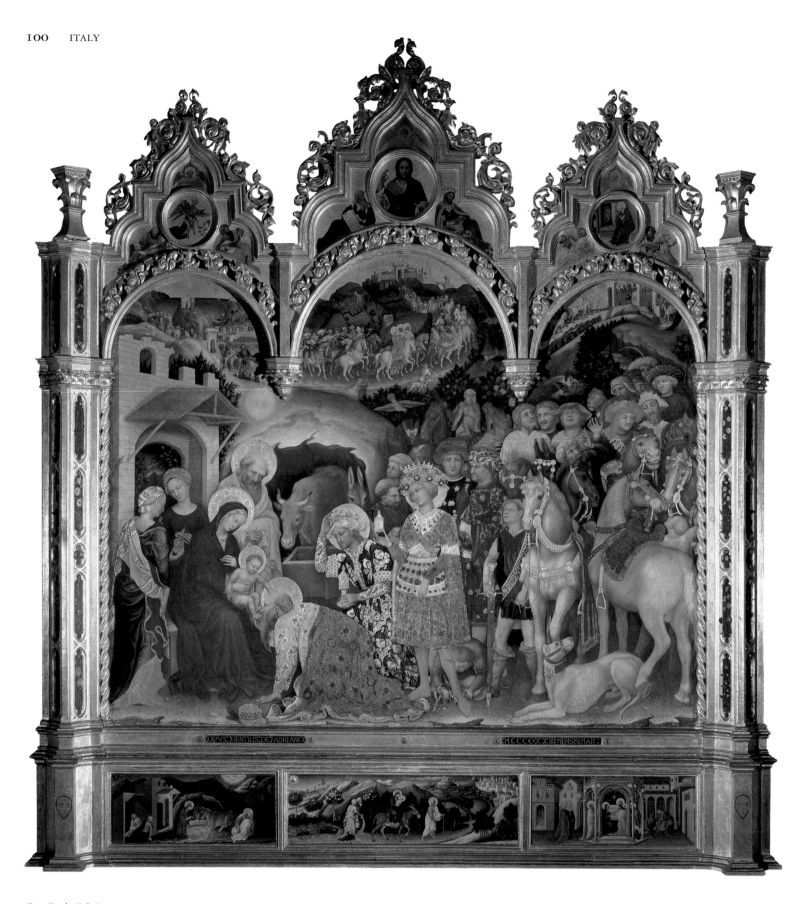

Gentile da Fabriano
Adoration of the Magi, 1423
(from the Strozzi Chapel in Santa Trinità, Florence;
the right-hand predella panel is a copy)
Tempera on wood, 303 x 282 cm (incl. frame)
Florence, Galleria degli Uffizi

GENTILE DA FABRIANO

C. 1370–1427

This panel for the Strozzi family chapel in
Florence is not a private altarpiece but a pub-
lic demonstration. The predella scenes of the
Nativity, the *Flight to Egypt* and the *Presenta-
tion in the Temple* are prize examples of preci-
sion painting and pay particular attention to
effects of light. The *Adoration of the Magi* uses
exactly the same setting as the *Nativity* on the
predella, but transforms it into a scene of

royal splendour. The Strozzi thereby place
themselves on a par with the princes of Italy.
Not only are the figures arrayed in sumptuous
fabrics, but these are rendered with supreme
skill in a wide range of gilding, engraving
and painting techniques. But Gentile also acts
as a master of ceremonies: the characters are
strictly ordered according to the richness of
their dress, documenting the hierarchy of
dress and court protocol. The falcons, hunting
leopards and monkeys appear to be added,
however, for the amusement of all the mem-
bers of the court.

FRENCH MASTER

ACTIVE 1405–1420

Characteristic of the Boucicaut Master are his slender but nevertheless voluminous figures, with heads now more coarse than delicate, together with his evident delight in complex spatial solutions, and his overloading of the composition with references to the donor. Thus he does not baulk at exploiting the draperies of his angels as a vehicle for his advertising, or from equipping none less than the Holy Trinity with the Marshal's coat of arms and devices. He likes to hang cloths in his interiors to create a greater sense of depth. In the *Nativity*, which is set outside, one lies like a screen in front of the stable wall and the view of the landscape. Deployed in this way, one might sooner expect it to conclude the composition at the rear, and indeed the painter humorously shows us the same open arrangement rotated through 90° in the *Adoration of the Magi* – complete with the holes in the roof, the bed and the annex for the livestock. The sumptuous bed, so utterly out of keeping with the stable scene, is not just intended to link the world of the Holy Family with that of the donor, but for once pays the newborn Saviour the honour which is his due. In the tradition of the vision of St Bridget, Mary is shown kneeling in prayer, whereby she is expressly provided with one of the Marshal's cushions. Just as the bed strikes a jarring note within the landscape, so the trees in the foreground are at odds with the modern use of perspective.

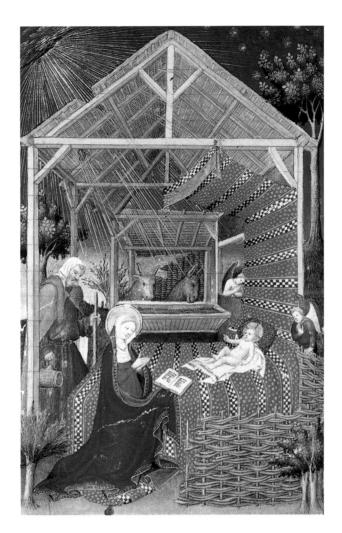

Boucicaut Master
Adoration of the Child, c. 1410–1415
(miniature from the *Book of Hours of Marshal Boucicaut*, fol. 73 v)
Body colour on parchment,
27.4 x 19 cm
Paris, Institut de France – Musée
Jacquemart-André (ms. 2)

FRENCH MASTER

ACTIVE C. 1405–1430

Included in this book of hours at the end of the traditional calendar were three miniatures, each full-page (excluding the caption) and framed like a painting. Two of them tell the story of Noah, an unusual subject for a book of hours. The first shows Noah building his ark, which takes the shape of a house, and bringing in the animals. The second combines several of the events surrounding their fortunate survival. The dove brings Noah's wife a fresh olive leaf from Mount Ararat, as around the ark the land slowly surfaces from beneath the receding waters and the mountain peaks begin to appear (Genesis 8:5).

At the same time, however, the door of the ark has already been let down. The animals and birds who have been saved are prancing and flying out, and Noah is thanking God with a burnt offering. Further forward again, we see Noah already pruning the vines in his freshly-planted vineyard, the first of humankind. The miniaturist has even incorporated the next stage of the story, the popular episode of "Noah's Shame", into his picture: lost in a drunken stupour, the patriarch falls asleep on his back and exposes himself. His son Ham brazenly shows Noah's nakedness to his brothers Shem and Japheth, one of whom piously covers his father up. A whole new enthusiasm for observing nature as faithfully as possible is evident everywhere in the composition.

Master of the Bedford Book
of Hours
The End of the Flood, c. 1423
(miniature from the *Bedford Book of Hours*, fol. 16 v)
Body colour on parchment, 26 x 18 cm
(dimensions of page)
London, British Library
(ms. add. 18850)

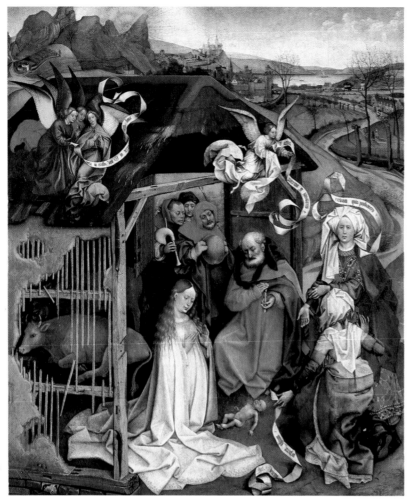

Robert Campin
Nativity, c. 1425–1430
Oil on oak, 85.7 x 72 cm
Dijon, Musée des
Beaux-Arts

ROBERT CAMPIN

C. 1375/80–1444

This portrayal of the Holy Family once again follows the vision of St Bridget (cf. ills. pp. 70, 94, 133). It also incorporates the story of the two midwives, towards one of whom the angel dressed in white is descending: her hand has been paralyzed as a consequence of her lack of faith, and can only be cured by the Infant looking at it. This somewhat frivolous embellishment to the story is not the only thing that separates this painting from the Ghent Altar (ill. p. 104) with which it is virtually contemporaneous. For all the richness of their apparel, its figures remain rather colourless and schematic. Their type-like faces lack the depth of expression found in the Eyck brothers. The swathes of drapery veil the fact that the figures are not truly three-dimensional. Making up for these deficits is the setting. The painting is one of the first great landscapes of Western art. The artist shows us the defects in the stone, beams and wicker walls of the stable, the pollarded willows and little stream which border the track leading deep into the background – towards the comfortable inn, the splendid town, the expansive lake and the fantastical mountain peaks behind which the morning sun is rising. The rays of the sun are thereby rendered in old-fashioned gold, which does not prevent them, however, from allowing the distant trees and passers-by to cast wonderfully observed shadows.

ROGIER VAN DER WEYDEN

C. 1400–1464

Only rarely did Netherlandish artists tailor their work to an Italian client not just in their choice of subject, but also in the format of their composition. This single panel with its strictly symmetrical composition follows the type of the *sacra conversazione*, in which saints stand around the Madonna in a "holy conversation".

The gold ground, plinth border and a vase emphasizing the central axis are entirely oriented to Florentine taste. The precision with which the flowers are detailed, on the other hand, together with the deep colours and finely drawn faces, belong to the Netherlandish qualities which first fired the enthusiasm of Italian collectors. But perhaps even they came to feel that northern painting was sacrficing too many of ist unique qualities in its accommodation of southern conventions.

The canonized doctors Cosmas and Damian seen on the Virgin's left were the patrons of the Medici, the most prominent family in Florence, whose coat of arms appears on the plinth. Rogier employs a standard inventory of forms. The Child thus cites older formulae, and at the same time doesn't seem to know himself quite why his head is lying so close to his mother's naked breast. Other than in Jan van Eyck, the saints' hands possess a masterly suppleness, but at the same time are of spidery thinness. Their gestures, too, are somewhat schematic.

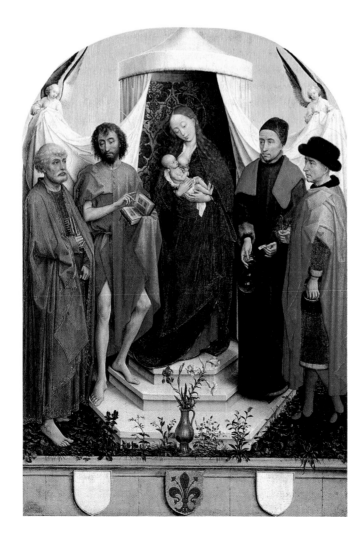

Rogier van der Weyden
Madonna and Child with SS Peter,
John the Baptist, Cosmas and
Damian (Medici Madonna),
c. 1450–1460
Oil on oak, 61.7 x 46.1 cm
Frankfurt am Main, Städelsches
Kunstinstitut und Städtische
Galerie

MASTER OF COVARRUBIAS

ACTIVE C. 1450

This evidently German painter took over such a wealth of motifs from his Netherlandish colleagues that he can at times offer valuable assistance in the reconstruction of lost or misplaced works. He was thereby even closer to Campin than to Jan van Eyck, with whom he was involved in the illustration of the Hours of Turin (ill. below). Alongside individual motifs, he also adopted whole compositions, figural types and some basic forms of drapery folds – but not the Netherlandish artists' confident handling of line, or the freshness and brilliance of their execution. His pearls fail to gleam, his fabrics seem wooden, his vegetation, compiled additively out of plants placed one beside the other, remains lifeless. His attempts at foreshortening regularly misfire, and his draped figures are constructed with no real understanding of the human form, so that their often overly small extremities seem to be stuck on the end of a puppet. Like Jan van Eyck, the painter is enamoured of detail, but he overburdens his space with all kinds of accessories and thereby loses sight of the overall concept. This fear of empty space compels him, for example, to cram in the bench seat with the two cushions, like a piece of stage scenery, behind the serving maid at the wash trough. The more conventional organization of the composition forces the painter to scoop the curtain in front of the bed boldly upwards, to enable the mother to be seen at all.

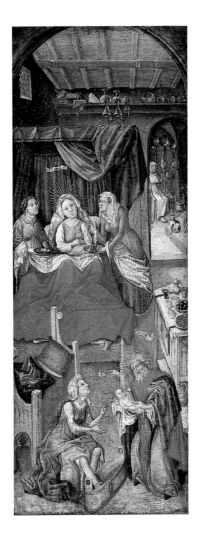

Master of Covarrubias
The Birth of Mary, c. 1450
Oil on wood, c. 75 x 31 x cm
Liège, University Library, Gift of Baron Wittert

Below:
Jan van Eyck
The Birth of John the Baptist, c. 1422
(miniature from the *Très Belles Heures de Notre-Dame*, fol. 93 v)
Body colour on parchment, 29 x 21 cm (dimensions of page)
Turin, Museo Civico d'Arte Antica (Inv. no. 47)

JAN VAN EYCK

C. 1390–1441

With a naturalistic sense of proportion that would remain unequalled for decades to come, Jan van Eyck keeps his figures small, in order to portray them in accurate relation to their surroundings. This impression is further heightened by his use of foreshortening, judged with astonishingly skill by eye alone, his lighting, his use of overlapping, and the views he offers into the background. A serving maid passes Elizabeth her tightly swaddled son, while Zacharias is sunk deep in a book in the room behind. He has lost the power of speech, because he refused to believe his wife could be pregnant at such an advanced age. Hence, in 15th-century painting, he is often shown having to write down the name of the baby being presented to him by a young woman who is to be understood as Mary.

Jan's figures are extraordinarily animated – we can almost see Elizabeth shuffling under the blankets. Zacharias rests his knee casually on the bench while reading. The scene is portrayed in loving detail: nappies, milk, essences and wine are set out for mother and child, and in the far room a picture of Moses hangs resplendent on the wall, as appropriate for the age before the birth of Christ. Green foliage glints through the bull's-eye panes of the window, decorated with coats of arms, and in front a cat and dog are playing. There are all sorts of practical items to be seen even in the chest on the left.

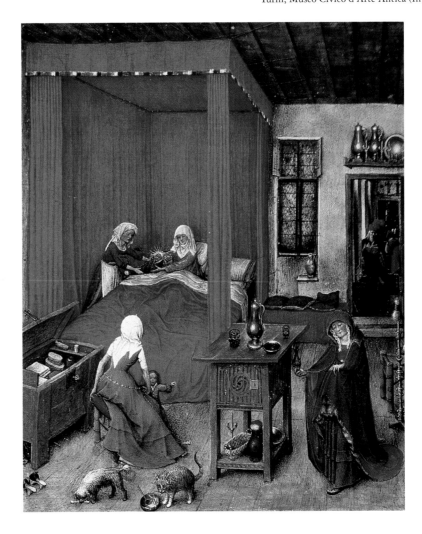

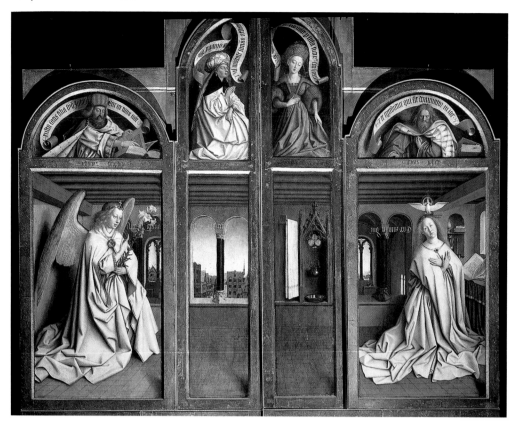

Jan and Hubert van Eyck
Annunciation, completed 1432
(from the exterior of the Ghent Altar)
Oil on oak, c. 180 x 260 cm
Ghent, St Bavo's cathedral

JAN AND HUBERT VAN EYCK

C. 1390–1441
c. 1370–1426

Despite the extremely tall format imposed upon him by the structure of the altarpiece, Jan van Eyck conveys the impression in the *Annunciation* of a perfectly foreshortened space. The graduated intensity of the palette, coupled with the subdued lighting and delicately gradated shading, further reinforce the impression of three-dimensional reality. That all of this was carefully planned is underlined by the shadows cast inwards by the uprights of the frame. At the same time, the setting as a whole transports the event which took place 1500 years earlier into the viewer's own times. The viewer would thus have looked out through the open windows onto a town of his day. In the dim light of the niches, he would have made out the familiar furnishings of a wealthy interior, including a washstand in the centre. Just as this refers to the Virgin's purity, which distinguishes her from ordinary mortals, so most of the other apparently naturalistic elements similarly carry a very specific symbolic meaning – not least the light, which projects the arched shape of the windows onto the wall behind Mary's head, even though the figures themselves are lit from the right. It is no more of this world than the winged visitor and the dove hovering above Mary's head. Her reply to the angel's words is addressed to God Himself – and hence is written upside down. Both the Virgin and Gabriel are nevertheless portrayed with the same realistic means. Their bodies are massive, their faces fleshy, their hair fine, their draperies full and heavy.

The wings bearing the *Annunciation* on their exterior open out to reveal, inside, a group of angels singing the praises of God the Father. They are flanked by the figures of Adam and Eve, whose sin has been redeemed by Christ's atonement, celebrated in the *Adoration of the Lamb* at the centre of the Ghent Altar. Above them is portrayed the story of their children, condemned to farm the land after the expulsion from Paradise. While Abel's sacrifice is acceptable to God, Cain crouches behind him in anger after his own offering has been rejected. In the spandrel above Eve, he slays Abel with the jawbone of an ass.

The artist employs grisaille in imitation of sculpture, an effect that one might sooner expect to find on the altar's exterior. All the greater is the impact made by the lifelike figures of Adam and Eve, emerging out of the grey of their niches in their naturalistic colouring. This is the first time that a painter from the North has attempted life-size nudes, and clearly, moreover, on the basis of studies made from life. In portraying Adam's projecting foot as seen from below, the artist took into account the height at which the completed altar would be displayed. There is a certain contradiction between this, however, and the floor beneath the angels' feet, which is seen from above. Its richly patterned tiles include a Christogram and a Sacrifical Lamb, while elsewhere Eyck imitates Arabic characters – a pointer to the source of his decorative forms. As in the *Annunciation*, the details make reference to the overall programme.

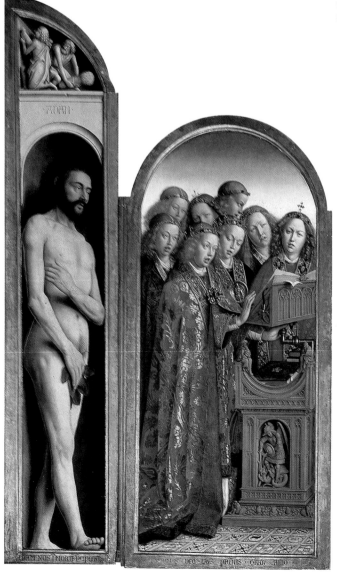

Jan and Hubert van Eyck
Adam and Singing Angels,
completed 1432
(from the left-hand wing of the
interior of the Ghent Altar)
Oil on oak, 204 x 33 cm
(Adam) and 162 x 69 cm
(Angels)
Ghent, St Bavo's cathedral

Lukas Moser
Magdalene Altar, 1432
Mixed technique on wood, c. 300 x 240 cm
Tiefenbronn, S. Maria Magdalena

Pediment: Feast in the house of Simon
From left SS Mary Magdalene, Martha, Lazarus,
Maximinus and Sidonius voyage by sea; SS Sidonius,
Maximinus, Lazarus and Martha asleep; St Mary
Magdalene appears to the prince and his wife in a dream
(above); Last Communion of St Mary Magdalene

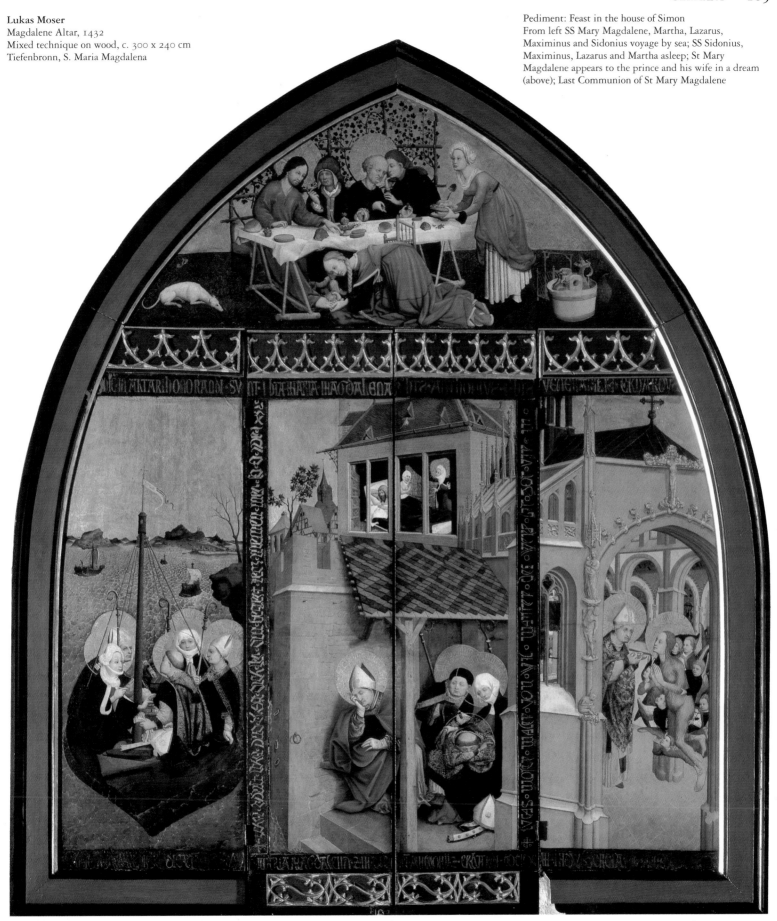

LUKAS MOSER

C. 1390 – AFTER 1434

Of all the artists of his generation, Moser was probably the most modern and the closest to the new realism issuing from the Netherlands. The main front of the Magdalene Altar is di-

vided into three scenes, all obeying the same perspective and lit from a single source. The landscape and architecture create an astonishing impression of depth and are observed with a keen eye: the sea is partly underlaid with a sheet of metal foil to make it look more watery.

The painted retable covers a fresco, but one

hardly notices that the middle section of the altarpiece conceals a sculpture of the ascension of Mary Magdalene. The painter is not interested in making a distinction between a weekday and a feastday side of the altar – he simply wants to create a homogeneous, permanently visible panel of the kind with which he was familiar from Italy.

Joos Ammann of Ravensburg
Annunciation, 1451
Fresco. Genoa, Santa Maria di Castello

JOOS AMMANN OF RAVENSBURG
ACTIVE C. 1450

In the gesture of the Virgin's hands, the arches, and the jug and basin, Ammann directly cites the Ghent Altar of twenty years earlier (ill. p. 104). He falls far short of the older work, however, not just in terms of perspective accuracy; the stylized, non-naturalistic treatment of the inset figure of God, the gold rays and nimbuses and the flaming Christogram are all archaic formulae which contrast abruptly with the realism of the Eycks. The lively palette is paralleled by an even greater wealth of detail, although virtually all of it is anecdotal in character.

The shoes on the window-ledge, on the other hand, are familiar from other versions of the Annunciation: just as God revealed himself to Moses in the shape of the burning bush, so he appears to Mary in the figure of Gabriel. Moses, however, was instructed to take off his sandals because he was standing on holy ground (ill. p. 126).

It is precisely its peculiarities, however, together with the less convincing modelling of its figures and its stylized faces, which make the fresco an eloquent witness to the changes undergone by Eyckian forms as they travelled to Germany and Italy: the outward expressions of the new realism were much easier to adopt than technical skill or intellectual depth.

Lluís Dalmau
Virgin of the Councillors, 1444/45
(former altar of the Casa del Consell chapel)
Mixed technique on wood, 311 x 311 cm
Barcelona, Museu Nacional d'Art de Catalunya

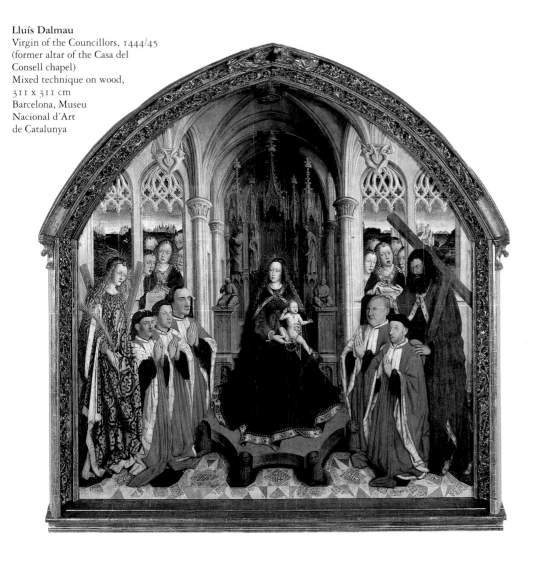

LLUÍS DALMAU
DOC. C. 1428–1461

In 1443, the search by the civic council of Barcelona for the "best available painter" to execute an altarpiece for their chapel yielded Dalmau. The city councillors evidently preferred the modernity of his style, since they thereby passed over the artistically more important, but evidently too old-fashioned Martorell (ill. p. 114 f.). Dalmau did not disappoint their expectations.

Seated on the mighty throne of Solomon borne by lions, the Virgin presides over the councillors who, lined up like the pipes of an organ, are being presented to her by the Apostle Andrew and St Eulalia, the patron saints of the city and the cathedral. Barcelona's coat of arms can be seen in the keystones, the bosses hanging down from the ceiling and clasped by angels, and – framed by decorative Moorish motifs – in the floor tiles. Van Eyck types live on in the pose of the Child and in the two saints. Beneath the arched windows, moreover, Dalmau literally cites the singing angels from the Ghent Altar (ill. p. 104) – albeit only in terms of their form. He manages only an echo of the Netherlandish artist's modelling, however. The weaknesses in his drawing are exposed in the heads of the town councillors, which broaden rather than narrow as they recede towards the back. The lusterless palette alone would suffice to guard the viewer against taking the picture for the work of a Netherlandish artist.

PISANELLO

BEFORE 1395–1455 (?)

Pisanello, who had well mastered the complexities of spatial depth and three-dimensional representation as can be seen below, here creates an emphatically two-dimensional portrait. The prince is shown in strict profile, set in sharp relief against a dark background. Even the modelling of his head remains flat, while the chest is presented as a solid but only weakly three-dimensional base. To suggest that the panel represents a design for a coin is insufficient to explain these features. Pisanello was certainly the greatest medallist of his time and inspired a renaissance in the genre. He liked the strict framework and simple forms of relief work. But severity of external form was also a feature of contemporary taste and extended to hairstyles and clothing, as can be seen here. With its dark blue ground and luminous rose blossoms, however, the overall mood of the portrait is softened and infused with a fairy-tale character.

The panel below documents the approach which Pisanello adopted towards the traditional genre of the domestic devotional picture during the last years of his career. In its tripartite division and symmetry, it recalls an altarpiece. Beneath a dazzling vision of the Virgin and Child, stand, on the left, St Anthony Abbot, protector against the plague and leprosy, and on the right, St George, the model of knightly virtue. The relationship between the two men is purely formal. For we surely cannot suppose that the stooping hermit with his grumpy expression and clanging handbell is gesturing at St George, nor that the aristocratic pose of the knight is directed at the old man.

In his portrayal of the two saints, Pisanello forgets the religious nature of his commission. In shape and material, George's fashionable hat is a beautiful display of artistry – but it cannot replace a halo. We can admire the figure of George for the accuracy with which the rounded volumes of his armour are drawn, and for the light effects on the metal, but not as a convincing portrayal of saintliness.

We might easily make do with the explanation that the artist simply had a different aim in mind. Things are not that simple, however. The hardness characterizing the two saints is set against the atmospheric backdrop of a forest. In a similar fashion to the portrait above, the overall character of the composition is thereby fundamentally altered. An even greater contrast, however, is provided by the visionary apparition of the Madonna. The gold radiates its celestial light both above the dark ground and over the clear daylight in which the figures stand. The Virgin is not dressed in true-to-life contemporary style but in the colours and forms of the International Gothic of around 1415.

Just as Duccio cited older, strictly speaking outdated Byzantine art when he wanted a figure to appear particularly dignified, so Pisanello here takes up a device invented by the Limburg brothers (d. 1416)!

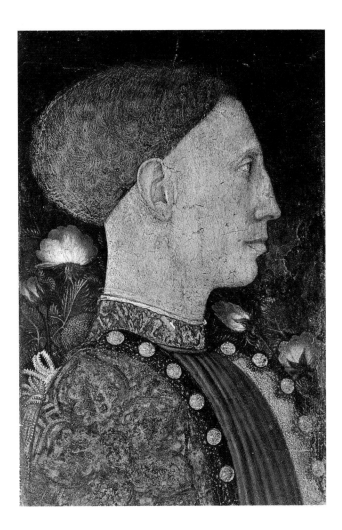

Pisanello
Portrait of Lionello d'Este, 1441 (?)
Tempera on wood, 28 x 19 cm
Bergamo, Accademia Carrara

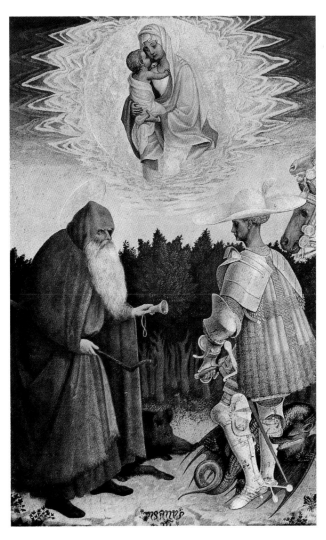

Pisanello
The Virgin and Child with
SS George and Anthony Abbot, c. 1445
Tempera on wood, 47 x 29 cm
London, National Gallery

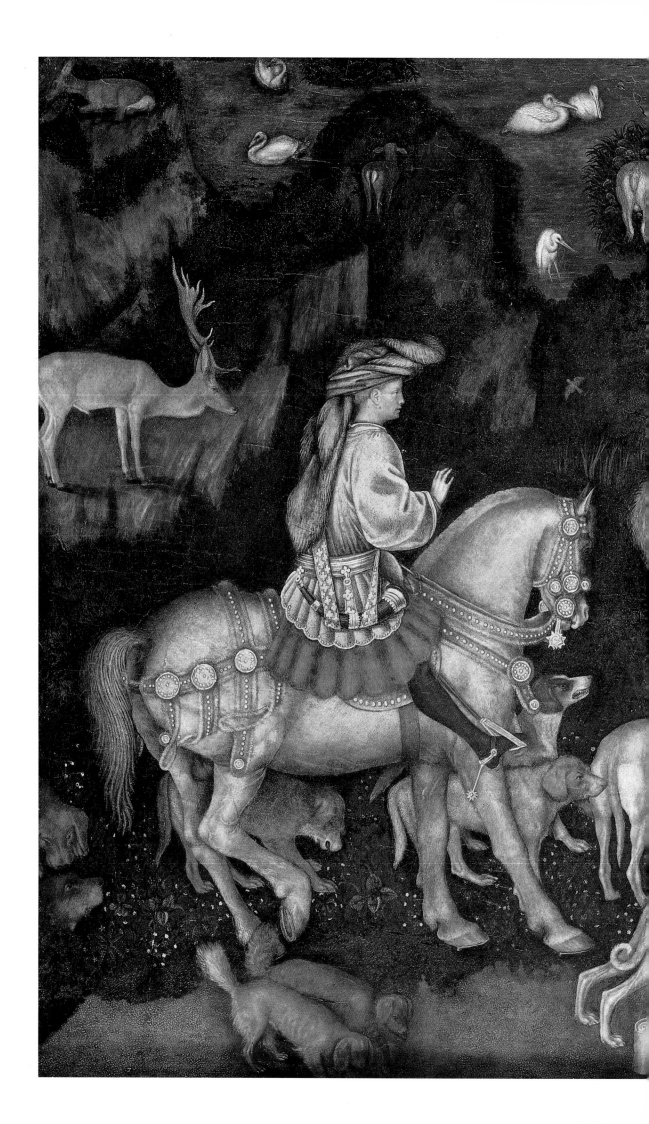

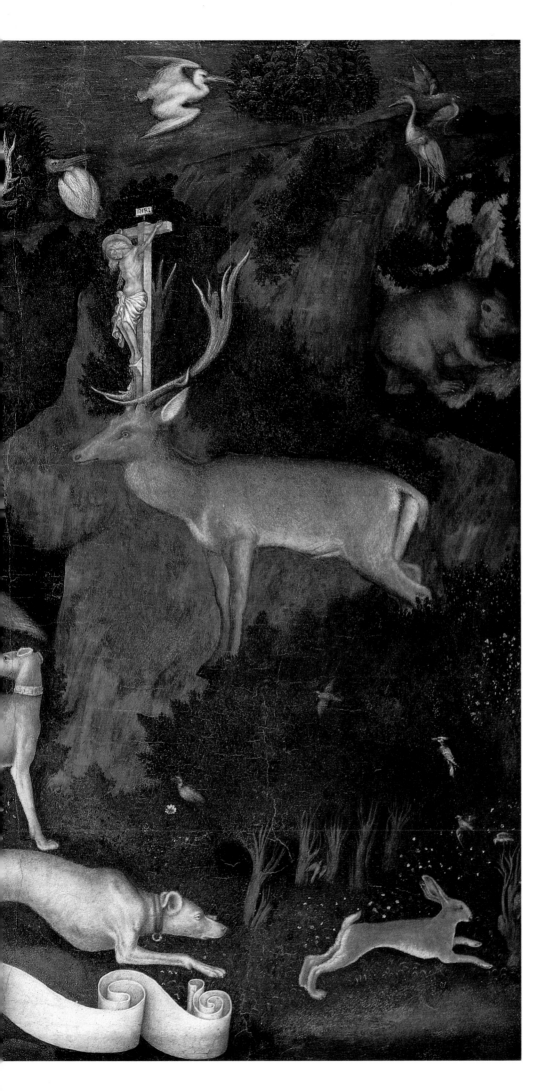

PISANELLO

BEFORE 1395–1455 (?)

According to legend, Eustace was a Roman knight. While out hunting one day, he came across a large stag and set off on its trail. After a long chase, the animal leapt up onto a steep cliff and stood still. Between its antlers there appeared a crucifix, which spoke to the huntsman and called upon him to convert to Christianity. In the 14th century, saints were traditionally portrayed as half or full-length figures identified by their attributes, or in a narrative cycle of several paintings. The present work is undoubtedly a single-figure portrait, yet it is neither a narrative nor an altarpiece, nor even a devotional picture. Nor, however, it is simply a painting of the hunt.

This enigmatic picture has many layers. The huntsman is dressed in contemporary fashion with a turban-like head-dress and a long, fur-trimmed tunic, but without the usual colourfulness. The gold, with its dark glaze, recalls both the magnificence of court dress and the gold of religious art. Indeed, the entire painting is plunged into a semi-darkness which can be explained neither by pigment discoloration nor by the lighting of the forest. The half-light infuses the picture with a mysterious atmosphere.

Hunters amongst the viewers would have enjoyed identifying the various different breeds of hunting dogs which Pisanello has included, each studied carefully and reproduced true to life. The dogs are not there merely to entertain the viewer, however, but are directly caught up in the events of the scene. Only the greyhound on the right, chasing a hare, has not yet noticed that his master has encountered something extraordinary. The other animals and the landscape impart a rich internal frame and backdrop to the miraculous scene, whereby even the landscape is simply "accompanying" the main figures. Pisanello studies the animals in much greater depth. His treatment of nature is not "naturalistic" on principle. Rather, he creates the overall impression of a paradise into which the hunter has disruptively intruded.

Unlike some of his older colleagues, Pisanello has here used a religious scene not merely as the vehicle for something else, nor as an excuse for cynical self-aggrandizement in the manner of the Visconti. In training his sights on the real world, he was not simply exploring new and attractive surface structures or satisfying his curiosity. He was too interested in animals and objects in their own right, and not just in their external appearance. The seriousness of Tuscan painting had given rise to a new intellectual and monumental approach which was also embraced by the artists of Upper Italy.

Pisanello
The Vision of St Eustace, c. 1435
Tempera on wood, 55 x 65 cm
London, National Gallery

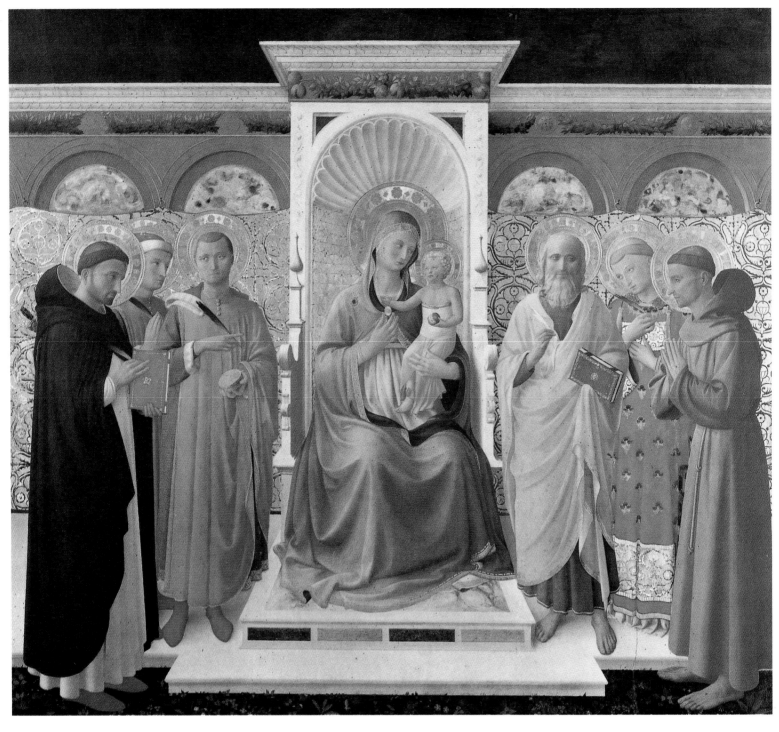

Fra Angelico
Annalena Panel, c. 1445
The Virgin and Child enthroned with SS Peter the
Martyr, Cosmas and Damian (left), John the Baptist,
Laurence and Francis (right)
Tempera on wood, 180 x 202 cm
Florence, Museo di San Marco

FRA ANGELICO

C. 1395/1400–1455

The precise origins of this large Florentine altar-
piece are unknown. Since Cosmas and Damian –
the patron saints of the house of Medici, doctors
and apothecaries – occupy positions of honour
on either side of the Virgin's throne, it is
thought that the painting may have been com-
missioned by the elder Cosimo de' Medici.

Florentine artists after 1400 took the rigid
assembly of saints around the Madonna tradi-
tionally found in older styles of altar painting
and transformed them into a lively group. The
saints are now all related in different ways to the
centre of the composition, whether through
their gestures or their expressions. The typical
frontality of the altarpiece is nevertheless re-
tained, as is the use of sumptuous gold brocade
and the rich decoration of the background, so

that the solemn spendour of the altarpiece is
preserved. The Madonna is magnified in size
and her appearance amplified by the steps and
the throne, with its scalloped niche and artfully
curved arms. Certain features of the painted
architecture, such as the garlands of fruit and
flowers with their pomegranates, testify to Fra
Angelico's interest in the Renaissance architec-
ture being developed by Filippo Brunelleschi
and his colleagues on the basis of their studies of
classical antiquity. In the robed figures, how-
ever, the artist-monk sticks closer to Gothic
tradition.

Fra Angelico bathes the group in a gentle
light. Shadows are clearly visible on the throne.
The light nevertheless intensifies towards the
centre of the composition. More luminous even
than the Virgin's dress, whose gloss colours lend
it a powerful sheen, is the polished gold leaf of
the engraved and embossed nimbuses.

The *Lamentation* is a painting which offers us a rather one-sided view of Fra Angelico's art. It nevertheless occupies an important position in his œuvre. In this work for a religious Florentine confraternity, Fra Angelico took an earlier 14th-century genre as his basis, as if the tradition embodied in the older model were a guarantee of devout sentiment. The new painting thereby also took on the quality of a meditation. The raising of the dead Christ's arms is a motif invented by Giotto to express ardent concern.

The similarity to Giotto is purely external, however, for the motif here serves a very different purpose. John and the saints in the foreground hold up Christ's arms in order to contemplate his countless welts and wounds – and thereby urge the viewer to do the same. Other details within the painting are similarly isolated and presented for individual meditation, with the result that the persons in the scene remain unrelated to one other, united only in their contemplation of Christ. Hence the artist had no difficulty introducing the figures of St Catherine and a 14th-century beatified woman on the right, and St Dominic on the left. This is in no sense a narrative painting, but one with a general mood rather than a central compositional focus. Its atmospheric quality is emphasized by the empty and pallid landscape and the austere city wall.

The *Entombment* is part of the high altarpiece installed in the convent church of San Marco in 1440. It formed the centre of a five-part predella bearing scenes from the lives of the saints Cosmas and Damian (patron saints of the Medici, who donated the altar). It is this picture which the priest officiating at the altar would have had before him. Christ's dead body is held up like the Host. The picture is saying: Christ, sacrificed for our salvation, is (like) the Host sacrificed in the Mass. This is why the scene shows the Entombment rather than the Deposition. For according to earlier thinking, Christ's tomb was essentially the same as the vessels or the tabernacle in which the Host was kept.

Like the painting by Giovanni da Milano (ill. p. 68), it is an expanded version of a Man of Sorrows. It is conceived as a devotional picture, as is clear from the reverence which the Virgin and John are showing to Christ's wounds. The dark ground of the tomb establishes an inner field – almost a picture within a picture – in which the most important theological elements are highlighted. It thereby cites an earlier genre of paintings attributed with miraculous powers.

Fra Angelico breathes subtle life into the strict symmetry and emphatic central axis, however: Christ is closer to Mary and leans towards her, underlining her special importance as the Mother of God, while Mary bends even more obviously towards her son. Christ's frontal and spatial position on the door of the tomb nevertheless serves to isolate him. The painting is both austere and animated, logical and full of feeling. The landscape and the rock form a dark foil against which the light – and within it the figure of Christ – appears luminous.

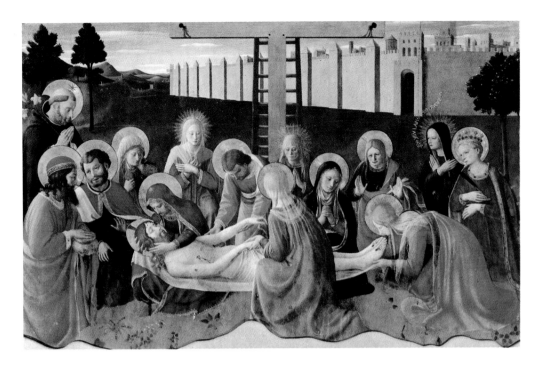

Fra Angelico
Lamentation of Christ, 1436
(from the church of the Confraternity of the Madonna of the Cross, Florence)
Tempera on wood, 108 x 165 cm
Florence, Museo di San Marco

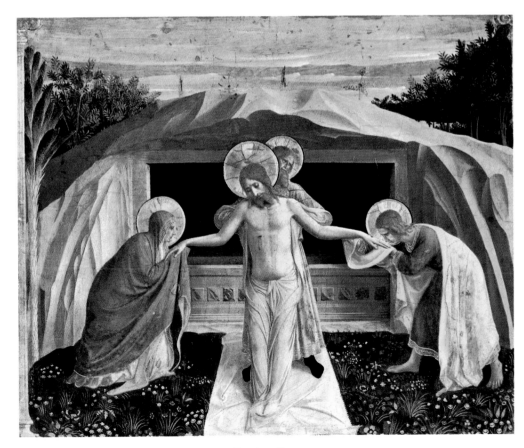

Fra Angelico
Entombment, 1438-1443
(from the predella of the high altar of San Marco, Florence)
Tempera on wood, 37.9 x 46.4 cm
Munich, Bayerische Staatsgemäldesammlungen, Alte Pinakothek

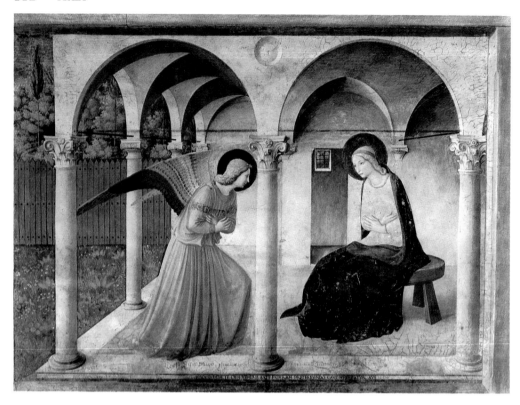

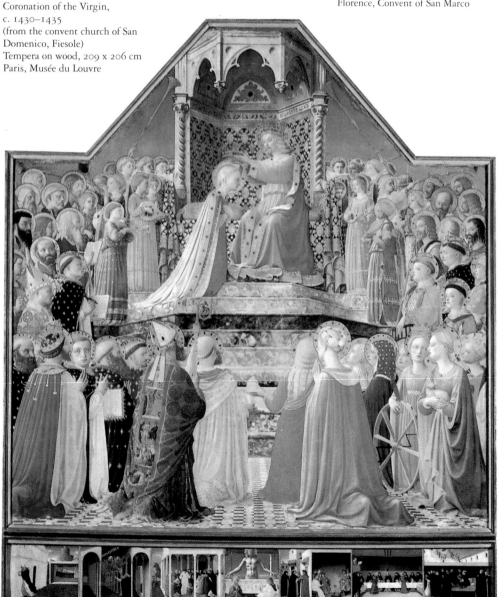

Fra Angelico
Coronation of the Virgin,
c. 1430–1435
(from the convent church of San
Domenico, Fiesole)
Tempera on wood, 209 x 206 cm
Paris, Musée du Louvre

Fra Angelico Annunciation, c. 1450
Fresco, 216 x 321 cm
Florence, Convent of San Marco

FRA ANGELICO

C. 1395/1400–1455

Fra Angelico painted the *Annunciation* for his
fellow brothers in the Dominican monastery. It
is situated at the end of the stairs leading to
the monks' cells, and invites the viewer to
linger and – as its inscription says – to pray.
The *Annunciation* cites a painting in the neigh-
bouring Servite church which was greatly ven-
erated for its miraculous powers, and thereby
itself assumes such powers. The divine protec-
tion it offered the monastery was nevertheless
just one aspect of its function. Addressed to
educated monks, it also operates at a more pro-
found intellectual level. It deals with the
dogma of the incarnation of Christ, his "entry"
into earthly life – hence its setting in front of a
doorway. The Annunciation takes place in the
porch of the Temple in Jerusalem. The en-
closed garden on the left is a reference to
Mary's virginity. It also contains a cypress,
which was equated with the cedar of Lebanon,
another popular symbol for the Virgin. In the
background we can see a cell resembling the
monks' cells in the Convent of San Marco.
Since Mary lived in the Temple like a nun, she
was a model of monastic life.

The cell has another, higher meaning, how-
ever: it illustrates the idea that Mary is the
nuptial chamber, the vessel in which God is
made man on earth. By taking up the familiar
arcades of the monastery, Fra Angelico places
the Annunciation firmly in the present. The
clear and strict order of Michelozzo's architec-
ture and the purity of its forms imprint them-
selves upon the scene, which despite its multi-
layered content remains a whole. The perspec-
tive composition makes clear, however, what
can also be read in the different intensity with
which the two figures are treated: namely, that
the two halves of the fresco have a differing
significance. The central focus of the painting
is the Virgin, as emphasized by the red gold
brocade of her dress (now peeled off). She is
also an example of humility, which was consid-
ered the highest of all monastic virtues.

The *Coronation of the Virgin* was a triumphal
subject which was excellently suited for an al-
tarpiece. It was believed that, at the moment
of the consecration of the Host on the altar, the
heavens opened and the community of Heaven,
i.e. the Church triumphant, took part in the
Sacrifice of the Mass. Since theology taught
that the Church was, in a mystic fashion, iden-
tical with Mary, the Mother and simultane-
ously the Bride of God, this painting of Mary's
coronation is also a metaphorical picture of the
triumph of the Church.

This idea was particularly welcome to the
Dominicans, who had made it their goal to
strengthen papal power and defend it against
all critics and deviationists. This also explains
why many members and patrons of the order of
the Black Friars are portrayed amongst the
saints in this celestial gathering. One of the
scenes on the predella underneath shows St
Dominic supporting the walls of the church
against collapse, illustrating the order's under-
standing of its role.

JEAN FOUQUET
C. 1414/20 – C. 1480

This book of hours seizes every opportunity to refer to the nouveau-riche patron who commissioned it, whom Fouquet also immortalized in a panel painting. As we have already observed in the Boucicaut Book of Hours (ill. p. 101), the scene unfolds within a setting borrowed, as it were, from the world of the manuscript's owner – an anachronism justifiable only with difficulty with the argument that it served to facilitate private worship and ensured a greater immediacy of events. Concrete examples are the Virgin's bed and the cloth covering her prieu-dieu, which are resplendent with the initials of the financier.

The subject is only rarely portrayed in art, although it is familiar from *The Golden Legend*. Shortly before her death, an angel appeared to Mary a second time and told her that she would be assumed into Heaven, an idea closely related to the belief in her innocence and assumption. Mary is correspondingly portrayed as an older woman wearing the veil of a married woman. The calm poses, mastery of colour and extreme delicacy with which the paint is applied are all characteristic of Fouquet. His handling of space is exceptional: he does not content himself with the usual foreshortening, but in the curvature of the ceiling beams and the knotted bast carpet imitates the sloping lines which the human eye does not normally consciously perceive.

Jean Fouquet
Second Annunciation,
c. 1453–1456
(miniature from the *Book of Hours of Etienne Chevalier*)
Body colour on parchment,
c. 20.1 x 14.8 cm
(dimensions of page)
Chantilly, Musée Condé
(ms. fr. 71)

NICOLÁS FRANCÉS
C. 1390 – C. 1468

The fashionable clothing, details of the composition and the poses of certain figures are evidence that the artist was precisely informed about the latest Netherlandish inventions. Like León cathedral itself, which in its architecture and décor was oriented particularly closely towards France, the altarpiece was dedicated to the Blessed Virgin Mary. Of the six main panels portraying episodes from her life, *Mary Enters the Temple* is the only one to have survived. Accounts not included in the Gospels relate that the three-year old Mary mounted unaided the – according to *The Golden Legend* – fifteen steps up to the Temple, where she was received by the high priest. Francés has sliced open a Gothic nave not just to provide us with a better view of events; the unfinished building in the modern Gothic style stands for Mary herself, the personification of the Church, through whom the age of salvation will dawn. Hence the artist portrays her as a young woman, only distinguished by her smaller size from the enormous figures of her family and the priests. These latter have their talliths draped over their heads, while the man on the far left is dressed in the latest Christian fashion. The luminous red and green robes in the left-hand side of the composition thereby provide an effective contrast with the areas of gold employed in the Temple.

Nicolás Francés
Mary Enters the Temple, before 1434
(from the high altar of León cathedral)
Mixed technique on wood, 154 x 272 cm
León, cathedral

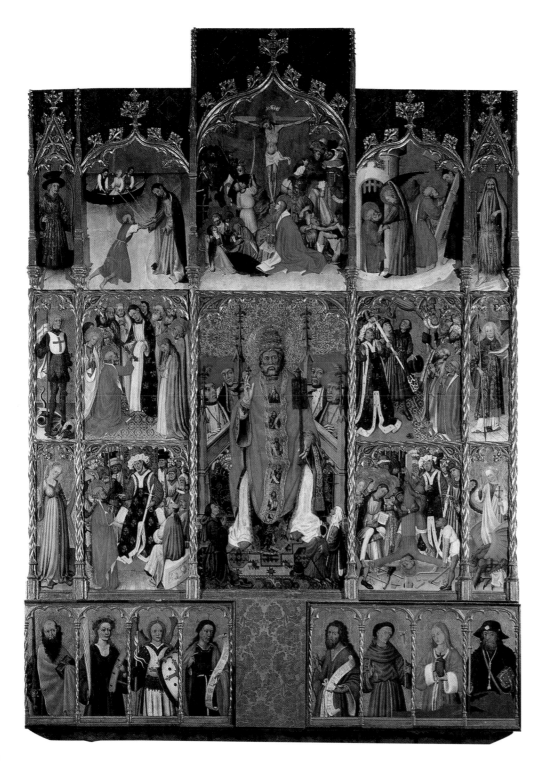

Bernat Martorell
St Peter Altar, 1437–1442
(from the chapel of Púbol castle)
Tempera on wood, 490 x 370 cm
Girona, Museu Diocesà de Girona

Page 115:
Bernat Martorell
Christ and the Samaritan Woman at Jacob's Well,
1445–1452
(from the predella of the Transfiguration Altar)
Tempera on wood
Barcelona, Santa Creu cathedral

BERNAT MARTORELL

ACTIVE FROM 1427–1452

Considering the painstaking care which he took over his painting, an astonishingly large number of altarpieces have survived from the workshop of Bernat Martorell. Amongst them, the altar which he executed between 1437 and 1442 for the chapel of Púbol castle displays the most complex structure. The format remains traditional: in the centre, beneath a *Crucifixion*, we see the saint to whom the panel is dedicated, bordered on either side by scenes from his life and the figures of various other saints. All the same, the obligatory gold is overshadowed by a wonderfully luminous red, and the artist has already begun to include the everyday details that will later lend his Transfiguration Altar in Barcelona cathedral its particular charm (ill. p. 115). The cardinals behind Peter are given individual features, while the oriental carpet at his feet was at that time a very new feature even in the Netherlands. The small figures in contemporary dress kneeling upon it represent the family of the donor, Bernat de Corbera. Margarida de Campllonch presents her son as if she were his patron saint.

In the narrative scenes on the left, the figure of Peter sinking as his courage deserts him during his attempt to walk on water is captured with the same vividness as his companions rowing the boat. Martorell even manages to suggest the refraction of Peter's red robe beneath the water. He relocates the *Presentation of the Keys*, the foundation of papal authority, to an interior setting, whereby his foreshortening of the floor is less successful – due to the rich patterning of its tiles – than in the *Dispute with Nero* below. Interestingly, the emperor wears a crown similar to the one which will later be worn by the Pope. The narrative continues top right with Peter's miraculous release from prison and the "Quo vadis?" episode: the risen Christ appears in the path of the fleeing Peter and commands him to shoulder his cross and return to Rome. There he is crucified upside down at his own request. Before this last scene, Martorell shows us Peter's adversary Simon Magus falling from heaven at Peter's command.

The standing saints on the far left are identified as Sebastian, George and Eulalia, the patron saint of Barcelona, by their respective attributes of the bow, the dragon and the St Andrew's Cross. St Sebastian is arrayed in a magnificent costume and tall hat of the day, as familiar from the paintings of such as Jan van Eyck. On the right, the ascetic Onuphrius is identified by his long hair covering his entire body. Beneath him, with a fish, is the Archangel Raphael, who used its gall to restore the sight of Tobias's blind father. The series ends with St Margaret, who is climbing out of the dragon which had swallowed her, and which has burst at the sign of the Cross. In the centre of the predella, less well preserved, St John the Baptist points across to Christ as the Lamb of God – a particularly appropriate surround for the now empty field containing the Sacrament. The two figures are flanked by the second great apostle, Paul, and by SS Catherine, Michael, Francis, Mary Magdalene and James, all of whom were popular in Martorell's day.

Despite her fashionable slippers, Martorell's Samaritan woman stands with both feet firmly on the ground. Her face, turned away from the viewer at a compositionally bold angle, has assumed a whole new plasticity. The jug and the coiled rope draped over her left arm are magnificently observed. Indeed, Martorell's painting as a whole is distinguished by its remarkably accurate detailing of the setting. Two steps lead up to the edge of the well, with a drinking trough for cattle beside them. The wooden cover of the well has been removed: in order to strike up a conversation, Christ used the pretext of asking the Samaritan woman, who was coming to draw water, for a drink.

Martorell translates this moment, in which Jesus surprises the Samaritan woman by addressing her, into a bold, highly successful diagonal composition. The disciples on the left are returning from buying food, as related in the Bible. Although Martorell dresses them in traditionally timeless robes, he equips them with a bag filled with bread rolls, a flask and a food basket.

The entire scenario, with its carefully built Gothic castle and ducks in the moat, contradicts all pictorial convention. In front of the wall, Martorell introduces two women who are evidently returning from market. They are dressed in everyday clothes like the Samaritan woman herself, with one holding a child by the hand and the other accompanied by a dog. Not until Pieter Breughel will we meet them again.

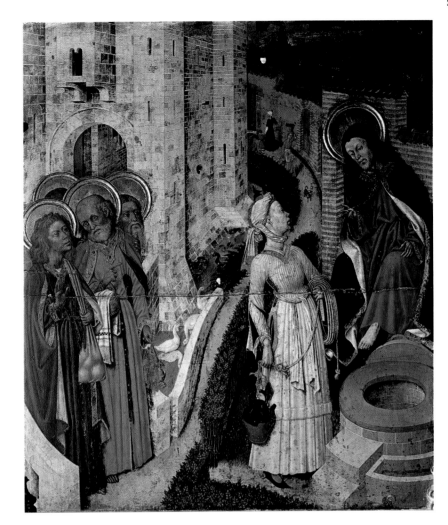

JORGE INGLÉS

ACTIVE C. 1445 – 1485

Don Íñigo López de Mendoza, Marquis of Santillana, was no ordinary donor. He was an important writer and launched the great era of Mendoza patronage, which brought the Italian Renaissance – and much besides – to Spain. His own tastes were still oriented very much towards the North, however. Before setting off to fight the Moors, he bequeathed in his will an "Angel Altar, which I had made by Master Jorge Inglés, painter". The painting is still in the possession of the family today. The only parts which have been lost are a *St George* painted by Jorge and the sculpture of the Virgin which stood at the centre. Íñigo and his wife, each accompanied by a servant, are kneeling on either side of the central niche, today occupied by another figure. In the enormous rectangular pictorial field above them, the angels mentioned in the will hold up texts, written by the Marquis himself, extolling the Virgin. The Mediterranean influences behind the artist's style are betrayed more by the motifs, drapery folds and clothing than by the extremely unusual construction of the altarpiece. The faces, with their overly large features, are more expressive and less smooth than those of Netherlandish artists – more roughly hewn, as it were. Jorge's particular importance is indicated by his very forward-looking landscapes, which replace the previously traditional gold ground.

Jorge Inglés Angel Altar ("Retablo de los Angeles"), before 1455
Mixed technique on wood, 399 x 338 cm. Madrid, Collection Duque del Infantado

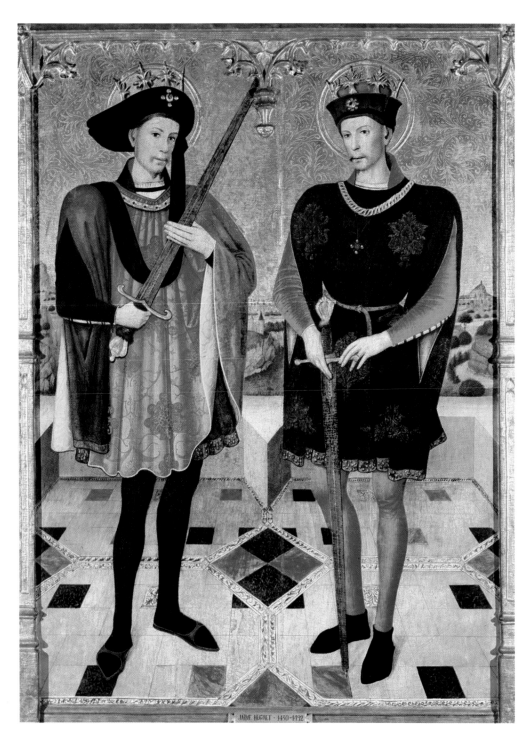

Jaume Huguet
SS Abdon and Sennen, 1459/60
(central panel of the SS Abdon and Sennen Altar)
Mixed technique on wood, c. 290 x 220 cm
Terrassa, Santa Maria d'Egara

JAUME HUGUET
C. 1414–1492

Jaume Huguet's best-preserved work is his SS Abdon and Sennen Altar, executed for St Peter's church in Terrassa, near Barcelona. Our detail shows the main picture, featuring the standing figures of the two martyrs of late antiquity. Although today relatively unknown, in Huguet's day they were highly revered by Catalan farmers. Their story was also included in the most famous medieval collection of biographies of saints, *The Golden Legend*. Abdon and Sennen were two lesser kings from the south of Spain, who took the bodies of Christians martyred at the hands of the emperor Decius and buried them in Cordoba. Decius subsequently had them bound in chains and taken to Rome. When they refused to sacrifice to the heathen gods, and even spat upon their idols, they were thrown to the wild beasts in the circus. Since the two lions and four bears stood guard around them rather than tearing them to pieces, they were eventually put to death by the sword.

Huguet portrays the two martyrs dressed in the style of nobles of his day. The crowns which they wear on top of their fashionable hats indicate their royal rank. In their hands they carry the instruments of their martyrdom. Tall, slender, almost boringly well-proportioned figures, with gentle faces and even features, were one of the painter's hallmarks. At the same time, they are probably not uninfluenced by the work of the Netherlandish artist Dieric Bouts (ill. p. 129). Huguet shades their faces with a gentle hand and carefully details the various materials making up their rich costumes.

In a similar fashion to Cologne (cf. ills. pp. 52, 95), Catalonia continued to employ lavish gold grounds far longer than in the Netherlands. In the present example, Huguet has even tooled a tendril pattern into parts of the gilding, while introducing raised relief into the crowns, haloes and decorative details. In a juxtaposition typical of the Late Gothic style, the panel's true date is betrayed by the modern foreshortening of its tiled floor and its landscape background. Despite Huguet's rather unconvincing cliffs, his expansive plain and his trees of staggered heights combine to achieve a relatively natural effect, based on Italian models.

The layout of the retable has barely altered since the days of Perre Serra (ill. p. 84) and Bernat Martorell (ill. p. 114 f). The central picture is crowned by a *Crucifixion*, and flanked on both sides by two episodes from the lives of the saints to whom the altarpiece is dedicated. Alongside their trial and martyrdom, these include the legendary transport of Abdon and Sennen's bones in two wine vats strapped to a donkey. In this way they are supposed to have been carried to Arles del Tec (Arles-sur-Tech) in northern Catalonia, today part of France. Although important classical ruins were still standing in Catalonia, Huguet portrays the Roman circus as a walled quadrangle.

MARTINUS OPIFEX

DOC. 1440–1456

These two miniatures stem from the hand of one of the most singular artists of the 15th century. His qualities as a draughtsman are endearing, but modest. His fragile figures resemble stick men, with heads far too big for them stuck on top. While their foreheads are often much too low, they are curly-haired and rosy-cheeked for all that. And perhaps this is precisely why Opifex is a narrator of such charming, indeed dazzling candour and freshness. Not just in the case of these Greek myths, subjects only rarely illustrated in his own day, does he leave all conventions behind him. His eyes are unbiased and open to everything human and divine. He searches out and treats even risqué material with the disarming directness which is so typical of him, and which finds few parallels in any era, not just his own.

Above all, however, the artist's pictorial language reveals a powerful tendency towards abstraction. Overlappings and diagonals heighten this effect. Perhaps for the only time in Gothic painting, not a single stretch of land is visible in the passage to Troy. An empty dinghy is the only boat not intersected by the red border or overlapped by other forms. But this is precisely why the fragments of eight ships are able to suggest a huge fleet. In a skilful contrast of colour, the bright sails, almost hitting each other, fall like three diagonal bars across the darker plane. Apart from their white, almost everything is reduced to dark grey and brown. Virtually none of the Greek heroes are made to stand out. They are sailing as a large, anonymous army towards the bloody, drawn-out Trojan War. The plumes of spray which hang down like white umbels from waves shaped like rocky ledges are one of the artist's trademarks.

The episode from the story of Jason strikes a quite different note. After Opifex has shown, amongst other things, how Medea sent an old woman after Jason to get him to sleep with her, we see the two here after their night of passion. Behind them is their rumpled bed, once again positioned along a bold diagonal. Medea, who is mostly portrayed as somewhat larger than her husband, is wearing only her undergarment, a simple shift which she covers in embarrassment with a rich reddish-blue cloak. Jason is barefoot. He appears to be reaching his left hand into his coat, while balancing the pointed shoes typical of the day in his right hand. The cool blue and powerful pink of the young couple's clothes, which contrary to all convention are identical in colour, are delicately coordinated with the pale violet of the tiles. The deep blue of the blanket offers a rich contrast to the luminous red of the gold brocade curtain.

Despite or perhaps because of the considerable gap between their legs, despite the fact that Jason is looking past his beloved, the small picture expresses a deeply touching intimacy. There is virtually no hint of the tragedy that awaits the couple, the moment in which Medea will tear her children to pieces – in despair over the unfaithfulness of Jason, who will consequently kill himself.

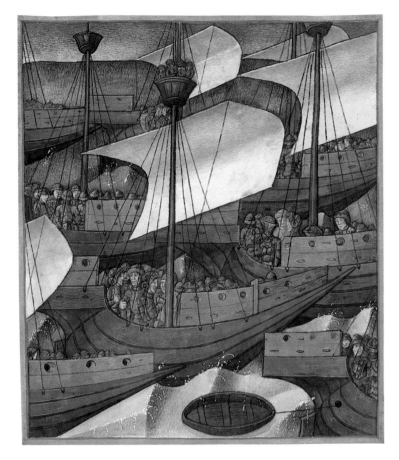

Martinus Opifex
"Here the Greeks sail for Troy", before 1456 (miniature from the *Trojan War* by Guido de Columnis, fol. 103 r)
Body colour on parchment, 37.5 x 27.5 cm (dimensions of page)
Vienna, Österreichische Nationalbibliothek (Cod. 2773)

Martinus Opifex
"Here Jason and Medea get out of bed", before 1456 (miniature from the *Trojan War* by Guido de Columnis, fol. 18 v)
Body colour on parchment, 37.5 x 27.5 cm (dimensions of page)
Vienna, Österreichische Nationalbibliothek (Cod. 2773)

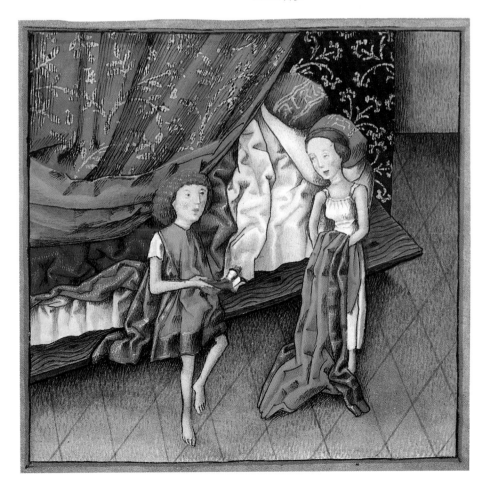

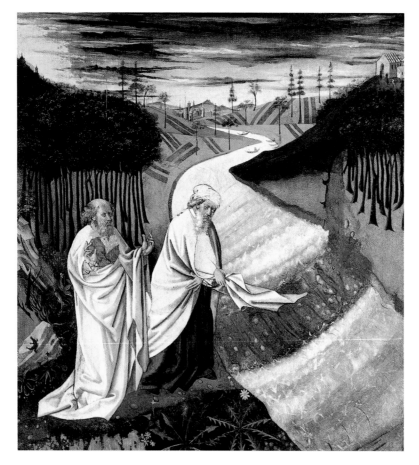

Master of the Albrecht Altar
Elijah Divides the River of Jordan, c. 1437 (from the former high altar, or Albrecht Altar,
of the Am Hof Carmelite church in Vienna). Mixed technique on wood, c. 126 x 113 cm
Klosterneuburg, Museum des Chorherrenstiftes

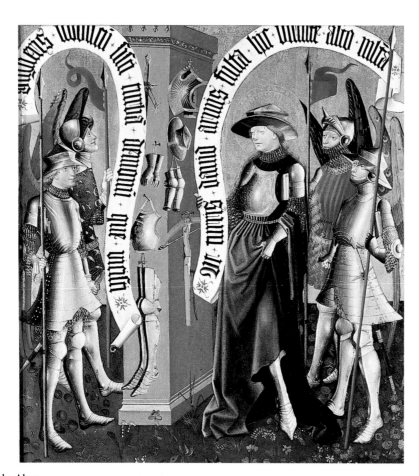

Master of the Albrecht Altar
Mary as Queen of the Powers, c. 1437 (from the former high altar, or Albrecht Altar, of the
Am Hof Carmelite church in Vienna). Mixed technique on wood, c. 126 x 113 cm
Klosterneuburg, Museum des Chorherrenstiftes

VIENNESE MASTER

ACTIVE 1430–1450

What makes this masterpiece of Viennese
painting so striking is not simply its sheer size,
but also its highly individual iconography and
its very early adoption of the new trend to-
wards greater realism. When both sets of
wings were opened out, as on the highest feast
days, the altar measured over ten metres wide
and revealed eight scenes from the life of
Christ and Mary on either side of a probably
carved shrine. The workday exterior, of which
only half has survived, serves to validate the
existence of the Carmelite Order to whom the
church belonged. A whole five panels are de-
voted to the story of Elijah and his disciple
Elisha, who performed a miracle on Mount
Carmel. During the Crusades, Mount Carmel
would become a refuge for hermits, out of
whose community the Carmelite Order would
later arise.

This painting shows one of the last mo-
ments of Elijah's life on earth. He divides the
waters of the river Jordan in order to cross and
then be taken up to Heaven. No less impres-
sive than the massive figures with their power-
fully expressive faces are the lovingly observed
details of everyday life. Strips of dark greeny-
brown, denoting fields, overlay the pale green
ground. The trees, with their slender silhou-
ettes, suggest influences from Italy. On its
horizons, the altar contains several views of the
city of Vienna.

The altarpiece was at its most sensational,
however, when its wings were opened. In place
of gentle landscapes, spread before the viewer
was a pictorial statement of abstract theologi-
cal concepts, portrayed on a monumental scale.
On 16 panels each employing an almost sym-
metrical format, Mary appears in the midst of
the nine angelic choirs and amongst patriarchs,
prophets, apostles, martyrs, church teachers
and female saints. From scattered references in
the Old and New Testaments, Pseudo-Denys
the Areopagite identified nine groups of an-
gels, which subsequently passed into the canon
and are faithfully reproduced in the Vienna
painting: seraphim, cherubim and thrones, do-
minions, virtues and powers, principalities,
archangels and angels. The example chosen
here gives the sixth choir, the powers, a face. It
makes clear how very much the Master of the
Albrecht Altar wanted to lend physical expres-
sion to his material, even if its meaning could
only be communicated, even to the people of
the Late Middle Ages, by means of clearly legi-
ble banderoles.

The sixth choir assisted in the fight against
evil, and the angelic host here appears suitably
armed. Astonishingly, Mary adapts herself to
their role and appears in full armour like Joan
of Arc, who had been burned at the stake just a
few years earlier in 1431. Only her long hair,
dress and halo betray her true identity. The an-
gels hail her as victor over the demons. In her
reply, Mary refers to the tower of David, men-
tioned in the extolling of the bride in the Song
of Songs. As a pillar hung with various compo-
nents of a suit of armour, it crowds Mary out of
the centre of the picture.

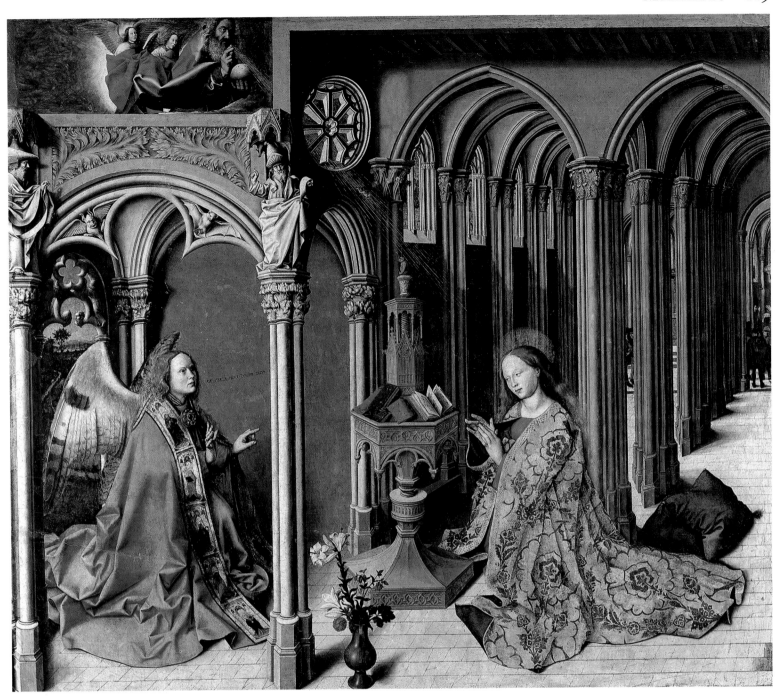

BARTHÉLEMY D'EYCK

DOC. FROM 1444 – C. 1476

Although Barthélemy d'Eyck can be assumed to be related to Jan and Hubert van Eyck, the present work falls fully in line with artistic practice in the Mediterranean sphere – from its thicker, less translucent application of paint to the gold brocade of the Virgin's cloak. At the same time, its astonishing realism at times goes far beyond even Netherlandish painting. There is a pronounced three-dimensionality to the composition as a whole; forms are weighty and substantial, while skin surfaces are sharply differentiated. Mary's hair is not perfectly coiffured, but instead full, almost flaxen. The wonderfully observed, plump cushions and the bunch of flowers also have a quite different spatial presence to their northern counterparts. This impression is reinforced on the one hand by the relatively plain metal jug and the quietly unforced

arrangement of the flowering Marian symbols plucked, so it seems, at random from the garden, and on the other by the surrounding empty space and the sharp, spotlight type of lighting.

The architecture also appears solid and three-dimensional, and is wonderfully observed against the light – as in the tracery on the left above the angel's wing, and the roundel through which the Christ Child floats down, already shouldering his Cross. The figures listening to Mass and strolling around at the back of the church lend the composition an astonishing depth – despite the deliberate ignoring of scale: the building is directly equated with Mary, who according to Christian thinking stands for the Church itself. While the first impression is of a plain and monumental setting, the painter in fact pays loving attention to the details of the stained glass, the leaves flickering like flames on the capitals, and the heads and bats in the tracery.

Barthélemy d'Eyck
Annunciation, 1443/44
(from Saint-Sauveur cathedral)
Mixed technique on wood, 155 x 176 cm
Aix-en-Provence, Ste Marie-Madeleine

Workshop of Konrad Witz
Madonna and Saints in a Church,
c. 1440 – 1445
Mixed technique on wood,
68 x 41 cm
Naples, Museo Nazionale di
Capodimonte

WORKSHOP OF KONRAD WITZ

C. 1400–1445

Whether the panel was executed by Witz him-
self or by his workshop, its lighting effects and
sense of realism make it one of the most excit-
ing inventions of the 15th century. The fact
that its construction and perspective are not
yet handled with the mastery of the following
generation is precisely what gives it its endur-
ing charm. The pale faces of the central fig-
ures, with their mighty lower bodies, gleam all
the more intensely against the grey of the
building, as do the cool red and the luminous,
gold-spangled dark blue of their draperies.
Even more impressive, however, are the altars
shimmering beneath and beyond the rood
screen and the brilliant sunlight streaming
through the portal. Long shadows break up the
extraordinarily realistic townscape outside,
with its buildings, shop counter and passers-
by. Details of the church bring to mind the
minster in Basle. The idea of portraying the
family of Christ, together with additional
saints, in a church interior is equally striking.
Mary's female companions include St Barbara,
identified by her tower, and St Catherine, to
whom, according to legend, the Infant Jesus
was betrothed, and who is here identified by
the gesture of receiving a ring (cf. ills. pp. 100,
129). The whole is viewed, as in contempora-
neous Netherlandish works, through an archi-
tectural frame which can be related to the
church interior only with difficulty.

Colantonio
St Jerome, c. 1445
Mixed technique on wood, 125 x 151 cm
Naples, Museo Nazionale di Capodimonte

COLANTONIO

ACTIVE 1440–1465

Around the middle of the 15th century, Naples
was the most important point of exchange be-
tween Netherlandish and Italian art. This was
due above all to the singular figure of King
René, who resided here from 1438 for a few
short years until losing power to Alfonso the
Magnificent. During his previous imprison-
ment in Brussels and Dijon (1435–1437), he
must almost inevitably have come into contact
with Jan van Eyck and the other Netherlandish
artists.

For us, however, more important than such
historical considerations is a painting long
since authenticated as the work of Colantonio,
the *St Jerome* from the church of San Lorenzo
Maggiore. It demonstrates – indeed, parades
the fact – that the South was already well ac-
quainted with the new Netherlandish realism
even before the middle of the century. The her-
mit is provided with a complete library along
with a scriptorium! Colantonio thereby creates
optical illusions which half a century later
would become a genre in their own right. He
gives greater thought to synthesis than his
Netherlandish counterparts. With his clever
organization of space, his use of foreshortening
and his skilful handling of light, he succeeds in
integrating saint, space, objects and the mag-
nificent study of the lion with a harmonious-
ness that would be sought in vain in the North
for many years to come.

HANS MULTSCHER

C. 1390 – C. 1467

Nowhere else in Germany in the 1430s do the figures become as massive and heavy as in the so-called Wurzach Altar. As here in the *Death of the Virgin*, Multscher frequently squashes his large, weighty heads much too close together. They are lent plasticity by powerful shading, and a somewhat sullen expression by their down-turned mouths.

The artist clearly loves groups, which consist chiefly of faces. He is at his most naturalistic in details such as the flowers, the ceramic jug and the books – somewhat artificially interleaved, it must be said. While Peter sprinkles holy water over the deceased, Christ, who has entered unnoticed by the apostles, receives Mary's soul, portrayed as the small figure of a girl (cf. ill. p. 53).

Both this panel and, in abbreviated form, the *Feast of Pentecost* bear the date 1437 and the lengthy signature of Hans Multscher from Reichenhofen (in the Allgäu region), citizen of Ulm. Amongst the body of Multscher experts, notorious for their bitter feuding, some have wrongly argued that these pieces of information relate solely to the sculptures in the lost shrine. The figures in many ways resemble a translation of Multscher's sculptures into just two dimensions. There are surviving paintings by members of Multscher's workshop which employ a very similar technique.

Hans Multscher Death of the Virgin, 1437 (from the Wurzach Altar). Mixed technique on spruce, c. 150 x 140 cm
Berlin, Gemäldegalerie, Staatliche Museen zu Berlin – Preussischer Kulturbesitz

AUSTRIAN MASTER

ACTIVE C. 1450–1470

In 1456, almost twenty years after completing the Wurzach panels, Multscher was commissioned to execute a retable for the high altar of the parish church in Sterzing (now Vipiteno). The altarpiece's very destination indicates just how far Multscher's fame had spread in the intervening years. Parts of the altar have never left South Tyrol, while others have since made their way back to it – Mussolini gave the paintings to Hermann Göring in 1941 as a birthday present. Unlike the sculptures, however, they are certainly not by the master who painted the Wurzach panels. They too mark a milestone, nevertheless, as they testify at an astonishingly early date to a new wave of Netherlandish influence washing over Germany. The powerfully animated figures have grown much more slender again, and are in places even gaunt. At the same time, the architecture around them has expanded; in place of the oppressive massing of people, plants and decorative accessories, there is now an odd liking for emptiness, which also extends to the unexpressive faces. The artist nevertheless scatters lilies – a Marian symbol – across the foreground. The overall impression anticipates the generation of Hans Memling (ill. p. 129). The anonymous painter of the *Annunciation* seems to have oriented himself towards the exterior of Stefan Lochner's altarpiece in Cologne cathedral (ill. p. 26).

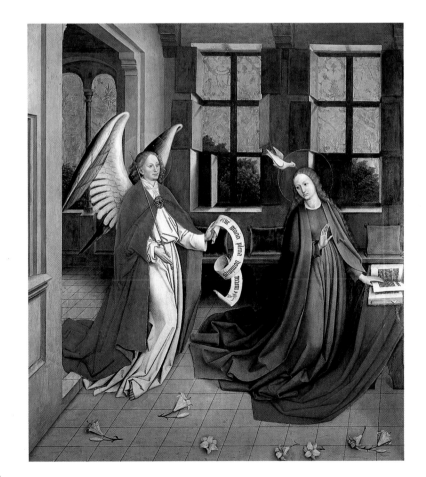

Master of the Sterzing Altar Wings Annunciation, 1456–1459
(from the Sterzing Altar). Mixed technique on wood, c. 194 x 174 cm (individual panel)
Sterzing (Vipiteno), Deutschordenshaus

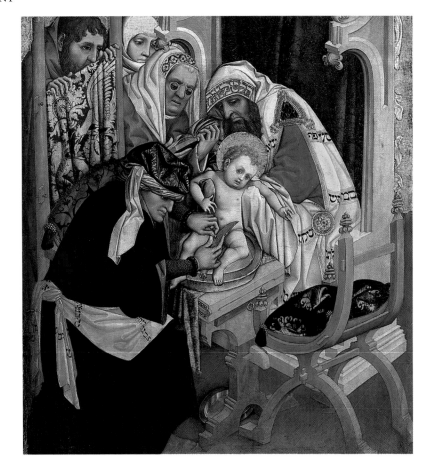

Master of the Tucher Altar
The Circumcision of Christ, c. 1440–1450
Mixed technique on softwood, trimmed on all sides, 102 x 92 cm
Aachen, Suermondt-Ludwig-Museum

GERMAN MASTER

ACTIVE C. 1430 – 1450

In the pogroms which followed the Black Death of 1348, the Jews were driven out of Nuremberg, as out of many other places. Their quarter was razed, and in 1349 the Church of Our Lady was founded by the emperor on the site of their synagogue. It is ironic, then, that the altarpiece which would end up here should have been executed by an artist born half a century later who strove for particular accuracy in his rendering of Jewish ceremonial dress and other accessories. Unlike the majority of his colleagues, he was not prepared to fake the Hebrew script with some made-up scribbles, but shows characters that really exist, even if they do not necessarily add up to a meaningful sentence. In this the artist resembles his Polling contemporary (ill. below).

In temperament, however, he is closer to the Wurzach Altar (ill. p. 121) executed by Multscher in Ulm a few years earlier. In Nuremberg it is he who replaces the elegance of the Soft Style with robust, massive, plastically-modelled figures. Their faces are broad and heavy, and rest without necks on shoulders that are far too narrow. They are nevertheless extremely expressive. Familiar from Multscher, too, are the glasses worn by the scribe. His Jewish prayer shawl is draped over his head. Joseph's head is bare, distinguishing him from the Jewish priests.

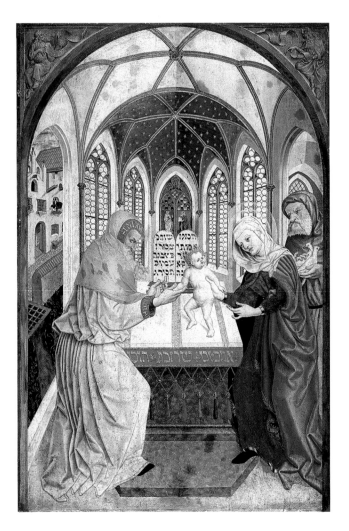

Master of the Polling Panels
Presentation in the Temple, 1444
(exterior of the Polling St Mary Altar)
Mixed technique on wood,
129 x 85.6 cm
Nuremberg, Germanisches
Nationalmuseum

BAVARIAN MASTER

ACTIVE C. 1439 – 1452

Gabriel Angler's anonymous contemporary was a similarly great individualist, but his talents lay in a very different direction. Although a brilliant draughtsman and master of composition, he had every reason to conceal the ungainly bodies of his figures beneath lavish draperies! The qualities of the Polling Master lie in his loving attention to detail in the manner of the great Netherlandish artists, in his precise rendition of interiors and lighting, and in his delicate, luminously clear palette. Heavily populated scenes are not his thing. In this *Presentation*, he even omits the obligatory maid with the sacrificial doves, giving them instead to Joseph to hold.

Mary and Simeon hold the Infant Christ over the altar table – an obvious reference to the Sacrifice of Christ symbolized in the Eucharist. In the spandrels top left and top right, and in the stained-glass window at the end of the chancel, we see the figures of Moses and another prophet, whose promises have now become reality.

The Tables of the Law displayed in the chancel identify the building as the Jerusalem Temple. Its richly detailed interior nevertheless belongs primarily to the artist's own day, as does the townscape in the background – right down to the box bush standing on the folded-down shutter.

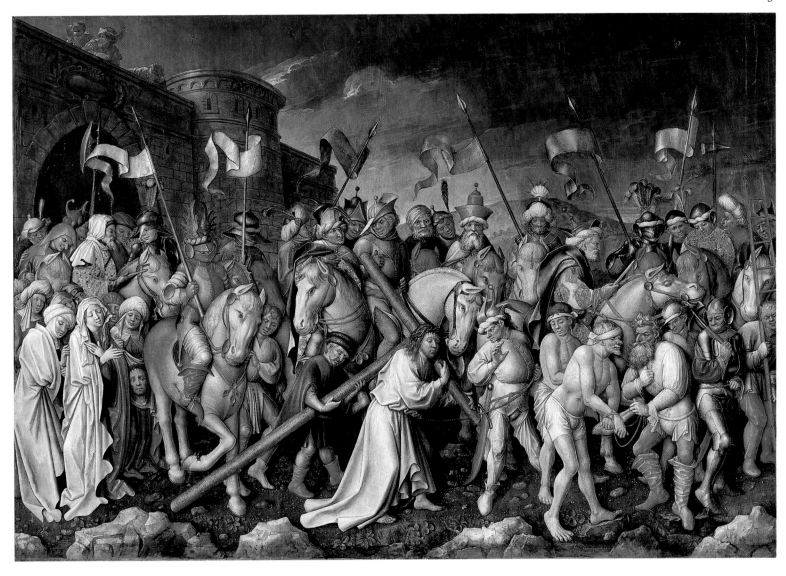

GABRIEL ANGLER THE ELDER

DOC. FROM 1429–1462

Bavarian painting regularly drew attention to itself throughout the 15th century with particularly powerful and original compositions, often characterized by dramatic themes. Gabriel Angler occupies a special position even within this school. The high altar from the Benedictine monastery in Tegernsee, the wealthiest monastery in the duchy of Bavaria, earned its Latin epithet *tabula magna* (large panel) on account of its size. At its centre stood *The Road to Calvary* and, above it, a *Crucifixion*, both measuring some 2 x 3 m on their own.

Before the Tegernsee high altar, Germany had virtually never seen a *Road to Calvary* so full of people. But Angler does not simply amass characterful heads like his great contemporary Hans Multscher (cf. ill. p. 121); in very modern fashion, he considers the figure as an animated whole. He loves bare flesh and sturdy, almost caricatured limbs.

His penetrating line and fluid organization would not be taken up again in Germany until the 16th century, and can probably only be explained by Italian influences. Indeed, there is documentary evidence that Angler spent time in Venice. Even the background with its city wall, Calvary hill and wildly dramatic sky – a

Baroque modification from the end of the 17th century – seems strangely Italian.

Utterly unique, too, is Angler's disregard of convention in his approach to composition and figural types. Whereas the mob is traditionally shown throughout the 15th century as sweeping past the viewer in a semi-circular curve, Angler opts for an elongated frieze-like disposition. He thereby achieves a stroke of genius in his staggered arrangement, behind and on top of each other, of a group of people on foot and a group of mounted horsemen. The well-proportioned, powerful steeds are further evidence of his contact with Italy. Nothing can better express the humiliation of the Saviour, lost against this wall, treading his last path. The two horses lowering their heads seem almost to crush Jesus, yet at the same time set him apart from the throng of indifferent or grimacing pursuers.

For this reason, too, the painting moves us: God has indeed humbled Himself as man, even unto death on the Cross. Christ's mother on the left, surrounded by holy women, also radiates much of this dignity. She has nothing in common with the world of bizarre suits of armour and standards, which fuse to form a threatening wall.

Gabriel Angler the Elder
The Road to Calvary, c. 1445
(from the Tegernsee high altar, or Tabula Magna, consecrated in 1445)
Mixed technique on wood, c. 188.5 x 266.5 cm
Munich, Bayerisches Nationalmuseum

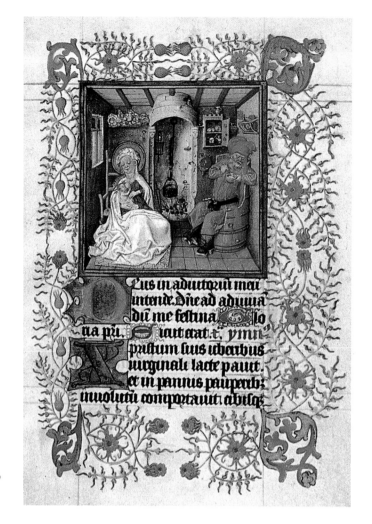

Master of Catherine of Cleves
The Holy Family, c. 1440
(miniature from the *Book of Hours
of Catherine of Cleves*, p. 151)
Body colour on parchment,
19.2 x 13 cm (dimensions of page)
New York, Pierpont Morgan
Library (ms. 917)

Master of Catherine of Cleves
St Vincent, c. 1440
(miniature from the *Book of Hours
of Catherine of Cleves*, p. 268)
Body colour on parchment,
19.2 x 13 cm (dimensions of page)
New York, Pierpont Morgan
Library (ms. 917)

NETHERLANDISH MASTER

ACTIVE C. 1435–1460

The œuvre of the Master of Catherine of Cleves essentially consists of this book of hours, which comprises over 150 pages of particularly lavish illuminations. It was executed some time around 1440, but certainly after 1434, the year in which the coins immortalized in its borders were first struck under Philip the Good, Duke of Burgundy. The artist was evidently active in Utrecht in Holland, but he must also have been well acquainted with the art of Campin and the van Eyck brothers.

He is anything but a master of mere reproduction, however. Both in his choice of subject and its translation into art, he ranks amongst the most original minds of the century. He also displays a marked sense of humour for his day. Once again, the wealth of lovingly observed detail offers us an insight into life in the artist's own times. Thus he invites us to share the Holy Family's daily routine, something of no interest to the Evangelists. At the Sixth Hour of the Saturday Prayer to the Virgin, he shows Mary weaving, Joseph doing some carpentry and Jesus in his playpen. The Ninth Hour, illustrated here, shows a quiet evening scene. The painter characterizes the two parents, located on either side of the open fire and with their heads turned away from each other, in line with their very different roles in the history of salvation. On the left, Mary is sitting on the rush seat of a high-backed chair, nursing her infant son, a gleaming gold nimbus around her head. On the right, Joseph has settled into a chair made out of a converted barrel and seems to be staring dreamily into space. The faces are devoid of any idealized majesty. The painter loves square, fleshy heads with bright red cheeks and full lips. He makes a point of showing us as many of the couple's household effects as possible. He deliberately leaves the little cupboard open for just this reason, while the hanging basket overflows with utensils. Although the stove is somewhat dilapidated, it is superbly equipped with bellows, poker, warming pot and curling tongs. Even a spare spoon is not forgotten, tucked into the hoops of the barrel.

Underneath the picture of Philip in the section of the manuscript containing the suffrages, or intercessory prayers to the saints, the artist introduces us to the workings of an entire bakery, and surrounds the picture of St Bartholomew with a border of pretzels and biscuits. His exquisite taste in composition and colour ensures that his borders in general are works of art of a highly original kind. As well as studying fish, shells, butterflies and dragonflies in the manner of a still life, he combines instruments of martyrdom into abstract patterns, plays with fish traps and, in particular, bird cages, and sparkles with all sorts of anecdotal detail. The resulting designs thereby bear at times some and at others absolutely no relation to the main scene. Thanks to the artist's exuberant imagination, the suffrages – whose otherwise identical format inevitably makes them somewhat dull reading – thus become one of the most exciting sections of the manuscript.

NETHERLANDISH MASTER

ACTIVE C. 1470–1480

In this, the most famous miniature by the most brilliant of the Late Netherlandish manuscript illuminators, the traditional layout has been broken up and the borders around the miniature, which is concluded at the top by a flattened arch, incorporated into the picture. The person of the patroness establishes her connection with the heavenly vision behind, while nevertheless maintaining a respectful distance from its celestial sphere. Indeed, despite the open window she appears not even to notice what is taking place. She is studying her book – just like the reader who held the finished Hours in her hand. On the other hand, she has guaranteed herself a share in God's grace by having herself portrayed a second time within the inner field. Angels holding tall candlesticks mark out an enclosed area around the Virgin. Within the "earthly" sphere of the frame, we see carnations and a vase of irises – flowers which decorate "normal" borders. The jewellery, gold brocade cushion and lapdog are all characteristic of the court circles in which the patroness – Mary of Burgundy or her step-mother Margaret of York – moved. Just as outstanding as the artist's innovative composition is his atmospheric portrayal of the architecture, which seems to be filled with light and air. We have the impression that, unlike the lady in the foreground, we are indeed watching the vision through a window.

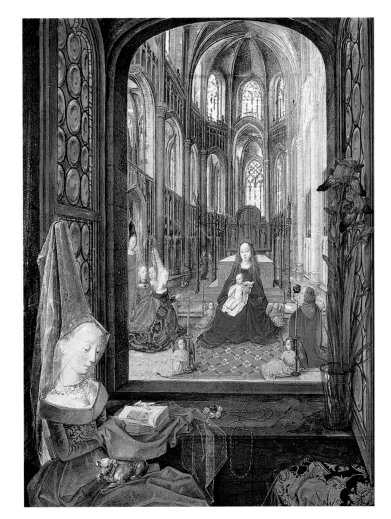

Master of the Book of
Hours of Mary of Burgundy
Dedication miniature for
Mary of Burgundy (?),
c. 1475–1477
(miniature from the *Book of
Hours of Mary of Burgundy
and Emperor Maximilian*,
fol. 14 v)
Body colour on parchment,
22.5 x 16.5 cm
(dimensions of page)
Vienna, Österreichische
Nationalbibliothek
(Codex Vindobonensis 1857)

BARTHÉLEMY D'EYCK

DOC. FROM 1444 – C. 1476

The most famous text by King René tells of the search by Cuer (the heart), accompanied by Désir (desire), for Doulce-Mercy (requited love). Just as these protagonists all stand for a lover's feelings, so too do their helpers and the obstacles in their way. In the story, Melancholie (here no longer portrayed) guides Désir, who is dressed like a Burgundian courtier, and Cuer, armed as a knight, down the wrong path. They arrive at a narrow, rickety bridge, the Pas Périlleux, where their way is further blocked by the black knight Soucy (worry or grief). The artist shows the scene after the fight which ensues. Soucy is riding away, and Esperance (hope) is rescuing Cuer from the river of tears into which Soucy has thrust him.

The horses are portrayed with great mastery. Cuer's horse is waiting on the right-hand edge of the picture, draped in a hanging decorated with winged hearts similar to those adorning Cuer's helmet: we are familiar with such attributes from the Manesse song manuscript (ill. p. 53). However abstract the synopsis of his story may seem, René describes the adventures of Cuer and Désir in atmospheric detail. Barthélemy seeks to do the same, as for example in his bold decision to portray Esperance from behind in the centre of the picture. She pulls hard at the knight in armour, her left arm stretched out behind her to counterbalance his weight.

Barthélemy d'Eyck
After the Fight at the Pas Périlleux, c. 1460–1467
(miniature from the *Livre du cuer d'amour espris* [*Book of the Enamoured Heart*], fol. 21 v)
Body colour on parchment, 29 x 17 cm (dimensions of page)
Vienna, Österreichische Nationalbibliothek (ms. 2597)

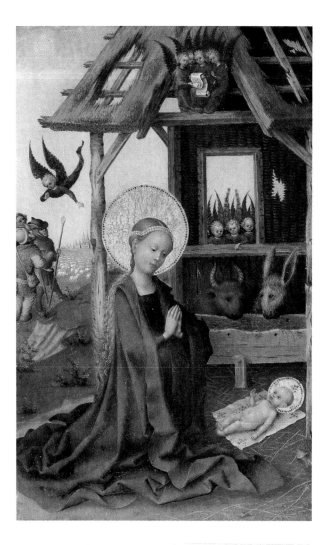

Stefan Lochner
Adoration of the Child, 1445
(part of a domestic altar or diptych)
Mixed technique on wood, 37.5 x 23.6 cm
Munich, Bayerische Staatsgemälde-
sammlungen, Alte Pinakothek

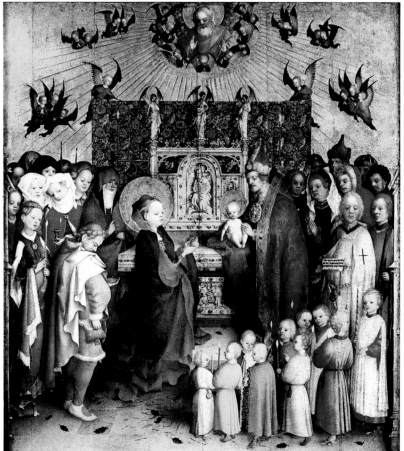

Stefan Lochner Presentation in the Temple, 1447
(from the high altar retable in St Katharina, Cologne)
Mixed technique on wood, 139 x 126 cm
Darmstadt, Hessisches Landesmuseum

STEFAN LOCHNER

C. 1400–1451

When assessing Lochner's historical signifi-
cance, it is important to bear in mind that all
his works arose after the death of van Eyck and
Masaccio. But this is not to conclude that
Lochner was an old-fashioned or even provin-
cial painter. When it came to technique, he
ranked alongside the best Netherlandish mas-
ters. He worked largely in oils, applying his
paints in wafer-thin layers. Thus the luminos-
ity of Mary's mantle is achieved not by mixing
the blue with white, but by allowing the white
ground to shine through. Just as he painted no
shadows, but rather shading, so he also dis-
liked radiant lustre and glittering light. He
loved the matt shimmer of pearl and similar
mild shades, avoided earth colours, and glazed
his gold in order to subdue and modulate its
gleam. In terms of technique, he was one of the
greatest masters of the century.

His attitude towards the art of his Nether-
landish contemporaries, who were primarily
concerned with the faithful reproduction of re-
ality, is stated in the large altarpiece which he
executed for Cologne cathedral. The outer
wings portray objects and space in a naturalis-
tic style and take up the broken drapery motifs
of the new painting of Robert Campin. The in-
terior, however, reiterates the soft, solemn
forms of the International Gothic. We sense
that, for Lochner, these older compositional
means and motifs represent not simply a stylis-
tic ideal but an ideal way of life. He is drawn
only to the gentle and sweet aspects of religion
– we find no representations of the Passion in
his art. Yet Lochner is never monotonous, but
responds with appropriate solutions to each
new commission and subject. Thus the *Adora-
tion of the Child*, a simple, small-format domes-
tic altar modestly executed without a gold
ground, restricts itself to the Virgin and the
Child, who is laid on a communion cloth like
the Host. The background lacks virtually all
spatial depth, its details merely grouped
around the figure of Mary dominating the
pictorial plane. By contrast, the *Presentation
in the Temple*, painted for a high altar, is much
richer, more complex and more ostentatiously
splendid.

Lochner displayed his greatest delicacy and
sensitivity in his painting of *The Virgin of the
Rose Garden*. In contrast to other versions of the
subject, there is nothing here to distract atten-
tion from the person of Mary. The panel is pri-
marily a statement of the Virgin's humility and
apotheosis, and only secondly a portrayal of her
characteristics (the flowers as symbols of her
virtues, the unicorn brooch as a token of her
virginity, the crown as a sign of her royal rank).
Lochner employs the entire spectrum of his
artistic means to express the purity, lightness
and sweetness of his subject.

Stefan Lochner
The Virgin of the Rose Garden, c. 1448
Mixed technique on wood, 51 x 40 cm
Cologne, Wallraf-Richartz-Museum

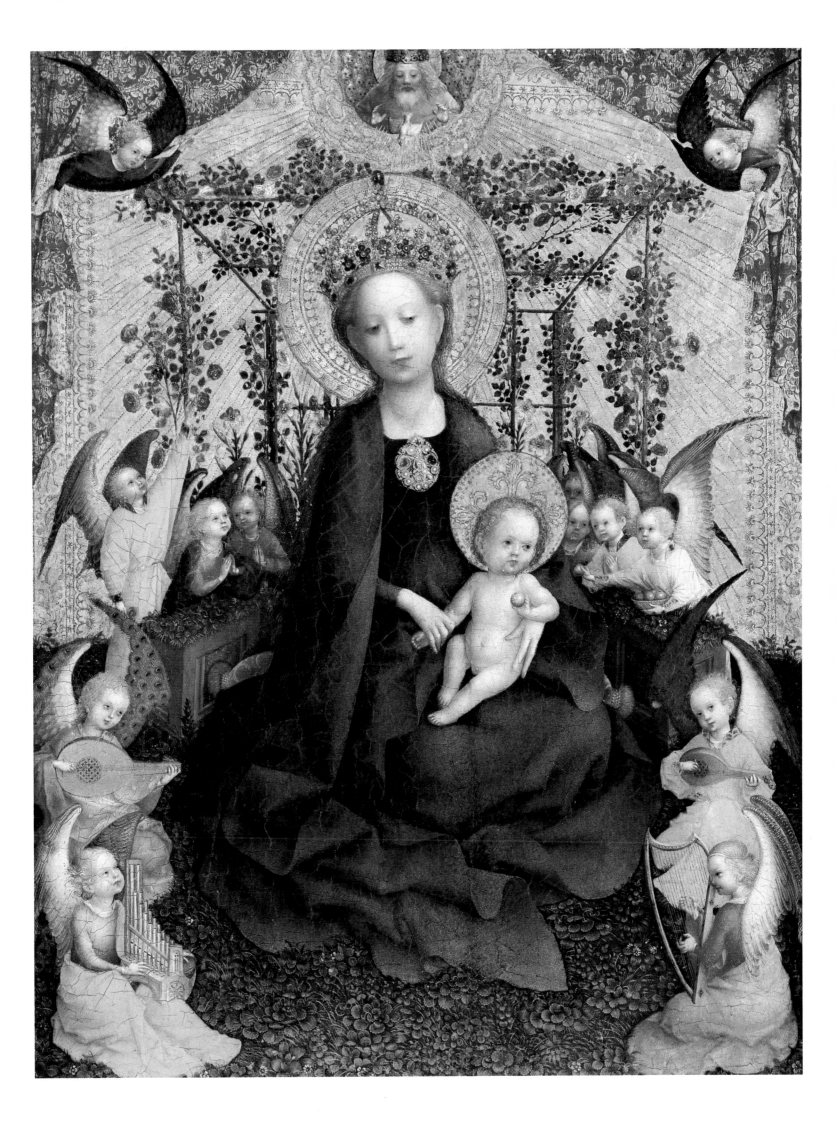

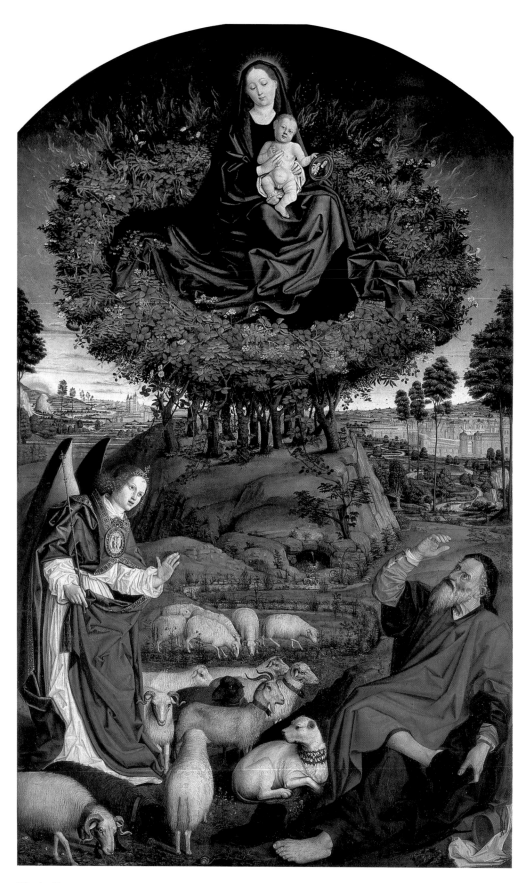

Nicolas Froment
Moses and the Burning Bush, 1475/76
(central panel of a triptych)
Mixed technique on wood, 305 x 225 cm
Aix-en-Provence, Saint-Sauveur cathedral

NICOLAS FROMENT

C. 1430 – C. 1485

Buried beneath the triptych to which this panel originally belonged were the viscera of Good King René. The central panel is devoted to a scene from the Old Testament. To find such a subject at the centre of a large altarpiece is something one might otherwise expect virtually only in Venice, where entire churches were dedicated to Old Testament figures such as Job and Zachariah. The unusualness of this choice is thereby tempered by the fact that the divine apparition seen by Moses in the middle of the burning bush is here interpreted as the Mother of God. Hence, too, the play upon the Marian symbol of the rose, as clearly evident in the foliage and the numerous white blooms woven around the Virgin and Child.

There seem to be formal echoes, too, of the Revelation of St John on Patmos. Just as John saw Mary "clothed with the sun", she is here surrounded by the flames which, according to the Bible, miraculously engulfed the bush without burning it up. Beneath her, Moses is tending the flocks of his father-in-law Jethro. Equally important within the composition is the large figure of the angel, who commands Moses to take off his sandals because he is standing on holy ground. The Fall depicted on the large clasp holding together the angel's liturgical vestments again makes reference to Mary, who represented the new Eve through whom the curse of the Fall was expunged. Just as the name of Eva (Eve) is reversed into the "Ave" spoken by the angel, so the mirror in the hand of the Child – another extravagance in this altar – seems to reverse the picture of the Original Sin into the picture of Salvation. Moses, on the other hand, as one of the unbaptized living before the birth of Christ, has to raise his hand to protect his eyes from the brilliance of the celestial vision.

The introduction of the angel allows Froment a strict triangular composition. The rocky outcrop, an abbreviation for the biblical Mount Sinai, divides the landscape into three sections, which bear almost no relation to each other either in their motifs or in their perspective. The particularly naturalistic idyll between Moses and the angel deserves the closest attention, despite its exaggeratedly winding stream. The sheep in the middle ground are especially successful, although the outstanding individual studies in the foreground are somewhat abruptly juxtaposed. A "black sheep" in the centre, with a wonderful gleam in its eye, ensures that the white goats and sheep can at least here be told apart. The watchful sheepdog with the heavy spiked collar lying at Moses' side is drawn and painted in masterly fashion. The altar is unmistakably a product of the Mediterranean sphere. Whereas its borrowings from Netherlandish realism remain somewhat generalized, the background landscape on either side of the hill looks, upon closer inspection, directly back to earlier Italian, and specifically Florentine, painting. A rarity in its own right is the illusionistic frame, which imitates a precious piece of jewellery.

DIERIC BOUTS

C. 1410/20–1475

Bouts was no great draughtsman. His figures
are usually somewhat wooden, and it costs
him visible effort to reproduce movement.
The artist's strengths lie in the exquisitess of
his painting – as seen here in the vessel
through which the light shines delicately
from behind – and his talents as a landscapist.
The most unusual feature of the present panel
is its rejection of the normal method of creat-
ing depth by stacking pictorial planes one be-
hind the other. The solitary rocky outcrops
which give the landscape a volcanic feel lead
step by step into the background, and the fig-
ures, too, are gradually scaled down in size.
The main group is distinguished much less
clearly than usual from the middle ground
and background. The reason for this lies with
the subject: even the five figures gathering
manna are only a small selection of anony-
mous individuals who are intended to repre-
sent an entire people.

Bouts uses the background to portray pre-
ceding episodes from the Exodus. Thus two Is-
raelites are hurrying towards the water which
Moses has made to gush out of the rock, by
striking it with his staff. Only here in the mid-
dle ground do we recognize the path which the
people of Israel followed for forty years. The
fact that it gleams in the light, whereas the
scene before it is veiled in darkness, also rein-
forces the impression of great depth.

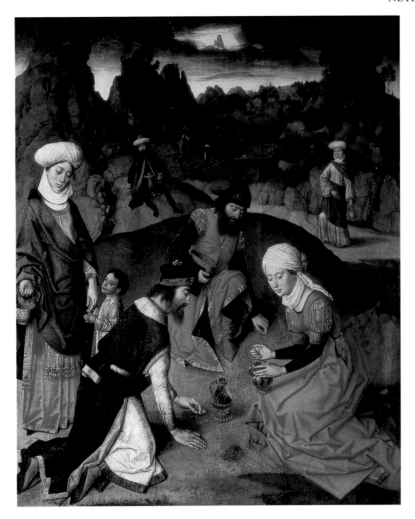

Dieric Bouts
Gathering Manna,
1464–1468
(from the Eucharist
Altar)
Oil on oak,
87.6 x 70.6 cm
(individual panel)
Louvain, Sint-Pieter

HANS MEMLING

C. 1430/40–1494

The fact that Memling moved from the Main
region to the Netherlands demonstrates the
powerful magnetism exerted by the small but
prosperous region, with its highly sophisti-
cated culture. Memling, on the other hand,
also contributed much to the popularity and
attraction of Early Netherlandish art. Al-
though Florentine art and Venetian art were
themselves just reaching the peak of their per-
fection, Memling's works were highly prized in
Italy nonetheless. His reputation becomes un-
derstandable in view of the unswervingly high
standard of craftsmanship which distinguishes
his œuvre, in all its scope. His temperament
seems to be wholly directed towards calm, har-
mony and solidity. He ultimately lacks the
powers of invention and observation of Hugo
van der Goes, even though he adopts many of
the Ghent artist's innovations and makes them
his own. The central panel of Memling's St
John Altar, one of his richest works, brings to-
gether many of the typical characteristics of his
art. The angels have no more need for wings
than the saints for nimbuses, so normal has it
become to use realistic forms taken from every-
day life for religious subjects. St Barbara and St
Catherine are identified by their attributes of
the tower and the wheel respectively. The fact
that the faces are so alike is explained not just
by the limitations of the artist: it is also part of
his programme.

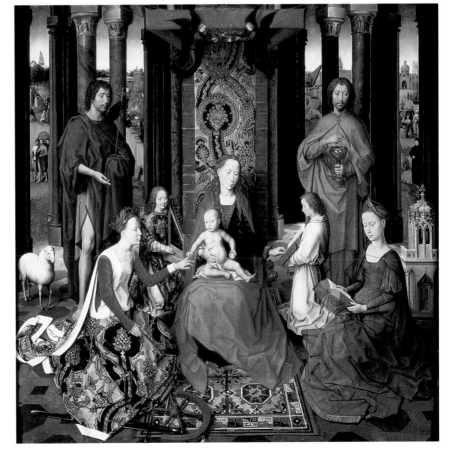

Hans Memling
The Mystic Marriage of St Catherine, 1474–1479 (central panel of the St John Altar)
Oil on oak, 173.6 x 173.7 cm. Bruges, Stedelijke Musea, Memlingmuseum

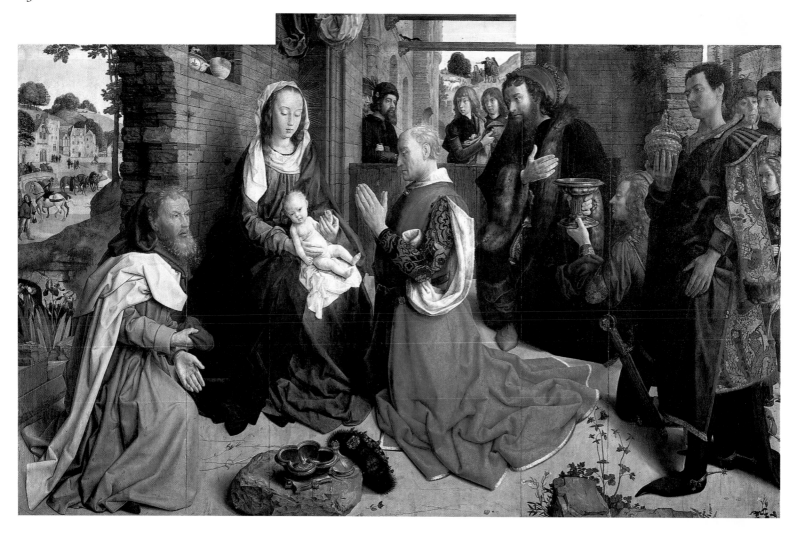

Hugo van der Goes
Adoration of the Magi, c. 1470
(central panel of the Monforte Altar, from Monforte
de Lemos monastery)
Oil on oak, 147 x 242 cm
Berlin, Gemäldegalerie, Staatliche Museen zu Berlin –
Preussischer Kulturbesitz

HUGO VAN DER GOES

C. 1440–1482

With this altar, Hugo van der Goes created a
masterpiece right at the start of his career. He
has breathed life into the fragile marionettes of
Rogier van der Weyden (ill. p. 102) and Dieric
Bouts (ill. p. 129) and made powerful individ-
uals out of types. They fill the entire height of
the panel, yet without being boxed in by the
architecture, as was common in the past. The
wooden gate defines the boundary of the Ado-
ration, but at the same time allows the compo-
sition to sweep out into the background, only
to draw the eye back via the on-lookers. The
poses are precisely counterbalanced and seem
entirely unforced. Powerful light and shade
lend depth to the faces and bring the texture of
the draperies to life.

As with the van Eycks, it is Goes' acute
powers of observation which are responsible for
his artistic innovations. Aquilegia and iris an-
ticipate the nature studies by Dürer and also
the scattered flowers with which manuscript
illuminators decorated their borders. Hugo of-
fers us another still life in the kitchen utensils
in the niche above the Virgin's head. He also
shows the Marian symbol of the lily of the val-
ley as a dried panicle, a testament to his inter-
est in signs of decay. The radicalness and na-
ture of his innovations point to influences from
the South. The head of the oldest king recalls
the painting of Fra Filippo Lippi.

Compared with the Monforte Altar, in his late
Death of the Virgin Hugo has largely toned
down his powerful local colours. The entire
painting is dominated by cool shades of pink
and blue. The interplay between the two
colours reaches its greatest intensity in the di-
vine apparition breaking into the earthly inte-
rior. Christ no longer mingles amongst the
mortals in order to receive his mother's soul, as
in Multscher (ill. p. 121); the spheres are
clearly separate. His hands, raised in greeting,
reveal the stigmata and point to his suffering
on the Cross, which has broken the power of
death. Jesus's cloak, held up by angels dressed
in blue, takes up the movement of his arms.
Pink and metallic blue are again, alongside the
heavenly gold, the only colours iridescent in
his rainbow-like aureole.

Not only is the face of the dying Virgin
drained of almost its colour, but the exposed
flesh of the disciples has also assumed a pale,
brownish hue. Whereas different physical
ideals were still competing in the Monforte
Altar, Hugo now chooses for the apostles a
large, bony type with finely drawn hands and
plastically modelled heads. The intensity of
their eyes and their finely detailed mouths
thereby lend them a visionary character and a
depth of expression unparalleled north of the
Alps. Hugo reduces the wealth of detail found
in his own earlier works to an absolute mini-
mum.

Page 131:
Hugo van der Goes
Death of the Virgin, c. 1480
Oil on oak, 147.8 x 122.5 cm
Bruges, Groeningemuseum

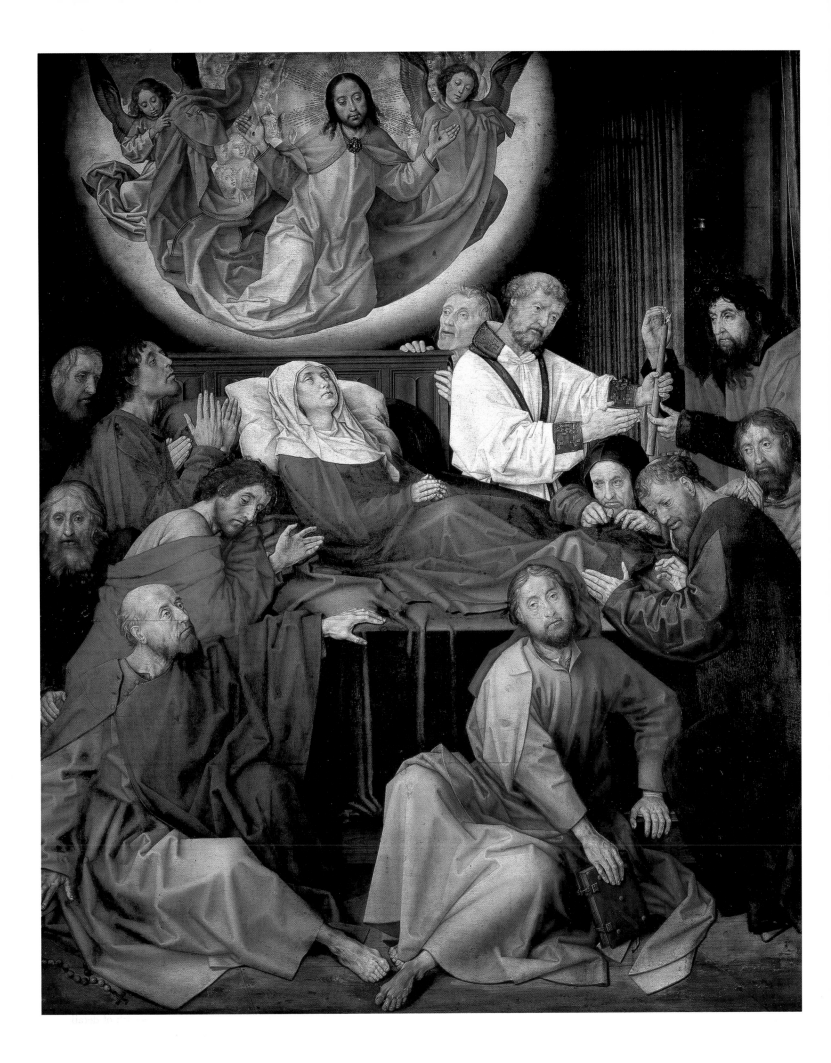

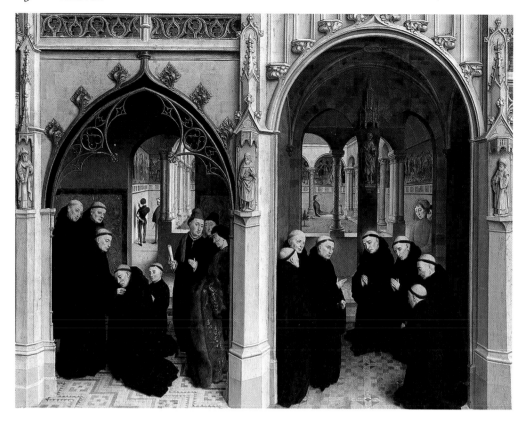

Simon Marmion
Scenes from the Life of St Bertin: The Healed Knight and his Son are Admitted
to the Monastery, together with Four Breton Nobles, before 1459
(2nd and 3rd compartments of the right wing of the St Omer Altar)
Oil on oak, 56 x 147 cm (total size of wings)
Berlin, Gemäldegalerie, Staatliche Museen zu Berlin – Preussischer Kulturbesitz

Simon Marmion
The Sacrifice of Isaac,
c. 1487–1489
(miniature from the *Huth Book of
Hours*, fol. 14 v)
Body colour on parchment,
14.8 x 11.6 cm
London, British Library
(ms. add. 38126)

SIMON MARMION
C. 1425–1489

The panels from St Omer are distinguished by
their extraordinarily generous sense of space
and the intensity of their atmosphere. They
owe both not least to the reduced scale of the
figures, who rarely fill more than the
lower half of the interiors. Whereas most Netherlan-
dish artists tend towards stylization,
Marmion's painting centres on the observation
of the individual object. The vegetation of his
landscapes is extraordinarily diverse, and we
only grasp the wealth of detail also concealed
in his interiors, when we focus on the individ-
ual compartments of the monastery architec-
ture.

The two panels from the right-hand wing
illustrate episodes in the life of St Bertin, the
founder of the monastery. The scenes in which
the noblemen are received into the monastery
take place against the backdrop of the cloisters,
Marmion's most dazzling invention of all. The
walls are decorated with a painted Dance of
Death, with fictitious captions beneath it, of a
kind which would have been quite common in
those days. The illusion is heightened by fig-
ures in contemporary dress meditating on the
scenes or resting on the parapet. The arches in
the foreground are silhouetted like dark
screens against the bright light streaming from
the open quadrangle. At the same time, the
main characters are submerged in the mysteri-
ous half-light of the foreground rooms, which
lends a masterly shimmer to the wall hangings
and the changing colours in the stone. The
pale heads of the monks, contrasting with their
dark habits, are deliberately placed only in
front of areas of shadow. Their flesh colour is
paler and more natural than in the Nether-
lands. As one would expect of a miniaturist,
Marmion applies his paint primarily with indi-
vidual brush strokes.

The Huth Book of Hours numbers amongst
Marmion's last works. In his mature work he
increasingly ignores local colour in favour of
ever more accurate perspective and a strictly
unifed palette employing several cool ground
shades. His interiors and landscapes grow
airier and more natural; the horizon is low-
ered. The individualized faces of the St Bertin
Altar soon give way to a more standardized,
at times almost puppet-like figural type.
Many elements of his technique, on the other
hand, have remained virtually unchanged for
four decades. The figure of Abraham in the
Sacrifice of Isaac is impressively heavy and
powerful. Stepping forward, he raises his arm
to strike the fatal blow; his hand grasps the
hair of the praying Isaac, who presses his feet
together in fear. The figure of the angel is
framed in a powerful red and gold. He inter-
venes to help, now that the patriarch has
demonstrated, through his readiness to sacri-
fice his only son, his obedience to God. In
Isaac's place, God himself provides a ram for
the sacrifice. The sky is composed of countless
small blue strokes, while the foliage is ren-
dered in a watery wash. The tree trunks and
the smoke of the sacrificial fire bear the gold
highlights typical of miniatures.

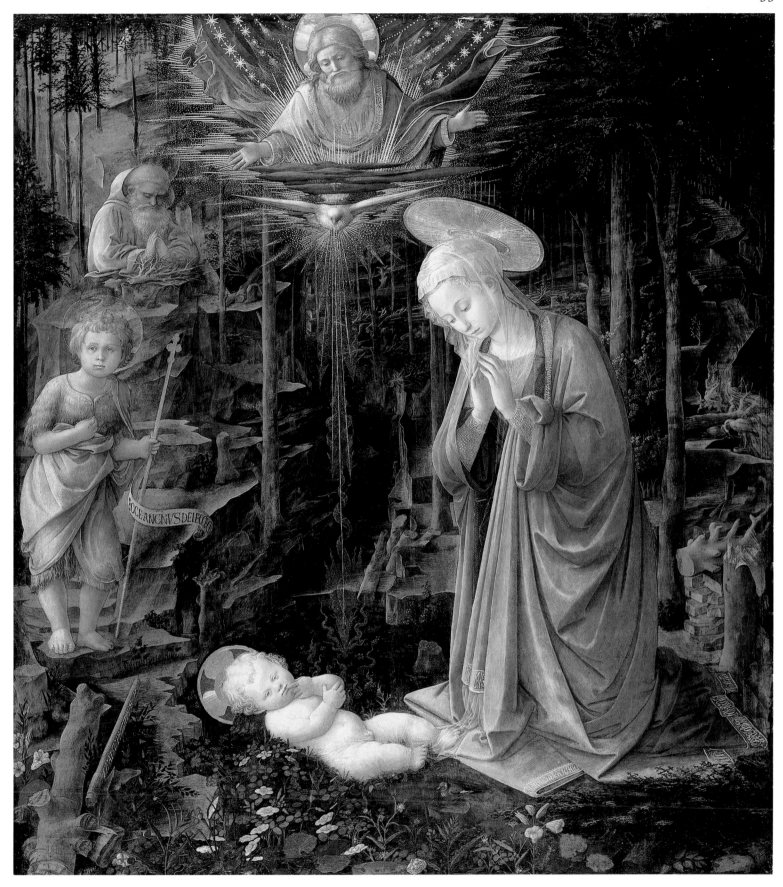

FRA FILIPPO LIPPI

c. 1406–1469

As in the vision of St Bridget, Mary is kneeling in worship before her newborn infant lying naked on the ground – but without stable or cave, Joseph or shepherds, ox or ass. The fact that the scene is being contemplated instead by the young, dreamy-eyed John the Baptist and Bernard of Clairvaux suggests that this is no narrative painting, but a devotional picture in the most literal sense.

The out-moded formulae employed for the landscape are disguised by the fantastical, deep forest. It has a fairy-tale atmosphere, but contains a very serious call to conversion: in line with the words of John the Baptist, the Kingdom of God is nigh and the axe laid to the tree – the artist-monk has even signed his name on it.

Fra Filippo Lippi
Adoration in the Forest, c. 1459
Tempera on poplar, 126.7 x 115.3 cm
Berlin, Gemäldegalerie, Staatliche Museen zu Berlin –
Preussischer Kulturbesitz

Master of the Life of Mary
Christ Receiving the Crown of Thorns, before 1464
(left-hand wing of the *Crucifixion* retable)
Oil on wood, 156 x 90 cm
Kues, St Nicholas' Hospital, chapel

COLOGNE MASTER
ACTIVE C. 1460–1490

Its origins and the mastery of its execution make the retable in St Nicholas' Hospital one of the most interesting paintings of the 15th century. Nicholas of Cusa was a leading scholar in the fields of the natural sciences and theology. In his native town on the Moselle river, he founded a charitable institution whose buildings continue to dominate the town even today. He was also buried in front of the altarpiece in which he appears as donor. The coarse anti-Jewish flavour of the portrayal of *Christ Receiving the Crown of Thorns* on the interior of the left-hand wing comes as something of a surprise. Even the number of Christ's tormentors is unusually large. Pressing the crown of thorns onto his already bleeding head with long poles, they pull faces at him, clench their fists to strike him, or mockingly hand him a "sceptre". Others in the background are taking a rest after the flogging they have just given Christ. Blood stains the ground around the central pillar, with the ropes used to bind Jesus still tied around it. Most alienating of all is the man in the fur-lined coat, who is wearing a hat normally used to characteristize prophets and other Jewish dignitaries. Whereas the Passion iconography of the day was familiar with wealthy Jews only in the role of passive onlookers, with his raised stick the man in Cusa is taking an active part in events.

Master of the Housebook
Christ before Caiaphas, c. 1480
(from the Speyer Altar)
Mixed technique on softwood, 131.5 x 77 cm
Freiburg, Augustinermuseum

MIDDLE-RHENISH MASTER
ACTIVE C. 1470–1500

The Master of the Amsterdam Cabinet, active in the Middle Rhine region, was one of the small band of individuals who, even before the advent of Dürer, largely emancipated themselves from Netherlandish influences and developed a very personal style. The diversity of his faces, which range from the grotesque to the almost sweet and which somehow fail to suit the slender legs beneath them, is typical of the artist. The Gothic love of complex curving lines is reflected not only in the play of the folds, but also in the affected movements of the protagonists. Even the yapping dog is incorporated into the choreography. It completes the circle around Christ, who stands out amongst the throng of his persecutors as a figure of moving humility. The painter's eye for atmospheric detail finds outstanding expression in the unusual night scene in the background. As related in the Gospels, Peter is warming himself by the fire in the company of guards and household servants. His head is turned towards the servant girl who is asking him if he is one of Jesus's followers. The cockerel is already standing on the wall above Peter's head, ready to crow upon his third denial. The second halo to Peter's left belongs to John, who had gained Peter admission to the high priest's courtyard (John 18:16). The lighting is wonderfully observed: the moon lends a rim of light to the clouds and trees and casts the silhouettes of the chilly figures towards us.

NETHERLANDISH MASTER

ACTIVE C. 1460 – AFTER 1515

The breviary was presented to Queen Isabella of Castille around 1497 by her ambassador to the Netherlands. As a magnificent example of a genre characterized by the particularly broad scope of its pictorial programme, which extended namely also to the Old Testament, it offered the artist ample opportunity for unusual, highly inventive compositions. His remarkable talents were nevertheless equal, to such serious subjects as Psalm 69 (Psalm 68 in the Greek-based translation), one of the most impressive laments in the Old Testament. Inside the temple, the singers are clustered in a large circle around King David, who is clearly identified by his crown, the colour of his garments and his throne. He is nevertheless presented boldy from the rear. On this occasion he has laid aside his harp. The lilies in the hands of a number of singers are a reference to the tune "Lilies" to which the psalm was set, as specified in its title. The blue medallions surrounded by a golden aura seek to illustrate the text, which contains passages which are acknowledged in the Gospels themselves as prefiguring the sufferings of Christ. Thus the seven middle fields portray the Passion of Christ, from his trial before the high priest to his death on the Cross. The destruction of Jerusalem seen in the large medallion on the right plays upon the psalmist's hope that God will rebuild the city of Judah.

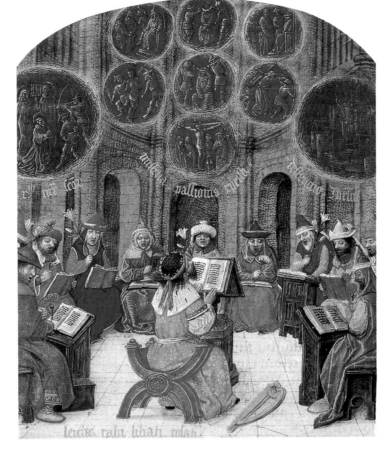

Master of the Dresden Prayerbook Illustration to Psalm 68, before 1497
(miniature from the *Breviary of Isabella the Catholic*, fol. 146 v)
Body colour on parchment, 23.2 x 15.9 cm (dimensions of page)
London, British Library (ms. add. 18851)

GERARD DAVID

C. 1460–1523

As a miniaturist, Gerard David does not seem to have been part of an organized workshop. He executed only a handful of miniatures, which were given pride of place in particularly lavish manuscripts. Not by chance, then, do his three most important illuminations illustrate this breviary, one of the most sumptuous books of its day.

David stands out from his colleagues, themselves important artists, in the extreme subtlety with which he applies his paint. Viewed close up, everything dissolves into a carpet-like weave of tiny accents of colour, nervously applied with the finest of brushes. This technique, which can only truly be appreciated in front of the original, sets the three miniatures clearly apart from the main body of – often rather monotonous – panel paintings attributed to David. These latter also lack the vibrancy of colour found in the miniatures, whose pigments are bound in water instead of oil. In the presence of such technical virtuosity, the actual subject becomes almost secondary. David's compositions do not have the emotional impact of a Rogier van der Weyden or a Hugo van der Goes. The painter is aware of this failing, and does not shy away from borrowing extensively from these two great draughtsmen of the Early Netherlandish school. The present miniature, too, is based on a work by Goes.

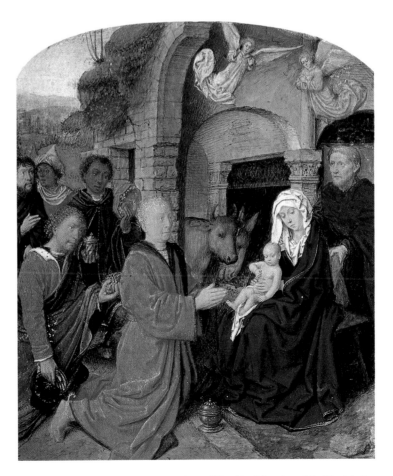

Gerard David Adoration of the Magi, before 1497 (miniature from the *Breviary of Isabella the Catholic*, fol. 41). Body colour on parchment, 23.2 x 15.9 cm (dimensions of page). London, British Library (ms. add. 18851)

Strasburg Workshop
Temptations, 1461
Stained glass. Donor pane
Walburg (Alsace), church

Strasburg Workshop
The Anointing of Christ's
Feet in the House of the
Pharisee, 1461
Stained glass. Donor pane
Walburg (Alsace), church

STRASBURG WORKSHOP
ACTIVE C. 1460 – AFTER 1470

Thanks to the highly efficient organization of
their workshops and the outstanding artistic
quality of their work, in the last third of the
15th century the Strasburg glass painters
established a sort of monopoly within the
whole of the southern German sphere. They
supplied stained glass not just to Alsace and
Lotharingia, but also to Frankfurt, Nuremberg
and even the Vienna region. At the pinnacle of
this development, from 1477 to 1481, four
leading masters even formed themselves into
an artists' cooperative financed by loans. This
flowering of stained-glass production was inau-
gurated by the windows in the church in Wal-
burg, which according to the inscription ac-
companying the donor were executed in 1461.

The first window portrays, beginning at the
top and reading downwards, the story of Anna
and Joachim, the legendary parents of Mary,
followed by the childhoods of Mary and Christ
and a few scenes from Christ's public life. Then
comes the picture of the donor. The second
window takes up the narrative with the Pas-
sion, this time leading in the opposite direc-
tion, i.e. from bottom to top, and culminating
in the Crucifixion, which spreads across all
three lights. The third window depicts the life
of St John the Baptist and contains the donor's
coat of arms.

Common to all the three windows is the
blue-black pomegranate pattern of the back-
ground, borrowed from contemporary brocades.
Its subtle combination with violet, luminous
golden yellow, shades of greyish white and a
number of powerful red accents demonstrates
the artist's mastery of colour. The donor, dressed
in the short gown of the day, kneels on a fore-
shortened tiled floor. A section of the donor in-
scription appears beneath him. The inclusion of
the donor's picture obliged the artist to portray
the Temptations separately from the Baptism
which immediately preceded them, namely in
the field above right. The freshly baptized
Christ arms himself for his public career with a
forty-day fast in the wilderness, during which
Satan tries three times to tempt him.

The fact that his medium was designed to
be seen at a distance obliged the glass painter
to distil the episodes to their essence. As if in a
roundelay, Christ and Satan appear three times
within a single pictorial field: in the fore-
ground, Satan points to the stone that he in-
vites Jesus to turn into bread; in the middle,
he is standing on the mountain top and show-
ing the Messiah the riches of the world; and on
the right, he is urging Jesus to jump from the
roof of the temple. Evangelists and artists dif-
fer in their versions of the anointing of Christ's
feet: importantly, however, the sinful woman
was associated very early on with St Mary
Magdalene, who was highly venerated in the
Late Middle Ages. The artist does not content
himself simply with combining panes of differ-
ent coloured glass within the leading. He uses
black solder, painted on and then baked, to
add extremely fine details, as can be seen here
both in the finely drawn, dignified and expres-
sive faces, and in particular in the table cloth
in the scene of the meal.

MICHAEL PACHER

C. 1435–1498

While Pacher remained essentially indebted to the northern Alpine tradition in his wood carvings, the rocks in this panel, rising in a stack of slender, stele-like stones, come astonishingly close to Upper Italian painting. At the same time, a number of poses can only be explained by a knowledge of the achievements of Mantegna. The most striking feature of the St Wolfgang Altar, however, is the ludicrous foreshortening of its townscapes and interiors. It is precisely the exaggerated rigour with which the artist applies the rules of perspective that betrays the fact that he is no Italian, however. This is reinforced by the affected, "Gothic" positioning of the feet, as here in the case of Christ, and the Late Gothic characteristics of the architecture. The toy-like townscape in the distant background, and the still life of plants in the foreground, lacking freshness for all its fastidiousness, are strangely at odds with the enormous modernity of the overall composition. Pacher seeks to combine the three temptations of Christ as naturally as possible within a single arena. In the foreground, the devil invites Jesus, exhausted after forty days in the wilderness, to change a stone into a loaf of bread; on the balcony on the left, he encourages Jesus to leap from the highest point of the temple, while in the right-hand background, he offers Jesus all the riches in the world if he will only bow down and worship him.

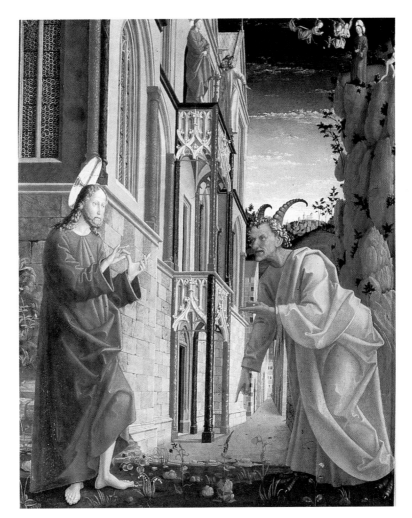

Michael Pacher
The Temptation of
Christ, 1471–1481
(from the St Wolfgang
Altar)
Mixed technique on
wood, c. 175 x 130 cm
St Wolfgang,
pilgrimage church

MARTIN SCHONGAUER

C. 1450–1491

The firm outlines, the rich detailing of every inch of the plane, and the precision of the drawing of the folds and hair betray the hand of the experienced graphic artist. Schongauer was also developing his mastery of colour and painterly effects, as evidenced not just by the reflections in the distant lake. He demonstrates his abilities in particularly impressive fashion in his accurate portrayal of the moth-eaten fringed blanket with the black and gold stripes, seen beneath the swaddling clothes on which the Infant Jesus is lying. That Schongauer was using the realistic portrayal of fabrics to showcase his talents is confirmed by the tattered clothes worn by the shepherds and the equally well-worn bags tied to Joseph's staff, which lead the viewer into the picture. Another indication of how carefully the artist has planned his composition is the diagonal descending through the heads of Joseph and Mary to the Child. Together with the calm poses of the three main figures, the faces of the shepherds and the head, seen frontally behind Christ, of the ox, it relegates the genre-like elements to the background. Thus silent adoration is truly able to become the subject of the painting, more than in the other Adorations of the day. In 1859 the panel was in Palermo and thus bears witness to the enduring enthusiasm – evidenced as early as 1505 – with which Schongauer's works were collected.

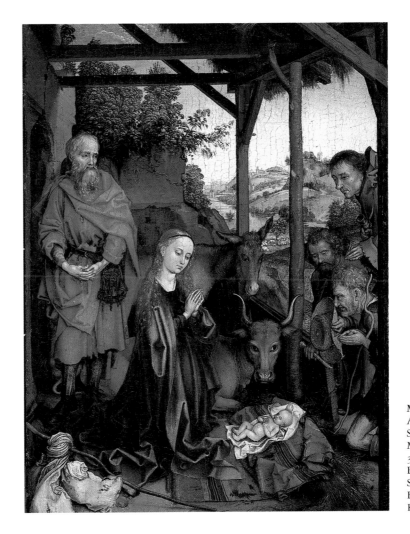

Martin Schongauer
Adoration of the
Shepherds, c. 1480 (?)
Mixed technique on oak,
37.5 x 28 cm
Berlin, Gemäldegalerie,
Staatliche Museen zu
Berlin – Preussischer
Kulturbesitz

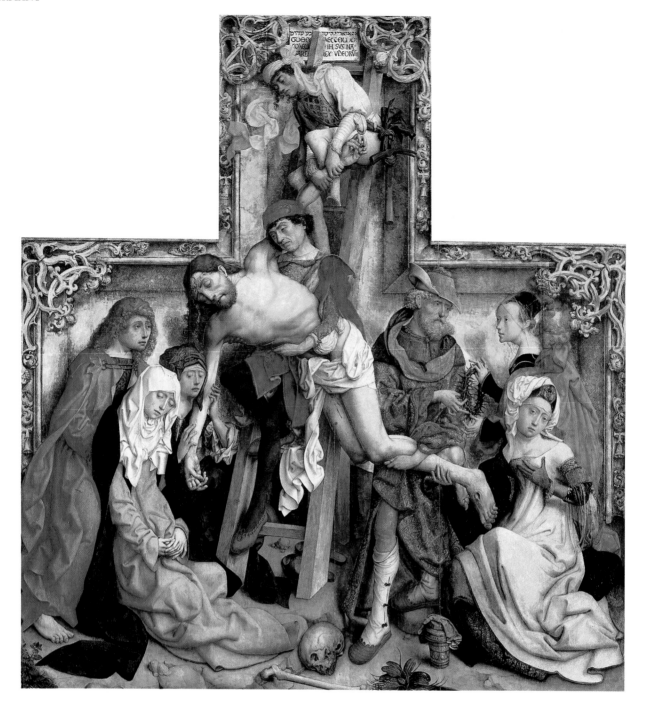

Master of the St Bartholomew Altar
Descent from the Cross, c. 1510
Oil on wood, 227 x 210 cm
Paris, Musée du Louvre

COLOGNE MASTER (?)

C. 1445–C. 1515

This painting orients itself towards Rogier van der Weyden's *Descent from the Cross* in the Madrid Prado, one of the works that would be taken back to Spain at the behest of Philip II, an avid admirer of Netherlandish painting. During the good hundred years that it stood in the Netherlands, however, it became perhaps the most influential painting of the 15th century north of the Alps.

Although it is the same width as the original, it is considerably taller. The top section has thereby been lent much greater weight within the composition. The artist adopts Rogier's basic idea of incorporating the group, as a sort of tableau vivant, in naturalistic colours within a gilt shrine, as if in two-dimensional imitation of polychrome sculptures. In the case of all the figures except Christ, he frees himself from the original to a much greater degree

than most of the Netherlandish artists. His figures are slender, with delicate, round heads, often with something of a childlike naïvety in their expressions. Their pointed chins indicate a knowledge of Dutch painting, but also look back to the work of Lochner fifty years earlier. As usual in the work of the Master of the St Bartholomew Altar, the forceful movements of his figures have something studied and dance-like about them, while their gestures are some-what capricious. A hint of decadence lies in the gloved hand which Mary Magdalene lays against her breast. The braided hair and open cap worn by the lady above are the height of extravagant fashion. The extreme refinement of the palette, drawing and sentiment indicate that the Gothic has here reached its final flow-ering. The painting is at the same time typical of artistic taste in Cologne, which was as con-servative as it was sophisticated. His painting technique places him in Cologne, while his figural types also point to the region of the Middle Rhine.

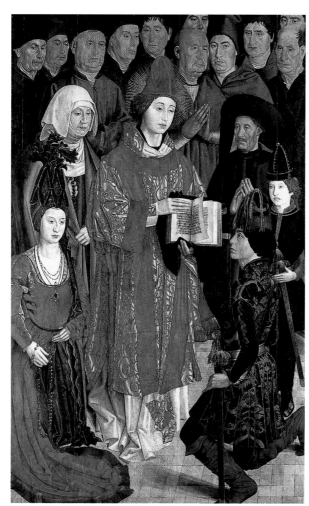
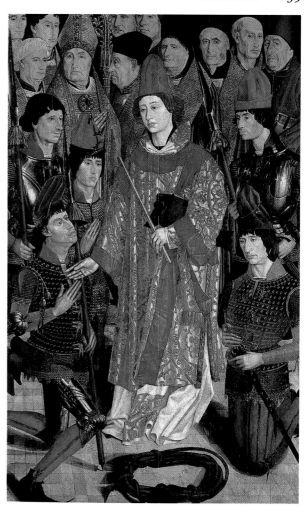

NUÑO GONÇALVES

DOC. 1450–1491

The present paintings form part of a polyptych comprising altogether two wide and four narrow panels. It formerly adorned the high altar of Lisbon cathedral, and would thus certainly have been one of the most important commissions of its day. Since virtually no other examples of 15th-century Portuguese art have survived into the present, it is almost impossible to reconstruct the indigenous artistic traditions in which Gonçalves' painting might be rooted. On the six panels, all a good two metres high, 56 men and two women are portrayed in life size around the saint who appears on the two main panels, St Vincent. The figures in the front row have sunk to their knees, whereby the men appearing directly before the saint bend only one leg, perhaps a royal prerogative in the protocol of the day. Particularly impressive is the figure of the hermit, who is the only one to bend his upper body right down to the ground, but without letting the viewer out of his sight.

The eyes looking out of the picture, the realism of the heads and the way in which they are lined up, somewhat artificially, side by side indicate that Gonçalves worked from studies made from life. Such a wealth of portraits on such a large scale and so close to life is unparalleled in the 15th century even outside Portugal. Both the overall format and the alignment of the heads recall the large tapestries, manufactured chiefly in the Netherlands, which in those days commonly adorned the walls of

churches and secular palaces. The question of the identity of those portrayed, some of them in fantastical costume, has been the subject of heated debate in Portugal for the past hundred years.

The three men behind the hermit have slung fishing nets over their cloaks. They indicate that the people who are gathered here in prayer around their patron saint include not just a large number of ecclesiastical and secular dignitaries, but also representatives of the lower classes. Striking amongst the representatives of the upper classes is a tendency towards grotesquely tall hats. This trend reaches a climax in the case of couple in the foreground of the left-hand *St Vincent* panel, who may consequently be connected with the royal family. The succulent foliage sprouting from the woman's already tall bonnet is something we might sooner expect to find crowning a Gothic finial. On the other hand, the man who is portrayed in prayer on the right above the book, and who has frequently been identified as Henry the Navigator, wears a turban-like cap which is familiar from Netherlandish paintings of the period. Although Nuño may have deliberately included representatives of a somewhat earlier era amongst his characters, the fashions they wear provide valuable clues to the painting's date, which has yet to be definitively established. In Portugal, the polyptych is popularly interpreted as a prayer of thanksgiving, offered up by the entire nation to St Vincent for his miraculous assistance in the battle of Arzila of 1471, when – for the first time in a long while – the country was victorious over the Moors.

Nuño Gonçalves
"Fishermen", "Infante" and "Archbishop" Panels,
c. 1469
(from the former high altar of Lisbon cathedral)
Mixed technique on oak, 207 x 59.8 cm,
206.4 x 128 cm and 206 x 128.3 cm respectively
Lisbon, Museu Nacional de Arte Antiga

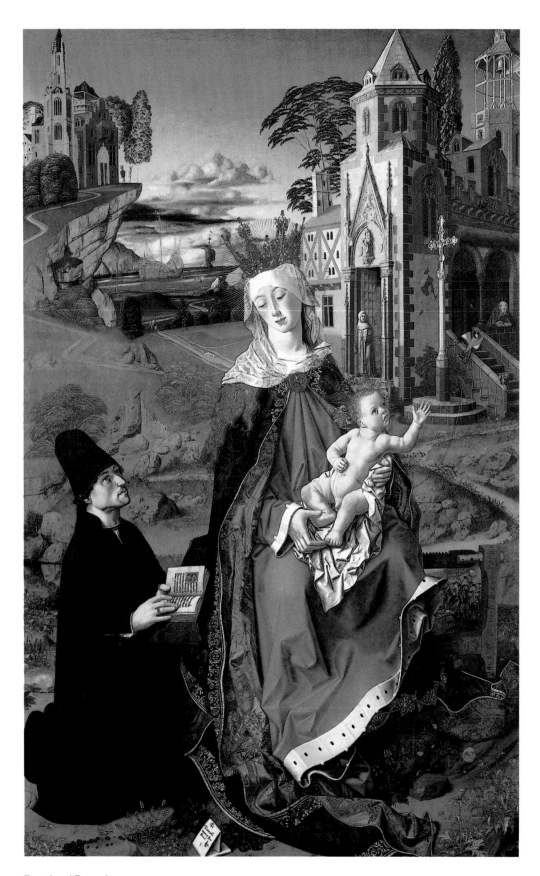

Bartolomé Bermejo
The Virgin of Montserrat, c. 1482–1485
(central panel of a triptych)
Mixed technique on wood
Acqui Terme, cathedral sacristy

BARTOLOMÉ BERMEJO

C. 1430 – AFTER 1498

The avenues which Bermejo explored in his painting were significant not just at the regional level, but also for Europe as a whole. His supreme mastery of the oil techniques pioneered by the North led him constantly to experiment with atmospheric effects, landscape moods and the specific surface effects of various, and in particular transparent, materials. He even went so far as to envelop the transfigured, naked body of the resurrected Christ in nothing but transparent veils. In our example, the details shimmering through the Virgin's veil – her ear, her hair, the landscape – point to this facet of his remarkable talent.

Within the Spanish painting of his day, Bermejo remained an isolated figure. Perhaps this explains his restless wanderings through various artistic regions. The style of the present triptych's two wings – which were begun but not finished by Bermejo, and whose standard of execution clearly deteriorates in places – echoes that of the painters Rodrigo and Francesc de Osona from Valencia, suggesting that Bermejo at some point left Saragossa and Daroca in Aragon to return to his native Andalusia. He later moved to Catalonia, where he is recorded as living in 1486. It is from here that the subject of this panel is derived. Although the audacious shape of the cliff in the background – which the Osona brothers would later borrow for a painting of their own – bears no resemblance to the characteristic teeth of the "serrated mountain" (Montserrat) southwest of Barcelona, in which the figure of the Virgin of Montserrat is venerated, the subject of our painting can be deduced from the sawhorse upon which the Virgin is enthroned. A goldfinch flutters on the end of a string held by the Christ Child, a symbol of Christ's passion adopted from Italian art.

Bermejo portrays the richness of Mary's crown, and the gloriously luminous poppy and other flowers in the foreground, with masterly skill. The very accurately foreshortened background confirms his standing as the most important Spanish landscape painter of the 15th century. Beneath the reddening evening sky, Bermejo depicts large ships of the kind that would have been an everyday sight in the bustling port of Valencia. It is also worth lingering over the details of the small monastery on the right, with its essentially still Late Gothic décor, its espalier roses visible through the open door, the exposed timbers of the clock tower gleaming against the light next to the southerly cypress, and the rolled-up sunblind (?) over the arch. Despite the omnipresent naturalism, Bermejo uses size to clearly distinguish the Virgin and Child, whose exposed areas of flesh are modelled with great plasticity, from the donor. Francesco Della Chiesa, an Italian merchant who was based in Spain, commissioned the painting for the family chapel in the cathedral of his home town, where it is still preserved today. The artist has written his name on the folded letter at the donor's feet, whereby he has replaced "Bermejo" (meaning "red") with the latin "Rubeus", as a sign of his learning.

JUAN DE FLANDES

DOC. FROM 1496–1519

The reduction of his palette to just a few light colours is very typical of Juan de Flandes. The all-dominating yellowish-brown hues of the meal table marry particularly well with the evening setting. Against the distant mountains in the background, rendered in the painter's characteristic turquoise, we see the two disciples inviting their companion to join them for supper in their lodgings. They have not yet recognized him as the same man whose death on the cross had so devastated them. Only when Jesus breaks the bread are their eyes opened. His abstract aura of light separates him from the two followers and a third on-looker, and at the same time indicates that he is about to vanish from their sight.

Rarely has this moment of recognition been translated so forcefully into the language of painting. Juan abandons all convention when he moves Christ to the edge of the composition and locates the supper within an extremely airy, open hall. The setting owes its sense of spaciousness not least to the way in which the hall is sliced by the top and the sides of the painting, and to the fact that the figures are kept relatively small. The contrast within the draperies between large, subtlely modulated planes and clustered folds is also very typical of the artist. The formally dressed disciple is to be understood as Luke, who recorded the events at Emmaus in his Gospel.

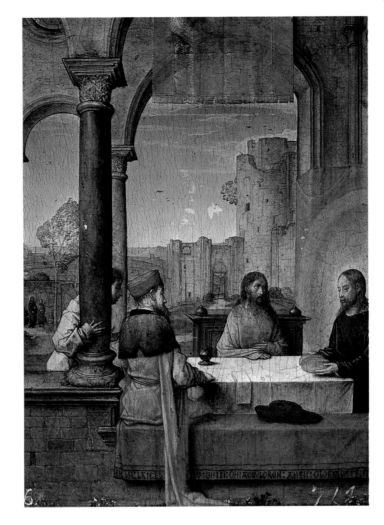

Juan de Flandes
Christ at Emmaus,
c. 1500–1504
Mixed technique on
oak, 21.3 x 15.6 cm
Madrid, Patrimonio
Nacional, Palacio Real

FRANCISCO HENRIQUES

DOC. FROM 1508–1518

Such was the level of technical expertise at-tained by the Portuguese painters that many of their works continue to be mistaken even to-day for imports – a confusion hardly possible in the case of Spanish paintings. The altarpiece in Evora stands at the start of a flourishing pe-riod of increasing artistic emancipation from the Netherlands under Manuel I. It was during his rule that the world was first circumnavi-gated and Portugal founded its colonies in In-dia and Brazil. Despite the advanced times, the Portuguese paintings of this epoch ultimately remained indebted to the Gothic style, as did the so-called "Manuelian" style of architecture and sculpture.

In our painting, this is immediately con-firmed by the magnificence of the brocades, the angular folds of fabric, the halberds emerg-ing out of the compact mass of people, the composition of the landscape, and the meticu-lously detailed bank of flowers. The pale, clear light of the background and the pinky-brown flesh tone, on the other hand, ensure that there can be no mistaking this for the product of a northern workshop. The panel portrays the un-expected meeting between Abraham, returning victorious from battle, and Melchizedek. This somewhat mysterious "king of Salem" gives Abraham bread, wine and a blessing, earning him his inclusion in the Eucharistic prayer in the Catholic liturgy.

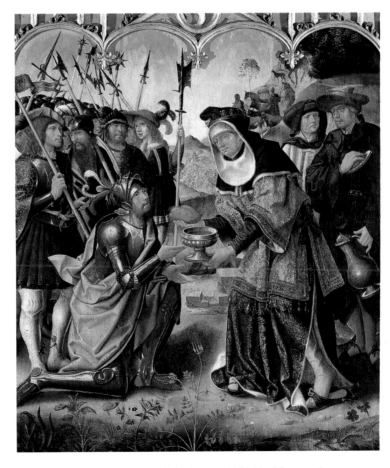

Francisco Henriques Meeting of Abra(ha)m and Melchizedek, c. 1508–1511
(from the former altar of São Francisco monastery church in Evora). Mixed technique on oak, 122.5 x 88.5 cm
(individual panel). Lisbon, Museu Nacional de Arte Antiga

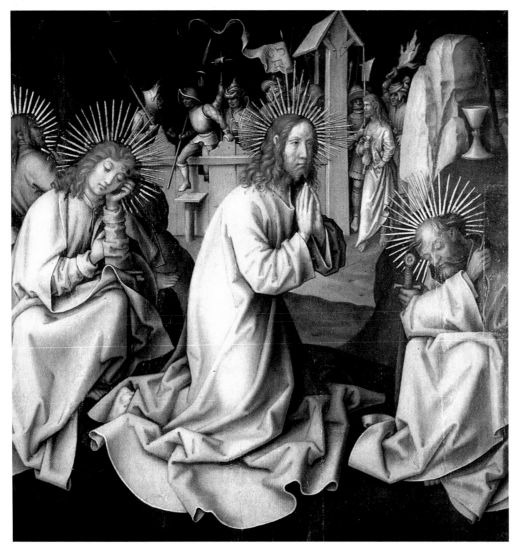

Hans Holbein the Elder The Agony in the Garden, c. 1505 (from the Grey Passion)
Mixed technique on spruce, 89 x 87.5 cm
Donaueschingen, Fürstlich Fürstenbergisches Schlossmuseum

HANS HOLBEIN THE ELDER
C. 1465–1524

A late phenomenon of Gothic aesthetic experimentation was the adoption of an almost monochrome palette, something which may ultimately be traced back to the age of the van Eycks. Although the exterior of the Grey Passion is dominated by shades of greeny-grey, areas of skin are rendered in flesh tones, and haloes and decorative elements in gold.

A number of other details also retain their natural colouring. In order to establish a particularly calm composition, Holbein places Christ between the sleeping figures of John and Peter, and squeezes the third companion, James, into the far corner. Peter half obscures the Mount of Olives, towards which – in accordance with pictorial convention – Jesus is praying.

In line with the basic horizontal structure of the composition, the wall in the middle ground also runs parallel to the bottom of the picture. The motif itself belongs to the standard repertoire of such paintings, just like the group of soldiers with Judas at their head, his purse with his thirty pieces of silver clutched to his breast. Holbein falls fully in line with Gothic tradition, too, in the angular folds of his draperies, while in the hem of Christ's robe, spread out in a broad arc, he returns to the curves and arabesques of the International Gothic abandoned some hundred years earlier. Yet expressing itself through this old-fashioned language is, paradoxically, a desire for peace and harmony which looks forward to the new age of the Renaissance.

ALBRECHT DÜRER
1471–1528

Page 143:
Albrecht Dürer
Lamentation of Christ, 1500/01
(devotional panel for Margreth Glimm)
Mixed technique on spruce, 151.9 x 121.6 cm
Munich, Bayerische Staatsgemäldesammlungen,
Alte Pinakothek

In this devotional panel, executed for the widow of an important goldsmith, Dürer addressed himself to a genre which was highly popular in Nuremberg, but one which he otherwise left unexplored. It was perhaps precisely because of this that his composition exerted an enormous influence in the city.

In comparison to Netherlandish and Italian works of the same period, the group of mourners is very large; it comprises Mary, Mary Magdalene and three female companions, Joseph of Arimathaea, who has provided a new tomb, Nicodemus and John. The size and disposition of the mourners make them seem even bigger. While much is great about this picture, however, its proportions do not quite ring true: compared with the two old men and Mary Madgalene, swathed in a red cloak, John appears comparatively slight. The jars of ointment are almost bigger than the donors at the bottom of the picture; their strongly subordinate position remains, for all the liveliness of the children, a strange concession to conservative Nuremberg taste.

An essential component of the painting's appeal are its asymmetries. The three standing figures on the right form a powerful diagonal, whose movement is heightened by the sweep of the cloth beneath the impressively modelled body of Christ, whose face remains expressive even in death. Contributing decisively to the impression of depth, too, is the way in which the same three figures obscure much of Calvary hill, which rises to the right of John in the centre. To the left of John, the eye is drawn far into the distance across three layers of landscape, each clearly differentiated by colour: first the rich green of the flourishing vegetation around the tomb, then the somewhat brownish hillside behind, on whose slopes Jerusalem rises in the guise of a northern city, and finally the greeny blue of the distant mountain peaks, which provides the transition to the sea – an element most unusual in such a subject.

Ominous thunder clouds call to mind the darkness and earthquakes which accompanied Christ's death, as described in the Gospels. The loving attention to detail evident in the treatment of the background makes it clear that Dürer always remained a draughtsman at heart. The almost Baroque, arabesque-like knot in the belt of the figure on the far right is yet further confirmation of this. For all their often wonderful luminosity, Dürer's colours frequently serve simply to fill in the elegant outlines of his planes.

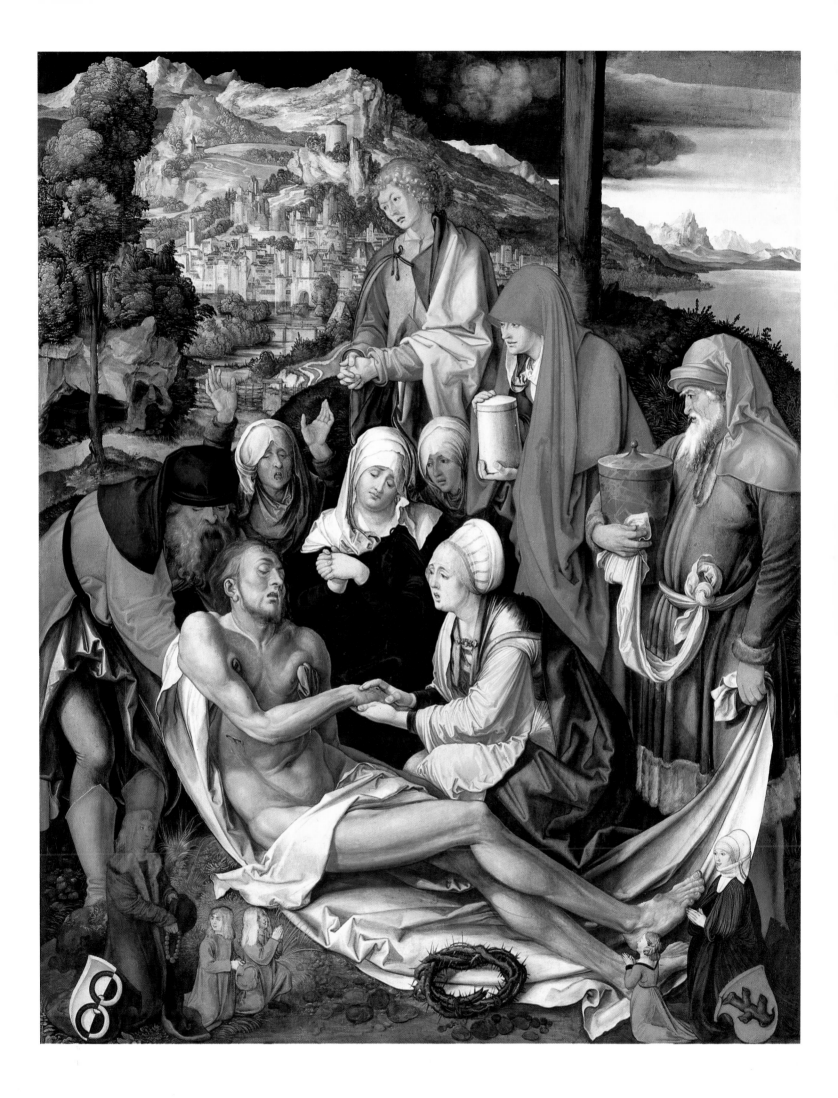

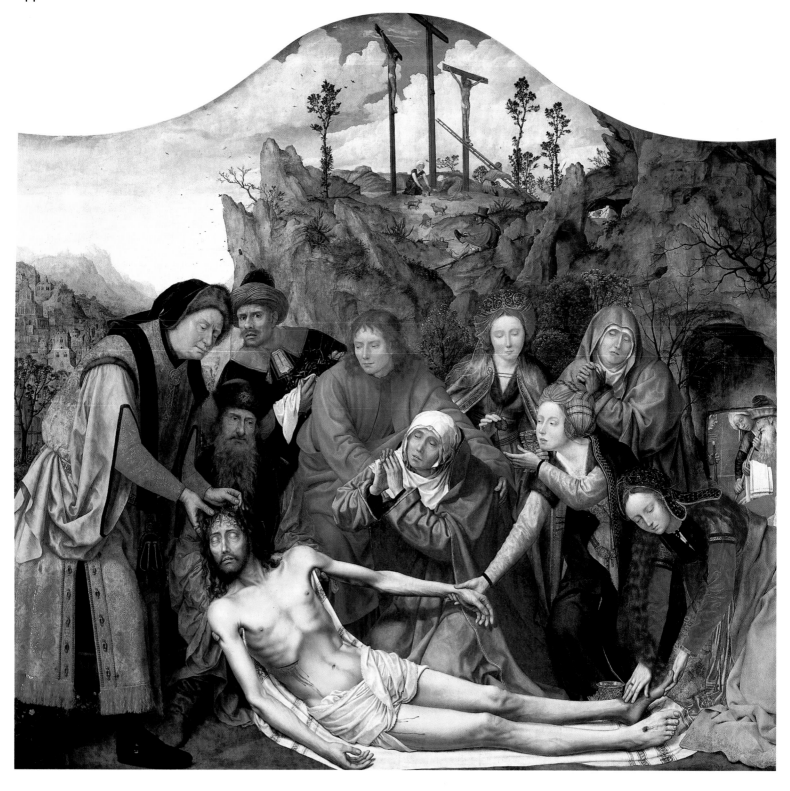

Quentin Massys
Lamentation, 1508 – before 1511
(central panel of the Guild of Carpenters' altarpiece
from Antwerp cathedral)
Oil on oak, 260 x 270 cm
Antwerp, Koninklijk Museum voor Schone Kunsten

QUENTIN MASSYS

c. 1465/66–1530

Correct anatomical proportions, as just labori-
ously achieved by the Early Netherlandish
painters, are here once again sacrificed to the
expressiveness of the gestures. The central
body of Christ, laid on out a cloth, is being
tilted slightly to one side by the two distin-
guished-looking older men so that the viewer
can see it better. They are also turning his
head, with its broken expression and the
thorns still stuck in its gouged flesh, to face
the front. Mary collapses with grief, with John
reaching out to support her.

The basic layout of the painting, with its

group of mourners and the bizarre rocky hill-
side behind, is conventional. Massys surpasses
all his contemporaries, however, in the econ-
omy and mastery of his technique. In thin,
light colours, he lends a transparent shimmer
to flesh and draperies. The harmony of red and
blue has an intensity found otherwise only
amongst the Venetians. Massys scratches orna-
mentation directly into the paint while still
wet and thereby achieves astonishing effects of
relief. Massys embellishes virtually every one of
his paintings with one particularly exquisite
detail. Here it is the view into the tomb in the
rock which is being readied for the corpse. The
candle shielded by the hand creates effects of
light such as would only be encountered a
hundred years later in the Dutch Caravaggisti.

ALTICHIERO DA ZEVIO

c. 1320/30 Zevio (near Verona) –
c. 1385/90

Although famous in his own day, we know almost nothing about this outstanding artist. Together with just one authenticated work in Verona, he has bequeathed us two large fresco cycles in Padua, both executed between 1379 and 1384 for the Lupi family, members of the nobility. He is documented during this period as living in Verona and Padua. Altichiero worked almost exclusively for the despotic rulers of northern Italy. His fame was established after working for the Scaliger family in Verona, who for half a century had been great patrons of the arts, helping Dante and employing Giotto. Altichiero differs from Giotto, his model, in his more pronounced characterization of groups. On the other hand, he portrays single figures, including saints, in a less heroic and monumental style. He looks with cool detachment at human life and emotions. He portrays his religious subjects in a new way, less by reinterpreting the principal figures than by closely observing the various reactions of the secondary characters, which he renders almost dispassionately. His paintings are thereby infused with a new sense of social realism, within which he is able to include portraits without disturbing the whole.
Illustrations:
71 The Beheading of St George,
 c. 1382
71 The Burial of St Lucy, c. 1382

AMMANN OF RAVENSBURG

Joos
active c. 1450

Possibly born in Ravensburg between 1410 and 1420, in 1451 he signed an *Annunciation* fresco located in the first cloister of the Dominican monastery of S. Maria di Castello in Genoa. The fresco is clearly inspired by Jan van Eyck. Ammann returned to Ravensburg in 1452; no manuscript illuminations, panel paintings or murals can be attributed to him with any certainty after this point, however.
Illustration:
106 Annunciation, 1451

ANDREA DA FIRENZE

(Andrea di Bonaiuto)
doc. from 1343 in Florence –
after 1377 Pisa

According to his entry in the records of the Florentine guild, Andrea was active as a painter and architect. It was in Florence that he executed, in 1365–1367, his most important work, the fresco cycle in the chapterhouse (known as the Spanish Chapel) of the Dominican monastery of Santa Maria Novella. During this same period he was also involved in the planning of the cupola for Florence cathedral. In 1368 he was active in Orvieto, but he is documented as being back in Florence in 1372 and 1374, first as representative of the guild of *Medici e Speciali*, then as a member of the Compagnia di S. Luca. Stylistically, he can be broadly termed a follower

of Giotto, whereby he also processes Sienese influences. Hence some of his works have occasionally been attributed to the similarly oriented Andrea Orcagna. Around 1377 Andrea went to Pisa, where he frescoed the south wall of the Camposanto with scenes from the life of St Raniero.
Illustration:
69 Triumph of the Church, c. 1367

ANGELICO Fra

(Beato Angelico, Guido di Piero da Mugello, Fra Giovanni da Fiesole)
c. 1395/1400 Vicchio di Mugello
(near Florence) – 1455 Rome

Angelico probably came from a well-to-do family and trained under painters and miniaturists of no particular note. Between 1418 and 1421, he entered the Observant Dominican convent of Fiesole, where a strict rule was observed. This reformed branch of the Dominican order enhanced the prestige and intellectual importance of the order in the Tuscan region. Angelico held various offices as a friar, such as that of prior of Fiesole between 1450 and 1452. During beatification discussions at the beginning of the 16th century, it was claimed on several occasions that Fra Angelico was to have been appointed Archbishop of Florence in 1446, but that, at his own suggestion, his fellow monk Antoninus (who was later canonized) was awarded the office. This suggests that the painter was by no means just a naïve, contemplative monk, detached from reality. In 1436 Cosimo de' Medici presented the convent of San Marco in Florence to the reformed Dominicans and made it the Medici family monastery: both the church and the monastery were restored at his expense. The architect Michelozzo added some new parts, including the famous library. Fra Angelico, with the help of assistants, executed the decoration between 1436 and 1445 and also after 1449.
The artist did not only undertake work for churches and monasteries of his own order, but also spent several years in the service of the popes in Rome (the chapel of St Nicolas in the Vatican still survives). He is also documented as working in Orvieto in 1447, together with four assistants, including Benozzo Gozzoli. Fra Angelico was a contemporary of Masaccio. Artistically, however, he looked back to the masters of the 14th century, such as Orcagna, and his some-

what older colleagues Lorenzo Monaco and Gentile da Fabriano. The innovations of Masaccio and the other young Florentines only make their way into his painting in latter years, chiefly in his handling of light and the architectural severity of his composition. His figures and settings do not deviate from his deeply spiritual ideal of "sweetness", as it was called in contemporary tracts. The experience of this sweetness had been the primary goal of monastic life since the 12th century.
Illustrations:
 31 St Laurence Receiving
 the Church Treasures,
 c. 1447–1450
110 Annalena Panel, c. 1445
111 Lamentation of Christ, 1436
111 Entombment, 1438–1443
112 Annunciation, c. 1450
112 Coronation of the Virgin,
 c. 1430–1435

ANGLER Gabriel

doc. from 1429, died 1462 Munich (?)

Angler's name first appears in 1429, when he was working as a journeyman in Nördlingen. The artist, who has often been wrongly taken for Gabriel Mäleßkircher, was evidently familiar with Italian painting at first hand, since he included the cost of paints purchased in Venice in the bill which he submitted in 1434 to Munich city council, for the high altar (now lost) which he executed for the Frauenkirche. His most important work, the so-called Tabula Magna (whose parts are today distributed between Munich, Nuremberg, Bad Feilnbach and Berlin), was painted in 1445/46 for the high altar of the monastery church in Tegernsee. The earlier Altar of the Cross in the same monastery featured a panel, dating from c. 1438, which can also been attributed to Angler with some certainty (today Munich, Alte Pinakothek). Executed in grisaille, it was probably influenced by Trecento painting in Padua. Around the mid–1450s Angler seems to have been forced to give up work due to eye trouble.
Illustration:
123 The Road to Calvary, c. 1445

BAEGERT Derick

c. 1440 Wesel or Darup – 1515 Wesel

While his father's family seem to have come from the Munster area in the Lower Rhine region, the family of his mother, Neesken von Birt, were long established in Wesel, in Westphalia. Baegert seems to have drawn upon both of these regions in his art, developing a realistic style with an emphasis upon colour, which from 1480 was increasingly stamped by Netherlandish influences. In 1489 he supplied a Passion Altar to Cologne, which was completed with the assistance of his son Jan and of Jan Joest of Kalkar. He is clearly documented as the painter of the wings of the St Anne Altar in Kalkar (c. 1490–1492) and of the large *Justice* panel of 1493/94 in Wesel town hall – works formerly attributed to the Duen broth-

ers. From c. 1490 to 1506 he and his son painted the retable for the high altar in Liesborn.
Illustration:
23 St Luke Painting the Virgin,
 c. 1485

BARNABA DA MODENA

doc. 1361–1383 in Genoa

The Emilia region, within which Modena lies, borders on Tuscany and Lombardy as well as Veneto. But it also absorbed Roman influences via neighbouring Bologna, which fell for a period under the rule of the Papal States. In the mid-14th century, as Tuscan art was declining but before Lombard and Venetian art had reached their zenith, the painters of Emilia earned particularly widespread renown (Tommaso da Modena). Barnaba da Modena comes to us through a number of signed works and some source material, yet we know nothing of his artistic origins. Sienese painting was certainly a major influence on his style, and he must also have been familiar with the Byzantine traditions of Venetian art. For the majority of the time he was based in Genoa; his panels were exported from there as far as Spain. Commissions from Piedmont and Pisa have also survived.
Illustration:
68 Madonna and Child, 1370

BASSA Arnau

doc. 1345 – 1348 in Barcelona

Around the middle of the 14th century, the son of the painter Ferrer Bassa was awarded a series of commissions for winged altarpieces, including one for the Franciscan convent of Pedralbes, which he completed together with his father. He also executed a wall-painting for the convent at the same time. In the following years his personal hand becomes difficult to distinguish amongst the works produced by the family workshop.
Illustration:
61 St Mark Altar, 1346

BASSA Ferrer (also: de Baço)

c. 1285 Tortosa – 1348 Barcelona (?)

The Catalan painter and miniaturist probably completed his apprenticeship in Italy, perhaps in Siena under Simone Martini, whose influence is clearly palpable in his work. It is possible that he also knew Duccio and Giotto personally. Following his return to Spain, in 1316 he entered the service of the royal family of Aragon and executed altarpieces for the palace of Lleida. From 1333–1339 he worked on a large illuminated codex (now lost) for King Alfonso IV. Bassa subsequently executed numerous altarpieces, including for Saragossa fortress, the chapel of Perpignan castle, and the castle chapel and cathedral in Lleida. His most important late works are the great frescos which he executed in 1345/46 for the Franciscan convent of S. Maria de Pedralbes.
Illustration:
61 Annunciation, 1346

BEAUNEVEU André

before 1335 Valenciennes –
1401 Bourges
Beauneveu, whose life is documented
between 1360 and 1403, was born
in Valenciennes, which only became
French under King Louis XIV. As Bon-
dol served King Charles V as court
painter, so his fellow Fleming Beau-
neveu became his court sculptor. In
1371 he was ennobled by Charles V. He
also worked as a sculptor for the Flem-
ish Count Louis de Mâle, who also em-
ployed Broederlam. However, Beau-
neveu's most important patron was the
Duc de Berry, who put him in charge of
all his artistic projects, including the
building of Méhun-sur-Yèvre château.
Beauneveu also executed miniatures and
stained glass for the Duke. Beauneveu
was regarded as an outstanding artist by
his contemporaries, so much so that in
1393 the Duke of Burgundy sent his
court sculptor Sluter and painter Jean
de Beaumetz to Méhun to study the
work in progress. Although, as his
authenticated works show, Beauneveu
starts from the established formulae of
French art in the first half of the 14th
century, he interprets them with great
virtuosity and a previously unknown
delicacy. Among his early works, his
portraits quite rightly enjoy the great-
est fame, such as his tomb statue of
Charles V in St Denis. His later work
reveals him processing the innovations
arriving from Italy and moving ever
more emphatically towards richly
sweeping forms.
Illustration:
90 The Duc de Berry between his
 Patron Saints Andrew and John
 the Baptist, c. 1300

BELLECHOSE Henri

c. 1380 Breda (Brabant) –
c. 1442 Dijon
In 1415 Bellechose succeeded Malouel
as court painter and *valet de chambre* to
the dukes of Burgundy in Dijon. He
worked for the ducal residences at Ta-
lant and Saulx and for the Carthusian
monastery of Champmol near Dijon,
for which he executed a panel portray-
ing a scene from the life of Mary as well
as the altarpiece devoted to the life of St
Denis. At court he was responsible for
the decorations at festivities and also
the painting of coats of arms and stan-
dards. Having initially enjoyed a good
income from the Burgundian dukes, he
subsequently had to take on private
commissions following the departure of
the court from Dijon. Bellechose is re-
garded as the chief representative of the
Franco-Flemish version of the Interna-
tional Gothic style.
Illustration:
83 The Last Communion and
 Martyrdom of St Denis, c. 1416

BERLINGHIERI Bonaventura

active 1228 – 1274
Bonaventura was the son of the Milan
painter Berlinghiero Berlinghieri, of
whom some works survive. He is docu-
mented as living in Lucca from 1228 to
1274. Records also mention his brother

Barone, also a painter, and a further
brother, Marco, a miniaturist. The *St
Francis* panel in Pescia is Bonaventura's
only authenticated work, on the basis
of its inscription: "Anno Domini MC-
CXXXV Bonaventura Berlinghieri de
Luc …". Thanks to the Berlinghieri
family, the Lucca school exerted an in-
fluence far beyond the city itself. The
Byzantine elements in the father's art
became even more pronounced in the
works of the son, where they assumed a
peculiar flatness and stiffness.
Illustration:
35 St Francis and Scenes from his
 Life, 1235

BERMEJO Bartolomé

(Bartolomé de Cárdenas,
Bartolomeus Rubeus)
c. 1430 Cordoba – after 1498 Catalonia
The family seems to have come from
Andalusia. He probably received part of
his training in Bruges, where he was
also able to learn the technique of oil
painting. He is documented as active in
Aragon from 1474–1477, as living in
Barcelona from 1486–1495, and as be-
ing in Vich in 1498. His best-known
works, in which he fuses Flemish, con-
temporary Italian and Spanish influ-
ences into a distinctive personal style,
include his *Pietà of Canon Luis Desplá*
of 1490 in Barcelona cathedral and –
undoubtedly his masterpiece – the
panels which he produced between
1474–1477 for an altarpiece for S.
Domingo de Silos in Daroca (Madrid,
Museo Arqueologico Nacional), which
remained unfinished and which were
completed by Martin Bernat.
Illustration:
140 The Virgin of Montserrat,
 c. 1482 – 1485

BONDOL Jean (also: Bandol, Bandolf)

born in Bruges, doc. 1368 –1381 in
Paris
Bondol is first mentioned in 1368 as
court painter to Charles V the Wise of
France. He received a large salary and
was later granted a life pension, a mark
of high esteem. The inscription on the
title page of the Bible of Jean de Vaude-
tar, his only surviving work, reads,
translated: "In the year of our Lord
1371 this work was painted at the be-
hest and to the glory of our illustrious
lord Charles, King of France, in the
35th year of his life and the 8th of his
reign, and John of Bruges, painter to
the afore-mentioned King, made this
painting with his own hand." Bondol's
picture forms the sole surviving repre-
sentative of Early Netherlandish panel
painting in its preliminary phase; all
other major examples have been lost.
At the same time, the esteem in which
Bondol and his art were held indicates
that the affected style which was the
tradition in court art was not always
what the patron wanted. Into this gap
stepped Netherlandish painters and
sculptors employing a more realistic
style. Bondol also undertook commis-
sions for other members of the royal
household, including Charles' brother
Louis I of Anjou, for whom, in 1376–

1379, he executed the cartoons for the
famous tapestry series of the *Angers
Apocalypse*. In these he draws upon an
English apocalyptic manuscript from
the 13th century in the possession of
the royal family.
Illustration:
90 The Donor Presents the Bible to
 King Charles V of France, 1371

BORRASSÀ Lluís

doc. from 1380 in Gerona – c. 1425
Barcelona
The son of a painter is first mentioned
in a document relating to the stained-
glass windows in Gerona cathedral. In
1383 he settled in Barcelona, where five
years later he established a workshop
whose production, influenced in part
by earlier French and Sienese art, would
prove a vital source of inspiration for
future Catalan painters. Amongst the
most important works to issue from
his workshop are the Guardiola Altar
executed in 1404 for S. Salvador in
Barcelona (today Private Collection),
the St Peter Altar of 1411 for S. Maria
in Terrassa, the St Clare Altar of 1415
(Vic, Museo Episcopal), and a painting
of saints in S. Maria in Manresa.
Illustration:
85 Nativity, 1403–1411

BOUCICAUT MASTER

active in Paris 1405–1420
If this artist, who ranked amongst the
most important miniaturists of his day
and who prepared the way for the art
of Jean Fouquet and Jan van Eyck, is
indeed identical with the Flemish
architect, panel painter and manuscript
illuminator Jacques Coene, then he is
recorded as being in Paris and Milan in
the years 1398–1404. He is named after
the miniatures illuminating the *Book
of Hours* produced around 1410–1415
for Jean le Meingre de Boucicaut,
Marshal of France (today Paris, Musée
Jacquemart-André). Here as in numer-
ous other works, he displays his innova-
tive interest in naturalistic detail, as
evident not least in the bold effects of
lighting and air in his landscapes and in
his virtuoso rendition of interiors.
Illustration:
101 Adoration of the Child,
 c. 1410–1415

BOUTS Dieric (also: Dirk, Dierick)

c. 1410/20 Haarlem – 1475 Louvain
Alongside Memling, Bouts can be con-
sidered the most important successor to
Rogier van der Weyden. Little is known
about his training and early work. Even
if not actually a pupil of Rogier him-
self, Bouts was profoundly influenced
by his work. He developed Rogier's
style to an almost radical degree in his
verticalization of architecture and fig-
ures, his reduction of the individual in
favour of the type, and his concealment
of the body behind exquisite, minutely
detailed garments. Whether we can
view these as the first indications of a
specifically northern Netherlandish art
with a Protestant flavour, or whether
Bouts was simply part of the more gen-

eral trend sweeping over Europe after
the middle of the century, is hard to de-
cide. Whatever the case, the stylistic
features already described intensified
from the Eucharist Altar in Louvain
(1464–1467) to the *Justice* panels in
Brussels (begun 1468). In 1465 Bouts
married Katharina van der Brugghen,
the daughter of a respectable Louvain
family. He remained based in Louvain,
enjoying an excellent reputation as a
painter. He is last mentioned in records
dated 17 April 1475. It is still fre-
quently difficult to draw a clear line be-
tween his own work and that of others,
including his son Dieric Bouts the
Younger. It is therefore impossible to
determine the full scope of his art. If
the winged altar at Munich known as
the "Pearl of Brabant" is indeed by his
hand, then he must have been one of
the greatest landscape painters of his
generation.
Illustration:
129 Gathering Manna, 1464–1468

BROEDERLAM Melchior

doc. 1381 – 1409 in Ypres
(West Flanders)
There are earlier documentary refer-
ences to persons of his name in Ypres,
yet nothing is known about his up-
bringing and what affected him artisti-
cally. As in the case of so many artists,
iconoclasm and wars in the Franco-
Flemish border region destroyed all his
work. If it were not for the altar pre-
served in the Carthusian monastery at
Dijon, he would only exist for us in
written records. These tell us that he
was highly esteemed by Duke Philip
the Bold of Burgundy, whom he served
as court painter and *valet de chambre*. He
participated in the decoration of Hesdin
château, one of the richest and most
finely furnished of the day. As court
artist he also painted portraits and de-
signed costumes. It is recorded that he
accompanied the altar to Dijon and vis-
ited Paris. His two surviving panels in
Dijon, which flank a carved altar by
Jacques de Baerze, show him to be a
painter whose handling of the effects of
light and whose gradation of colour was
so masterly that, when in front of these
pictures, one recognizes how imperative
the evolution of the old techniques into
oil painting had become.
Illustration:
79 The Presentation in the Temple
 and The Flight to Egypt,
 1394–1399

BRUNECK Hans von

doc. 1440/41 in the Puster valley
(South Tyrol)

A receipt of payment issued in 1440/41
by the bishop of Bressanone, and bear-
ing the name of Master Hans Painter
of Bruneck, is essentially the only date
in the artist's biography of which we
can be certain. On the stylistic basis
of a number of frescos in Tramin, a
body of frescos by Hans von Bruneck
has been reconstructed which spans the
years 1400 to 1420 (namely in St Mar-
tin's, near St Lorenzen in the Puster
valley; in St Nikolaus in Stegen, near
Bruneck; in the Salvatorkirche in Hall;
in an arcade in the cloister of Bres-
sanone cathedral; in the cloister in
Neustift; and in the Spitalkirche in
Sterzing). Since considerable doubt has
recently been cast on a number of these
attributions, however, the painted
wings of the carved altarpiece in St Sig-
mund's in the Puster valley (c. 1430)
and the small Altar of the Cross in St
Korbinian's in Thal-Assling are the
main other surviving works attributable
to the artist. They thereby indicate that
he must also have been familiar with
Italian painting in Padua.

Illustration:

89 Angels, Symbols of the
 Evangelists, Busts of Prophets,
 1417

CAMPIN Robert

c. 1375/80 Tournai (?) – 1444 Tournai
Recent research is more or less agreed
that the artist who has long been
known as the Master of Flémalle (after
a triptych thought to have come from
Flémalle Abbey near Liège, and today
in the Städelsche Kunstinstitut in
Frankfurt) can be identified as Robert
Campin. The issue is not altogether
resolved, however, since although
Campin is documented in records on
numerous occasions, he has left no
signed works. Some have tried to
equate him with the young Rogier van
der Weyden, but for all their stylistic
commonalities, their differences remain
such that they seem more likely to
have enjoyed a teacher-pupil relation-
ship.

Campin was born around 1380 in
Tournai, where he qualified as a master
in 1406/07 and was probably Rogier's
teacher from 1427 to 1432. Together
with the van Eyck brothers, he may
be considered the founder of the
Netherlandish painting of the Early Re-
naissance. While the influence of the
Limburg brothers and Burgundian
court art can still be felt in his early
work (*Betrothal of the Virgin and Annun-
ciation*, Madrid, Prado, c. 1410), he soon
turned to three-dimensional figure rep-
resentation and the exploration
of depth (*Nativity*, Dijon, c. 1425 –
1430). These reach a climax in
Campin's late works, in which the
painter becomes almost obsessed with
perspective (e.g. the Mérode Altar, so-
called after its original location;
New York, Metropolitan Museum, c.
1430).

Illustration:

102 Nativity, c. 1425–1430

CIMABUE

(Cenni di Pepo, called Cimabue)
c. 1240 Florence (?) – after 1302
Cimabue (doc. 1272–1302) was the
most famous painter of his generation.
As one of the first great Tuscan painters,
he executed commissions far beyond the
bounds of his native Florence, such as
the large fresco cycles in the Upper and
Lower Church of St Francis in Assisi,
stained glass for Siena cathedral, mosaics
for Pisa cathedral, and work for ecclesi-
astical patrons in Rome. He evidently
had a large, well-organized workshop,
one of the first of its kind in 14th-cen-
tury Tuscany; it is probably where
Giotto trained. His stylistic characteris-
tics, as evidenced by his panel paintings,
include a generosity and clarity of form,
a restriction of colour to just a few, usu-
ally somewhat schematically distributed
tones applied in flat planes, a precise de-
lineation of outline, but a summary exe-
cution of detail. Cimabue soon found
himself rivalled by the young Sienese
artist Duccio. His Santa Trinità *Maestà*
probably represents his response to this
new challenge.

Illustrations:

12 Maestà, c. 1270 (?)
42 Madonna and Child Enthroned
 with Angels and Prophets
 (Maestà), after 1285

COLANTONIO (Niccolò Antonio)

active between 1440 and 1465 in
Naples and France

Almost nothing is known of the life
of this southern Italian artist. Around
1440, when King René of Anjou was
also ruler of Naples, he probably went
to France, where he would have encoun-
tered Flemish painting; more recent
theories also see Provence as playing an
intermediary role. He took the Flemish
style back home with him and thereby
influenced the important Renaissance
painter Antonello da Messina, who was
his pupil from 1450. His most impor-
tant works are his *St Jerome* of 1445
and his polyptych of *St Vincent Ferrer* for
S. Pietro Martire in Naples, c. 1465.

Illustration:

120 St Jerome, c. 1445

DALMAU Lluís

doc. c. 1428 in Valencia,
active until 1461

Probably born in Valencia, in 1428 the
painter was in the service of Alfonso V,
King of Aragon, who sent him to Flan-
ders in 1431–1436 in order to study
the Early Netherlandish school. Dal-
mau may have been engaged during
that time in the workshop of the van
Eyck brothers. In 1438 he moved to
Barcelona, where he is officially
recorded as a painter and citizen in
1453; the last mention of his name is
found in 1460, when he is documented
as working for King Juan II. Alongside
a number of attributions, a Madonna
panel of c. 1444/45 is authenticated as
his work. Originally destined for the
Barcelona council chapel, it represents
the most important testament to the
assimilation of the art of the van Eycks
in Spain.

Illustration:

106 Virgin of the Councillors,
 1444/45

DAVID Gerard

c. 1460 Oudewater (near Gouda) –
1523 Bruges

David is the only Netherlandish painter
who, without direct knowledge of
Italy, achieved an overall compositional
homogeneity comparable to that of
the Italian High Renaissance. For his
starting-point he went back over two
generations to the van Eyck brothers,
combining their realism with the differ-
entiated treatment of space and the hu-
man figure championed by the great
Netherlandish masters of his own day.
It is not known under whom David
trained, but the influence of van der
Weyden and van der Goes in his early
work is unmistakable. In 1484 he was
registered as a member of the Bruges
guild. His works, executed for ecclesias-
tical patrons, reach their highest perfec-
tion where the subject allows a certain
stateliness (*The Baptism of Christ*,
Bruges, Groeningemuseum, c. 1505).
More dramatic scenes did not always
suit his temperament (*The Wedding at
Cana*, Paris, Louvre, c. 1503). David's
great skill in unifying figure and land-
scape was of great importance for future
development. He inspired a significant
following in Bruges, particularly
amongst miniaturists.

Illustration:

135 Adoration of the Magi,
 before 1497

DUCCIO DI BUONINSEGNA

c. 1255 Siena (?) – c. 1319 Siena
Duccio is first mentioned in 1278 in
connection with minor commissions
such as the decoration of book covers.
His first authenticated masterpiece is
the *Rucellai Madonna* in the Uffizi in
Florence, which he executed for the
chapel of the Laudesi confraternity in
the Dominican church of Santa Maria
Novella in Florence. While Duccio was
probably thereby seeking to compete
with Cimabue, the painting also con-
firmed his importance as an artist even
before the advent of Giotto – and that
in the city of Florence, the bitter rival
of Duccio's native Siena. Alongside
smaller paintings, chiefly devotional
panels, Duccio's greatest masterpiece is
his *Maestà* (Virgin in Majesty) for the
high altar of Siena cathedral. Duccio's
painting reflects a profound and inten-
sive study of Byzantine art, which then
became a springboard for the evolution
of his own individual style. He re-
mained very open to contemporary de-
velopments in art, represented above all
by the sculptors of the Siena cathedral
pulpit, Niccolò and Giovanni Pisano.
Their stylistic proximity to classical and
Gothic sculpture, coupled with their
vehement expressiveness, prompted
Duccio to rethink many Byzantine for-
mulae (as is particularly apparent in the
large *Crucifixion* on the back of the
Maestà). We can also see him processing
the influence of French art and the
painting of his somewhat older Floren-
tine contemporary, Cimabue – and
probably even also the innovations of
Giotto. Duccio exercised great influence
in his own day; he left behind him a
prosperous workshop with painters who
perpetuated his style. Unlike Giotto
and the Florentine painters, he had a
stimulating rather than stultifying
effect on the younger generation of
Sienese painters such as Simone Martini
and the Lorenzetti brothers.

Illustrations:

13 Rucellai Madonna, c. 1285
24 Christ Entering Jerusalem,
 1308–1311
27 The Temptation of Christ on the
 Mountain, c. 1308–1311
47 Madonna of the Franciscans,
 c. 1300
47 Adoration of the Magi,
 1308–1311
48 Peter's First Denial of Christ and
 Christ Before the High Priest
 Annas, 1308–1311

DÜRER Albrecht

1471 Nuremberg – 1528 Nuremberg
As the son of a Hungarian goldsmith
who settled in Germany, Dürer may
well have learnt his father's craft before
entering the workshop of Nuremberg's
leading painter, Michael Wolgemut, in
1486. In 1490 he travelled through the
southwestern parts of the country, also
visiting Basle and Colmar, where he
discovered that Schongauer, whom he
admired and who had influenced his
early work, was no longer alive. In 1494
he went to Venice for the first time. A
year later he opened his own workshop
in Nuremberg and established links
with humanist circles, and in particular
with Willibald Pirckheimer, who was
to become a life-long friend. Graphic
series dominate his early period. In the

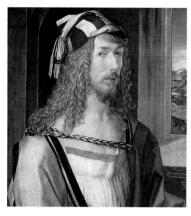

15 woodcuts of his *Apocalypse* cycle, Dürer lends his line a previously unknown power of expression. They were followed by the woodcut cycles of *The Great Passion* (1498–1500) and *The Life of the Virgin* (1501–1511). His second trip to Italy, from 1505 to 1507, which again centred on Venice, brought his development to maturity, and – in particular in his processing of the work of Giovanni Bellini – made him one of the great European painters of the High Renaissance. His *Madonna of the Rose Garlands* (Prague, Národni Galeri), which he painted for the German Corporation of Traders in Venice, is the first evidence of his new approach to composition. Apart from a trip to the Netherlands (1520/21), Dürer remained in Nuremberg after his return from Venice, highly esteemed by his contemporaries and becoming a fervent supporter of the Reformation in the last ten years of his life. It was in Nuremberg that he executed his greatest paintings (*The Adoration of the Trinity*, Vienna, Kunsthistorisches Museum, 1511, *Four Apostles*, Munich, Alte Pinakothek, 1526), including numerous portraits, such as that of *Hieronymus Holzschuher* (Berlin, Gemäldegalerie, 1526). His most famous single plates date from the period 1513/14 (*Knight, Death and the Devil, Melancholia, St Jerome in his Study*). Of great significance for the development of pure landscape painting are Dürer's watercolours, in which he portrays identifiable topographies.
Illustration:
143 Lamentation of Christ, 1500/01

EYCK Barthélemy d'
doc. from 1444 – c. 1476
Our knowledge of the life and work of this artist is based on a series of assumptions. It is thought that he trained in the workshop of Jan van Eyck, and from the 1440s onwards executed miniatures and panel paintings for René of Anjou and others of his circle. It is uncertain whether he accompanied René to Italy in 1440, during the latter's brief rule over Naples, or whether he was employed for the Dukes of Burgundy during that period. Following René's return in the mid-1440s, Barthélemy added about five miniatures to one of his older codices (London, British Library), and also illuminated a book of hours for him, in collaboration with Enguerrand Quarton (New York, Pierpont Morgan Library). Between 1443

and 1445 he is believed to have executed a winged altarpiece for Aix-en-Provence. After another extensive series of miniatures, he produced his masterpieces, namely seven miniatures in a French edition of Boccaccio's *Théséide* (Vienna, Österreichische Nationalbibliothek) and the 16 illustrations to the *Livre du Cuer d'Amour espris* – these latter representing one of the supreme artistic achievements of their day.
Illustrations:
119 Annunciation, 1443/44
125 After the Fight at the Pas Périlleux, c. 1460–1467

EYCK Jan van
c. 1390 Maaseyck (near Maastricht) – 1441 Bruges
Jan van Eyck can claim to be as important for painting north of the Alps as Masaccio for Italian art. His portrayal of the human figure as a three-dimensional body, his portraiture in the modern sense, his minutely observed landscape, and his perspective construction of interiors combine to give a suggestion of reality which can only be described as "Renaissance" to distinguish it from medieval art. At the same time, van Eyck was the chief representative of a new chapter in the history of colour. Although he did not, as Vasari would have it, invent oil painting, he employed oil as a transparent binder. This allowed him to lay down a succession of translucent layers of paint (glazes) and thereby achieve an intensity and depth of colour never seen before. This technique particularly complements the portrayal of jewellery and costly fabrics, which attain an unparalleled degree of realism in his painting. Jan van Eyck's importance was recognized in his own day: until 1422 he was employed in the service of Duke John of Bavaria, for whose residence in The Hague he executed paintings no longer extant. He was subsequently employed at the court of Philip the Good of Burgundy, who entrusted him with various diplomatic missions – a sign of the high regard in which he was held. From about 1430 Jan van Eyck lived and worked in Bruges as painter to the court and the city. In 1432 he completed the Ghent Altar, which he had originally begun with his brother Hubert van Eyck, who is named first in its inscription. How much of the altar – the greatest work of Netherlandish painting of the first half of the 15th century – actually stems

from Jan's hand remains a matter of dispute, since we have no authenticated works by Hubert against which to compare it. As Hubert died in 1426, however, Jan must have worked alone on its execution for another six years.
Illustrations:
103 The Birth of John the Baptist, c. 1422
104 Annunciation, completed 1432
104 Adam and Singing Angels, completed 1432

FOUQUET Jean
c. 1414/20 Tours (?) – c. 1480 Tours
Historical records provide almost no information about the life and work of the most famous French painter of his day. His only authenticated works are the miniatures in the *Antiquités judaïques* (Paris, Bibliothèque Nationale). That he was a painter of international repute is evidenced by documentary sources from the 15th and 16th century, which allow us to reconstruct his career. Fouquet probably learnt the art of manuscript illumination under Flemish-Burgundian masters, possibly the Limburg brothers. The illumination of lavish manuscripts clearly remained a central focus of his art throughout his life. In the 1440s Fouquet went to Italy, where he painted a portrait (now lost) of Pope Eugene IV, who died in 1447, giving us an approximate date for Fouquet's visit. He must also have attained a certain degree of fame to have attracted a commission from such high quarters; since a reputation takes time to build, this same commission allows us to at least approximate Fouquet's date of birth. Fouquet's confrontation with Italian painting – and in particular with the more three-dimensional modelling of the human figure in the work of Uccello and Castagno – exerted a pronounced influence upon his own style. As court painter to the French king from 1475, he succeeded in fusing these diverse influences into a courtly classicism unique in the painting of the 15th century, characterized by compositional rigour and a certain detachment.
Illustration:
113 Second Annunciation, c. 1453–1456

FRANCÉS Nicolás
c. 1390 (France?) – c. 1468 León
The painter, who was perhaps born in France and who may have started his

artistic career in Burgundy, was active in Léon in Spain from about 1430–1468. There he was decisively influenced by the Italian Early Renaissance painter Niccolò Fiorentino, who lived in Salamanca. His best-known works are the five surviving panels of the high altar retable for León cathedral, which he had completed by 1434. Only a handful of other works have come down to us, although documentary sources testify that he executed further panel paintings and designs for stained glass and frescos.
Illustration:
113 Mary Enters the Temple, before 1434

FROMENT Nicolas
c. 1430 Uzès (Gard) – c. 1485 Avignon
Together with the Master of the Aix Annunciation and Enguerrand Quarton, Froment illustrates the rich variety which characterized Provençal painting in the 15th century. Thanks to its geographical location, Provence was open to the most diverse influences. As Froment painted his first authenticated work – a *Lazarus* triptych (Florence, Uffizi) for the Minorite monastery in Mugello near Florence – in 1461, his date of birth can be put at around 1430 at the latest. Although probably executed in Italy, the triptych shows no Italian influences whatsoever, but suggests that Froment trained in the Netherlands in the circle of Bouts. Records give Uzès as his place of birth. The fact that he owned several houses in Uzès around 1470 indicates a healthy income earned from important commissions. From 1475/76 he was connected with the court of King René, for whom he executed his surviving masterpiece, the *Moses* triptych in Aix-en-Provence. He subsequently decorated the royal residence in Avignon, and his name appears repeatedly in account books until 1479. Sadly, these works have no more survived than his designs for tapestries and festive decorations. Froment, whose œuvre consists mainly of unauthenticated attributions, remained indebted all his life to his Netherlandish training. His few authenticated works nevertheless show a dynamic development towards a freer handling of space and landscape and a more realistic approach to detail.
Illustration:
128 Moses and the Burning Bush, 1475/76

GENTILE DA FABRIANO
(Gentile di Niccolò di Giovanni Massi)
c. 1370 Fabriano – 1427 Rome
Gentile, born in Fabriano in the Italian Marches, was the son of a cloth merchant. No doubt he must have encountered Sienese art at an early age, but all the evidence suggests that he trained in the great cultural centres of Milan and Verona. He is first officially recorded in Venice, where he remained from 1408 to at least 1414. There he earned great fame, above all with his paintings in the Doge's Palace. One of his Venetian

pupils was Jacopo Bellini, who became a famous painter in his own right – although later overshadowed by his sons Giovanni and Gentile. Nothing of Gentile da Fabriano's Venetian work survives, nor of the commissions he carried out for the Malatesta in Brescia, for the Pope in the Lateran Basilica in Rome and for clients in Siena. In 1427 he died while working on the frescos in the Lateran Basilica. His assistant and pupil Pisanello took charge of the project and his workshop, assimilating the artistic legacy of his mentor. The goals towards which the Sienese painters of the first half of the 15th century were striving found their fulfilment in Gentile. With his use of gold leaf and his wealth of colour effects and surface structures, he created an art of great visual and tactile charm. It provided an ideal medium through which the princes and rulers of the day could express their love of opulence and splendour. Amongst his contemporaries he ranked as a master of masters, and perhaps within his own generation he was. Art history singles him out for other reasons, particularly for his unusually modern treatment of light: thus the gold ground is seen as a source of light, irradiating the scene or casting shadows. He was also one of the first to use the medium of the freehand drawing as a basis of further studies and sketches.

Illustrations:

99 A Miracle of St Nicholas, 1425
99 St Nicholas and the Three Gold Balls, 1425
100 Adoration of the Magi, 1423

GIOTTO DI BONDONE
1266 (?) Colle di Vespignano (near Florence) – 1337 Florence
According to legend – Giotto was one of the first artists around whom legends have sprung up – he was discovered by Cimabue as a boy, sketching his father's sheep. Although he was indeed a pupil of Cimabue, he worked more or less independently within his workshop, as evidenced by a number of frescos in the Upper Church in Assisi, which are attributed to him with great certainty. Impressed by the classical art to be seen in Rome, and by French sculpture (in particular in Reims and eastern France) and the Tuscan sculptors Giovanni Pisano and Arnolfo di Cambio, he developed his own, innovative style – one which nevertheless defies explanation in terms of other influences. Giotto's au-

thorship of the famous *Life of St Francis* fresco cycle in the Upper Church of Assisi is disputed. If we assume that large sections were executed by other masters and various assistants, and that the cycle represents a very early work in which Giotto has not yet fully developed his own characteristic style, there seems little question but that the most accomplished frescos in the cycle are Giotto's. Amongst his few surviving works, however, his masterpiece is undoubtedly his decoration, from 1303 to 1305, of the private chapel built by the financier Enrico Scrovegni for his family in the Arena, a former Roman amphitheatre, in Padua. Documentary sources tell us that Giotto was the most famous painter of his generation in Italy. His services were engaged by numerous high officials and princes, including the Pope and his cardinals for works in Bologna and Rome (surviving in copies), King Robert of Anjou for large cycles in Naples, and the Scaligeri in Verona and Visconti in Milan. All these works, including large secular cycles, are lost. Of his late work, only some badly preserved frescos in side chapels of Santa Croce in Florence survive in outline. Giotto was an excellent organizer. He had a large workshop with a great number of well-trained assistants, so that he was in a position to undertake even the largest of commissions. In this he is comparable to Rubens. And like any professional painter (right up to the age of Dürer and Titian), it goes without saying that he was also a good businessman – in other words, he charged exorbitant fees. Towards the end of his life he was appointed chief architect of the city of Florence. Although little more than a title, Giotto does seem to have tried his hand at architecture. As the pioneer of modern painting, his impact was so enormous that his artist colleagues in Florence, however capable, were left struggling to keep up. It prompted more fruitful cross-fertilization in Siena and Upper Italy, but would only be taken further in Florence in the following century, with the generation of Masaccio.

Illustrations:

2 The Devils Cast out of Arezzo, c. 1296/97
15 Crucifixion, 1303–1305
16 The Marriage Procession of the Virgin, 1303–1305
43 Enthroned Madonna with Saints, c. 1305–1310
44 Joachim Takes Refuge in the Wilderness, 1303–1305
45 Anna and Joachim Meet at the Golden Gate, 1303–1305
46 The Lamentation of Christ, 1303–1305
46 St Francis Giving his Cloak to a Poor Man, 1296–1299

GIOVANNI DA MILANO (Giovanni di Jacopo di Guido da Caversago)
born in Caversaccio (near Milan), active 1346–1369, mostly in Florence
Giovanni probably trained in Lombardy, which had its own painting school of good repute. Giotto was also

employed in Milan by the Visconti (in the last year of his life), and thus Giovanni would have been introduced to the Florentine's innovations at the very start of his career. He is documented as living in Florence himself from 1346, although he continued to carry out commissions in Lombardy. He only finally became a Florentine citizen in 1366. His most important works are the frescos decorating the Capella Rinuccini, located in the chancel of the sacristy in Santa Croce in Florence. Giovanni proved himself to be one of the few painters who went beyond Giotto in Florence. In the delicacy of his palette and the smooth application of his paint, he was indebted to Sienese panel painting, but without becoming its imitator. From his background in northern Italy he brought a close study of nature, especially of animals. His figures appear solemnly calm, their faces strongly idealized. The ambivalence between ideal beauty and actual nature – so typical of the International Gothic – is already evident in Giovanni's work.
Illustration:
68 Pietà, 1365

GIRARD D'ORLÉANS
doc. 1344–1361 in Paris
Possibly issuing from the family of the painter Evrard d'Orléans, from 1344 Girard worked for the French court as a furniture painter. In 1352 he was appointed court painter and *valet de chambre* to John II, upon whose instructions he added to the oil paintings by Jean Coste at Vaudreuil château in Normandy. Only a few other authenticated works have survived. Alongside the portrait of John II, taken from a square triptych and executed during his imprisonment in England, there are records of a much-admired *Madonna*, which he painted for the small Carthusian monastery in Paris and at whose feet he was buried.
Illustration:
91 Portrait of John II "The Good", King of France, c. 1349

GOES Hugo van der
c. 1440 Ghent – 1482 near Brussels
Alongside the somewhat younger Hieronymus Bosch, van der Goes is the most important Netherlandish painter of the second half of the 15th century. Little is known about his life, and his artistic origins are also unclear. Records of 1480 name him as being born in Ghent. Since he was granted the title of master painter in Ghent in 1467, he must have been born around 1440–1445. As early as 1477 he gave up his workshop and became a lay brother at the Red Monastery near Brussels, where he died in 1482 after a severe mental illness. The Portinari Altar (Florence, Uffizi, 1476–1478) is his only authenticated surviving work, around which others can nevertheless be grouped with some certainty (Monforte Altar). Van der Goes had at his disposal all the techniques of the previous generation of Netherlandish masters, in particular van der Weyden, as regards the

representation of space, the organic construction of the human body, and the masterly portrayal of the material properties of luxurious accessories. But he wields these tools to quite different ends, employing them to achieve the greatest possible expressiveness in the gestures and faces of his figures, taking them even to the point of "ugliness". His Portinari Altar exerted a revolutionary influence upon Florentine painting; apparent in the works of Ghirlandaio and Filippino Lippi, it would prove most profound in the work of Leonardo da Vinci.
Illustrations:
130 Adoration of the Magi, c. 1470
131 Death of the Virgin, c. 1480

GONÇALVES Nuño
doc. 1450 – 1491 in Portugal
Portugal's most important artist was appointed court painter by King Alfonso V on 20. 7. 1450. In 1470 he was elevated to the knighthood, and in 1471 was made City Painter of Lisbon. In his treatise *De Pintura antiga* of 1548, the writer Francisco de Hollanda described the artist as a "lion amongst painters" and placed him a par with Michelangelo and Leonardo da Vinci. Francisco also recounts that, towards the end of the 1460s, Gonçalves executed the St Vincent Altar for Lisbon cathedral – one of the greatest works of Late Gothic painting anywhere – and in all probability the *Ecce Homo* (Lisbon, Museu Nacional de Arte Antiga) for the Holy Trinity monastery. Gonçalves' art is profoundly shaped by that of Jan van Eyck, who made an extended trip to Lisbon in 1428/29, and by the innovations of Rogier van der Weyden and Hugo van der Goes. His painting also reveals stylistic parallels with works

by the Provençal painter Enguerrand Quarton and the Spaniard Bartolomé Bermejo.
Illustrations:
139 "Fishermen", "Infante" and "Archbishop" Panels, c. 1469

GRASSI Giovannino de'
doc. from 1389–1398
Giovannino was court artist to the Visconti in Milan. He is first mentioned in connection with work on the building of Milan cathedral by the Visconti. His versatility is astonishing. He executed several sculptures (a medium which, judging by the surving results, did not suit him), decorated church banners, painted altarpieces, produced designs for tracery windows and probably also a wooden model of the cathedral, and acted as consultant on the building of the Carthusian monastery in Pavia. Of all these works, almost none have survived. As with Michelino da Besozzo, we have to turn to his manuscript illuminations in order to get an idea of his work. Most important thereby is a signed sketchbook in Bergamo library, containing some remarkable animal studies and other scenes of equally high quality. The difficulty surrounding this sketchbook, however, is that some of the drawings seem to have been done direct from nature, while others are probably copied from paintings. Nor are all the sketches by the same hand. It was probably a workshop compilation. We know that Giovannino was assisted in his work by his brother Porrino and his son Salomone as well as others. His artistic origins are not clear but he had many followers. His most important pupil and successor was Michelino da Besozzo.
Illustration:
75 Onions, c. 1380–1390

HENRIQUES Francisco
doc. from 1508 – 1518 in Lisbon
This artist was probably of Flemish extraction. He is documented in Portugal in the service of King Manuel I. After executing several works, above all for the Franciscan church in Evora, he spent the years 1512–1514 in Flanders. Shortly before 1518 he embarked upon a series of paintings for the royal court of justice in Lisbon, before being carried off – together with seven Flemish assistants – by the plague which had broken out in the city.
Illustration:
141 Meeting of Abra(ha)m and Melchizedek, c. 1508–1511

HOLBEIN Hans the Elder
c. 1465 Augsburg–1524 Basle (?)
The artist's parents were members of the upper strata of the artisan class. He probably trained in Ulm and in the Upper Rhine region. In 1493 he is recorded as a citizen of Ulm; one year later he returned to Augsburg and acquired citizenship through marriage. This marriage produced two sons, Ambrosius and the brilliant Hans the Younger. The elder Holbein seems to have saved up

some money fairly quickly, for in 1496 he purchased his own house on the lower Lech. His workshop also expanded during this period. From 1499 the commissions came pouring in, making him the best-known and most sought-after painter in southern Germany for a good decade. In 1502–1504, after a trip to the Upper Alsace, he executed the famous altarpiece for the Cistercian abbey in Kaisheim (the painted wings are today in Munich, Alte Pinakothek). In 1515 he left Augsburg, and is subsequently documented as working in Isenheim and Lucerne. Alongside elements of the Late Gothic style, he also processes new stimuli from the Italian Renaissance in his wide-ranging œuvre.
Illustration:
142 The Agony in the Garden, c. 1505

HUGUET Jaume (Jaime)
c. 1414 Valls (near Tarragona) – 1492 Barcelona
Huguet is an exemplary representative of Catalan painting of the 15th century, which remained indebted to medieval tradition and almost untouched by the innovations of the Early Renaissance. There are no records documenting his work before the year 1448, when he was commissioned to paint a *St James* altar for Arbeca. Between then and 1486, he executed a lengthy series of polyptychs, of which his *SS Abdon and Sennen* altar (1458–1460) and *Three Kings* altar (Barcelona, Museo de Historia de la Ciudad, 1464) stand out in particular. Huguet's painting underwent no notable stylistic development. He generally stuck to a gold background; spatial details were kept to a minimum, and the two-dimensional plane prevailed over physical volume. Huguet was so busy that he gradually employed more and more assistants in his workshop, which resulted in his works deteriorating in technical quality and becoming somewhat hackneyed in their appearance.
Illustration:
114 SS Abdon and Sennen, 1459/60

IVERNY Jacques
doc. 1411–1435 in Avignon
The attribution of the La Manta fresco cycle to Iverny has been disputed, but no useful alternative suggestions have been made. Nor has it been noted that, in the early 15th century, artists em-

ployed different styles for profane and sacred subjects, and that the religious sections of the La Mantua cycle in fact reveal great similarities with Iverny's signed altarpieces. There is no doubt, however, that the frescos in La Mantua castle, which lies some forty miles south of Turin, are the work of a French artist, which is not surprising as both the older and the younger Marchese of Saluzzo lived most of the time at the French court. The cycle is also notable for its large picture of the Fountain of Youth, which makes the elderly people who bathe in it young again and amorous. This unaccountably appears in the same room as a *Crucifixion* altarpiece. Very little is known about Iverny; he is documented longest in Avignon. But he also seems to have travelled widely, giving him an excellent knowledge of the art practised at the courts of northern France.
Illustration:
75 Five Heroines, c. 1420

JORGE Inglés
active c. 1445–1485 in Castille
The only authenticated work by this painter, whose origins are unknown, is the retable executed before 1455 which Iñigo López de Mendoza, Marquis of Santillana, commissioned for the chapel of Buitrago hospital. Its style suggests that the artist trained in the Netherlands.
Illustration:
115 Angel Altar, before 1455

JUAN DE FLANDES (Felipe Morros)
doc. from 1496, died 1519 probably in Palencia
The artist, who was surely born in Flanders, was active as painter to the Spanish court from 1496–1504. In c. 1500 he was commissioned by Queen Isabella of Castile to paint 46 small scenes from the life of Christ for her oratory. The resulting panels rank amongst the masterpieces to issue from the sphere of Early Netherlandish art (approx. one third of them are housed in Madrid castle). From 1505–1508 he was employed in Salamanca. Alongside a number of portraits, he also executed the high altar retables in Palencia and Salamanca cathedrals.
Illustration:
141 Christus at Emmaus, c. 1500–1504

KONRAD OF SOEST
c. 1370 Dortmund – after 1422 Dortmund
Konrad was born into a family of painters who had settled in Dortmund two generations previously, although they still seem to have had connections with Soest. His marriage in 1394 is the first date we have for him; the witnesses came from some of the town's more respected families. His surviving paintings suggest that he trained in Westphalia, as they follow older local traditions in their organization and their interpretation of the subject. At the same time, it must be assumed that

Konrad possessed an extensive knowledge of French and Netherlandish painting. Indeed, he seems so closely linked to this art that it may be possible to draw inferences from his paintings about much that has been lost in those countries. By the time he embarked upon the Wildung Altar (1403), he must already have had a large workshop assisting him, as not all the scenes appear to stem from his hand, not even in their overall concept. A major work from his later years is the altarpiece in St Mary's church in Dortmund, of which only fragments survive. From 1413 to 1422 he is recorded as a member of the confraternity of St Nicholas in Dortmund. He probably died soon afterwards. Konrad's painting served as a model for artists far beyond his own region. His influence was felt in central Germany and along the coast.
Illustrations:
81 Annunciation, 1403
81 Nativity, 1403

LEVI Juan de (Yojanán)
doc. 1388–1410
The Spanish painter came from a converted Jewish family. Between 1392 and 1403 he executed a large altarpiece for the cathedral in Saragossa. This was followed by further retables for the church in Montalbán, the church in La Hoz de la Vieja and for Tudela cathedral.
Illustration:
84 Peter Recognizes the Risen Christ on the Lake Shore, c. 1400

LIMBURG Paul, Jean, Herman
after 1385/90 Nimwegen (?) – 1416 Bourges (?)
The Limburg family came from the Aachen area. The three brothers were born in Nimwegen. Their father was a woodcarver, their uncle the celebrated Burgundy court painter Jean Malouel. The two younger brothers, Jean and Herman, are documented as apprentices to a Paris goldsmith in 1399. In 1402 the three brothers were commissioned by Duke Philip the Bold of Burgundy to illuminate a *Bible moralisée* (which still survives). Their fee was very high, which suggests that they had already established a name for themselves. After Philip's death, the Duc de Berry succeeded in securing the services of all three of them. When the Duke relocated their workshop to Bourges in

1411, Paul, the eldest and most prominent of the brothers, was given a magnificent house previously occupied by the Duke's treasurer. A close relationship existed between the Duke and the artists. According to records, Paul in particular received frequent gifts and was appointed *valet de chambre* in 1413, while another brother was made a canon of Bourges cathedral chapter. All three brothers are recorded as having died in 1416, probably the victims of an epidemic. They had not yet reached their thirtieth year, and left the *Très Riches Heures* unfinished. The Duke died in the same year at the age of 76. The brothers' artistic starting-point seems to have been the art of Malouel. They also spent time in Italy on behalf of the Duc de Berry; there they would have studied Lombard art, which the Duke greatly admired. The brothers' work simultaneously represents the high point of the period around 1400, the conclusion of one era and the transition to the next.
Illustrations:

10 Calendar of the months: May, 1414–1416
76 The Temptation of Christ, 1414–1416
76 Calendar of the months: June, 1414–1416
77 Calendar of the months: January, 1414–1416
78 The Expulsion from Paradise, 1414–1416
78 Miniature Accompanying the Prayer "Before setting out on a journey", after 1410

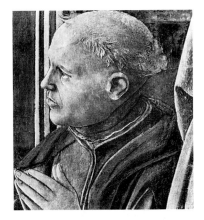

LIPPI Fra Filippo

c. 1406 Florence – 1469 Spoleto
Lippi is one of the most important successors to Masaccio. In 1421 he entered the monastery of Santa Maria del Carmine in Florence and was able to witness at first hand Masaccio's execution of his fresco cycle in the Brancacci Chapel. This encounter is reflected in Lippi's first surviving work, the now somewhat fragmentary frescos in the monastery cloister (1432), with their plastically-modelled figures and individual facial expressions. In the clear articulation of her body, his *Tarquinia Madonna* of 1437 (Rome, Galleria Nazionale) is similarly reminiscent of the main panel of Masaccio's Pisa Polyptych. In the 1440s, a tendency towards complicated turning movements and a restless treatment of drapery gains the upper hand (*Annunciation*, Florence,

San Lorenzo). Here lay the roots of the style subsequently evolved by his great pupil Botticelli. With the decoration of the choir of Prato cathedral between 1452 and 1465, a commission he took over in place of Fra Angelico, Lippi's artistic development reached its culmination. The cycle itself places him amongst the most outstanding fresco painters of his day. From 1456 Lippi was chaplain to Santa Margherita in Prato, but had to leave the order for a while after an affair with the nun Lucretia Buti. In c. 1457 she bore him a son, Filippino, who as a pupil and assistant of Botticelli would carry the latter's late style to to the point of "linear" Mannerism. In his own late period Lippi painted numerous versions of the *Adoration of the Child*, the most famous of which stood on the altar of the Medici private chapel.
Illustration:

133 Adoration in the Forest, c. 1459

LOCHNER Stefan

c. 1400 Meersburg (?) – 1451 Cologne
According to one source, Lochner (doc. 1442–1451) was born in Meersburg on Lake Constance, but subsequently left Constance for Cologne. It is not known where he was trained or when he came to Cologne. Most of his works would appear to date from the 1440s. Although Lochner must have been familiar with contemporary Netherlandish painting (Campin, van Eyck), its motifs are only rarely adopted directly. In Cologne, he undeniably oriented himself towards older painting. His art gives the impression of being first and foremost his personal own: any connections with earlier generations or other schools take second place. Lochner tailored his artistic means with great sensitivity to the subject, the genre, and the client. In the confidence and sophistication of his compositions, he had no equal in central Germany until Schongauer. Lochner was elected to the city council of Cologne in 1447 and 1450. He also had a flourishing workshop, which continued after he died (of the plague) in 1451. His manuscript illuminations are probably essentially products of his workshop.
Illustrations:

26 Annunciation, c. 1440–1445
126 Adoration of the Child, 1445
126 Presentation in the Temple, 1447
127 The Virgin of the Rose Garden, c. 1448

LORENZETTI Ambrogio

c. 1290 Siena (?) – c. 1348 Siena (?)
Ambrogio was probably the younger brother of Pietro Lorenzetti and certainly came from the same artistic background. Ambrogio, who is documented as living in Siena from 1319 to 1347, paid at least two lengthy visits to Florence. This may explain his detailed knowledge not just of the painting of Giotto, but also that of his Florentine successors. It may explain, too, the influence of Sienese art upon Florence, and particularly upon the genre of the small-scale devotional picture. In the

thoroughness with which he established space and depth, he was the most modern master of the 14th century. Noteworthy, as in the case of his brother, is his faithful observation of nature, and even more so the assurance and lightness with which he portrays movement and life, rhythm and emotion. While the mood in Pietro's painting tend towards sombreness, Ambrogio creates a more cheerful, more relaxed, richer atmosphere.
Illustrations:

42 Nursing Madonna, c. 1320–1330
58 Allegory of Good Government, c. 1337–1340
59 The Effects of Good Government: Life in the City, c. 1337–1340
59 The Effects of Good Government: Life in the Country, c. 1337–1342
60 Madonna and Child Enthroned, with Angels and Saints, c. 1340

LORENZETTI Pietro

c. 1280/90 Siena (?) – 1348 Siena (?)
Lorenzetti is documented from 1306 (?) until 1345, but as is the case with the other great Sienese masters, we know little about his life. Although a number of signed and dated paintings survive, question marks still hang over the chronology of his works. If the work carried out in 1306 for the Siena city council was really by his hand, then he must have been born around or before 1290. His first dated work is an altarpiece of 1320 for Arezzo parish church. The frescos in the Lower Church of Assisi are possibly somewhat earlier. These show that Pietro attempted a synthesis of Duccio – his starting-point – and Giotto, whose work he must also have studied. Even elements of Cimabue can be recognized, as can the innovations of Martini and the powerful expressiveness of Pisano's sculpture. And yet, as in the case of Duccio, an individual style emerges, characterized by an astonishing sensitivity to the time of the day and the year, a feel for light and its various reflections and shadows, and above all a great attention to the details of the real world in which his figures move. In his frescos Pietro aimed at massed effects, sometimes at the expense of narrative clarity. In his panel paintings, he adopted a different approach, demonstrating the scope and adaptability of his art. Striking in his art is a preference for sequences of cool, in particular greenish and grey tones. Pietro was probably Ambrogio's elder brother, and the two sometimes collaborated. They probably both died in the great plague of 1348, which carried off half the population of Siena.
Illustrations:

56 Sobach's Dream, 1329
56 Deposition, c. 1320–1330
57 Birth of the Virgin, 1342

LORENZO MONACO

(Piero di Giovanni)
c. 1370 Siena (?) – c. 1425
Lorenzo Monaco, who is documented as living in Florence between 1388 and

1422, was born in Siena in c. 1370. Of the Sienese painters, the most influential upon his work was Simone Martini, although the manner of his tonal sequences suggests that he also studied Pietro Lorenzetti. His early Florentine works reflect the style of Giotto's successors, such as Agnolo Gaddi. Even when these influences faded, he never returned to the strict two-dimensionality of older Sienese painting. In 1390 he entered the Camaldolensian monastery of Santa Maria degli Angeli in Florence. In 1402 he was admitted to the Florentine guild of painters. It seems that he left the closed monastic community at this time, but without giving up the monkhood. In 1414 he rented a house near to, and owned by, the monastery. He executed a number of miniatures in the service of his order. No other painter of the period around 1400 in Florence went so far in their stylization of form and colour. Lorenzo thereby sometimes departed entirely from plausibility. But it would be unjust to call him a merely decorative artist, for he opened up new possibilities in the credible representation of the celestial and the visionary.
Illustrations:

97 Annunciation, c. 1410–1415
97 Adoration of the Magi, 1421/22

MALOUEL Jean (Jan Maelwael)

c. 1397 in Paris–1419 Dijon
Malouel came from the Dutch province of Gelderland. In 1397 he was recorded as painter to the French queen. A year later he became court painter to the dukes of Burgundy in Dijon. He was in charge of the decoration of the Carthusian monastery of Champmol and was commissioned to paint five altarpieces. He also designed the decorations for court festivities. Alongside Bellechose, Malouel ranks amongst the outstanding exponents of the International Gothic at the Burgundy court. The two paintings attributed to him, a *Madonna with Angels and Butterflies* (Berlin, Gemäldegalerie, c. 1410) and a *Pietà* stand out for their measured composition, the plasticity of their figures and their delicate palette.
Illustration:

82 Pietà, c. 1400

MARMION Simon

c. 1425 Valenciennes or Amiens – 1489 Valenciennes
He probably received his initial training under his father, the painter Jean Marmion. From 1449 numerous sources document him as working for the cities of Amiens, Lille, and above all Valenciennes. In 1468 he became a member of the Tournai painters' guild. From 1454–1459 he worked on an altarpiece in the abbey of St Bertin, although in his own lifetime he was primarily known as a miniaturist, who produced numerous works of an extremely high artistic standard. In 1467, for example, he was commissioned to illuminate the Book of Hours of Duke Philip the Good of Burgundy (today London, British Museum).

Illustrations:

132 Scenes from the Life of St Bertin, before 1459

132 The Sacrifice of Isaac, c. 1487–1489

MARTORELL Bernat

active from 1427–1452

He worked chiefly in Barcelona, where he is first mentioned as a master in 1427. Already highly regarded, in 1433/34 the artist was in the service of the city. In 1433 he met the Florentine painter Dello Delli in Barcelona, and thereby came into contact with the new style of the Tuscan Renaissance. First and foremost, however, he was the most important Catalan representative of the International Gothic. He thereby also absorbed considerable influence from Lluís Borrassá. His earliest surviving work is the altarpiece from Púbol; he is also attributed with a St George Altar in the Louvre and a *Transfiguration of Christ* retable in Barcelona cathedral (c. 1447).

Illustrations:

114 St Peter Altar, 1437–1442

115 Christ and the Samaritan Woman at Jacob's Well, 1445–1452

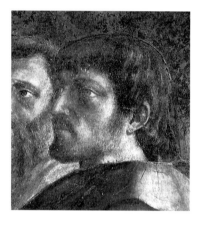

MASACCIO

(Tommaso di Ser Giovanni di Simone Guidi Cassai)

1401 San Giovanni Valdarno (Arezzo) – 1428 Rome

Masaccio's formative influences were the great Florentine sculptors, and in particular Donatello and Nanni di Banco, as well as the early works of Brunelleschi. In the field of painting, Giotto is the only adequate yardstick against which his achievement can be measured: for over a hundred years, Masaccio remained the only pupil and follower of Giotto whose art ranked with Giotto's own. At the same time, however, Masaccio's painting is infused with a new, passionate striving towards true-to-life representation. In 1422 he joined the Florentine Guild of Painters as a master. From 1424 he worked with Masolino on the decoration of the Brancacci chapel in Santa Maria del Carmine in Florence, and a little later executed the fresco of the *Holy Trinity* in Santa Maria Novella (1425/26). Masaccio shows himself in these works already a supreme master of his art, seemingly without having undergone any preceding stages of development. His painting

thereby combines a confident handling of perspective with a three-dimensional, "statuary" portrayal of figures. Architecture and landscape are highly naturalistic, but never become ends in themselves; rather, as in the works of Giotto, they serve to focus our attention even more intensely upon the events taking place within their midst. Light and shade thereby play a previously unknown role.

Illustration:

18 The Expulsion from Paradise, c. 1424/25

MASO DI BANCO

active 1320–1350 in Florence

As a master painter, Maso worked under the direction of Giotto on the great frescos in the Castel Nuovo in Naples, commissioned by King Robert d'Anjou. With Taddeo Gaddi, Maso is probably the most important pupil of Giotto known to us. His compositions employ a rigorous, two-dimensional layout. Records indicate that his career was badly hit during the crisis years of 1340–1350, during which Florence experienced first famine, and subsequently both economic and political upheaval.

Illustration:

49 St Sylvester Sealing the Dragon's Mouth, c. 1340–1350

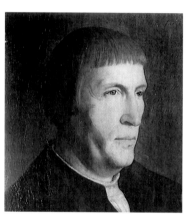

MASSYS Quentin

(also: Matsys, Metsys)

c. 1465/66 Louvain – 1530 Antwerp

Massys probably completed his training in Louvain under the influence of Bouts. His art ultimately remained dominated by its Early Netherlandish components, although he also adopted formal elements of the Italian Renaissance, which he probably only knew at second hand. We know nothing about his early work. His *St Anne* altarpiece of 1507–1509 (Brussels, Musées Royaux,) shows his fully-developed style. Elements of van der Weyden and new approaches to the representation of the human figure and space are combined in his St John Altar (Antwerp, Koninklijk Museum voor Schone Kunsten, 1508–1511). Massys's interest lay above all with the – often monumentalized – human figure. Hence his talent for portraiture, which he sometimes used as the starting-point for genre paintings.

Illustration:

144 Lamentation, 1508 – before 1511

MASTER OF THE ALBRECHT ALTAR

active 1430–1450 in Vienna

This anonymous master, who executed his later, high-quality works in a very hard, veristic style, takes his name from a large folding altar made up of 24 individual panels, which was donated by King Albrecht II to the Carmelite "Church of the Nine Choirs of Angels" in Vienna (today Klosterneuburg, Stiftsmuseum, and Vienna, Kunsthistorisches Museum). He is also attributed with a slightly earlier St Mary altarpiece. The pronounced Netherlandish influences evident in both of these works, in the style of Robert Campin, suggest that the artist had visited northern Europe.

Illustrations:

118 Elijah Divides the River of Jordan, c. 1437

118 Mary as Queen of the Powers, c. 1437

MASTER OF THE ANTWERP POLYPTYCH

active c. 1400

in southern Holland and on the Lower Rhine

On grounds of his style and iconography, the painter of the six small panels currently housed between the Walters Art Gallery in Baltimore and the Museum Meyer van den Bergh in Antwerp is considered to have lived in the wider region of Aachen, and has been dated to the period around 1400. The panels make up an altarpiece which probably came from the Carthusian monastery of Champmol near Dijon; strikingly, its layout follows that of the Orsini Polyptych by Simone Martini. The central panel comprises two scenes, the *Nativity* and the *Crucifixion*, and is flanked on the left by the *Annunciation*, and on the right by the *Resurrection*. The backs of the wings show (without a gold background) the *Baptism of Christ* and *St Christopher*.

Illustration:

79 Nativity, c. 1400

MASTER OF THE BEDFORD BOOK OF HOURS

active c. 1405–1430 in Paris

The anonymous miniaturist, influenced not least by the manuscript illuminations of the Limburg brothers, takes his name from a book of hours illuminated between 1423 and 1430, which was presented to Anne, sister of Duke Philip the Good of Burgundy, to mark her marriage to the Duke of Bedford (today London, British Museum). The Salisbury book of hours (Paris, Bibliothèque Nationale), which was also intended for the Duke of Bedford, remained unfinished after his death in 1435. Together with the Boucicaut Master and the Master of the Rohan Book of Hours, with whom he worked for a while in Paris, the Bedford Master was one of the most important French miniaturists of his day.

Illustration:

101 The End of the Flood, c. 1423

MASTER OF THE BERLIN NATIVITY

active c. 1330–1340 in southern Germany

Owing to its similarities with a manuscript of 1330–1340 currently housed in the Bayerische Staatsbibliothek in Munich (inv. no. clm 17005), but originally presented by Emperor Ludwig the Bavarian to Schäftlarn monastery south of Munich, it is possible to date and localize the Berlin *Nativity* fairly accurately. Its painter probably worked in Munich, and possibly also in Nuremberg, as the Heilsbronn altarpiece of c. 1346 is in the same tradition. Other works from his circle can be seen at the Bayerisches Nationalmuseum in Munich. The painter had a first-hand knowledge of Italian art. He comes particularly close to Florentine art in his forms and palette, and also in his use of embossing within the gold ground. He also seems to have been familiar with Sienese painting.

Illustration:

64 Nativity, c. 1330–1340

MASTER BERTRAM OF MINDEN

c. 1340 Minden (?) – c. 1414/15 Hamburg

Precisely where this important painter and possibly also woodcarver was trained remains a matter of dispute. His artistic roots appear to lie in Westphalia and Lower Germany, and above all in the Bohemian painting of the Prague court, whereby he also draws upon the French miniatures of such as Jean Bondol. Bertram is first documented in the Hanseatic city of Hamburg in 1367. He subsequently rose to become not just the leading master in Hamburg, but indeed one of the most important artists in northern Germany as a whole. In c. 1380 he executed his most important work, the high altar retable for St Peter's church in Hamburg. In 1383 Bertram is mentioned as owning a piece of land in Hamburg; further sources indicate that he must have run a large workshop. In 1390 he drew up his first will, in which he also speaks of a planned pilgrimage to Rome. A second will of 1400 mentions a daughter, Gesa, and his brother Curd von Byrde. In 1414/15 Bertram and his wife Grete are recorded as deceased members of the Confraternity of the Holy Cross of St John. In addition to his St Peter Altar, Bertram is attributed with a Passion Altar (Hanover, Niedersächsisches Landesmuseum), two panels in Paris and an Apocalypse Altar in London.

Illustrations:

29 Rest on the Flight to Egypt, c. 1379–1383

80 The Creation of the Animals, c. 1379–1383

MASTER OF THE BIBLE MORALISÉE

active c. 1250 in France

The *Bible moralisée* was commissioned by the French royal court and executed between c. 1220–1230. On each page of the manuscript, four pictorial medallions illustrating events from the Old

Testament are confronted with scenes from the New Testament or Biblical exegesis. Of the altogether 14 surviving examples of this type of manuscript, the Vienna version is the only one to be written in French. The miniatures, whose colours, style and arrangement recall the stained-glass windows of French cathedrals, can be dated to the middle of the 13th century, and would have issued from a workshop in Paris or the region north-east of the city.
Illustration:
41 Demiurge (God as Architect), c. 1250

MASTER OF THE BOOK OF HOURS OF MARY OF BURGUNDY

active c. 1470–1480
Derived from the book of hours compiled after 1470 and today housed in Vienna, this is the problematical name under which experts have grouped a number of southern Netherlandish illuminators. These include Nicolas Spierinc, Lievin van Lathem (formerly known as Philippe des Mazerolles) and the Master of Mary of Burgundy proper, who is attributed with the two most famous miniatures in the manuscript, showing the view through a window. Simon Marmion and Willem Vrelant also contributed illuminations. In addition to the present manuscript, which was completed – after a probable change of plan – for the heiress to the Burgundian throne and wife of Emperor Maximilian I, the Master of Mary of Burgundy and his workshop or followers are also attributed with another book of hours in Vienna, the *Book of Hours of Engelbert of Nassau* (Oxford, Bodleian Library), a number of miniatures in Berlin, and the *Prayerbook of Mary of Burgundy* in the Berlin Kupferstichkabinett. According to a recent hypothesis, this last is illuminated by Sanders Bening, while the main miniatures in the Vienna book of hours are ascribed to the painter Joos van Gent.
Illustration:
125 Dedication miniature for Mary of Burgundy (?), c. 1475–1477

MASTER OF THE BREVIARY OF PHILIP THE FAIR

active in Paris c. 1290 until shortly before 1318
In the so-called *Decretals of Gratian* (Tours, Bibliothèque Municipale), it is noted that the manuscript was purchased in 1288 from a certain Master Honoré, resident in the rue Erembourc-de-Brie in Paris. In 1296 this same Honoré is named in the inventory of the Louvre treasury as the master of the *Breviary of Philip the Fair*, which is probably identical with the copy today in the Bibliothèque Nationale in Paris. The master is also listed as a house-owner in Parisian tax records of 1293. The amount of tax he had to pay suggests that he must have run a large workshop. By 1318 he must have been dead for a while, as his son-in-law Richard de Verdun was already established as head of the workshop.

Illustration:
51 The Anointing of David and David and Goliath, c. 1290–1295

MASTER OF CATHERINE OF CLEVES

active 1435–1460 in Utrecht
The artist numbers amongst the most important representatives of northern Netherlandish manuscript illumination of the mid-15th century. He takes his name from a book of hours commissioned by Catherine of Cleves, Duchess of Gelderland, which is today housed – in two parts – in New York. The illuminations betray the influence of Jan van Eyck and Robert Campin. Miniatures in 14 other manuscripts have been attributed to the Master of Catherine of Cleves, suggesting that he ran a flourishing workshop.
Illustrations:
124 The Holy Family, c. 1440
124 St Vincent, c. 1440

MASTER OF COVARRUBIAS

active c. 1450
This artist executed an altarpiece whose parts are today distributed across several European museums. While stylistically rooted in southern Germany, it also reveals an in-depth knowledge of the Early Netherlandish painting of such artists as Jan van Eyck and Robert Campin. A Madonna painting in the Spanish collegiate church of Covarrubias, near Burgos, has recently been attributed to this master.
Illustration:
103 The Birth of Mary, c. 1450

MASTER OF THE DRESDEN PRAYERBOOK

active c. 1460 – after 1515
The artist takes his name from a richly illuminated prayerbook, now severely damaged, which is housed in Dresden. On the basis of these illustrations, he has been attributed with numerous other manuscript illuminations, including for example the Breviary of Isabella of Castile dating from the end of the 15th century (London, British Museum). He may have trained under Philippe de Mazerolles and the Master of Margaret of York. The influence of other Flemish miniaturists is equally present in his work.
Illustration:
135 Illustration to Psalm 68, before 1497

MASTER OF THE EICHHORN MADONNA

active c. 1350 in Prague
Named after the *Madonna* panel which came from Eichhorn castle in Moravia, but which probably originated in Prague. No other works have so far been attributed to his master. Although he is related in his motifs to the Master of Hohenfurth, as an artist he surpasses him to such a degree that, were we to postulate a master-pupil relationship, the Master of the Eichhorn Madonna

must have been the teacher. The style of the painting nevertheless suggests a younger artist, one who has embraced the greater stateliness and monumentality which Emperor Charles IV wanted Bohemian art to express and thereby made these "imperial" tendencies all his own.
Illustration:
62 Eichhorn Madonna, c. 1350

MASTER OF THE EVESHAM PSALTER

active c. 1250
The miniaturist, named after a psalter in London, deploys a dramatically expressive style which falls into the tradition of earlier Anglo-Saxon art, as found for example in the Amesbury Psalter in Oxford, which dates from the middle of the 13th century.
Illustration:
37 Crucifixion, c. 1246

MASTER, Franco-Flemish

active c. 1410
The outstanding *Portrait of a Lady* recalls portraits by the Italian painter Pisanello, to whom the work was indeed formerly attributed. It is now generally agreed that its artist belonged to the Franco-Flemish school and probably stemmed from the immediate circle of the Limburg brothers.
Illustration:
91 Portrait of a Lady, c. 1410

MASTER FRANCKE

c. 1380 Hamburg (?) – c. 1436 Hamburg
Francke (doc. 1424–1436) seems to have come from a family of shoemakers who had moved to Hamburg from Zutphen in Gelderland. He is estimated to have been born around 1380, as he must have been several years younger than Konrad of Soest, who was one of his formative influences. Francke entered the Dominican monastery of St John in Hamburg and was active as a painter there. This may have been why he did not have a large workshop of his own. Being a monk does not appear to have restricted his freedom of movement: his extensive knowledge of western European art must surely have been acquired over the course of several trips further afield. He was highly regarded by the Hamburg merchants, who supplied him liberally with commissions. We know that he also executed paintings for Reval and the See of Münster. His influence was profound, and continued to be processed by other artists even into the 1460s. Unfortunately, the major part of his work was destroyed at the hands of iconoclasts during the Reformation.
Illustrations:
94 The Miracle of the Wall, 1414
94 Nativity, c. 1424–1436

MASTER, French

active c. 1205–1215 in France
The master who was responsible for several stained-glass windows in the southern side aisle of the nave in Chartres cathedral cannot be pinned down in the shape of a single artist. Rather, the windows can be assumed to represent the combined efforts of a large workshop, which may perhaps be traced back to earlier works in Laon cathedral.
Illustration:
40 The Good Samaritan and Adam and Eve, c. 1205–1215

MASTER, French

active c. 1210–1215 in France
The master responsible for this window in Bourges is also called the Master of the Discovery of the Relics of St Stephen. He and his workshop executed eleven of the 22 stained-glass windows in the choir of Bourges cathedral.
Illustration:
41 The Road to Calvary and Donors, before 1214

MASTER OF THE GLATZ MADONNA

active c. 1345 in Prague
The anonymous master, named after the panel in Berlin, may equally well stem from Germany as from France or Bohemia. In the middle of the 14th century he headed a flourishing workshop in Prague. Together with pronounced influences from the art of the Italian Trecento, his paintings also reveal borrowings from the Rhineland. Stylistically related to the *Glatz Madonna* are the *Eichhorn Madonna* and a Madonna from Strahov monastery (Prague, Národni Galeri).
Illustration:
63 Glatz Madonna, c. 1343/44

MASTER OF GUILLAUME DE MACHAUT

active c. 1350–1355 in Paris
This miniaturist's œuvre, which was discovered and dated by François Avril, comprises several manuscripts produced chiefly for the court. He is named after the most important of these, the collected writings of Guillaume de Machaut. Although he held a position in the Church, Machaut's poetry was courtly rather than sacred in its themes and character. His favourite subject was love, disguised and paraphrased in allegory and accompanied by many decorative elements. In line with the courtly lifestyle of around 1340, Machaut formulated his sensual poetry in strangely artificial language. This style of writing ran parallel with contemporary tastes in art and dress. Never before had fashion been so sensuous; clothes emphasized the shapes and curves of the body, and were at the same time covered in a profusion of flounces, frills, ribbons and the like. In the fine arts, too, nature was beginning to find a place, but in a most artificial manner and without being studied directly from life. The Master of Guillaume de Machaut was an artist who, together with his large workshop, succeeded in fulfilling this same desire for a fantastical, artificial world.
Illustration:
74 · The Secret Garden, c. 1350–1355

MASTER OF HOHENFURTH
active c. 1350 in Bohemia
This master is named after a series of nine panels from the Cistercian monastery of Hohenfurth in southern Bohemia, today housed the Národni Galeri in Prague. His style suggests that he was a minor artist. His paintings are made up a mixture of elements of varying origin and tradition, and combine a variety of motifs without much originality. This may explain the heterogeneity of the œuvre of the Master of Hohenfurth.
Illustration:
64 Agony in the Garden, c. 1350

MASTER OF THE HOLY KINDRED
active c. 1410–1440 in Cologne
This master takes his name from his most important work, a triptych of *The Holy Kindred*, housed in Cologne (Wallraf-Richartz-Museum). Alongside the Master of St Veronica, he is the chief representative in Cologne of the International Gothic style. It is possible that he originated from the northern Netherlands, or completed his training there. His known œuvre is not very extensive. It thereby includes a *Crucifixion and Donors* triptych in Cologne (Wallraf-Richartz-Museum), a *Crucifixion with SS Catherine and Barbara* triptych (Darmstadt, Hessisches Landesmuseum), and finally a winged *Calvary Hill* altarpiece (Münstereifel, Kirchsahr parish church). He shares his name with another painter, who was active in Cologne in c. 1500. This latter is known as the Younger Master of the Holy Kindred in order to distinguish him from the present artist.
Illustration:
96 The Holy Kindred, c. 1425–1430

MASTER OF THE HOUSEBOOK
active c. 1470 – 1500 in the Middle Rhine region
This important painter and draughtsman, active in the Middle Rhine region, is called the Master of the Housebuch (*Hausbuchmeister*) after a number of drawings in a *Hausbuch* in the possession of the Princes of Waldburg-Wolfegg, near Ravensburg. Since no fewer than 88 of the engravings by his hand are in the Amsterdam Print Room (Rijksprentenkabinett), he also appears in the literature as the Master of the Amsterdam Cabinet. Of all the attempts to establish the real name of the artist, whose work reveals both Upper Rhenish and, above all, Early Netherlandish influences, the most convincing is his identification with Erhard Reuwich from Utrecht, who is documented in Mainz in 1484. His most important paintings are his Passion Altar of c. 1480 and a panel of a *Pair of Lovers* of 1480 (Gotha, Schlossmuseum) – works admittedly displaying pronounced differences in their painting technique.
Illustration:
134 Christ before Caiaphas, c. 1480

MASTER OF THE KAUFMANN CRUCIFIXION
active c. 1340 in Prague
The only work we possess by this important master is the present panel from the Kaufmann Collection (now Berlin, Gemäldegalerie). What makes it so valuable is the fact that it confirms the supremacy of Bohemian panel painting within central Europe as from c. 1330–1340. It also proves that several major artists were already active in Prague at the start of Charles IV's reign, including the masters of the *Glatz Madonna* and the Boston *Death of the Virgin* as well as the present artist. Although the geographical origin of the work is still the subject of dispute, its gold ground and flesh tones, its choice of palette and actual application of paint are paralleled only in Bohemian panels of the same period. Two of its motifs, moreover, were taken up by the Master of Hohenfurth. The Master of the Kaufmann Crucifixion was thoroughly conversant with the Italian art of his day, and was familiar with its essential achievements. But his painting reflects no preference for a particular artist or school – he was no mere imitator. His delight in bizarre hats, some of them clearly the product of his own imagination, is a northern Alpine characteristic. His artistic achievement lies above all in his exploitation of opposites, or at least powerful contrasts. The precepts of homogeneity and harmony underpinning Italian composition here give way to the deliberate juxtaposition of expression and ideal, beauty and ugliness.
Illustration:
62 Crucifixion, c. 1340

MASTER OF THE KLOSTERNEUBURG ALTAR
active c. 1330
The name given to the master who, in 1331, executed four tempera paintings on the reverse of a winged altar made up out of enamels by Nicholas of Verdun (from the end of the 12th century). The painter of these panels was an outstanding artist who must have studied at first hand the frescos by Giotto in the Arena Chapel in Padua, dating from the beginning of the century, and who transplanted the monumentality of Giotto's figures, and his new feeling for spatial depth, into art north of the Alps. The Central European Late Gothic style nevertheless continues to live on in his paintings. Also surviving from the artist's immediate circle is a Passion Altar, probably the work of a pupil, whose central section is housed in the Klosterneuburg Stiftsmuseum; one panel from its otherwise lost wings is in the collection of the Bayerisches Nationalmuseum in Munich.
Illustration:
53 Death of the Virgin, 1331 (?)

MASTER OF THE LIFE OF MARY
active c. 1460–1490 in Cologne
The painter derives his name from an altarpiece from St Ursula's church in Cologne, of which the larger part is today housed in Munich (Alte Pinakothek), with one panel in London (National Gallery). He is artistically related to the Master of the Lyversberg Passion, active at the same time, with whom he was for a while identified. On stylistic grounds he may be assumed to have trained in the Netherlands, where he must have encountered the work of van der Weyden and Bouts; although he was also influenced by the Cologne painting of the era of Stefan Lochner. The Master of the Life of Mary ranks amongst the most important Cologne painters in the years after 1450.
Illustration:
134 Christ Receiving the Crown of Thorns, before 1464

MASTER OF THE LONDON THRONE OF GRACE
active c. 1420–1440 in Austria
Named after the *Throne of Grace* in the National Gallery, London, probably originating from Styria. This master belonged to the same group of painters as the Master of the Offerings. Whether they actually worked exclusively in Vienna, or whether individual members of the workshop were based in Wiener Neustadt or in Styria, is not yet clear. The attribution of the small panel from St Lambrecht to the Master of the London Throne of Grace is itself a matter of debate. Its palette points to a knowledge of both Bohemian and Franco-Flemish art.
Illustration:
96 Madonna, c. 1420

MASTER OF THE NARBONNE PARAMENT
active c. 1370 – c. 1400 (?) in Paris
This outstanding artist is named after a grisaille painting on white silk, which at the start of the 19th century was still housed in Narbonne cathedral (today Paris, Musée du Louvre). He belongs to a group of manuscript illuminators in the school of Jean Pucelle who worked for the French court in Paris. The Master of the Narbonne Parament, who also seems to have been familiar with Sienese Trecento painting and who may be identical with the court painter Jean d'Orléans, documented from 1361 – 1407, also contributed to the first round of illuminations for the *Très Belles Heures de Notre-Dame* (Paris, Bibliothèque Nationale), begun in c. 1380.
Illustrations:
70 Entombment, Descent into Hell and Noli me tangere, c. 1375
70 Adoration of the Child, c. 1390 (?)

MASTER OF THE NEUHAUS MADONNA
active c. 1400 in Prague
It is not in fact certain that this panel was executed specifically for Neuhaus. It is probably a picture of the sort which were turned out by Prague workshops and kept permanently in stock, for sale to visitors to the city. Nevertheless, there is a fresco in the Minorite church in Neuhaus of a Madonna of exactly the same type, albeit of a later date. There might thus be a kernel of truth in the panel's historical connection with Neuhaus. The work itself is in poor condition. The upper section has been extensively restored. In stylistic terms, it comes closest to the illuminations in the 1409 missal executed for the Prague archbishop Sbinko von Hasenburg (in Vienna).
Illustration:
73 Madonna, c. 1400

MASTER, Norwegian
active c. 1340–1350
The painted antependium from Odda, Norway, which gives this artist his name is one of a number of works grouped under the heading of the School of Bergen. This also includes, for example, the antependium from Årdal and the antependium from Nedstryn, both in the University of Bergen (Historisk Museum). The close stylistic parallels between these works does not, of course, mean that they must all have issued from one and the same hand.
Illustration:
52 Antependium from the church in Odda, before or c. 1350

MASTER OF THE OFFERINGS
active c. 1420–1435 in Austria
This is the provisional name to which a number of pictures have been attributed, although – as experts have convincingly argued – greater differentiation is needed, since closer inspection of the group reveals more than one hand at work. However many they were, the artists in question were Austrian, and were active in Vienna, and perhaps also in Wiener Neustadt and Styria, in the years around 1420–1440. They drew their influences in part from the earlier works of the Master of Wittingau in Bohemia, but also from 14th-century Italian painting and western trends in the manner of the Limburg brothers (above all in the execution of dress). The workshop produced a great number of drawings, albeit more as if copied from a pattern book than in the sense of the Italian sketch. These may very possibly be derivations of types formulated by a single major artist working around 1420, whose style was subsequently perpetuated and varied by his workshop colleagues, but in paintings which mostly just repeated his pictorial types and individual motifs. The influence of this group of painters was felt as far as Regensburg and Middle Franconia. The panel illustrated here is probably one the earliest works in the group, and is certainly one of the best.
Illustration:
93 Christ at the Foot of the Cross with Mary and John, c. 1420

MASTER OF THE PÄHL ALTAR
active c. 1400 in Prague
The fact that this altarpiece came from Pähl castle on Ammersee lake, a castle which belonged to the Augsburg bishops, is more confusing than it is helpful, since it is most unlikely that it was painted for a chapel dedicated – as was

the case at Pähl – to St George. All attempts to trace its origins back to Salzburg or Augsburg have failed, however. The motifs it employs and the manner of its composition are undoubtedly Bohemian, and it contains elements which look back to Master Theoderic and the Master of Wittingau – compelling arguments for locating its origins in Prague around 1400. The present master aims less at inventing new motifs than at modifying old ones. While drawing upon standard canons of form in his draperies, gestures and heads, however, he at the same time refines them, in a process analogous to that seen in French art around 1300. He attaches supreme importance to subtle modulations of colour and sophisticated surface effects; these were paintings which appealed to a circle of buyers interested less in compositional innovation than in aesthetic refinement.
Illustration:
72 The Crucifixion of Christ between John the Baptist and St Barbara, c. 1400

MASTER OF THE PARADISE GARDEN
active c. 1410–1430 on the Upper Rhine
As a consequence of iconoclasm and the many wars in the region, very little Upper Rhenish painting has survived. What fragments do remain demonstrate very clearly, however, the important role played by the art of this region in the 14th and 15th centuries. During the first part of the 15th century, in particular, art production would have been given a significant boost by the Councils of Constance and Basle. Due to its affinity with other works of known provenance, such as the *Madonna of the Strawberries* in Solothurn, the *Paradise Garden* is undoubtedly a work of Upper Rhenish art. Whether it was painted in Strasburg, Basle, Constance or somewhere else is harder to answer. Its style has its origins in the *Crucifixion* in Colmar Museum, which dates from 1410 and whose artist trained in Bruges, as corroborated by miniatures also from Bruges. This indirect link may explain the proximity of some of the motifs used in the *Paradise Garden* to the early works of the van Eyck brothers.
Illustration:
87 Garden of Paradise, c. 1410

MASTER OF THE POLLING PANELS
active c. 1439–1452 in south Germany
The southern German painter takes his name from the wings of a St Mary altarpiece from the Augustinian canons' church in Polling, near Weilheim in Upper Bavaria (today Munich, Alte Pinakothek). He is also attributed with the wings of a Holy Cross altar from the same church, for which he worked from c. 1440–1450. There is no conclusive evidence to support his identification, as has sometimes been attempted, with Gabriel Angler.
Illustration:
122 Presentation in the Temple, 1444

MASTER OF THE PSALTER OF ROBERT DE LISLE
active before 1339 in England
The manuscript illuminator, based in the east of England, deploys a style typical of the region and the time, and characterized by abstract, geometrically patterned backgrounds. Related manuscripts include the Bromholm Psalter in Oxford, the Gorleston Psalter in Malvern and the St Omer Psalter in London (British Museum).
Illustration:
50 Crucifixion, before 1339

MASTER OF THE RAIGERN ROAD TO CALVARY
active c. 1415–1430 in southern Moravia
This master is named after a group of panels which came from the Benedictine monastery of Raigern, although whether they were originally painted for the monastery is not at all sure. Most of the master's surviving works come from Moravia, the eastern part of what is now the Czech Republic. This does not necessarily mean that the Raigern panels were also executed in Moravia, however, since there are other panels in a similar style which are more likely to have been produced in Prague. The artist certainly drew upon the motifs of the painters of the Prague school, such as the Master of Wittingau. There is also some affinity with the slightly earlier illuminations by the miniaturists around the Workshop of the Gerona Martyrology – another argument in favour of Prague as their place of origin. The painter must have sympathized with the Hussite reforms without breaking entirely with the old Church; he continued to paint subjects, such as legends of saints, which did not correspond with Hussite ideas.
Illustration:
88 The Road to Calvary, c. 1415–1420

MASTER OF THE RHEINAU PSALTER
active c. 1250 in south Germany
The artist takes his name from the miniatures of a manuscript, today housed in the Zurich Central Library, in which he interprets the zigzag style with outstanding originality. Although he must certainly have absorbed influences from Mainz and the Middle Rhine region, he cannot be linked with any one specific school of painting in 13th-century Germany. The psalter can thus only be localized somewhat broadly within the Regensburg-Salzburg area.
Illustration:
39 Resurrection, c. 1250

MASTER OF THE ROHAN BOOK OF HOURS
doc. c. 1420–1430 in Paris
The master was named after a book of hours in the Bibliothèque Nationale in Paris, formerly in the possession of the Rohan family. It was executed, however, for Jolanthe of Aragon, of the French house of Anjou. She had recently inherited the *Belles Heures* and *Très Riches Heures* from the Duc de Berry, following his death in 1416. The present artist would have had direct access not just to these, but also to the many illuminated manuscripts produced for the family in Italy, above all in Naples. Only a few miniatures in the Rohan Book of Hours are both drawn and executed by the master himself. This was true even more so of other manuscripts produced for court circles. He was probably a panel painter (there are pictures from his workshop in the museum in Laon) who executed miniatures as a sideline. He was anything but a courtly court painter; as one of the generation of the Bohemian Hussite painters, he produced unlovely, inelegant work with an aversion to decoration. Not without reason did he become the first painter to make the subject of death all his own.
Illustrations:
28 Portrait of Ludwig II of Anjou, c. 1435
83 Lamentation, c. 1420–1427

MASTER OF THE ST BARTHOLOMEW ALTAR
c. 1445–c. 1515 Cologne
The present artist, named after the altarpiece which he executed at the start of the 16th century for St Columba's church in Cologne (today Munich, Alte Pinakothek), was a panel painter and miniaturist who originated either from the Lower Rhein or, more probably, from the Netherlands. He seems to have spent some of his youth in Utrecht, as evidenced by his only dated early work, a book of hours for Sophia von Bylant (Cologne, Wallraf-Richartz-Museum) of 1475. While his first paintings, such as his *Virgin and Child with St Anne* completed c. 1480 (Munich, Alte Pinakothek), are similarly indebted to Netherlandish influences, in c. 1500 he developed his own characteristic style, which would in turn come to stamp Late Gothic painting in Cologne. The altar wings of c. 1505–1510 in Mainz (Mittelrheinisches Landesmuseum) and London (National Gallery) point to the former existence of a pendant to the St Bartholomew Altar from St Columba's.
Illustration:
138 Descent from the Cross, c. 1510

MASTER OF ST VERONICA
active c. 1400–1420 in Cologne
This artist, named after the panel today housed in Munich, is a particularly typical representative of Cologne painting from the years around 1400–1420. Since there seem to have been many other artists in Cologne working in a very similar style – a consequence partly of the weighty tradition of Cologne's own school of painting, and partly of the great influence which the Master of St Veronica exerted upon his colleagues – it is hard to determine the precise extent of his œuvre. The dating of individual panels also poses a problem, one that has yet to be convincingly resolved. The upheavals wrought by secularization erased their entire history – for not one of his paintings is dated, and in not one of them can we identify a donor, or even establish the painting's purpose, with complete certainty.
Illustration:
95 St Veronica with the Sudarium, c. 1420
95 Calvary Hill, c. 1415

MASTER OF THE ST VITUS MADONNA
active c. 1390–1400 in Prague
The panel from St Vitus' cathedral in Prague is the only surviving work by this late 14th-century painter. Unfortunately, we know neither whether it was originally executed for the cathedral, nor whether it actually depicts one of the bishops. The mitre on its own might denote one of Bohemia's Benedictine or Cistercian abbots just as much as a canon of Prague cathedral. The saints portrayed within the frame, namely Wenceslas, Vitus, Sigismund, Adalbert and Procopius, are all patron saints of Prague cathedral, but at the same time also patron saints of Bohemia. Of the stylistic factors which might suggest a date of origin, the small frame reliefs would date the panel clearly before 1400.
Illustration:
73 Madonna, c. 1390–1400

MASTER OF THE SCHLOSS TIROL ALTAR
active c. 1370
The painter of this important altarpiece probably trained in c. 1360 under Master Theoderic in Prague, and would thus have been thoroughly versed in the Bohemian painting of the day, with its Italian influences. He will subsequently have moved on to become a court painter in Vienna. It seems most probable that he was employed by Duke Albrecht III., and may have been the Master Konrad documented in sources from 1368 until before 1402. Whether the latter is identical with the painter who executed the portrait of Duke Rudolf IV must remain a matter of speculation.
Illustration:
93 Nativity, c. 1370–1372

MASTER OF THE STERZING ALTAR WINGS
active c. 1450–1470
The artist is named after the wings which he painted for the Sterzing Altar, whose carved figures were executed by Multscher in 1456–1459. The panels are masterpieces of Ulm painting and clearly betray a knowledge of Early Netherlandish works, such as those of van der Weyden. The artistically outstanding panels were long attributed to Multscher himself. They nevertheless differ considerably in style to the panels of the Wurzach Altar in Berlin, completed in 1437, which are confidently believed to stem from Multscher's own hand. It is possible, however, that Multscher delegated the painting of the Sterzing panels to an independent master, or to one of the senior journeymen in his workshop, who may well have executed the compositions to Multscher's own designs.

Illustration:
121 Annunciation, 1456–1459

MASTER THEODERIC

doc. from 1359, died c. 1381
Records of 1359 mention a house owned by Theoderic, painter to the emperor. Since he is later referred to as *familiaris*, Theoderic can be seen as closer than most artists to the court he served. In 1367 he was granted tax exemption for an estate in Morin which lay at the foot of Karlstein castle, and which had probably previously belonged to his predecessor at court, the Strasburg painter Nikolaus Wurmser. This exemption from taxes was granted, it was explained, because Theoderic had created "skilful and solemn paintings" and had decorated the chapel in an "inventive (including in the technical sense) and ingenious" fashion. These words from the emperor's own lips were praise indeed. Yet it is unclear where Theoderic came from and where he trained. While Bohemian and Italian art form his starting-points, he seems to have absorbed certain influences from German art of the day, such as the sculpture of the Parler workshop, with its block-like character and monumental heaviness, which thereby incorporates stylistic elements of 13th-century sculpture. Theoderic's art is in turn distinguished by its monumentality, its orientation towards the past, and its integration of various trends, including Italian, western European and Byzantine. In artistic terms, he thereby seems to have expressed precisely what the emperor wanted to say. From 1355 to 1375, painting in Bohemia was entirely under his sway.
Illustrations:
17 St Gregory, c. 1360–1365
66 Crucifixion, c. 1370
66 St Jerome, c. 1360–1365

MASTER OF THE TUCHER ALTAR

active c. 1430–1450 in Nuremberg
The anonymous artist takes his name from an altarpiece commissioned by the Tucher family in Nuremberg and today housed in the Frauenkirche. Nothing is known of the artist's origins. Aspects of his style suggest that he may have trained in Austria in the circle of the Master of the St Lamprecht Votive Panels. This was probably followed by extended trips to the art centres of the Netherlands and Burgundy, during which he encountered the work of Campin and others. His own painting is distinguished by the extremely three-dimensional modelling of its figures, something probably inspired by Claus Sluter, the great Burgundian sculptor. An important master, he left no direct successors in Nuremberg.
Illustration:
122 The Circumcision of Christ, c. 1440–1450

MASTER, Upper Rhenish (?)

active c. 1310 – 1320 (?) in Zurich
It is to this anonymous artist that we owe 110 of the altogether 137 full-page miniatures accompanying the Manesse song manuscript. This richly illuminated collection of German lyric poetry was compiled in the 1st third of the 14th century in Zurich. Typical of the chief miniaturist, who probably also employed workshop assistants and was active in c. 1310–1320, are his contrasts of powerful, unmixed colours, dominated above all by vermilion and purple, blue, green and gold. He demonstrates a masterly wealth of invention in the composition of his secular subjects, for which he had virtually no existing models upon which to draw. His Upper Rhenish origins are indicated by stylistic parallels between his miniatures and contemporary wall painting and stained glass from the same area, and with earlier works from the Alsace. Since no other illuminations by this master are known, it is possible that his artistic roots lay in another discipline.
Illustration:
53 Schenk of Limburg, c. 1310–1320

MASTER, Viennese or Bohemian (?)

active c. 1360–1365
Stylistic analyses of the portrait of Rudolf IV have regularly spotlighted its links with the Prague court art of just a few years earlier, and with its leading protagonist, Master Theoderic. The Vienna painting also features other innovations derived from Bohemian painting. In view of the numerous artistic exchanges taking place between Bohemia and Austria, however, it is equally conceivable that the portrait was the work of an Austrian artist, whose style looks forward to the somewhat later Master of the Schloss Tirol Altar.
Illustration:
92 Portrait of Duke Rudolf IV of Austria, c. 1360–1365

MASTER OF THE WASSERVASS CALVARY

active 1415–1435 in Cologne
The artist, who in the past has been wrongly identified with the Master of St Veronica, takes his name from the *Calvary* panel donated to St Columba's church in Cologne by Gerhard von Esch, who was also called "von dem Wasservass". He stands outside the main currents of contemporary Cologne painting of his day, and left no school behind him. No other works can be attributed to him. He probably originated from the Netherlands, or at least trained there; he also seems to have been well acquainted with Burgundian manuscript illumination.
Illustration:
25 Calvary Hill, c. 1420–1430

MASTER OF THE WESTMINSTER ALTAR

active c. 1270–1290
The anonymous painter is named after an artistically outstanding retable in Westminster Abbey – the sole surviving example of the panel painting issuing from the Anglo-French court in the 13th century. It is correspondingly difficult to categorize its artist, whose style bears some affinities with that of the miniatures in, for example, the Douce Apocalypse (Oxford, Bodleian Library) of c. 1270, as well as with a number of murals, probably dating from the 1260s, formerly in the medieval Westminster Palace. The retable also recalls the decorative style employed in the Ste-Chapelle in Paris around the middle of the 13th century.
Illustration:
50 Westminster Altar, c. 1270–1290

MASTER, Westphalian

active c. 1230–1240 in Soest
Although the earlier *Crucifixion* retable from Soest, today housed in the Berlin Gemäldegalerie, can be broadly positioned within the artistic currents of its day, the fact that so few examples of 13th-century German panel painting have survived means that it cannot be grouped into any more specific stylistic context.
Illustration:
36 Trial, Crucifixion and Resurrection, c. 1230–1240

MASTER, Westphalian

active c. 1260–1270
The artist behind the Soest retable with the *Throne of Grace* at its centre has also tentatively been attributed with a panel painting of the *Virgin in Glory* from the Carrand Collection in the Bargello, Florence. For the moment, however, this attribution remains hypothetical.
Illustration:
37 Throne of Grace with Mary and St John, c. 1260–1270

MASTER OF THE WILTON DIPTYCH

doc. c. 1390–1395
The unknown master of the Wilton Diptych was probably English, and active at the English court around the period 1380–1395. A painter in the International Gothic style, his name is derived from the fact that his diptych was formerly located at Wilton House, the seat of the Earl of Pembroke. This is the only work to have been attributed to him. His painting is distinguished by its delicate colours, its tendency towards an ornamental handling of line, and the precision of its ornamentation.
Illustration:
82 The Wilton Diptych, c. 1395 (or later)

MASTER OF WITTINGAU

active c. 1380–1390 in Bohemia
We know nothing about this master, and have to deduce everything from his pictures. He was named after his principal work, the former altarpiece in the Augustinian Canons' church in Wittingau in southern Bohemia. Its high altar was consecrated in 1378; the altarpiece was perhaps already completed at this point, or finished soon afterwards. The Master of Wittingau must certainly have been active by no later than 1395, since the Jérén epitaph of this same date makes clear stylistic references to his art. His paintings for Wittingau coincided with the reform of the monastery, in which the emperor played an active role. Hence, too, it is suspected that his workshop was in Prague, rather than in southern Bohemia. A Madonna panel from his workshop, which originated from Raudnitz, north of Prague, seems to confirm this. The reconstruction of the altarpiece still presents problems. The two panels illustrated are from the workday side of the altarpiece, as evidenced by the fact that the painter has used a red ground instead of gold. The master employed assistants on the Wittingau Altar. He had a large workshop and was extremely influential in his own day. We can only speculate about his artistic origins. He shows no evidence of any links with Italian art. His starting-point was undoubtedly older Bohemian painting. Thus the soldier on the left in *The Resurrection* cites the pose of the Child in the *Eichhorn Madonna*. His grasp of lighting can also be traced back to Master Theoderic. The Master of Wittingau may also have been influenced by Franco-Flemish panel painting, of which nothing now survives, and which we can only attempt to reconstruct from the – somewhat later – paintings of Broederlam. In his innovative interpretation of subject and composition, and above all as a colourist, the Master of Wittingau is outstanding amongst the artists of central Europe between 1350 and 1400.
Illustrations:
67 The Agony in the Garden, c. 1380–1390
67 The Resurrection, c. 1380–1390

MASTER OF THE WORCESTER ROAD TO CALVARY

active c. 1420–1435 in Bavaria
The artist, named after a small panel now in Chicago, exerted a decisive influence upon manuscript illumination in the Regensburg of his day. His style can be traced back to the traditions of Bohemian art of c. 1400. It is apparent, too, that the painter trained in the sphere of Vienna court art, which he reinterprets, however, in favour of an ever more dramatic realism. His former identification with Martinus Opifex has now been dismissed.
Illustration:
88 Worcester Road to Calvary, c. 1420–1425

MEMLING Hans

c. 1430/40 Seligenstadt (Main) – 1494 Bruges
Little is known about his apprenticeship and early work. He may have trained in a Middle-Rhenish or Cologne workshop before moving to the Netherlands. In 1465 he is documented in Brussels; from 1466 he was active in Bruges. He was probably amongst the last pupils of van der Weyden. Whatever the case, Memling's earliest authenticated works are greatly influenced

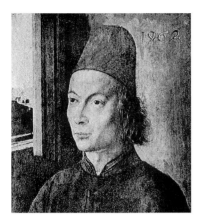

by him, right down to their composition. The young artist was also impressed by the work of Bouts, as evidenced by his *St Mary* altar of 1468 (London, National Gallery). He subsequently evolved his own style, which is characterized by the graceful movements and expressions of his figures, an exquisite palette and a wealth of narrative detail. Up to a certain point, Memling could be described as the Gozzoli of Netherlandish painting. He lacks depth of expression and the ability to handle crowd scenes convincingly. Memling's paintings are the sum of accurately observed and life-like details (*Scenes from the Life of Mary*, Munich, Alte Pinakothek, 1480). He reveals little personal development. The influence of the Italian Early Renaissance can be felt in his late work, albeit restricted to isolated elements (*Madonna and Child*, Florence, Uffizi).

Illustration:
129 The Mystic Marriage of St
 Catherine, 1474–1479

MICHELINO DA BESOZZO
(Michelino Molinari)
doc. 1388–1442
Michelino, who came from Pavia, is mentioned as the painter of a cycle of frescos in 1388, and must therefore have been born around 1370 at the latest. A contemporary source relates that he could paint animals excellently even before he had learnt to speak. His contemporary Alcherius, who in his capacity as art agent to the Duc de Berry met Michelino in Venice in 1410, called him "the most outstanding of all the painters in the world". Documents relating to the building of Milan cathedral, begun under Giangaleazzo Visconti, praise him as *pictor supremus* (supreme painter) and a master of stained glass. Neither his stained glass nor any of the other works which he executed for the cathedral have survived. All evidence of his work as an architect has similarly vanished. In view of his talent for animal painting, he may have trained under Giovannino de' Grassi; Stefano di Giovanni (or da Verona) was more likely to have been his pupil. The works that survive are essentially miniatures, in which he reveals himself to be an artist who deploys the French canon of form against highly original backgrounds of flowers and other ornamentation. He was also a fine colourist and an accomplished portrait painter.

Illustrations:
86 The Christ Child Crowns the
 Duke, c. 1402/03
86 The Mystic Marriage of St
 Catherine, c. 1410–1420

MOSER Lukas
c. 1390 Weil der Stadt – after 1434
Lukas Moser (doc. 1419–1434) was born in Weil der Stadt near Stuttgart, but probably worked mostly in Ulm, where he also produced designs for stained glass. Moser's reputation is based on his *Magdalene Altar* in Tiefenbronn. It is his only signed and authenticated work. It bears a strange inscription on its frame: "Schri kunst schri und klag dich ser, din begert iecz niemen mer so o we 1432 lucas moser, maler von wil maister dez werx bit got vir in." ("Cry, art, cry and lament greatly, for none covets thee now, oh woe! 1432 Lucas Moser, painter of Weil, master of this work, pray to God for him". The words may sound like the lament of an ageing artist, yet in terms of style Moser was one of the most modern. Perhaps no one wanted his art because it was too modern; perhaps his outburst can be traced back to the undercurrent of hostility towards painting following Huss's condemnation of icons and following the reforms of the Council of Constance. Moser was certainly familiar with Upper Italian art, and perhaps also with earlier Tuscan painting. He probably visited Provence and southern France, and also had first-hand knowledge of Franco-Flemish innovations.

Illustration:
105 Magdalene Altar, 1432

MULTSCHER Hans
c. 1390 Reichenhofen – c. 1467 Ulm
Alongside Witz, Multscher is the most important German painter and sculptor of the first half of the 15th century. His first signed work, the carved Karg Altar in Ulm Minster, was badly damaged by iconoclasts in 1531. His sandstone model for the tomb of Duke Ludwig the Bearded (Munich, Bayerisches Nationalmuseum) has been dated to around 1434. While the master here applies painterly qualities to the genre of sculpture, the painted panels of his 1437 Wurzach Altar, which probably once stood in the parish church of Landsberg am Lech, are full of sculptural vitality. Around 1450 Multscher entered a new stylistic phase. In his woodcarvings for St Laurence's chapel in Rottweil, he renounces pure decorativeness in the draperies of St Barbara and Mary Magdalene, and replaces it instead with an emphasis upon the physical form and upon the logical fall of the fabric, as determined by the shape of the body. This development culminated in his altarpiece for the Frauenkirche in Sterzing, executed between 1456–1459. Unfortunately, this work, too, has been dismembered. The painted panels are closely related to those of the Wurzach Altar in terms of motif, but betray the hand of a younger master.

Illustration:
121 Death of the Virgin, 1437

OPIFEX Martinus
doc. c. 1440–1456
The Regensburg miniaturist, who gives his latinized name in the manuscript of the *Trojan War* (Vienna, Österreichische Nationalbibliothek), was a pupil of the Master of the Ottheinrich Bible (Munich, Bayerische Staatsbibliothek). He first appears in Regensburg records between 1440 and 1446, where he is recorded as owning a large workshop. It is in Regensburg that he would have met Emperor Friedrich III, for whom he worked in Vienna between 1446 and 1449. From 1451 he was once more living in Regensburg.

Illustrations:
117 "Here the Greeks sail for Troy",
 before 1456
117 "Here Jason and Medea get out
 of bed", before 1456

PACHER Michael
c. 1435 Bruneck (Tyrol) – 1498
Salzburg
Pacher ranks amongst the small number of 15th-century artists who played a leading role in two different genres. His contribution as a painter was equalled by his importance as a woodcarver. Pacher's training and early work are still areas of conjecture. However, he may have absorbed influences from the altarpiece which Multscher completed for Sterzing parish church in 1459. From 1467 Pacher is documented in Bruneck, where he ran a large workshop. The winged altarpiece which he began in 1471 for the parish church of Gries, near Bozen, and which features a *Coronation of the Virgin* in its shrine, provided the stepping-stone to his masterpiece, a winged altar combining reliefs, statues and panel paintings and destined for the church of St Wolfgang in the Salzkammergut. The contract for the altar was drawn up in 1471, and stipulated that Pacher had to deliver and instal the final work himself. The altarpiece is signed 1481. The portrayal of the *Coronation of the Virgin* interweaves with the rich forms of the tracery into a unified pattern of lines. Light and shade – painterly properties, as it were – are employed to create the suggestion of indefinite depth. The life-size figures reveal Pacher as a contemporary of Verrocchio and Pollaiuolo: both north and south of the Alps, artists were simultaneously striving to depict the human figure moving in space and seen from different angles. The altar wings comprise paintings whose bold handling of perspective calls to mind the works of Mantegna, such as Pacher could have studied in Verona, Mantua and Padua. Just as Pacher invokes painterly qualities in his woodcarving, so he translates categories of woodcarving into his painting. In his 1483 Church Fathers' Altar for Neustift monastery near Bressanone, the blurring of the border between painting and sculpture reaches an extreme unequalled in Early Renaissance art north of the Alps.

Illustration:
137 The Temptation of Christ,
 1471–1481

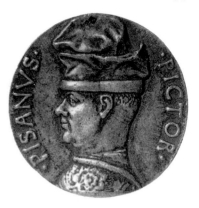

PISANELLO
(Antonio di Puccio Pisano)
before 1395 Pisa – 1455 Rome (?)
Pisanello's father came from Pisa, his mother from Verona, both these cities then being under the rule of the Visconti. He received his training in the Lombardy region, though it is not possible to say exactly where. He is first documented as working with Gentile da Fabriano on the decoration of the Doge's Palace in Venice, and may perhaps previously have been Gentile's pupil. The two artists certainly worked closely together from this time onwards. Pisanello is suspected to have collaborated on the *Adoration of the Magi* in the Uffizi, painting the horses and other animals. It is certain that he assisted Gentile on the frescos in the Lateran Basilica in Rome, and completed them after Gentile's sudden death. Both masters have bequeathed us a large number of drawings, which is itself remarkable for the time. More important still, however, are the insights which they offer into Gentile and Pisanello's art. Thus their intensive study of nature is no longer limited to animals and plants, but extends to all sorts of interesting things, such as a hanged man and a bathing girl. They explore their new interest in classical antiquity, copying statues and reliefs from Roman sarcophagi. They also make drawings of the works of their contemporaries, such as Michelino da Besozzo and Altichiero, and the Tuscan innovators Donatello, Fra Angelico and Luca della Robbia. Pisanello executed commissions for the rulers of Upper Italy, the Gonzaga in Mantua, the Este in Ferrara, the Malatesta in Rimini and even King Alfonso of Naples. But he never became dependent on any of these patrons. He was enormously admired amongst his contemporaries for his naturalism.

Illustrations:
107 Portrait of Lionello d'Este,
 1441 (?)
107 The Virgin and Child with SS
 George and Anthony Abbot,
 c. 1445
108 The Vision of St Eustace,
 c. 1435

PUCELLE Jean
active c. 1319–1335 in Paris
Pucelle, the greatest of the miniaturists working for the French court in his day, probably trained in the workshop of Maître Honoré of Amiens, where he

may have already been working by around 1315. He is first documented in connection with a remittance made between 1319 and 1324 for the design of a seal for the exclusive confraternity of the Hospital St. Jacques aux Pélerins in Paris. The master is named several times in classification systems and inventory notes. In the Duc de Berry's inventory, for example, the Book of Hours of Jeanne d'Evreux is referred to as the *Heures de Pucelle*. Classifying a book by its artist was far from normal practice in those times, and may be seen as a great accolade. Pucelle's style was perpetuated by colleagues virtually right up to the end of the 14th century, and was also extensively copied at the specific request partly of King Charles V, and partly the Duc de Berry. Pucelle must have visited Italy around 1320. Alongside a thorough knowledge of Duccio's art, motifs from Giotto and other Italian painters can also be identified in his work.

Illustration:
51 The Betrayal of Christ and The Annunciation, 1325–1328

SASSETTA (Stefano di Giovanni)
c. 1392 Siena (?) – 1450 Siena
Sassetta is first documented in 1423. Nothing is known about his origins and training. His paintings suggest that he oriented himself largely towards the art of Simone Martini and to some extent the Lorenzetti brothers, whereby he drew fruitful inspiration from their example, rather than remaining – like some of his Sienese colleagues – merely their imitator. Contrary to Sienese fashion, he also absorbed influences from Lombardy and Florence, as evidenced in his treatment of space. In his original handling of his subjects and forms he surpassed all the Sienese painters of the 15th century. His contemporaries viewed him as an authority on a par with the giants of the Trecento. Some of them imitated his style so faithfully that their works were for a long time thought to have been painted by Sassetta himself.

Illustrations:
98 The Mystic Marriage of St Francis, 1437–1444
98 The Procession of the Magi, c. 1432–1436

SCHONGAUER Martin
c. 1450 Colmar – 1491 Colmar
His name probably derives from the town of Schongau, although from 1329 the family are documented in Augsburg, where there were members of the gentry. Schongauer's father Caspar, evidently a well-known goldsmith, moved from Augsburg to Colmar in 1445. Having first been sent to Leipzig to study at the university, Martin subsequently returned to his father's workshop, where he learned the engraving and drawing which would prove so decisive for his future. Only then did he go on to train as a painter, probably under Caspar Isenmann in Colmar. Schongauer is the most important engraver and draughtsman in German art before Dürer. Schongauer's painting is characterized by his mastery

of the fine detail, primarily rendered through fanciful line. In this he follows the general trend in European art in the 1470s and 1480s – comparable, for example, to Botticelli in Italy, only a few years his senior. Stylistic features of his figural and landscape painting suggest that Schongauer visited the Netherlands, where he must have been profoundly influenced by the works of van der Weyden and his followers.

Illustration:
137 Adoration of the Shepherds, c. 1480 (?)

SERRA Pere
doc. c. 1343 – 1405 in Catalonia
Serra is one of the most important representatives of the early International Gothic in Catalonia. In 1363 he is still documented in the workshop of his brother Jaime, but towards 1368 he seems to have set up on his own. His most important work is the Holy Ghost Altar in the cathedral of Santa María in Manresa. There are six known copies of the painting, testifying to the great popularity which Serra enjoyed. Several Madonna panels also stem from his hand.

Illustration:
84 Holy Ghost Altar, 1394

SIMONE MARTINI
(Simone di Martino)
c. 1280/85 Siena – 1344 Avignon
Simone's projected date of birth is based on a 16th-century source, but may well be accurate, even though the date of his first signed work, the fresco of the *Maestà* in the Palazzo Pubblico in Siena, is a relatively late 1316. Such is his stylistic diversity that it has proved impossible so far to table a chronology of his works. It is not inconceivable, for example, that the *Maestà* in Siena, the devotional panels comprising the Orsini Polptych, and the altarpieces in an old-fashioned style which he executed for Pisa and Orvieto, are all in fact contemporaneous. Whatever the case, Simone's works indicate that he had studied Duccio, Giotto and French art with the same intensity. He also drew inspiration from his sculptor colleagues, and in particular Giovanni Pisano. Even though this eclecticism is still detectable in the Orsini Polyptych, we can be certain that, by c. 1315, Simone must have already been a famous master. Otherwise it is most unlikely that he would have been awarded the *Maestà* commission in

Siena. Nor would we find him, in 1317, being paid an astonishingly high salary in the service of Robert d'Anjou, who even raised him to the nobility. The Angevin kings of Naples and their supporters were his major patrons during these years. Together with his large workshop, he also worked for the City of Siena and various other clients in central Italy. Simone introduced some of the most significant innovations in the genre of the devotional panel, such as the so-called Madonna dell' Umiltá (Mary kneeling and at the same time suckling the Child). From 1339 at the latest he is documented in Avignon, where he worked for Cardinal Stefaneschi and other senior clergymen. While he left a school of followers both in Siena and Avignon, some of his achievements became the common property of all 14th-century art. Already highly praised in his lifetime – including by Petrarch, for whom he executed several works – his fame lived on not only in Siena, where in the early 15th century he was considered the greatest Sienese painter of all, but also, for a long time, north of the Alps.

Illustrations:
14 Maestà, 1315/16
54 Guidoriccio da Fogliano, c. 1328
54 Musicians, 1317 – 1319
55 The Road to Calvary, c. 1315 (or later)
55 The Deposition, c. 1315 (or later)

STEFANO DI GIOVANNI
(Stefano da Verona, Stefano da Zevio)
c. 1374/75 – after 1438
Recent research has shed significant new light on this important Upper Italian artist. From now on we must call him by a new name: Stefano di Giovanni or da Francia (from France). His father was the painter Giovanni d'Arbois (in the Franche Comté), who left Lombardy upon being appointed court painter to the Duke of Burgundy. Sadly, nothing of his work remains – it would undoubtedly have yielded important information about early painting in Burgundy and Lombardy, and about their intertwinement. His son Stefano must have been very familiar with French art, although it is not known whether he actually visited France. Records show that he spent an extended period in Padua (1396–1414) and paid an earlier visit to Treviso. He is documented in Verona only from 1425 onwards. If his *Virgin of the Rose Garden* was intended from the start

for the nun's convent of San Domenico in Verona, from where it reached its present home, then it can only have been executed in 1425 or later. Alongside some important drawings, Stefano's surviving works are found chiefly within and around Verona, and include numerous frescos. His style reflects the influence above all of Michelino da Besozzo, just a few years his senior.

Illustration:
87 The Virgin of the Rose Garden, c. 1425

TOMMASO DA MODENA
c. 1325/26 Modena – 1379
Tommaso was the son of a painter called Barisino dei Barisini, and his own son Bonifacio also became a painter. Tommaso probably trained in Bologna. Having previously been overshadowed by Tuscan art, by the mid-14th century the Bolognese school, embodied by such masters as Vitale da Bologna, was asserting its own identity. Tommaso evidently regarded Sienese art very highly, above all that of Simone Martini. He probably produced miniatures as well as panel paintings. He lived and worked in Modena, but carried out commissions all over Upper Italy. Alongside his frescos in Mantua and Trento, his reputation was cemented by the works which he executed for Treviso in Venetia. Emperor Charles VI also commissioned him to paint panels for Karlstein castle. Tommaso was a keen-eyed observer of people and objects. His most famous work, executed in 1352 for the chapterhouse of the Dominican church in Treviso, is his series of precisely drawn portraits of Dominican theologians, in which the "famous men" of the Order are presented in their small studies in order of clerical rank. Tommaso concentrates in his painting above all on the portrayal and grouping of figures; he does not concern himself with translating them into three dimensions, or indeed addressing spatial problems of any kind.

Illustration:
49 The Departure of St Ursula, c. 1355–1358

WEYDEN Rogier van der
c. 1400 Tournai – 1464 Brussels
Rogier was the most important representative of Netherlandish painting in the years immediately following Jan and Hubert van Eyck. Like no other painter of the 15th century outside Italy, he thereby developed formulae – both compositional and figural – which were adopted into every genre of painting north of the Alps. Nor should we underestimate the extent of his influence in Italy, where he was considered one of the most important artists of his day. Rogier was apprenticed to Campin in 1427 – a surprisingly late date. Although it has frequently been argued in the past that his early work is identical to that of Campin, such a theory does not appear to hold water. Having only become a master in 1432, in 1436 he was appointed official painter to the City of Brussels. A visit to Rome in the jubilee year of 1449/50 precipitated an ex-

change between art north and south of the Alps which would prove one of the most fruitful of the entire 15th century. Rogier took as his starting-point the three-dimensional figural ideal of Campin and Jan van Eyck, and proceeded to clarify its anatomical structure. At the same time, he perfected the portrayal of interiors and landscapes in proper perspective. Direct references to earlier masters – as, for example, in his several surviving versions of *St Luke painting the Virgin*, which cite Jan van Eyck's *Virgin of Chancellor Rolin* (Paris, Louvre, 1434–1436) – became far less frequent from about 1440 as he strove to find an artistic balance between depth and plane. Figures grow more slender, draperies and interior décors become more elegant, and realistic detail gains in importance within the overall design.
Illustration:
102 Madonna and Child with SS Peter, John the Baptist, Cosmas and Damian, c. 1450 – 1460

WITZ Konrad
c. 1400 Rottweil – 1445 Basle or Geneva
Witz was the most multi-talented German painter of the first half of the 15th century. His significance can be compared in various respects with that of Masaccio and Jan van Eyck. His birthplace, Rottweil, was an important centre of trade which was independent of any feudal or ecclesiastical authority, and must have helped fuel his interest in the portrayal of the real world. We neverthless know little about his early training. Historical records yield only a few items of information about his life and work. In 1434 "Master Konrad of Rottweil" was admitted to the Basle Guild of Painters, and in the same year was granted citizenship of Basle. The last we hear of him is in the inscription accompanying *The Miraculous Draught of Fishes*, in which Witz gives his name and the date 1444. Witz addressed himself in equal measure to the problems of translating three-dimensional figures into two-dimensional painting, and of portraying interior and exterior spaces in correct perspective. In his sculptural treatment of the painted "statues" in his *Mirror of Salvation* altarpiece (Basle, Kunstmuseum, c. 1435), Witz surpassed his contemporaries in Italy (Masaccio) and the Netherlands (van Eyck) to such a degree that it has prompted the question as to whether

he was also a woodcarver. No proof of this exists. Although his interiors (e.g. *Annunciation* in Nuremberg, *Virgin and St Catherine in a Church*, Strasburg) employ a mathematically imprecise system of perspective, they succeed in suggesting remarkable depth. Witz seeks to capture landscape and architecture with the greatest possible fidelity to life. While it can be confidently assumed that he was familiar with Netherlandish painting, it is possible, too, that he also had some knowledge of Italian art.
Illustrations:
20 The Miraculous Draught of Fishes, 1444
120 Madonna and Saints in the Church, c. 1440–1445

WORKSHOP, Cologne
active c. 1330 – 1340
Just how many artists made up the workshop which executed the murals in the north parclose of Cologne cathedral – outstanding examples of the German painting of their day – remains thoroughly uncertain. Attempts to link the paintings stylistically with other works of the era have similarly been rewarded with little success up till now.
Illustration:
52 The Baptism of Constantine; "The Donation of Constantine"; Sylvester's Dispute with the Jewish Scholars, c. 1335

WORKSHOP OF THE INGEBORG PSALTER
active c. 1213
So-called after the psalter of Queen Ingeborg of France, second wife of King Philippe Auguste. Ingeborg, who came from Denmark, was disowned by her husband. They were reconciled in 1213, and the psalter was probably a conciliatory gift. The workshop was active in Paris and comprises two principal painters and several assistants. The two painters, both of equal quality, also illuminated other manuscripts, sometimes together and sometimes alone, mainly for the court. As well as being thoroughly familiar with Byzantine art, they were probably in touch with contemporary manuscript illumination from northern France and England. They must also have known the works of the Meuse goldsmith Nicholas of Verdun. The miniatures appear as a complete series of pictures before the actual psalter itself, and without reference to the text, with two double pages of illuminations followed by two blank ones.
Illustration:
35 Embalming of the Body of Christ and The Three Marys at the Empty Tomb, c. 1213

WORKSHOP OF THE LOUIS PSALTER
active 1258 – 1270
This Paris-based workshop is named after its most important work, the psalter produced for King Louis IX, the Saint, of France. Another magnificent psalter, now in Cambridge, probably belonged to Louis' sister, the Abbess Isabella.

These works can only be dated on the basis of entries in necrologies and other stylistic and historical considerations (thus after 1258, the year in which one of the king's daughters married the Count of Champagne, but before 1270, the year of the king's death). The workshop was well organized. Its master had probably earlier worked on the illumination of manuscripts for the royal library of Sainte Chapelle in Paris. He impressed his style so forcefully upon his assistants – of whom at least six contributed to the psalter – that their hands are difficult to separate. The uniformity underlying the decoration and composition of the miniatures is part of the tendency towards standardization which had become palpable in art even before 1350. With the basic principles thus laid down, illuminations differed only in their degree of sophistication and the lavishness of their décor.
Illustration:
39 Joshua Stops the Sun and Moon, c. 1258–1270

WORKSHOP, Lower Saxon
active c. 1230 – 1240
The style of the painted ceiling in the nave of St Michael's in Hildesheim argues against the dating of c. 1200 frequently put forward in earlier times. It is highly likely that the paintings were executed by monks in a workshop within St Michael's monastery itself. Other, directly related works are unknown, but there are clear parallels with a group of Lower Saxon illuminations from the mid-13th century.
Illustration:
38 Jesse and The Fall, c. 1240

WORKSHOP OF THE GERONA MARTYROLOGY
active c. 1405–1425
Currently assembled under this name are patently different illuminations, which have yet have to be distinguished. They include the so-called Joshua Master of the Antwerp Bible, the Martyrology in the Gerona Diözesanmuseum, and illuminations cut out of the Book of John of Mandeville in the British Library. Together, their artists comprised the dominant trend in Prague manuscript illumination from the first decade of the 15th century into the 1420s. Their style reveals them processing influences from western Europe and Upper Italy in equal measure. They must also have had close links with panel painting, as evidenced both by their use of its techniques and by their preference for strict pictorial layouts.
Illustration:
92 The Story of Creation, c. 1415

WORKSHOP OF THE PAPAL PALACE
active c. 1340 in Avignon
The chief surviving paintings by this workshop are the frescos of various hunting scenes which decorate the Deer Room in the Tour de la Garde-Robe, built in 1342/43 under Pope Clemens VI, in the Papal Palace in Avignon. The

style of the paintings suggests that they were designed by Italians, while their execution was probably entrusted to French assistants. The master in charge may possibly be identical with Matteo di Giovanetto da Viterbo, who was the current court painter to the Pope.
Illustration:
74 Fishing, 1343

WORKSHOP, Strasburg
active c. 1460 until after 1470
The workshop which manufactured the stained-glass windows for the Alsatian church of Walburg thereby inaugurated a flowering of Late Gothic stained-glass production in Strasburg. In the last third of the 15th century, Strasburg workshops supplied stained glass not just to the Alsace and Lotharingia, but across the whole of southern Germany.
Illustrations:
136 Temptations and The Anointing of Christ's Feet in the House of the Pharisee, 1461

WORKSHOP, Thuringian
active c. 1350
The workshop which executed the parclose retable with *Crucifixion* remains an isolated artistic phenomenon. Even as it lends its figures the pronounced modelling found in Bohemian painting of the mid-14th century, it renders other components in a more two-dimensional, linear style.
Illustration:
65 Parclose retable with Crucifixion, c. 1350

WORKSHOP OF THE WENCESLAS BIBLE
active c. 1390–1410 in Prague
This name in fact describes a loose association of several workshops, in turn consisting of various, and in part very different, artists. Some of them, thanks to signatures, we know personally; others have been given provisional names reflecting their individual characteristics. It is nevertheless acceptable to assemble these various artists and workshops under the heading of the "Workshop of the Wenceslas Bible". The fact that they were executing large, private commissions for the king means that they must have been initiated to some degree into his esoteric symbolism and personal tastes. They must have included leading figures with close connections to the circle of royal courtiers and favourites, who understood the meaning of their private symbolism and so could insert witty cross-references between the principal picture and the illustrations in the margins. Providing the artistic starting-point for the workshop as a whole was the earlier manuscript illumination from Bohemia and Italy, in particular Bologna. When its royal patronage ended in around 1405 – the Wenceslas Bible remained unfinished – the workshop dissolved back into its individual components.
Illustration:
72 Emperor Wenceslas as an Astronomer, c. 1395–1400

Photo credits

The editor and publisher wish to express their gratitude to the museums, public collections and galleries, the archivists and photographers, and all those involved in this work. The editor and publisher have at all times endeavoured to observe the legal regulations on the copyright of artists, their heirs or their representatives, and also to obtain permission to reproduce photographic works and reimburse the copyright holder accordingly. Given the great number of artists involved, this may have resulted in a few oversights despite intensive research. In such a case will the copyright owner or representative please make application to the publisher.

The locations and names of owners of the works are given in the captions to the illustrations unless otherwise requested or unknown to the publisher. Below is a list of archives and copyright holders who have given us their support. Information on any missing or erroneous details will be welcomed by the publisher.

The numbers given refer to the pages of the book, the abbreviations a = above, b = below.
Antella (Firenze), Scala Instituto Grafico Editoriale S. p. A.: 58. – Barcelona, Archivo Iconografico, S. A.: 61 a, 116. – Barcelona, Institut Amatller d'Art Hispànic: 84 a, 113 b, 115 a, 115 b, 141 a (© Patrimonio Nacional Madrid). – Barcelona, © Servei Fotogràfic Museu Nacional d'Art de Catalunya (Calveras/Mérida/Sagristà): 85, 106 b. – Bergen, © Historisk Museum Universitetet: 52 a (S. Skare). – Berlin, Archiv für Kunst und Geschichte: front cover, 55 b, 60, 64, 105, 137 a. – Berlin, Bildarchiv Preussischer Kulturbesitz (J. P. Anders): 36, 37 a, 63, 121 a, 130, 132 a, 133, 137 b. – Chicago, photograph © 1999, The Art Institute of Chicago. All Rights Reserved: 88 a. – Cologne, Dombauarchiv: 52 b

(Matz and Schenk). – Cologne, Rheinisches Bildarchiv: 25, 26, 95 b. – Darmstadt, Hessisches Landesmuseum: 96 b (W. Kumpf). – Florence, INDEX s.a.s., Ricerca Iconografica: 69, 71 b (Magliani), 106 a (Agosto), 120 b (L. Pedicini), 121 b (Comune di Vipiteno). – Geretsried-Gelting, Lisa Bahnmüller: 89. – Graz, Akademische Druck- und Verlagsanstalt: 35 b, 39 b, 41 b, 125 a. – Hamburg, Elke Walford Fotowerkstatt: 94 b. – Hildesheim, Manfred Busch: 38 a, 38 b. – Koblenz, Landesmedienstelle Rheinland-Pfalz: 134 a. – Lisbon, Divisão de Documentação Fotográfica – Instituto Português de Museus: 139 (J. Pessoa), 141 b (L. Pavão). – London, The Bridgeman Art Library: 37 b, 74 a, 101 b, 103 b, 120 a, 129 a, 129 b, 131. – London, © Dean and Chapter of Westminster: 50 a. – Lucerne, Faksimile Verlag Luzern: 10, 70 b, 76, 77, 78 a. – Milan, Gruppo Editoriale Fabbri: 43, 108 f. – Munich, Archiv Alexander Koch: 62 b, 111 b, 126 a. – Munich, Bayerisches Nationalmuseum: 72 b, 123 – Munich, © Praun Kunstverlag: 33. – Münster, Westfälisches Landesmuseum für Kunst und Kulturgeschichte: 23 (R. Wakonigg). – Paris, Photographie Giraudon: 40, 41 a, 104 a, 113 a, 119. – Paris, © Photo RMN: 138 (H. Lewandowski). – Peißenberg, Artothek: 18 (Bridgeman), 102 b (Blauel/Gnamm), 104 b, 143 (J. Blauel). – Trondheim, Nidaros Domkirkes Restaueringsarbeider: 21. – Vic, Museu Episcopal: 82 b (J. Gomis). – Vienna, © Bundesdenkmalamt (Foto Beranek): 118 a, 118 b. – Vienna, Foto Stefan Fiedler: 53 a. – Weimar, Constantin Beyer: 65. – Wiesbaden, Hessisches Landesamt für Denkmalpflege: 81 a.

The remaining illustrations used belong to the collections mentioned in the captions or to the editor's archive, and the archive of Benedikt Taschen Verlag, Cologne. The portraits of the artists in the biographical section are reproductions from the archives of the editor and the publisher.